This book, benefitting AIDS education in Africa, is made possible by:

Underwriters

OLYMPUS

ANHEUSER BUSCH
Companies

ChevronTexaco

Partners

 Apple

Le **MERIDIEN**

BMG
BERTELSMANN

LJCB Investment Group

Sponsors

 LEXAR
Media

The World Bank Group

Eskom

 PUBLISHERS GROUP WEST

@radical.media

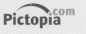 Pictopia.com

SOUTH AFRICAN
AIRWAYS

Important additional support was provided by:

Air France, Minds@Work, Rush Labo,
RFI Radio France Internationale, Blue Pixel,
Camera Bits, GretagMacbeth, and
nik multimedia, Inc.

For the children of Africa:
Its future
And its hope.

— Lee Liberman

First published in 2002 by Tides Foundation, San Francisco. Distributed by Publishers Group West.

Copyright © 2002 Western Arts Management.

A Day in the Life® is a registered trademark of HarperCollins Publishers and is used with their gracious permission.

ISBN 0-9718021-0-6

Library of Congress Control Number: 2002107856

Project Director: David Elliot Cohen
Producer: Lee Liberman

Printed in Singapore
First printing October 2002

10 9 8 7 6 5 4 3 2 1

Previous Page > *Photograph by Larry C. Price*

A DAY IN THE LIFE OF AFRICA

Photographed by the world's
leading photojournalists on one day

Directed by David Elliot Cohen
Produced by Lee Liberman
Senior Editor, Charles M. Collins

Foreword by Archbishop Desmond Mpilo Tutu
Introduction by Kofi A. Annan

TIDES

FOUNDATION

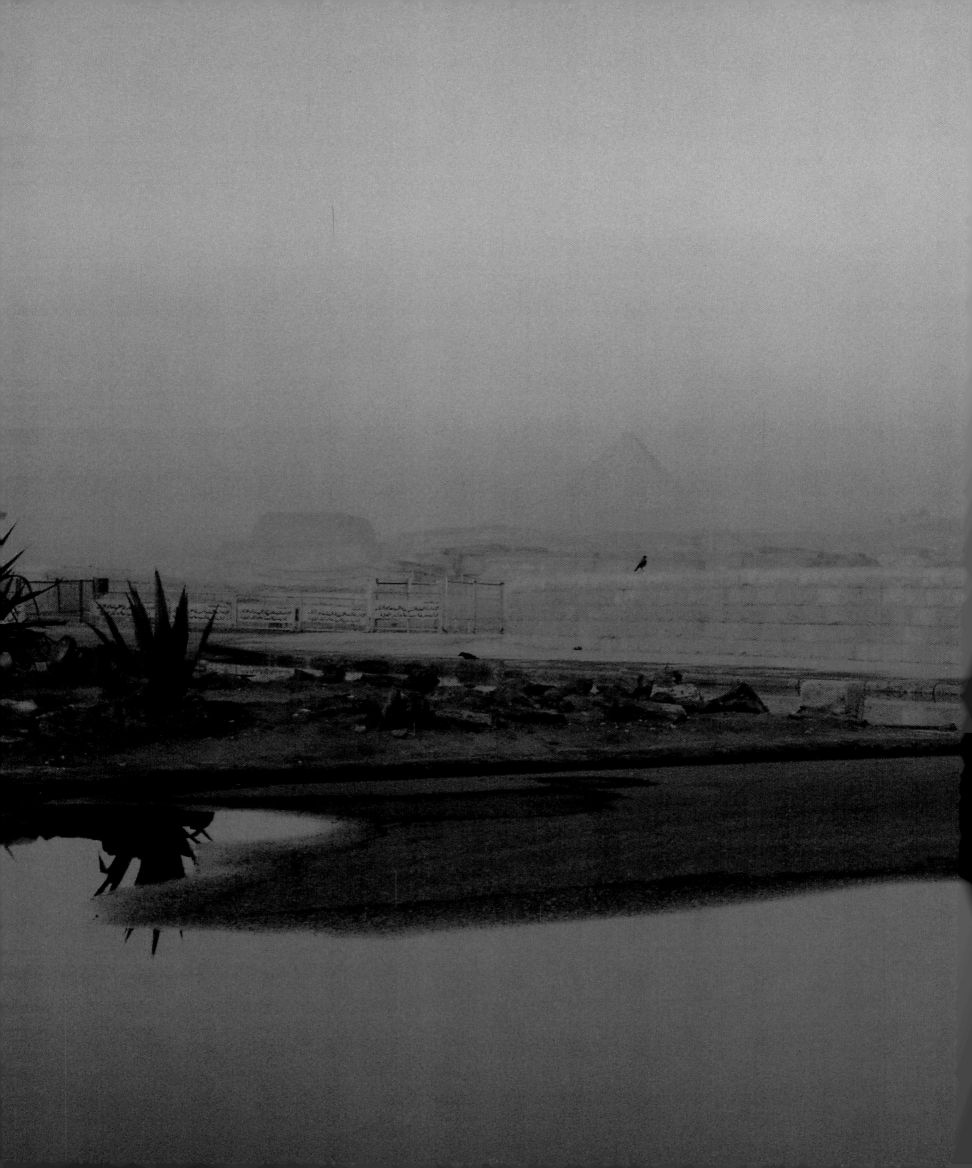

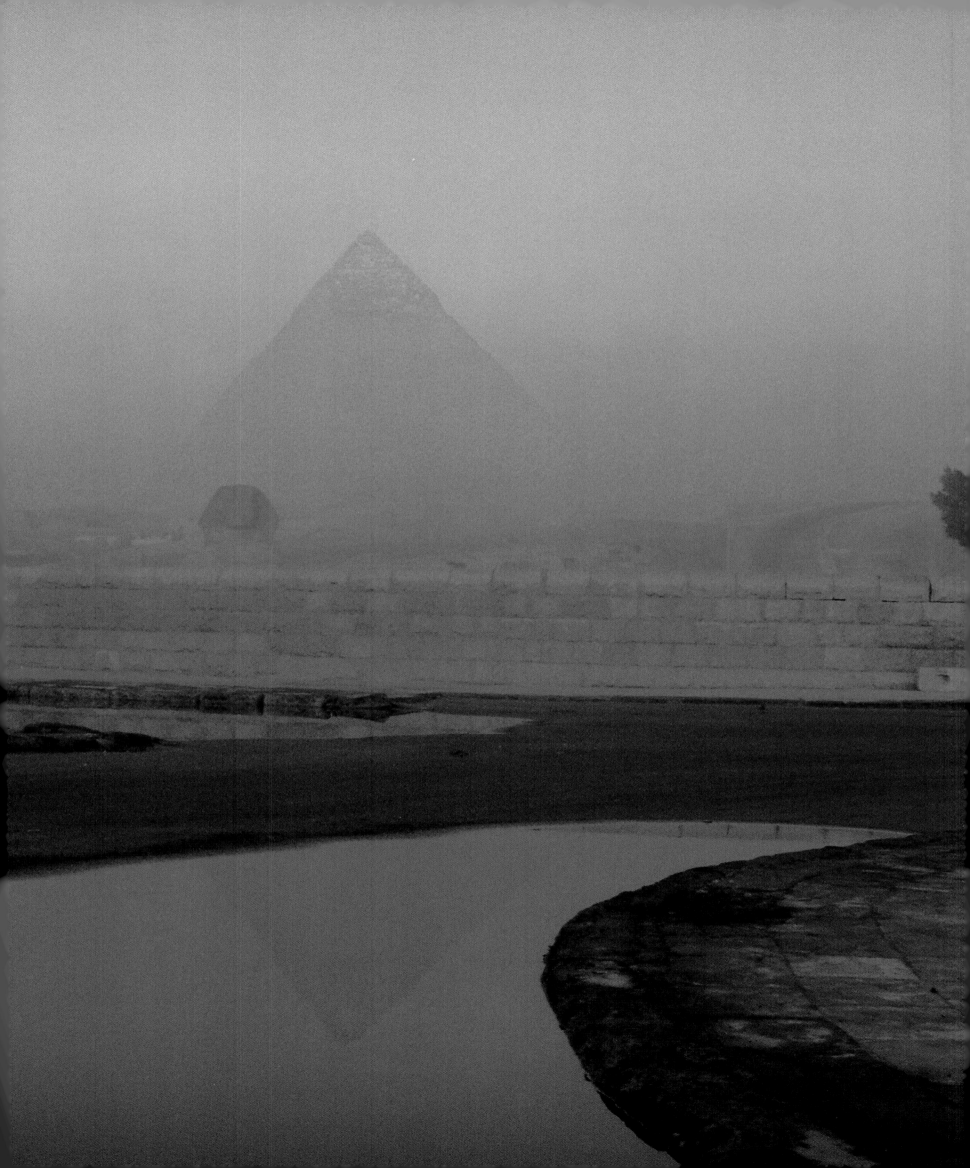

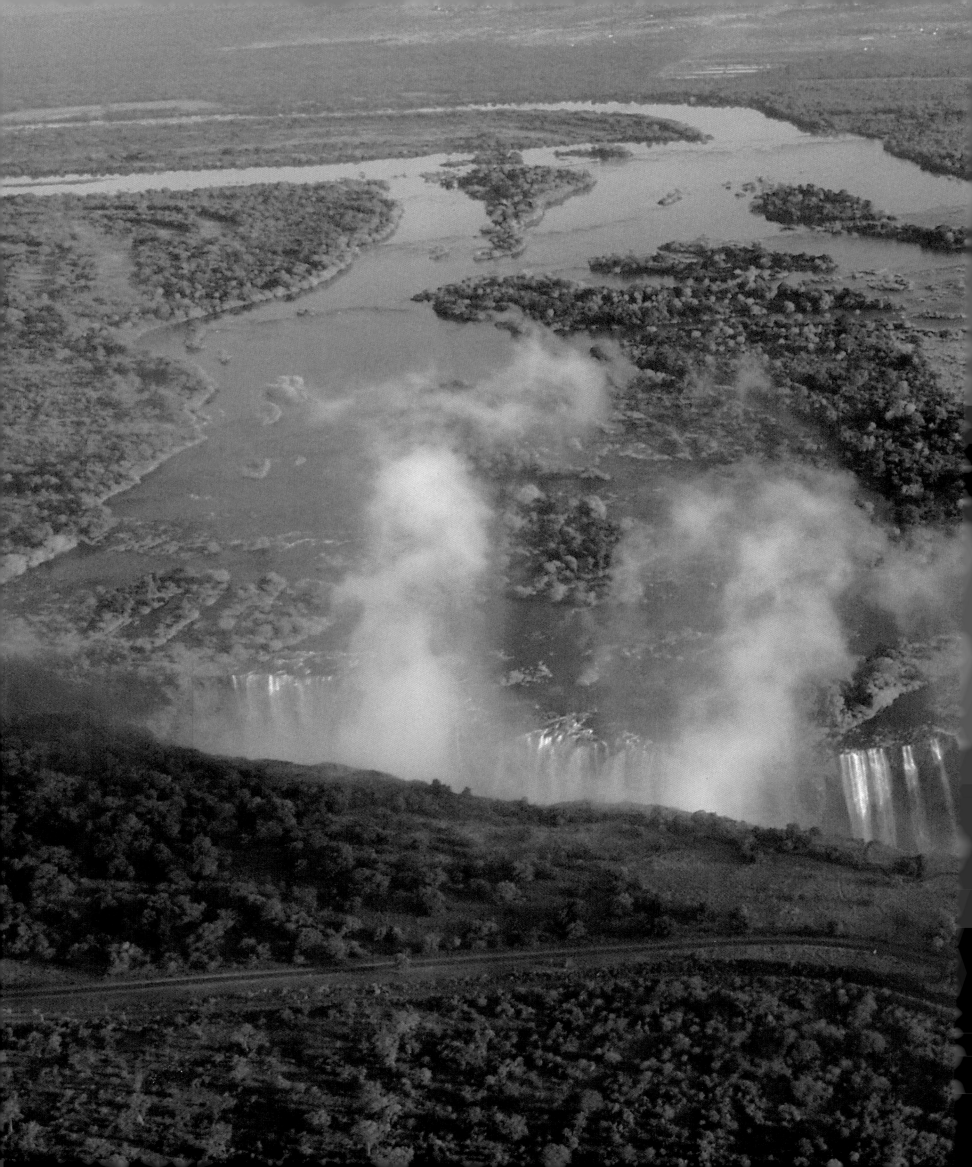

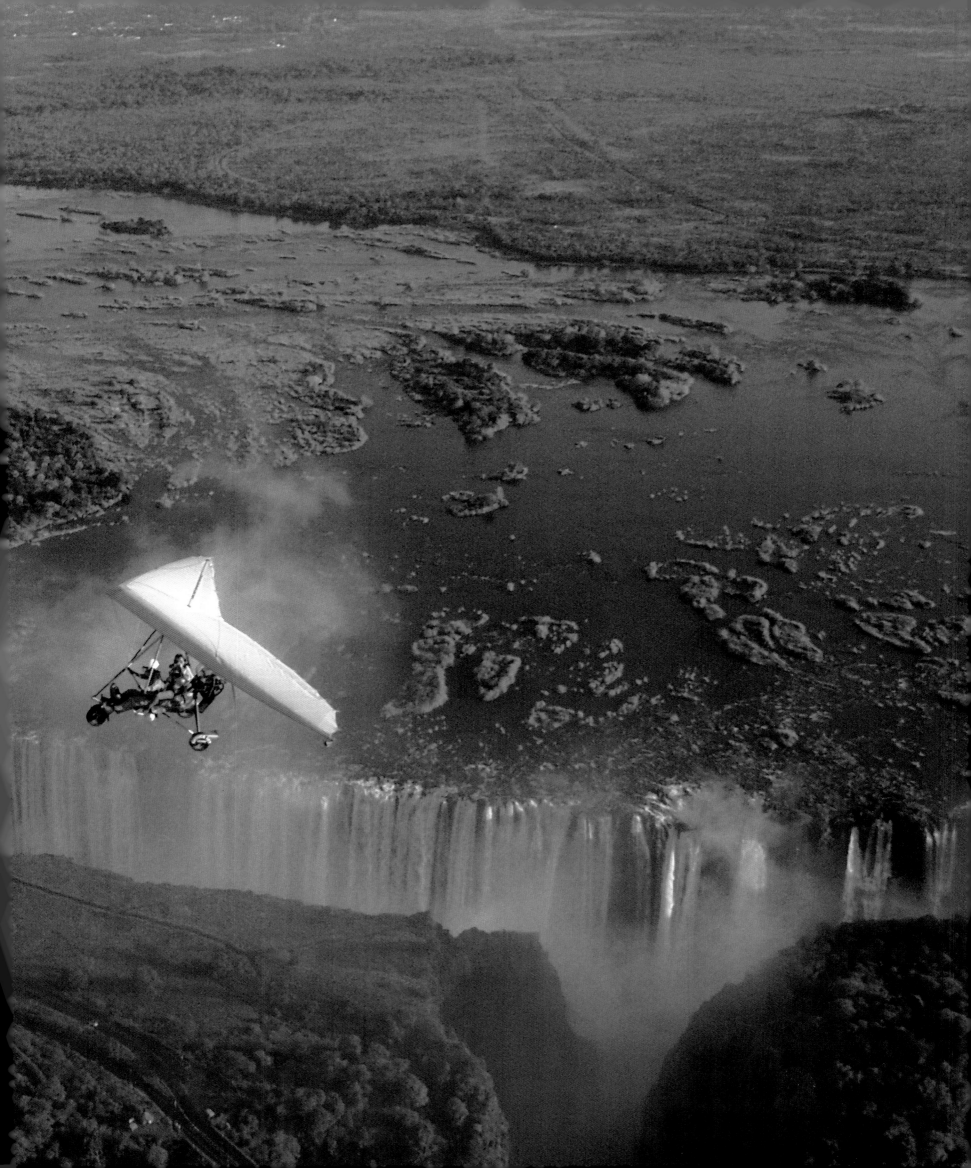

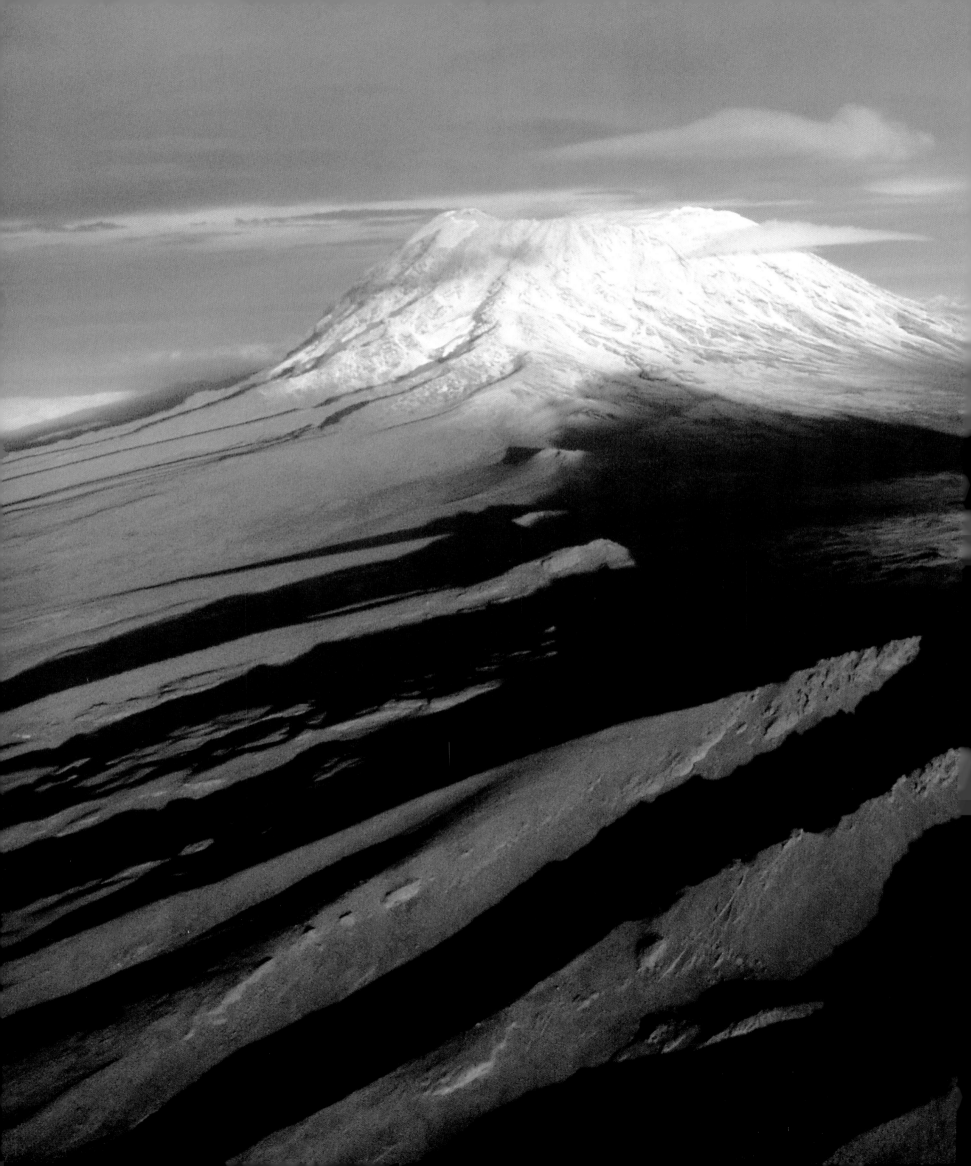

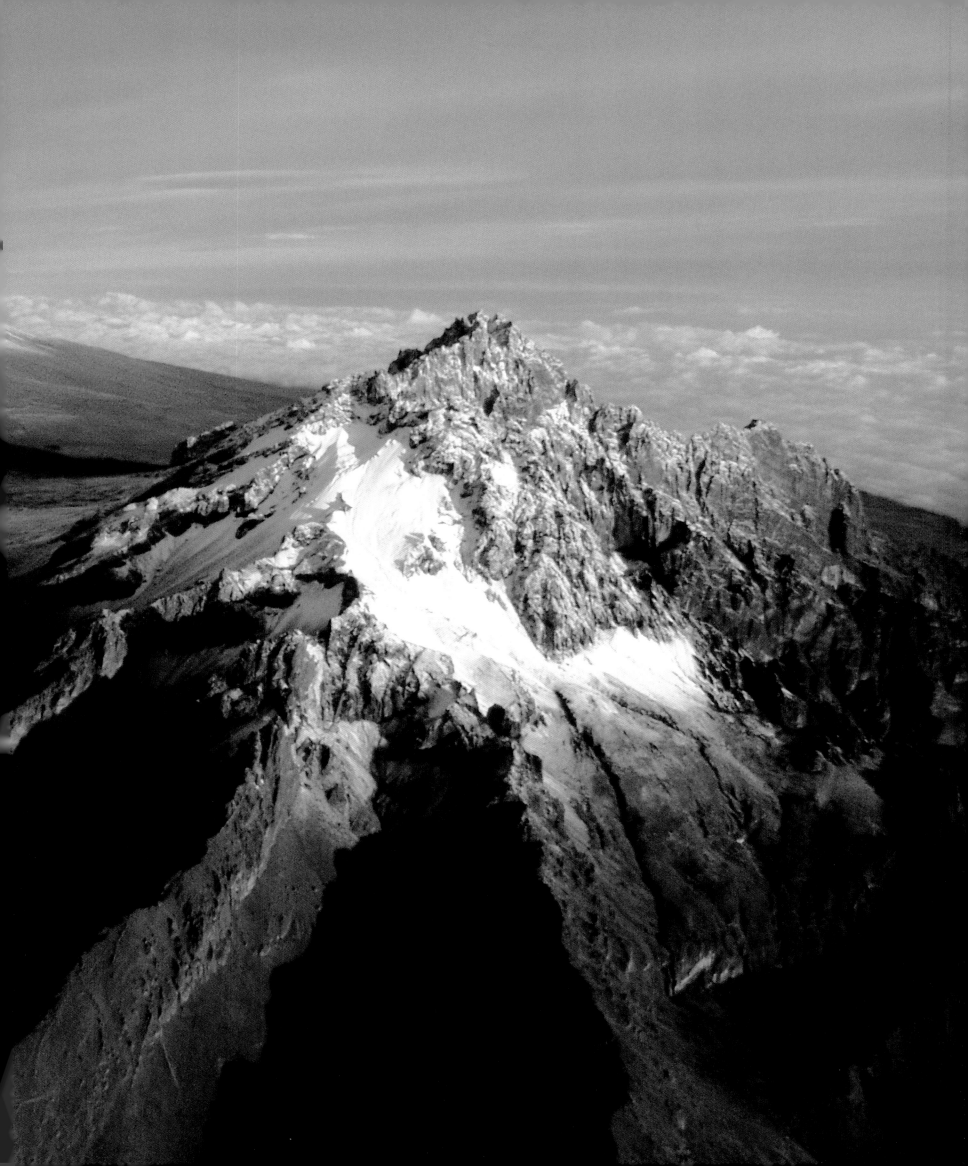

Previous Pages and Right
From the pyramids and sphinx at Giza, swathed in pink dawn ... to a microlight aircraft buzzing high above the roaring cascades of Victoria Falls ... to Kilimanjaro's glaciered peaks ... to the sensuous sand dunes of the Namib Desert, nearly 100 Day in the Life photographers swept across 53 African nations on a single day— February 28, 2002— capturing the grandeur of its landscape, the richness of its culture, and a full day's worth of work and play, life and death, struggle, hopes, and dreams.

◻ *Pyramids and sphinx by Dilip Mehta in Egypt*

◼ *Victoria Falls by Mark Greenberg in Zimbabwe*

◯ *Mount Kilimanjaro by Taiji Igarashi in Tanzania*

● *The Namib Desert by George Steinmetz in Namibia*

10

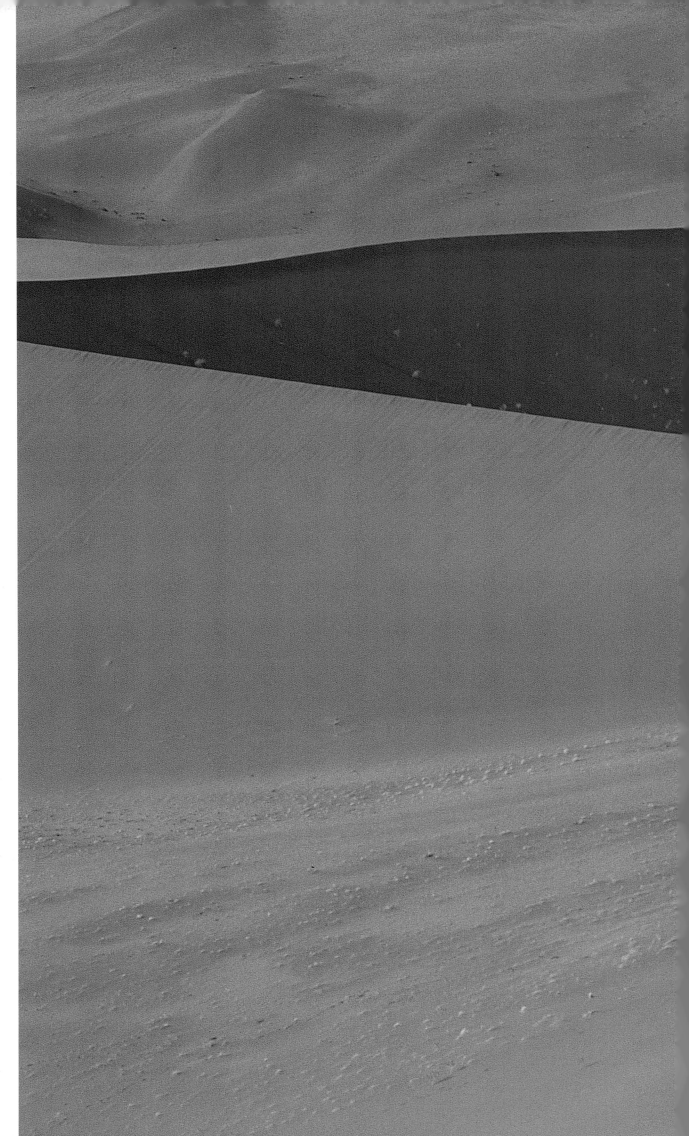

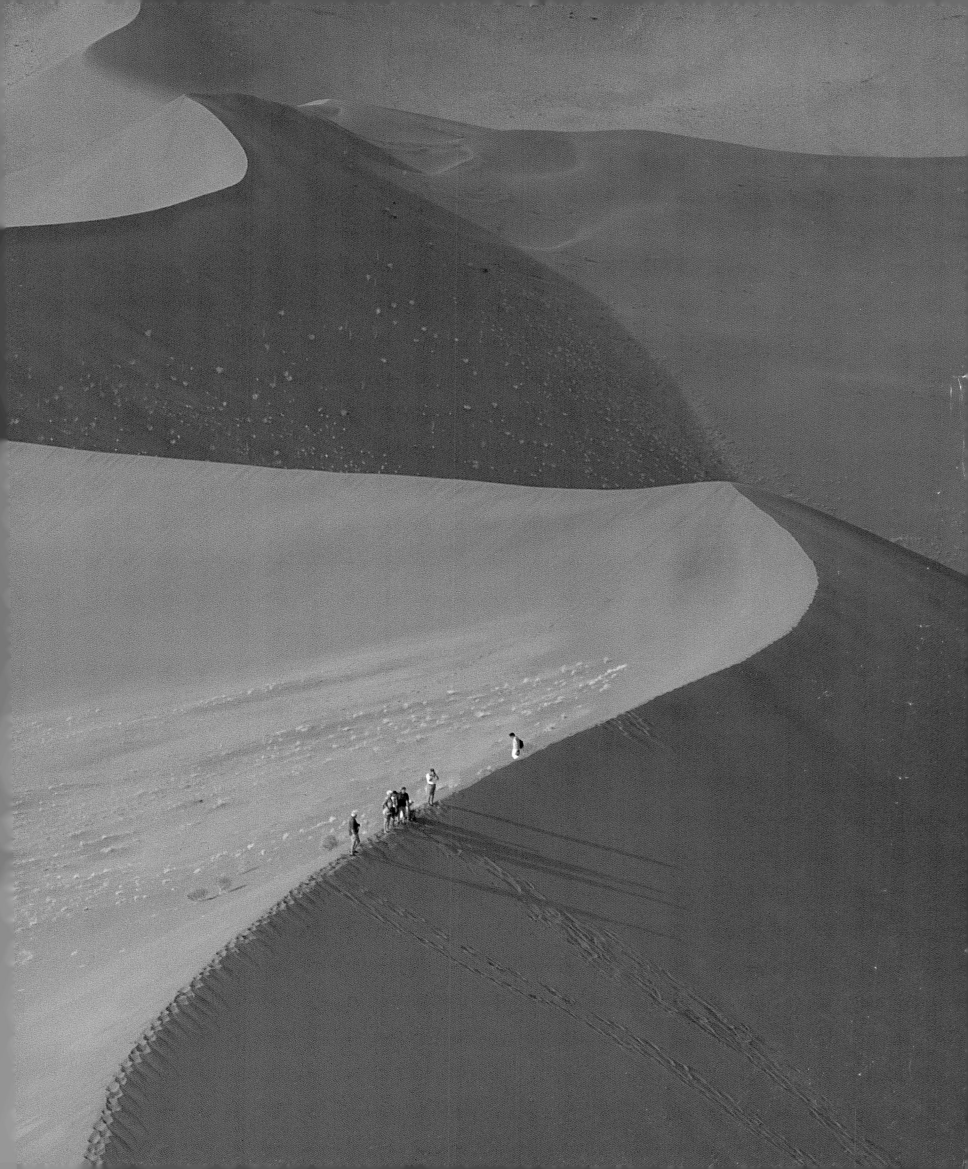

We dreamed in South Africa of a world beyond apartheid, and the world dreamed with us. We dreamed of swords beaten into plowshares, spears into pruning hooks, and a world of forgiveness. Together, we fought back the oppression of a society arbitrarily divided along the lines of color and caste. And in our victory, we recognize that eternal vigilance is the price of maintaining freedom.

We now dream of a new continent of Africa that is free and democratic, non-racist, and non-sexist—that allows all of its people to become better educated and more economically prosperous within self-determined, independent states. Our vision of this continent is unfinished, and we continue our struggle with the painful legacy of colonialism and the modern scourge of HIV/AIDS and other preventable diseases. But if we are to realize the true potential of our African motherland, it will take immense effort and commitment from those who call the continent of Africa home, as well as the entire international community.

On February 28, 2002, nearly 100 photojournalists from 26 countries took the remarkable photographs that comprise this book. These photographs speak eloquently about the wide range of human conditions that exist within this vast continent. You will see people going about their daily lives, men and women at work, parents caring for their families, children in school and at play. You will see landscapes, cities, villages, and homes, customs, cultures, and religious practices that are uniquely African. These portraits of the daily lives of African people and places can invoke deeper public understanding of our continent.

This sort of understanding is the foundation upon which peace and reconciliation can be built and intractable problems can be solved. South Africa's victory—indeed the world's victory—over apartheid tells us that

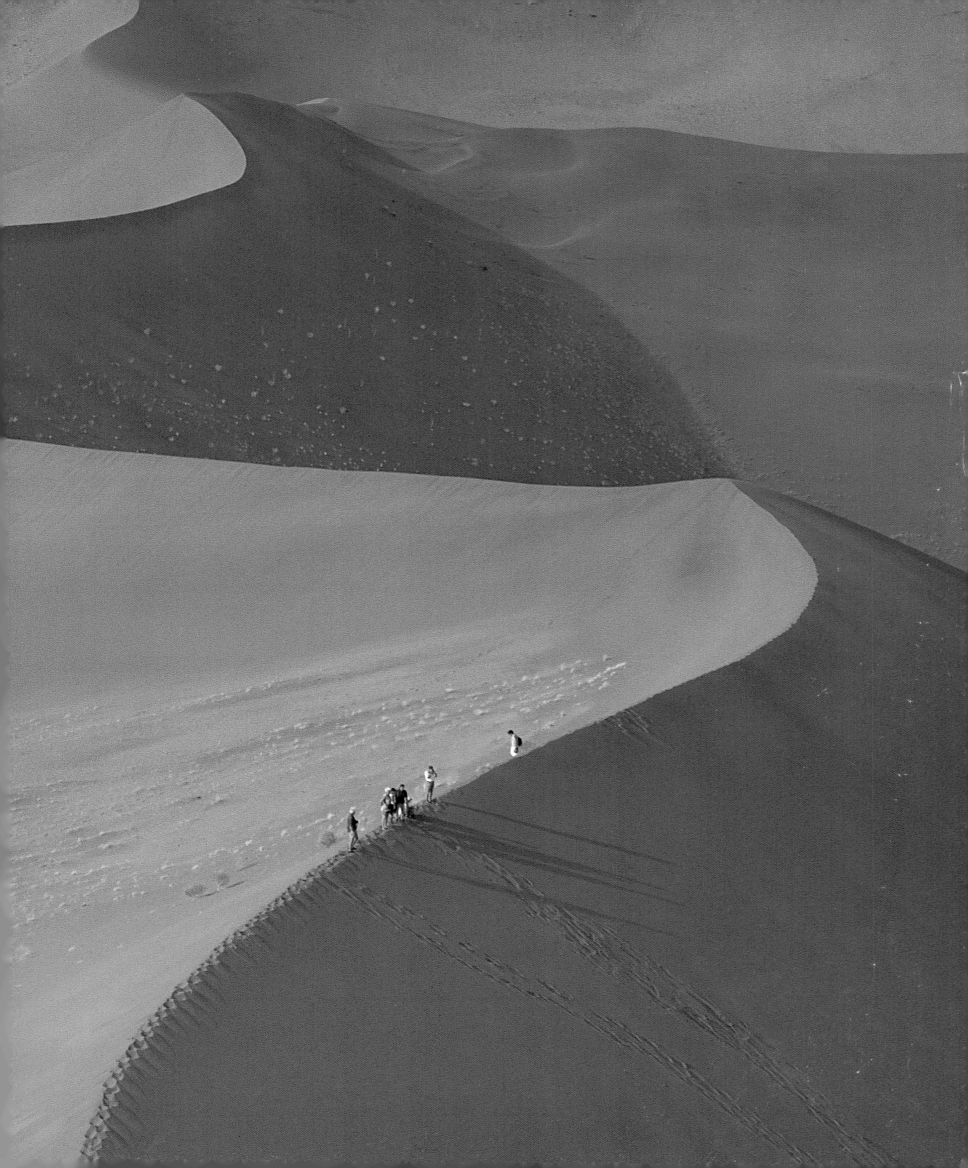

We dreamed in South Africa of a world beyond apartheid, and the world dreamed with us. We dreamed of swords beaten into plowshares, spears into pruning hooks, and a world of forgiveness. Together, we fought back the oppression of a society arbitrarily divided along the lines of color and caste. And in our victory, we recognize that eternal vigilance is the price of maintaining freedom.

We now dream of a new continent of Africa that is free and democratic, non-racist, and non-sexist—that allows all of its people to become better educated and more economically prosperous within self-determined, independent states. Our vision of this continent is unfinished, and we continue our struggle with the painful legacy of colonialism and the modern scourge of HIV/AIDS and other preventable diseases. But if we are to realize the true potential of our African motherland, it will take immense effort and commitment from those who call the continent of Africa home, as well as the entire international community.

On February 28, 2002, nearly 100 photojournalists from 26 countries took the remarkable photographs that comprise this book. These photographs speak eloquently about the wide range of human conditions that exist within this vast continent. You will see people going about their daily lives, men and women at work, parents caring for their families, children in school and at play. You will see landscapes, cities, villages, and homes, customs, cultures, and religious practices that are uniquely African. These portraits of the daily lives of African people and places can invoke deeper public understanding of our continent.

This sort of understanding is the foundation upon which peace and reconciliation can be built and intractable problems can be solved. South Africa's victory—indeed the world's victory—over apartheid tells us that

we can succeed in these struggles for the sake of a better world where each individual is a ray of hope and a testament to goodness.

We invite you to gain a better understanding of this great continent. We know that this understanding cannot be made complete within the span of this book, or for that matter, within the span of a single lifetime. Still, as you experience this book, we hope that you will discover a culturally rich continent, abundant in physical beauty. A continent overcoming the complex burden of colonial oppression, struggling with overwhelming public-health challenges, and vitally anxious for democracy and self-determination. A continent with an indomitable spirit, broadening its participation within the global community and offering the world its unique sense of community and cooperation.

As much as the world has an instinct for evil and is a breeding ground for genocide, holocaust, slavery, racism, war, oppression, and injustice, the world has an even greater instinct for goodness, rebirth, mercy, beauty, truth, freedom, and love. The coexistence of these aspects of human character is a great and universal paradox. That is why the struggle for peace and the need for reconciliation exist not just in Africa, but throughout the world.

13

africa is a continent of remarkable human, cultural, and natural diversity—a place of both tradition and transformation—and a deeply cherished home to millions of people. At the dawn of the 21st century, Africa is also a place of opportunity regained.

Certainly, Africans face challenges that would dishearten even the richest and most powerful members of the human family. Conflicts continue to cause untold human misery, disrupt normal economic life, swell the ranks of refugees and displaced persons, and frighten away investment even from countries that are not directly affected. The AIDS pandemic is taxing already overstretched public-health services and killing far more people than all the region's conflicts combined. Poverty is widespread and severe. Crushing debt burden, insufficient international aid, and high tariffs imposed on African goods make it extremely hard for African nations to compete in the global economy. For too many Africans, daily life is unremittingly grim and painful.

But there are also places—far more than are commonly recognized—where we are witnessing dramatic changes for the better. A majority of Africans now live under democratic systems, led by democratically elected leaders accountable to their peoples. Where attempts to undermine democratic gains have occurred, they have been met with strong resistance from people determined to see their rights respected. A vibrant civil society is emerging, overcoming the legacy of colonial and authoritarian regimes that stifled the voices of ordinary people. African nations are also reforming their economies, and doing their utmost to liberate the creative and entrepreneurial energies of their peoples. They are confronting the scourge of AIDS with innovative community-based programs and relentless campaigns of public education. And they are beginning to harness the great power of the Internet for education, health

care, and commerce. Africans have made clear not only their yearning for peace, stability, and development, but also their willingness to work for it and take control of their own destinies.

A Day in the Life of Africa gives us a complex and nuanced portrait. These beautiful and deeply moving images compel us to see that despite the tragedy that afflicts some parts of the continent, the bright spots must not be forgotten, nor the achievements overlooked. The vast majority of Africans are striving to bring positive change to their countries, and in many places these efforts are beginning to bear fruit. The United Nations, for its part, has long championed African rights, progress, and self-sufficiency. I hope that people of goodwill throughout the world will see the great dignity and resilience of my fellow Africans, and join them in their struggle for the chance to create a better life that is every human being's birthright.

February 28, 2002...

The world's foremost photojournalists fan out across Africa. Their mission: to create a glorious portrait of an entire continent on a single day, to raise global awareness about Africa, and to raise money for African AIDS education. Listed below are the participating photographers and their locations.

Jeffrey Aaronson, American
Djénné, Mali (11)

Abbas, Iranian
Bandiagara, Mali (12)

Yann Arthus-Bertrand, French
Mindif, Cameroon (40)

Kristen Ashburn, American
Ruhengeri, Rwanda (46)

Jane Evelyn Atwood, American
Sanguere-Ngal, Cameroon (41)

Bruno Barbey, French
Marrakech, Morocco (1)

Anthony Barboza, American
Dakar, Senegal (19)

Nadia Benchallal, French
Cairo, Egypt (8)

Nina Berman, American
Cairo, Egypt (8)

Peter Bialobrzeski, German
Addis Ababa, Ethiopia (28)

Jodi Bieber, South African
Lagos, Nigeria (38)

Alexandra Boulat, French
Aswan, Egypt (9)

Paul Chesley, American
Marrakech, Morocco (1)

Stéphane Compoint, French
Alexandria, Egypt (7)

Seamus Conlan, Irish
Otjekwa, Namibia (61)

Jean-Claude Coutausse, French
Porto-Novo, Benin (37)

Anne Day, American
Cape Verde (55)

Xavier Desmier, French
Conakry, Guinea (31)

Jay Dickman, American
KwaZulu-Natal, South Africa (73)

Quintilhano dos Santos, Angolan
Luanda, Angola (56)

George Esiri, Nigerian
Lagos, Nigeria (38)

Frank Fournier, French
Kumasi, Ghana (35)

Mariella Furrer, Swiss
Zanzibar Island, Tanzania (53)

Paul Fusco, American
Monrovia, Liberia (33)

Tim Georgeson, Australian
Awasa, Ethiopia (26)

Kevin T. Gilbert, American
Port Louis, Mauritius (69)

Liz Gilbert, American
Narok, Kenya (50)

Diego Goldberg, Argentine
Malabo, Equatorial Guinea (44)

Mark Greenberg, American
Victoria Falls, Zimbabwe (64)

Stanley Greene, American
Southern Sudan (25)

C. W. Griffin, American
Abidjan, Côte d'Ivoire (34)

Lori Grinker, American
Zinder, Niger (23)

Louise Gubb, South African
Johannesburg, South Africa (71)

Benoit Gysembergh, French
São Tomé (43)

Themba Hadebe, South African
Kalong, Zambia (76)

Ron Haviv, American
Kampala, Uganda (48)

Robert Holmes, British
Eldoret, Kenya (49)

Françoise Huguier, French
Beira, Mozambique (66)

Taiji Igarashi, Japanese
Mount Kilimanjaro, Tanzania (51)

John Isaac, American
N'Djamena, Chad (15)

Fanie Jason, South African
Cape Town, South Africa (75)

Alexander Joe, Zimbabwean
Harare, Zimbabwe (65)

Ed Kashi, American
Hargeysa, Somalia (30)

Nick Kelsh, American
Bangui, Central African Republic (78)

Douglas Kirkland, Canadian
Lagos, Nigeria (38)

Gary Knight, British
Olduvai Gorge, Kenya (51)

Antonin Kratochvil, Czech
Ndoki, Congo (45)

Joachim Ladefoged, Danish
Tangier, Morocco (3)

François Lagarde, French
Cape Fria, Namibia (82)

Daniel Laîné, French
Lomé, Togo (36)

Andre Lambertson, American
Freetown, Sierra Leone (32)

Michael S. Lewis, American
Lalibela, Ethiopia (27)

Kim Ludbrook, South African
Ghanzi, Botswana (63)

Gerd Ludwig, German
Tiebélé, Burkina Faso (22)

Pascal Maitre, French
Mauritania (10)

Alex Majoli, Italian
Djibouti (29)

Jean-Luc Manaud, French
Agadez, Niger (14)

Greg Marinovich, American
Opuwo, Namibia (60)

James Marshall, American
Lagos, Nigeria (38)

Victor Matom, South African
Soweto, South Africa (71)

Dilip Mehta, Indian
Cairo, Egypt (8)

Susan Meiselas, American
Lambaréné, Gabon (79)

Pierrot Men, Malagasy
Soatanana, Madagascar (67)

Gideon Mendel, South African
Cape Town, South Africa (75)

Doug Menuez, American
Maweni, Tanzania (52)

Pedro Meyer, Mexican
Port Elizabeth, South Africa (80)

Yoshiko Murakami, Japanese
Mautsi Mountain, Lesotho (74)

James Nachtwey, American
Khutsong, South Africa (71)

Claude Pavard, French
Seychelles (54)

Pierre Perrin, French
Algiers, Algeria (4)

Per-Anders Pettersson, Swedish
Kinshasa, Congo-DRC (57)

Larry C. Price, American
Entebbe, Uganda (47)

Noël Quidu, French
Kinshasa, Congo-DRC (57)

Chris Rainier, Canadian
Meroë ruins, Sudan (17)

Eli Reed, American
Mtunthama, Malawi (59)

Leslie Reti, Australian
Johannesburg, South Africa (71)

Patrick Robert, French
Kinshasa, Congo-DRC (57)

Sebastião Salgado, Brazilian
Jamaame, Somalia (83)

Jeffery Allan Salter, American
Kampala, Uganda (48)

Lougue Issoufou Sanogo, Ivorian
Abidjan, Côte d'Ivoire (34)

Emmanuel T. Santos, Australian
Tunis, Tunisia (5)

Jeffrey Henson Scales, American
Teshi, Ghana (39)

John Stanmeyer, American
Banjul, Gambia (20)

Chris Steele-Perkins, British
Lokichokio, Kenya (42)

George Steinmetz, American
Windhoek, Namibia (62)

Tom Stoddart, British
Lusaka, Zambia (77)

Djibril Sy, Senegalese
Dakar, Senegal (19)

Guy Tillim, South African
Kuito, Angola (81)

David Turnley, American
Abidjan, Côte d'Ivoire (34)

Peter Turnley, American
Asmara, Eritrea (18)

Laurent Van der Stockt, French
Maputo, Mozambique (84)

Lori Waselchuk, South African
Ezulwini Valley, Swaziland (72)

Patrick Zachmann, French
Ouagadougou, Burkina Faso (13)

Hocine Zaourar, Algerian
Algiers, Algeria (4)

Francesco Zizola, Italian
Northern Sudan (16)

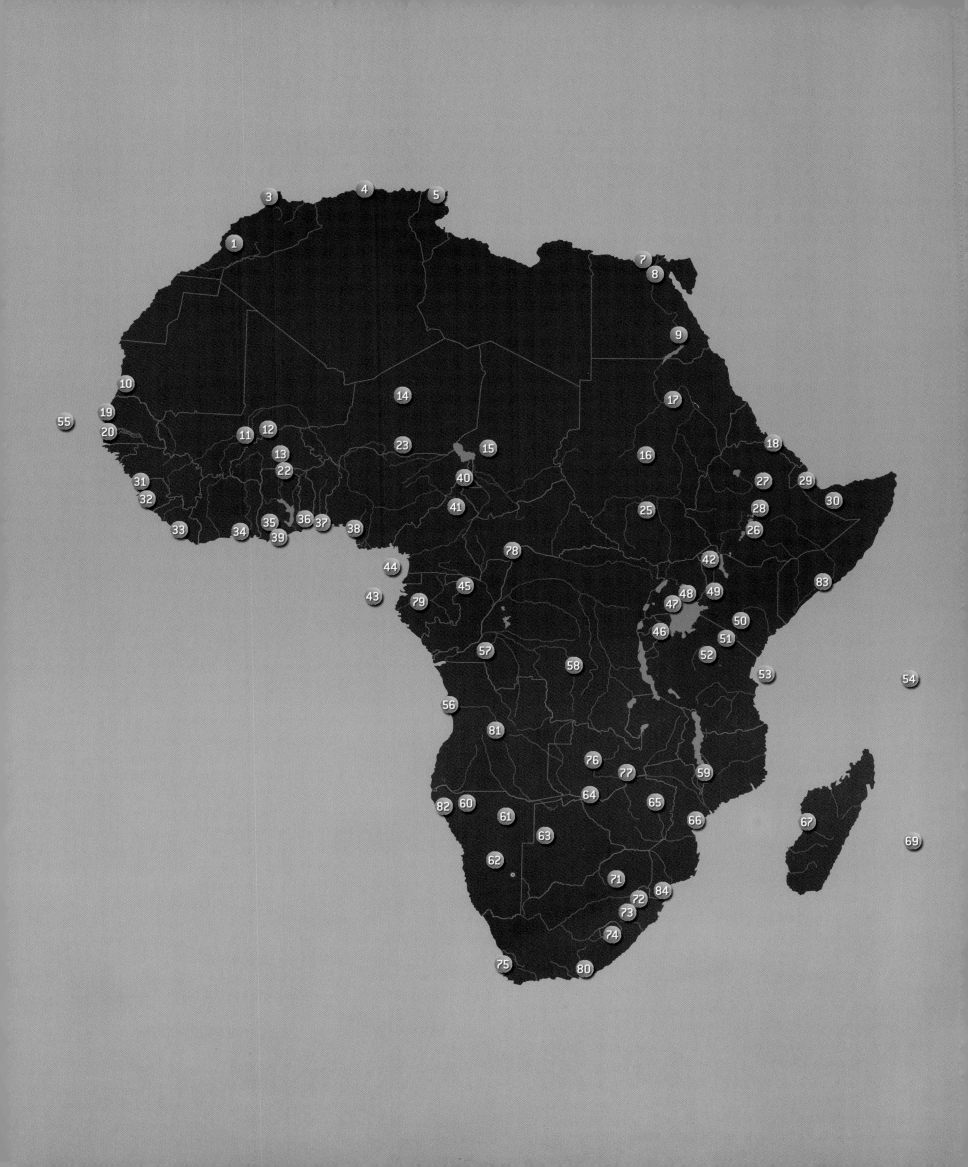

◘ **Right**
Near Eldoret, Kenya, runners train along the rim of the Great Rift Valley. Many of Kenya's legendary distance runners developed their stamina as children, running miles to school in the thin highland air. Nearby St. Patrick's High School has traditionally attracted many of the best young runners in Kenya. Since the early 1970s, its students—coached by Irish priest Colm O'Connell—have won 14 Olympic and world-championship titles.
> Robert Holmes in Kenya

■ **Previous Pages 18-19**
Fishing boats set off at dawn from São Vicente, one of 15 rugged islands comprising the Republic of Cape Verde, 500 miles off the coast of Senegal.
> Anne Day in Cape Verde

○ **Previous Pages 20-21**
A !Kung San settlement in Otjozondjupa, Namibia.
> Seamus Conlan in Namibia

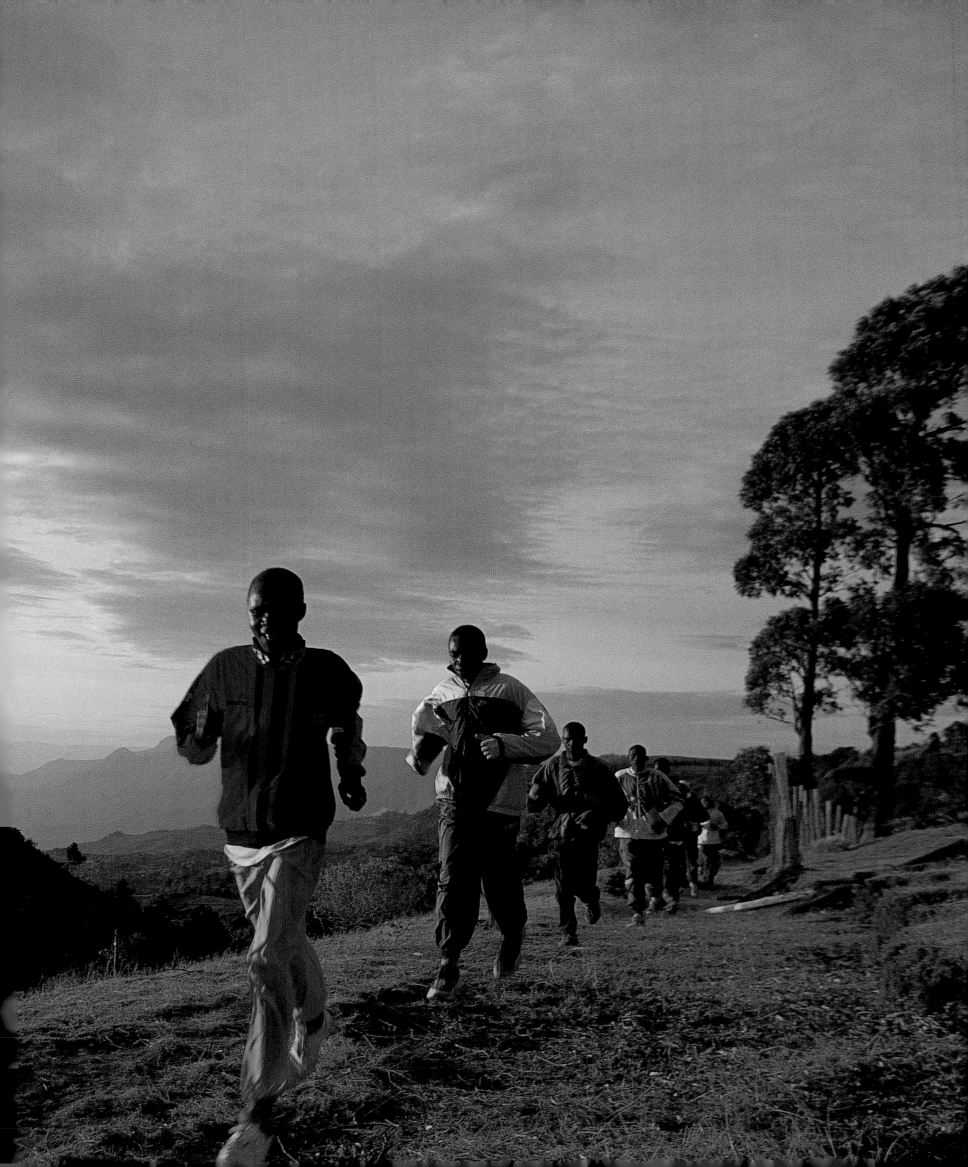

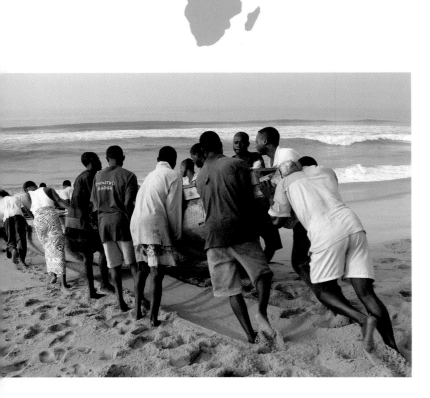

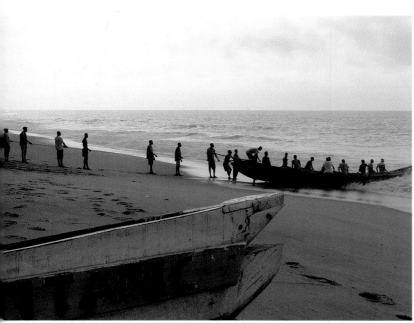

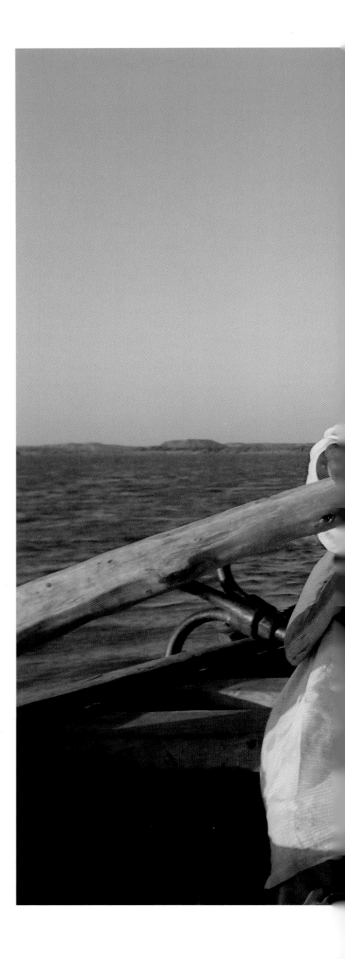

▫ Top Left
Fishermen push their boat, loaded with nets, into the surf off Ibeshe Island. After the men haul in the catch, the women cure the fish over a coconut-husk fire on the beach, then bring it to market in nearby Lagos.
> *George Esiri in Nigeria*

■ Bottom Left
As dawn breaks, fishermen in the Côte d'Ivoire village of Anani launch their *pirogue* into the gray Atlantic waters.
> *Lougue Issoufou Sanogo in Côte d'Ivoire*

◐ Right
In the Nubian Desert, near the ancient royal pyramids of Meroë, Sudanese ferrymen row farm workers across the Nile.
> *Chris Rainier in Sudan*

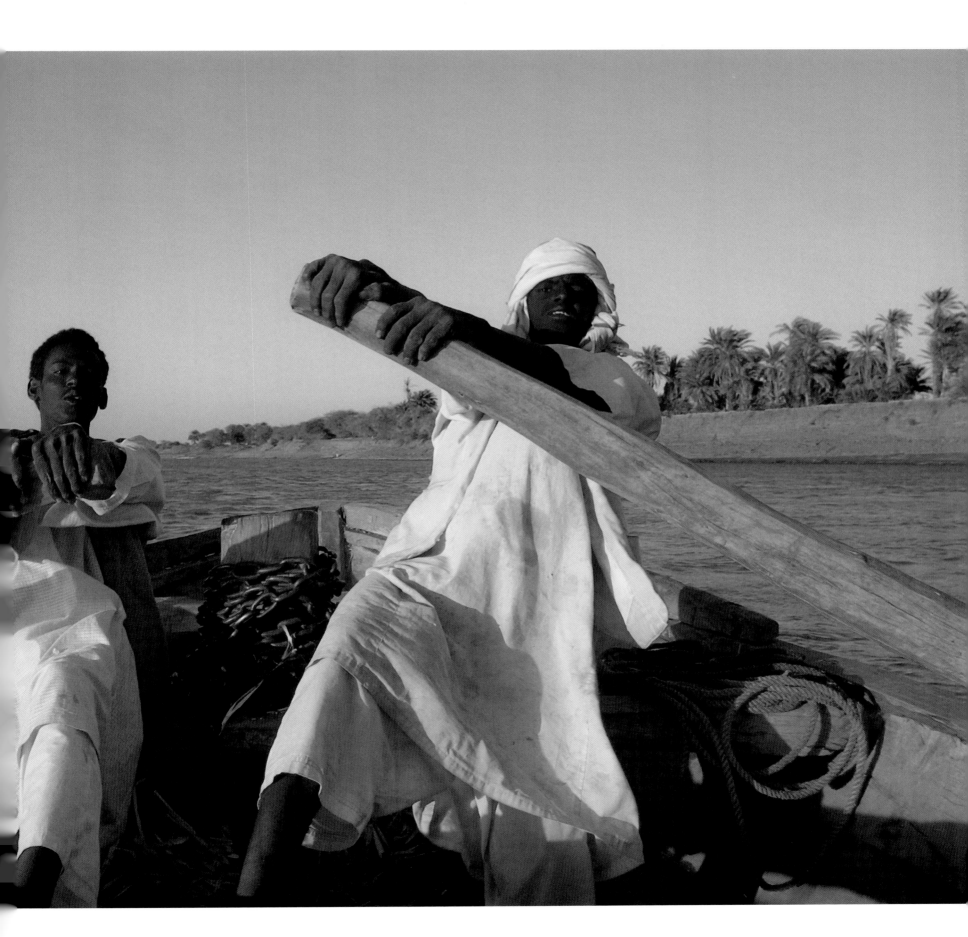

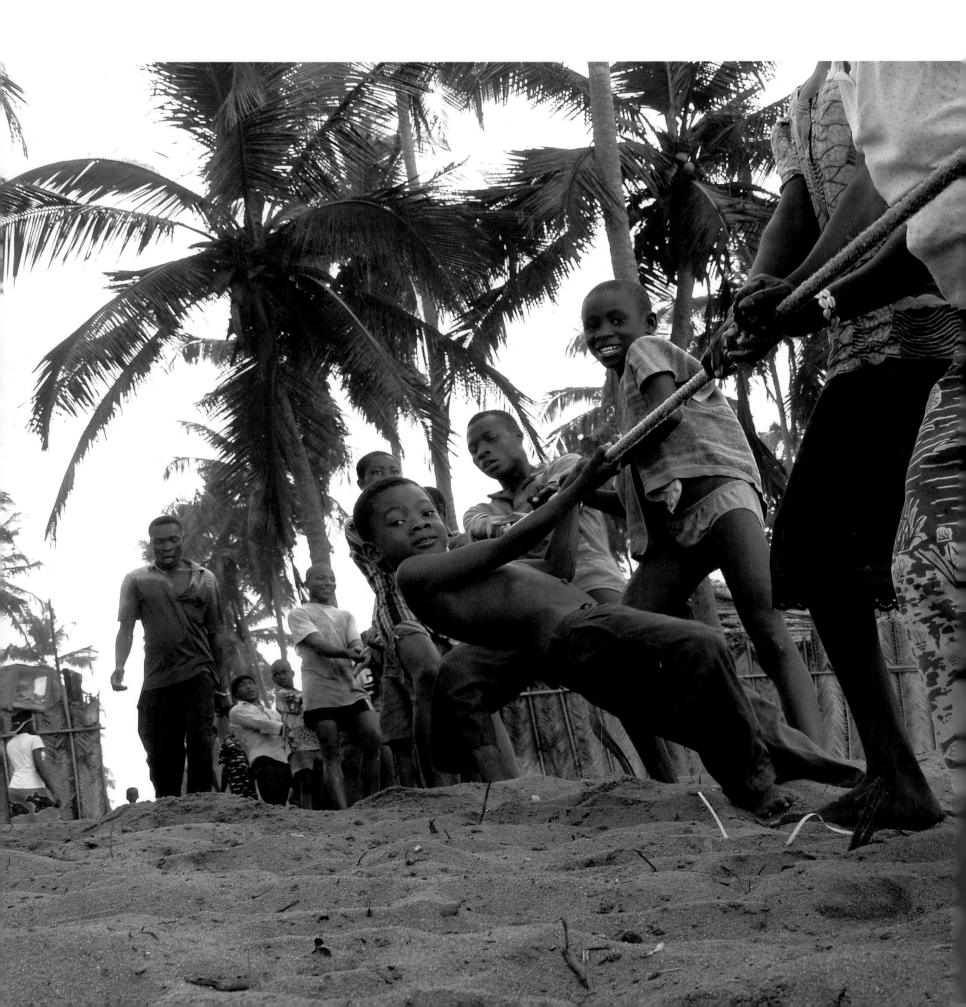

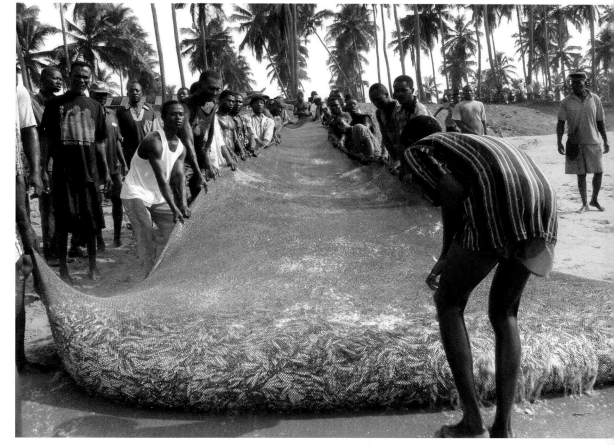

◼ **Above and Left**
In tiny Anani, Côte d'Ivoire, it takes a village to pull in huge fishing nets laden with the morning's catch. Day in the Life photographer Lougue Issoufou Sanogo describes the scene: "When fishermen from the little village throw their nets into the Atlantic Ocean, it's a celebration. With songs and cries of encouragement, the men, women, and children plant their feet in the sand under the coconut trees and pull in a net hundreds of meters long filled with glistening silver fish."
> *Lougue Issoufou Sanogo in Côte d'Ivoire*

27

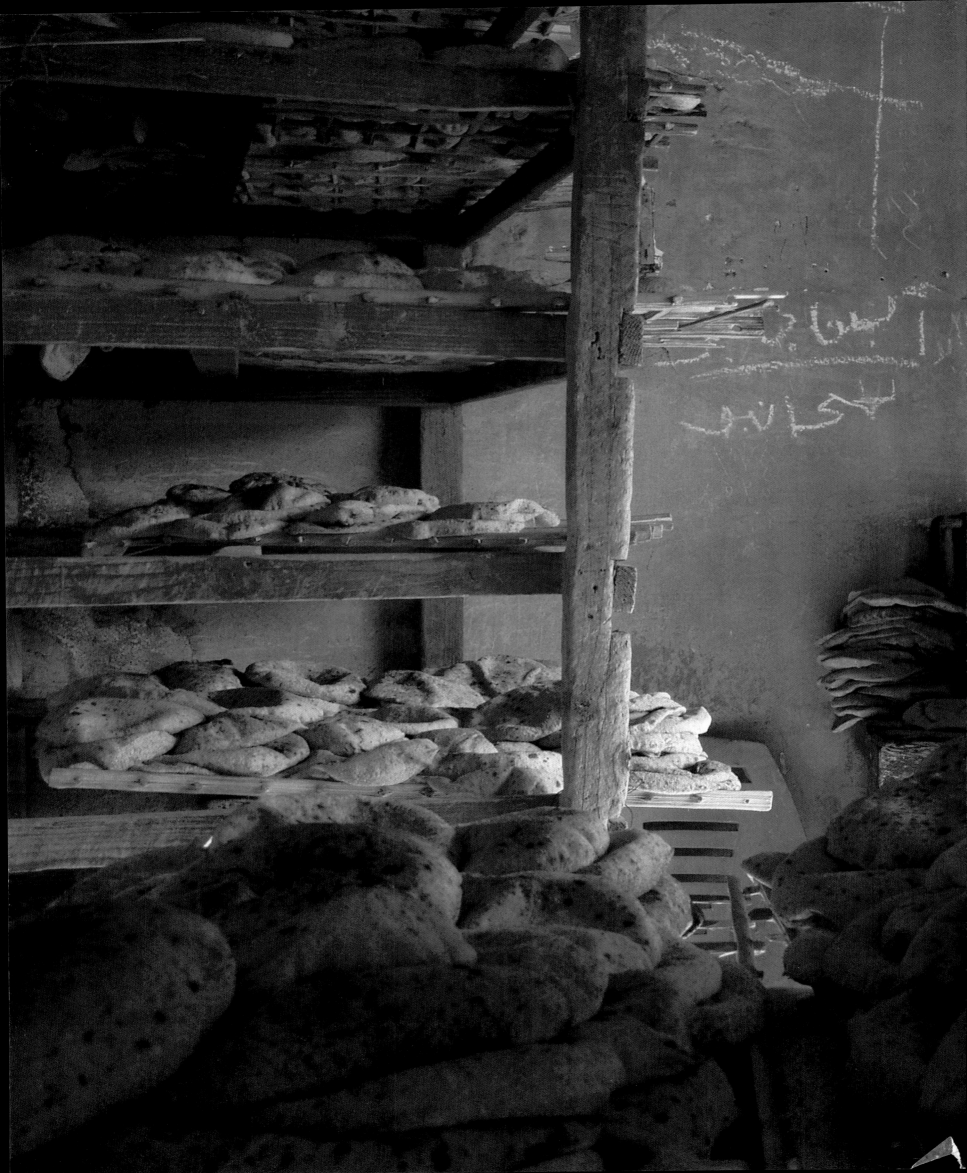

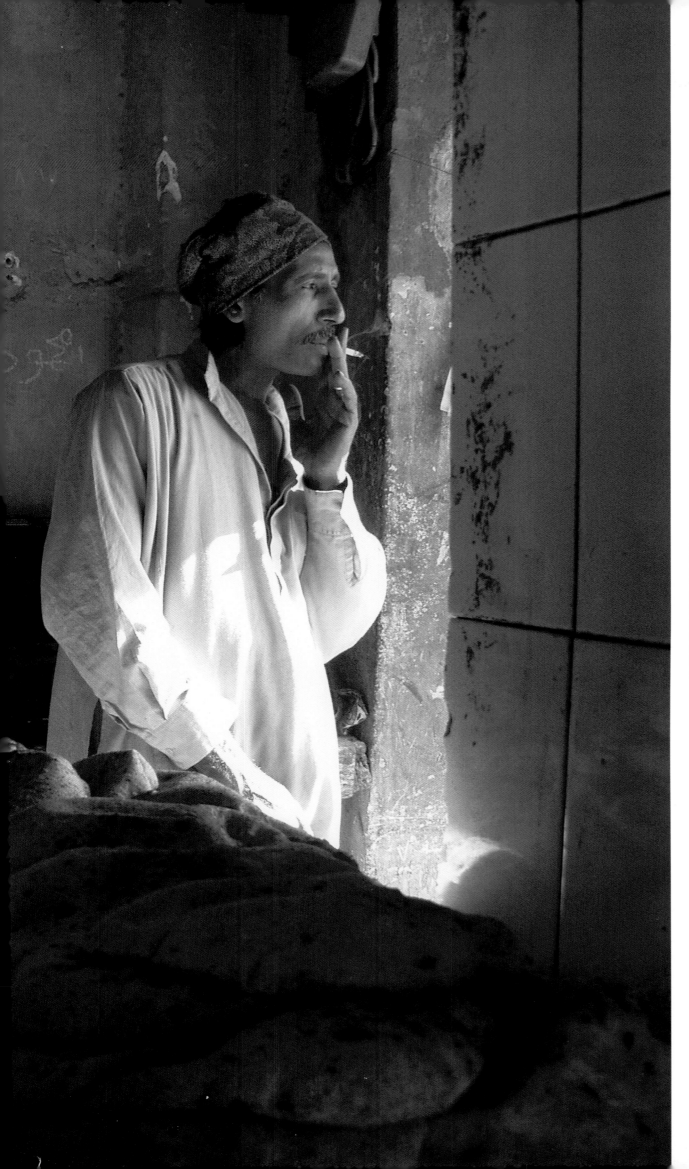

■ Left
Surrounded by stacks of *aish*—
the Arabic word for both
"humanity" and "bread"—the
baker breaks for a smoke in
Mena, a village near the great
pyramids. One of the world's
most ancient forms of bread,
aish has been baked in Egypt
for at least 1,500 years.
> *Dilip Mehta in Egypt*

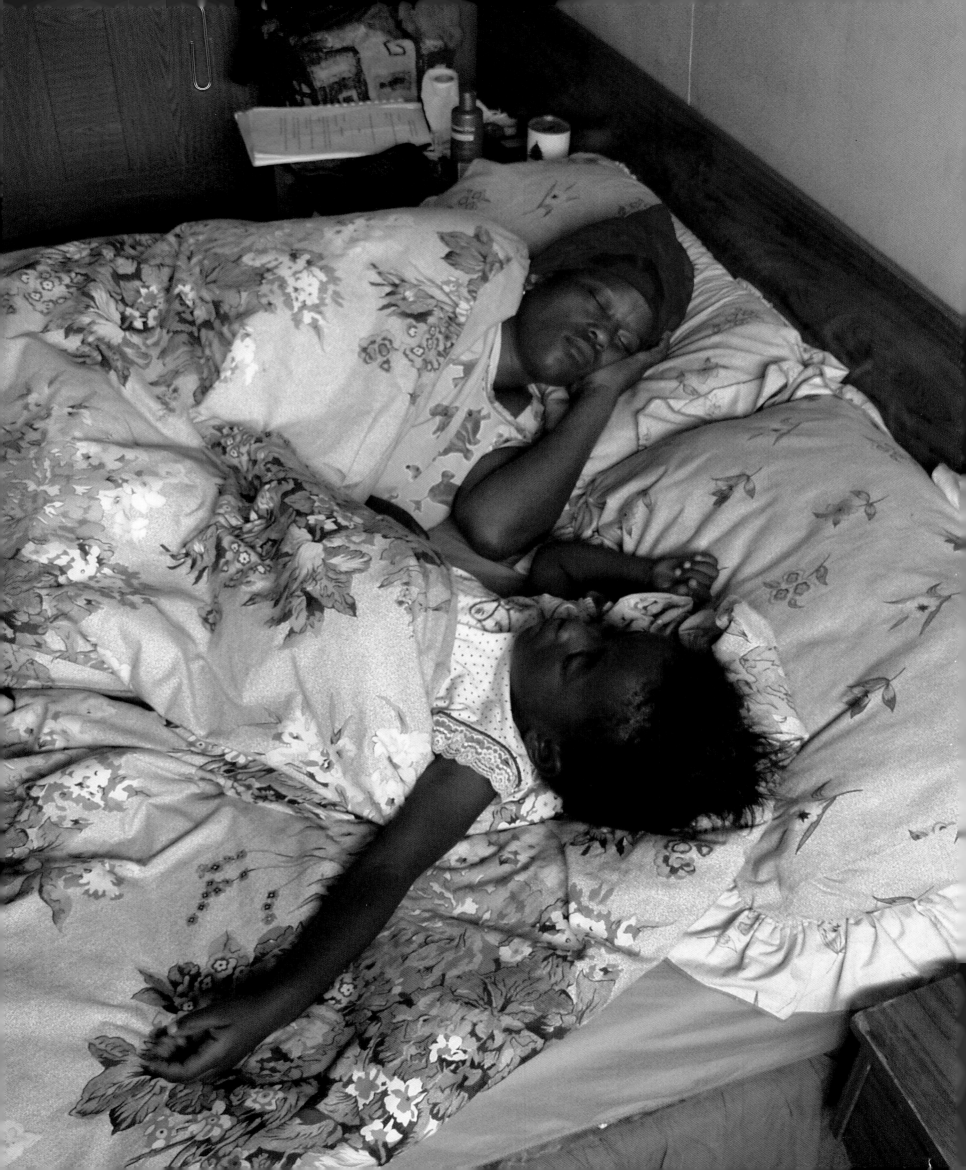

Thandeka Mantshi, 30, and her three-year-old daughter, Okhule, are still asleep in their home in Khayelitsha, a sprawling settlement near Cape Town, South Africa. Three years after learning she was HIV positive, Thandeka became pregnant with Okhule, who also tested positive for the virus. Thandeka and Okhule are among the lucky few in Khayelitsha who have been helped by antiretroviral therapy, showing that these medicines can be used effectively even in low-income African communities.
> *Gideon Mendel in South Africa*

■ Above

A shopkeeper in the Egyptian town of Mena soaks the sidewalk to keep down the desert dust.
> *Dilip Mehta in Egypt*

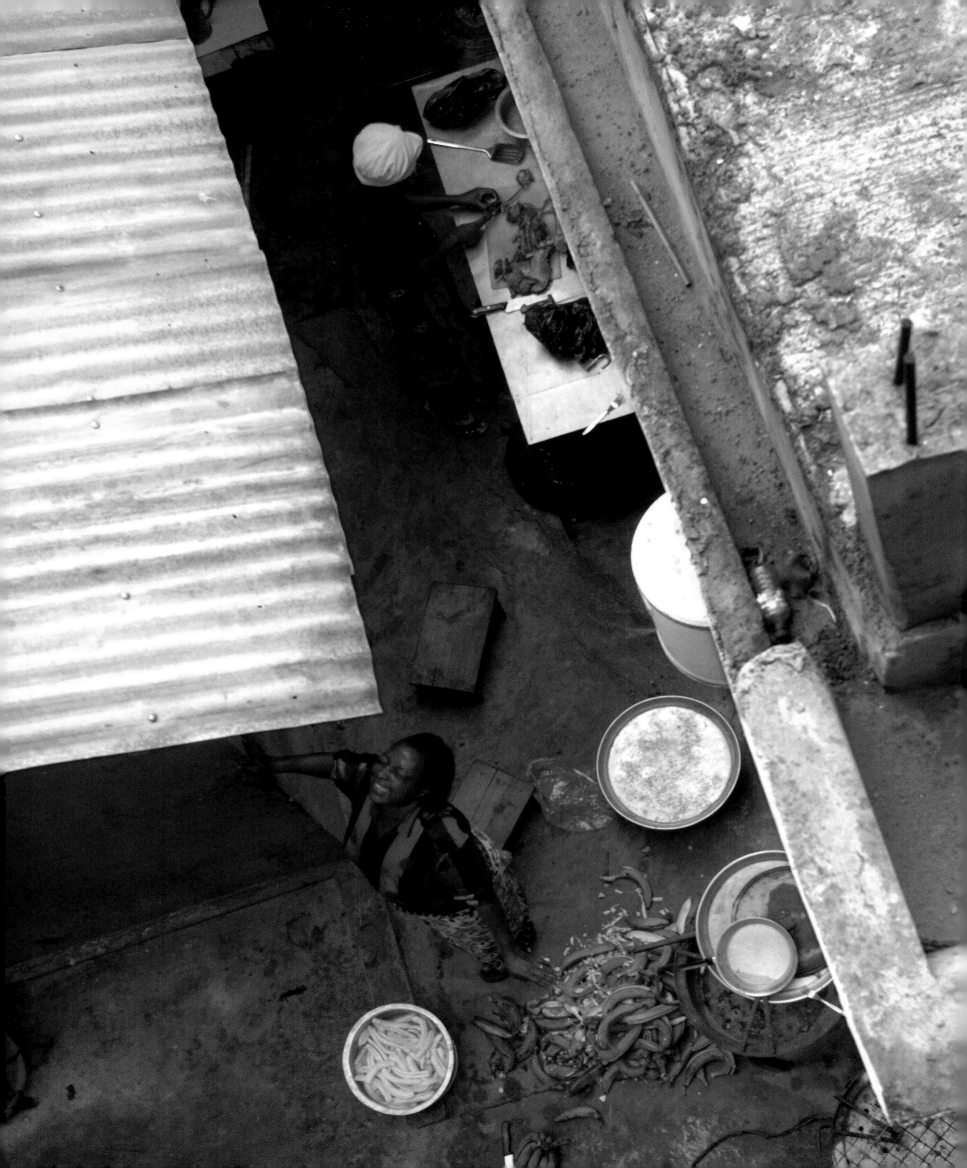

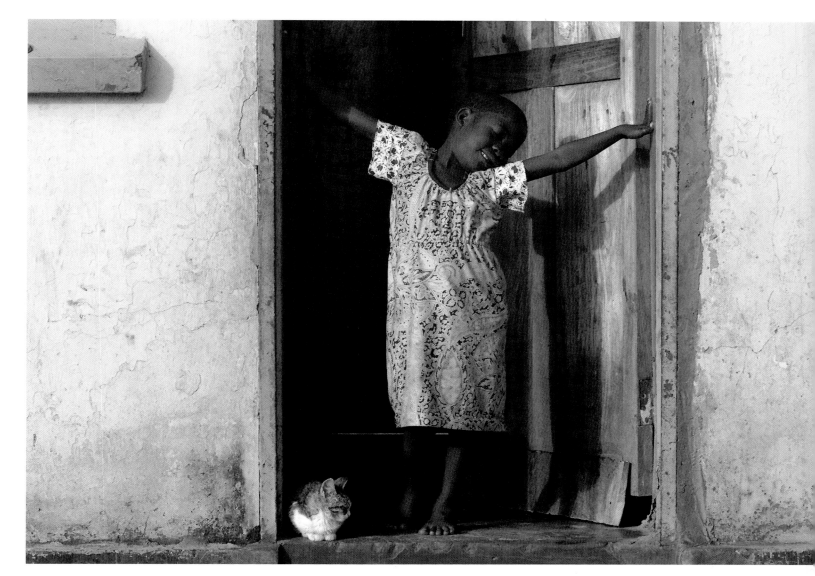

Six-year-old Kazungu
Kautingu stretches in the
kitchen doorway of her
home in Kelongwa, Zambia.
Kazungu's father, David,
runs the Kelongwa Rural
Health Center—a clinic
equipped with a refrigerator
for vaccines, a few cots, and
some mattresses on the floor.
Although not a trained
physician, Kautingu provides
medical care for 4,000
local residents.
> *Themba Hadebe in Zambia*

■ **Left**
Preparing breakfast and
joyfully welcoming a summer
day in Dar es Salaam.
> *Douglas Menuez in Tanzania*

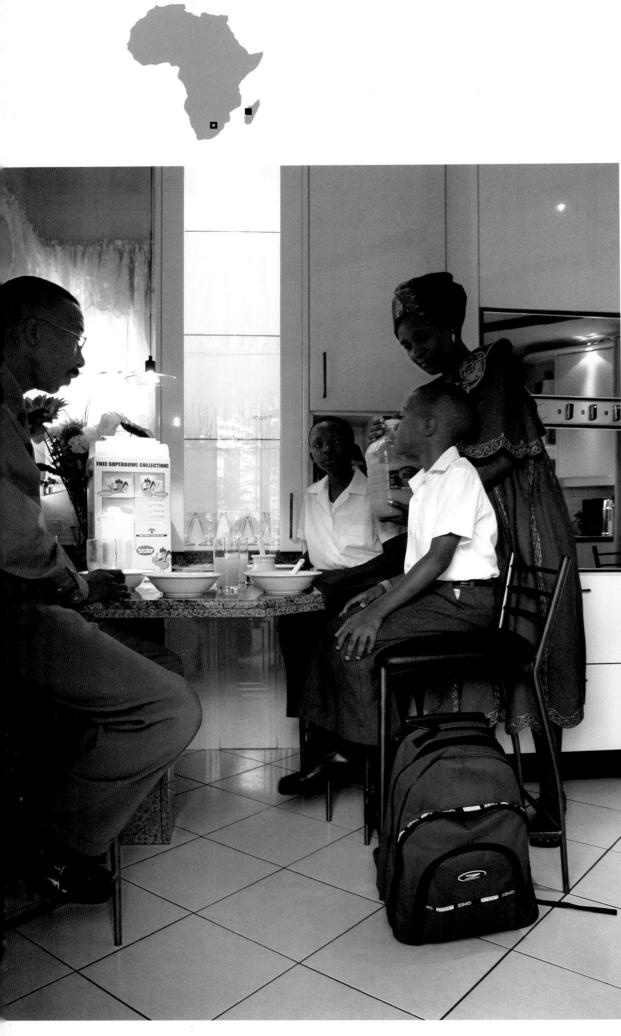

◻ **Left**
In their new home in
suburban Johannesburg,
Reuben and Sylvia Mamorare
enjoy breakfast with sons
Modise and Matsebe. The
Mamorares both work for
Eskom, southern Africa's
electrical utility—Sylvia in
human resources, Reuben
in the company's commercial
division.
> *Louise Gubb in South Africa*

■ **Right**
A morning chat in Soatanana
("beautiful village") on the
high plains of Madagascar.
Soatanana is home to the
pious Fifohazana community
("church of the awakened
apostles of God") whose
members dress entirely in
white as a sign of purity.
> *Pierrot Men in Madagascar*

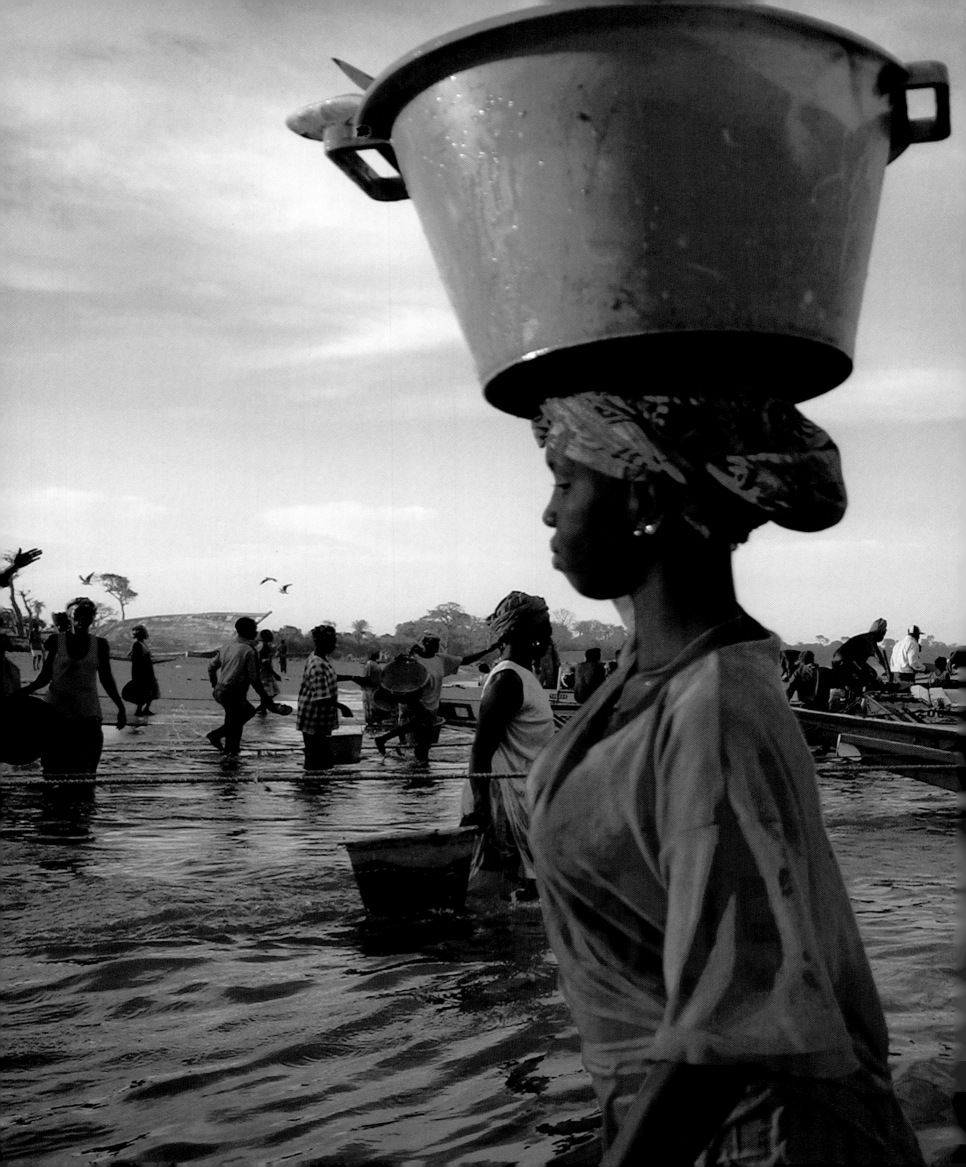

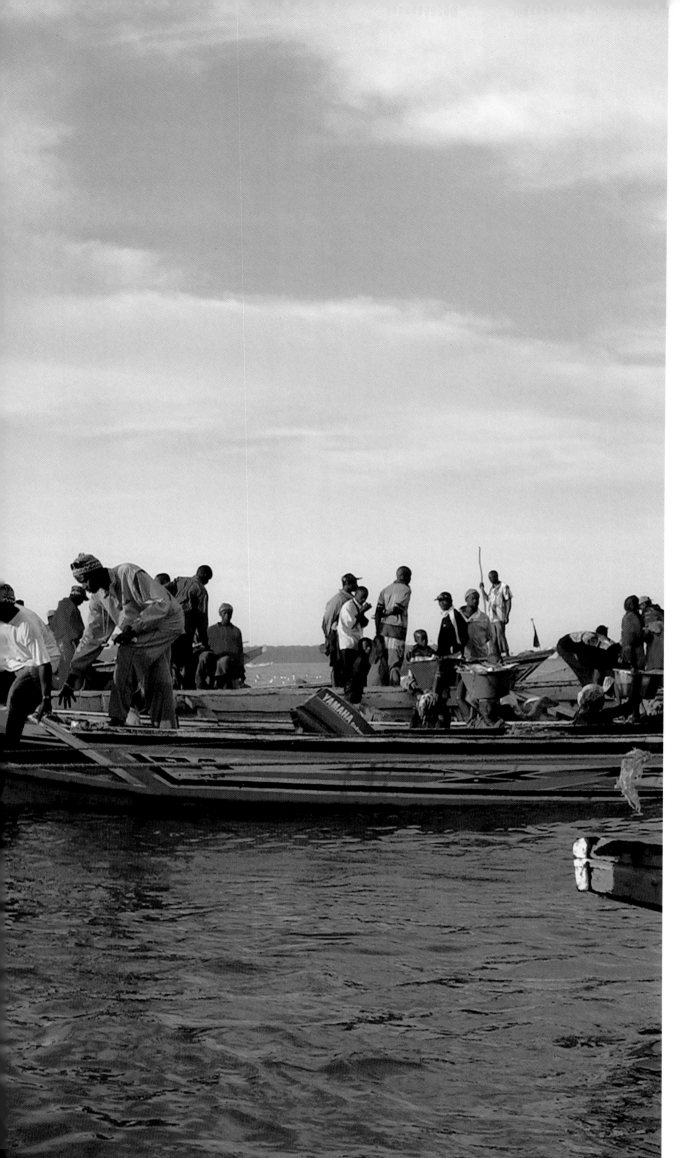

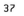

□ Left
Balancing a heavy tub of
fresh-caught fish on her head,
a woman in Tanji, Gambia,
wades to shore after meeting
the village boats at dawn.
Women in Tanji haul the
loaded tubs—which can weigh
up to 100 pounds—back to the
beach where they sell for
around five U.S. dollars each.
> *John Stanmeyer in Gambia*

■ Following Pages
An army of community
volunteers sweeps through a
neighborhood in Khayelitsha,
a vast South African township
of nearly 2 million people
that tumbles across the sandy
flats behind Cape Town.
Khayelitsha was created in the
1980s to permit "controlled
squatting" by rural blacks who
migrated to the Cape Province
in record numbers.
> *Gideon Mendel in South Africa*

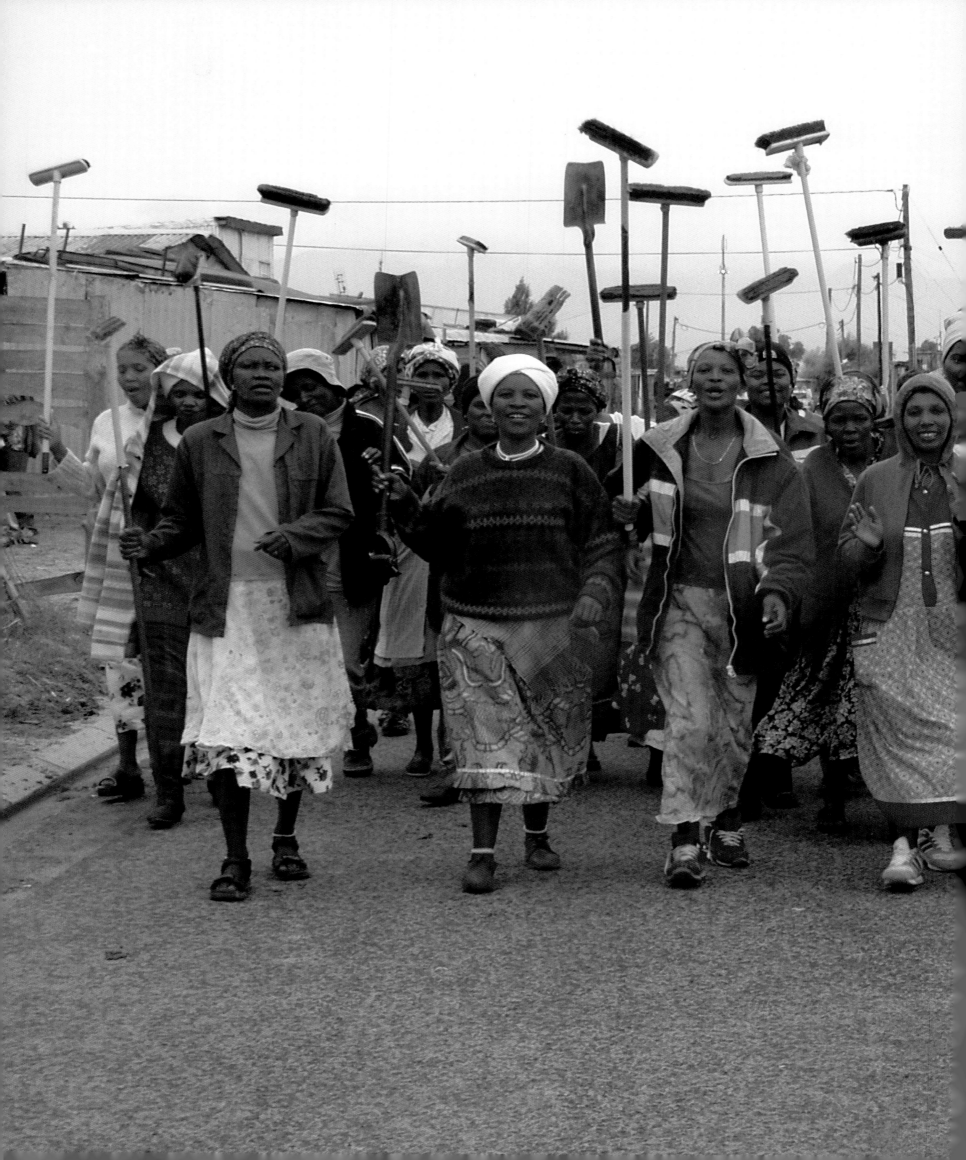

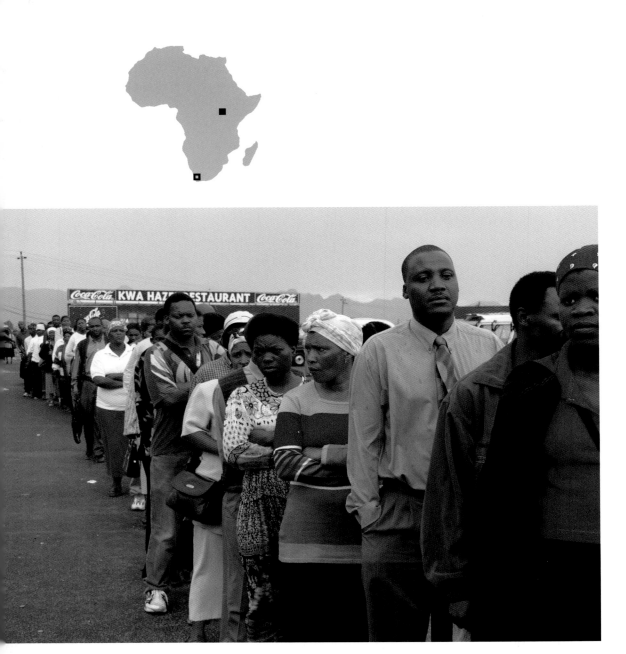

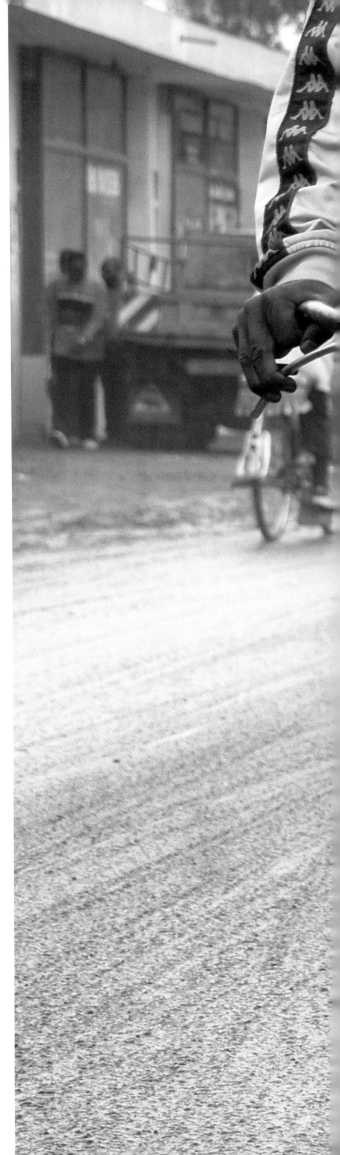

■ **Above**
Commuters in Khayelitsha, South Africa, line up for minibus taxis to neighboring Cape Town. Township residents rely on privately run minibuses to get to work, since public transportation is expensive and unreliable. Feuds over minibus turf have led to deadly shootings in Cape Town's poorer suburbs. Because of frequent gunfire, this spot has been dubbed "the Kuwait Taxi Rank."
> *Gideon Mendel in South Africa*

■ **Right**
In Kampala, Uganda, a bicycle taxi saves soles on the muddy streets near Owino Market.
> *Jeffery Allan Salter in Uganda*

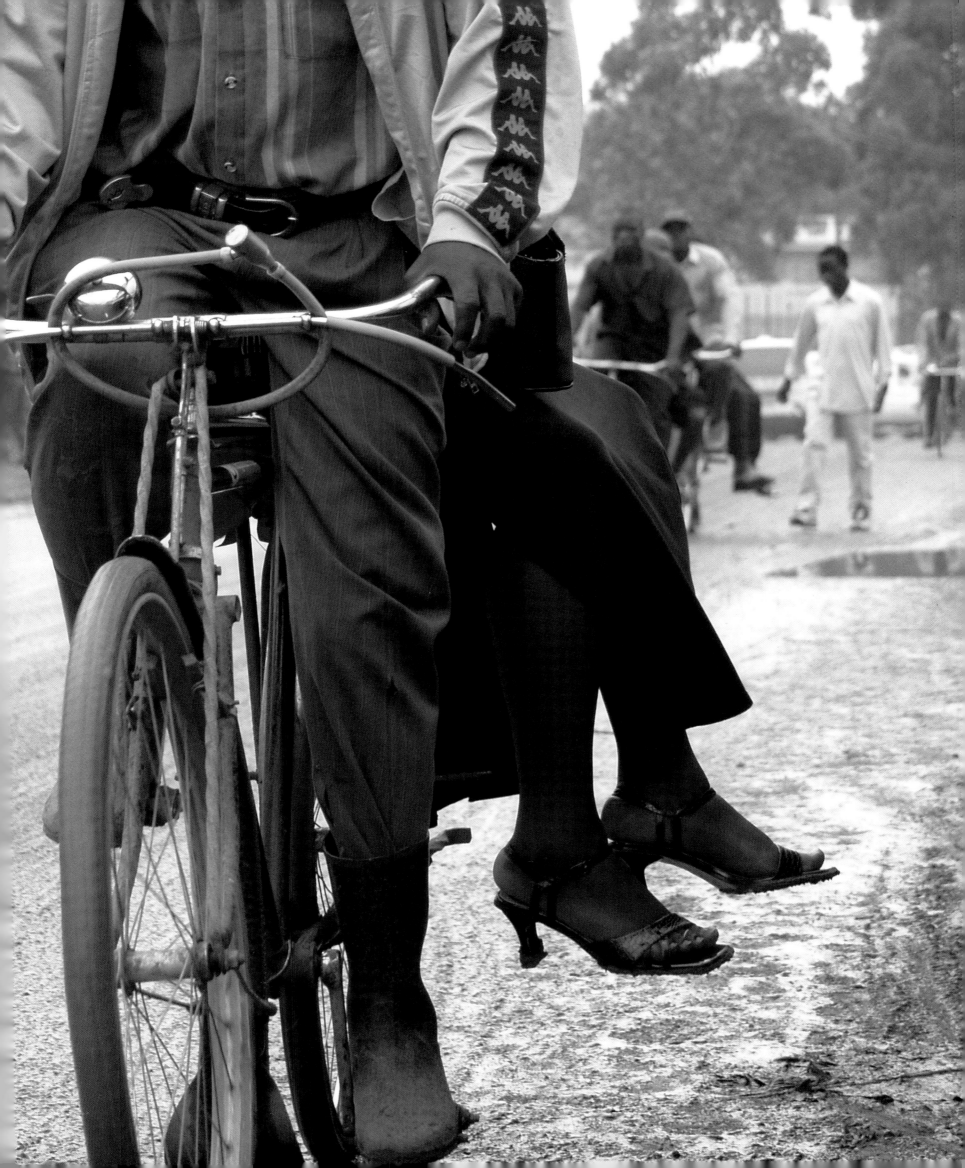

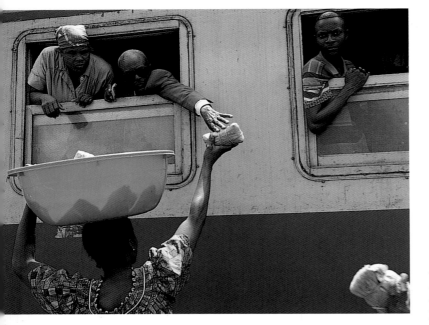

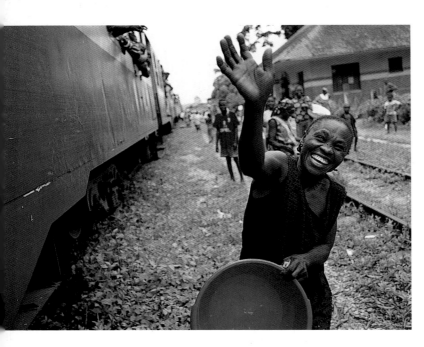

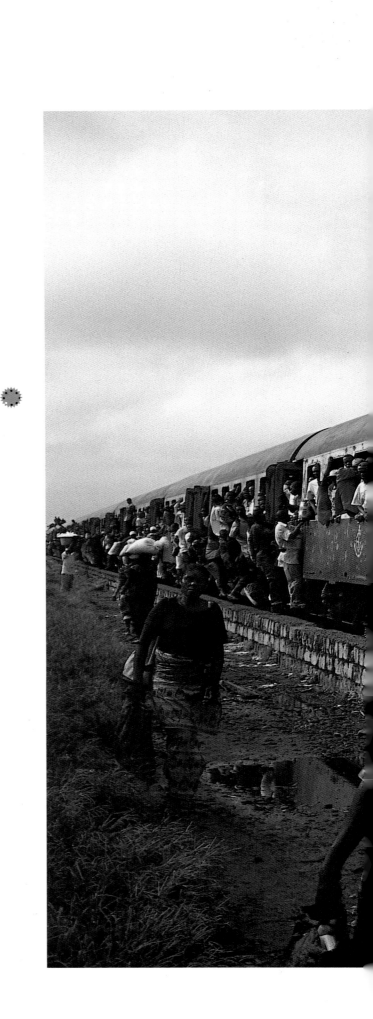

◾ **Left**
The Democratic Republic of the Congo's Blue Train travels weekly from the capital, Kinshasa, to the port city of Matadi. With more than 50 stops along the 200-mile trip, passengers have plenty of opportunity to shop for bargains from train-side vendors.
> *Noël Quidu in Congo-DRC*

◾ **Right**
A precariously crammed commuter train rolls into the center of Kinshasa, the capital of Congo-DRC. After decades of government corruption and a bloody four-year civil war, Congo-DRC—nearly the size of western Europe—has few maintained roads and a decaying transportation infrastructure, making over-burdened rail lines one of the few viable travel options.
> *Per-Anders Pettersson in Congo-DRC*

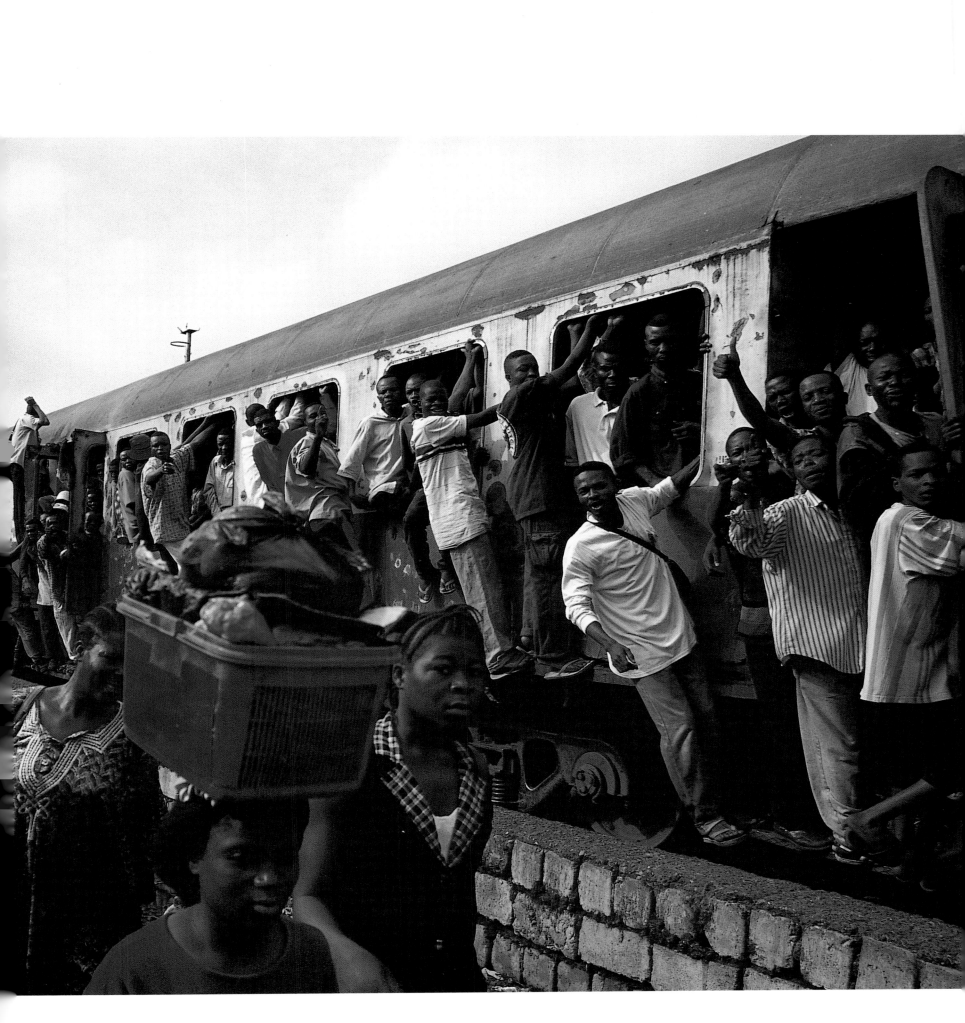

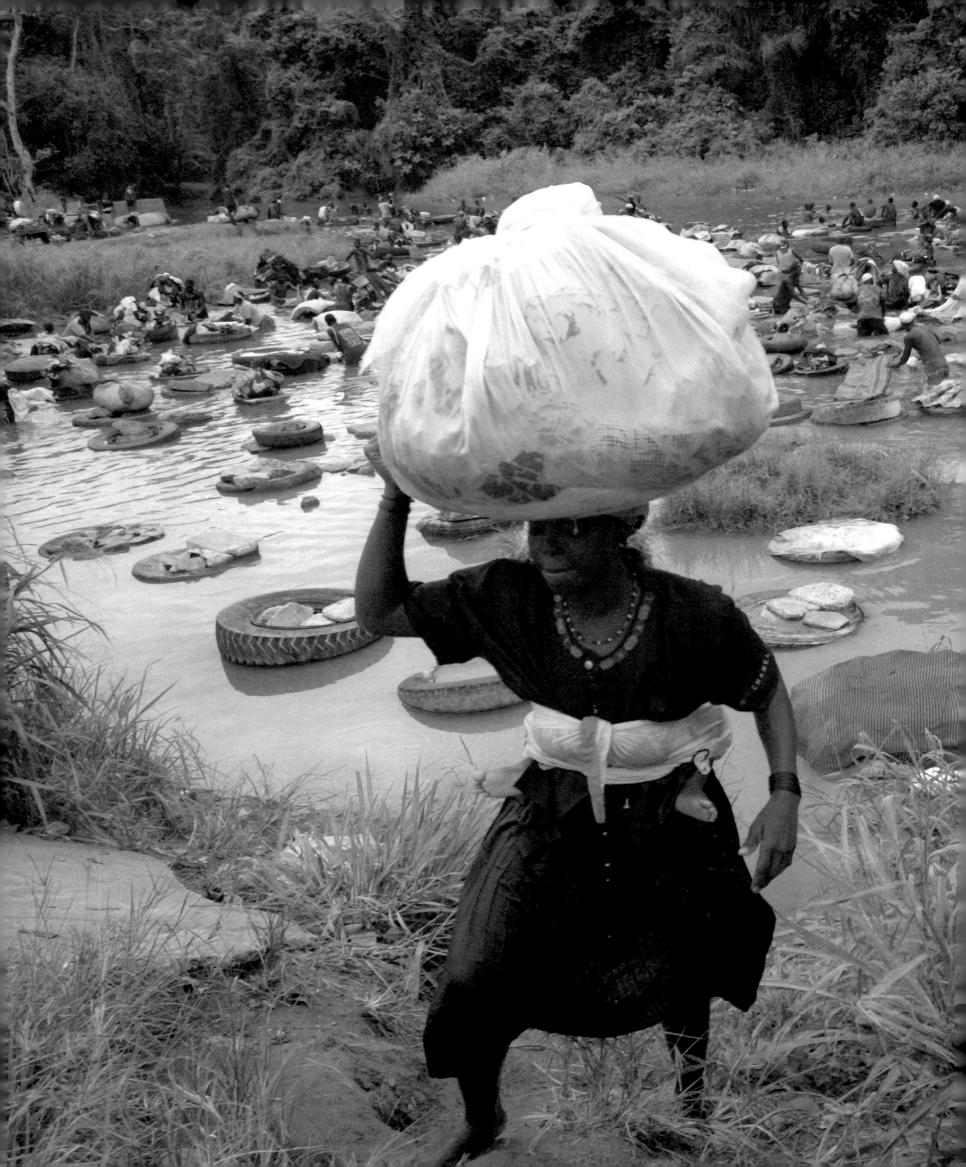

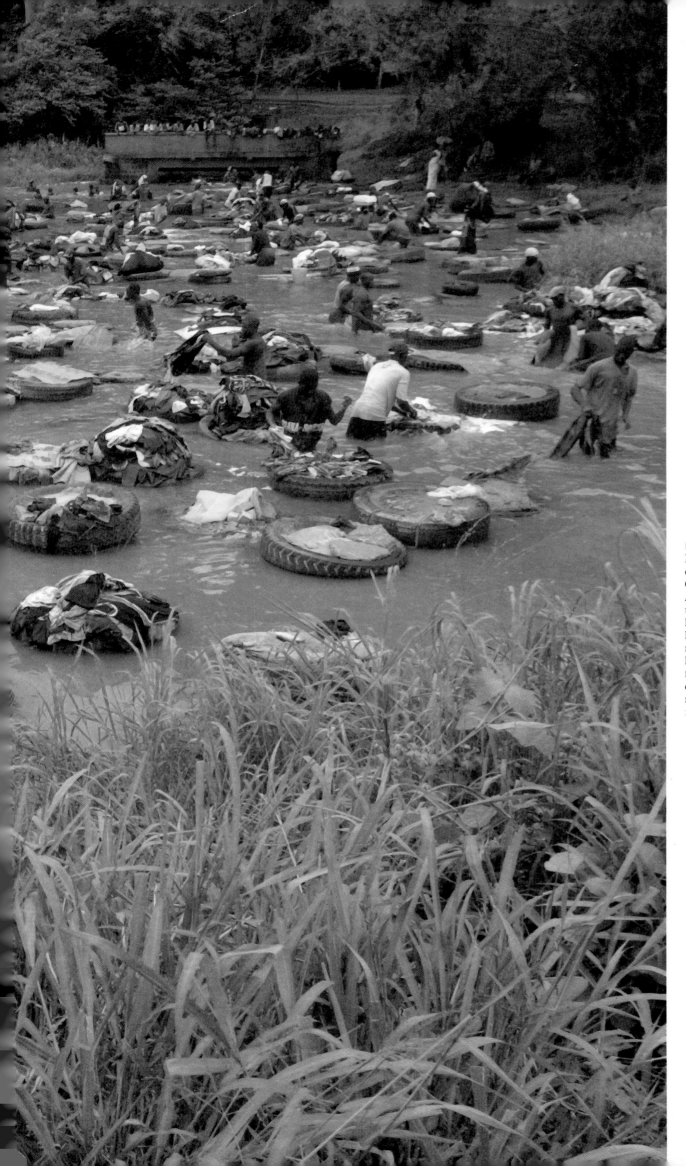

In the lush rainforest reserve of Parc du Banco, near the Côte d'Ivoire capital of Abidjan, launderers or *fanicos* use truck tires as floating laundry tables. Each fanico has an assigned position in the river. After scrubbing the laundry on large rocks, the fanicos carefully spread the clean clothes and linens on the riverside grass to dry.
> *C. W. Griffin in Côte d'Ivoire*

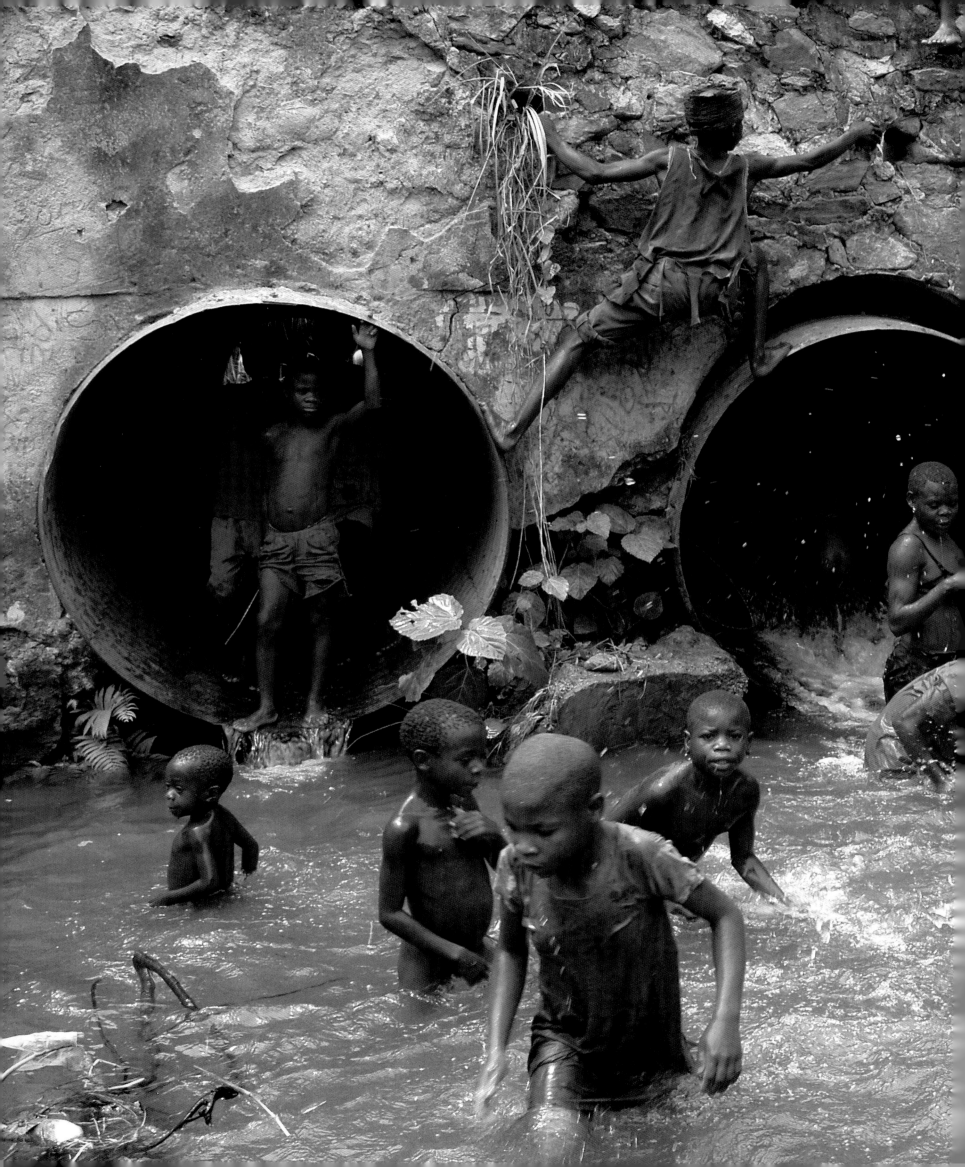

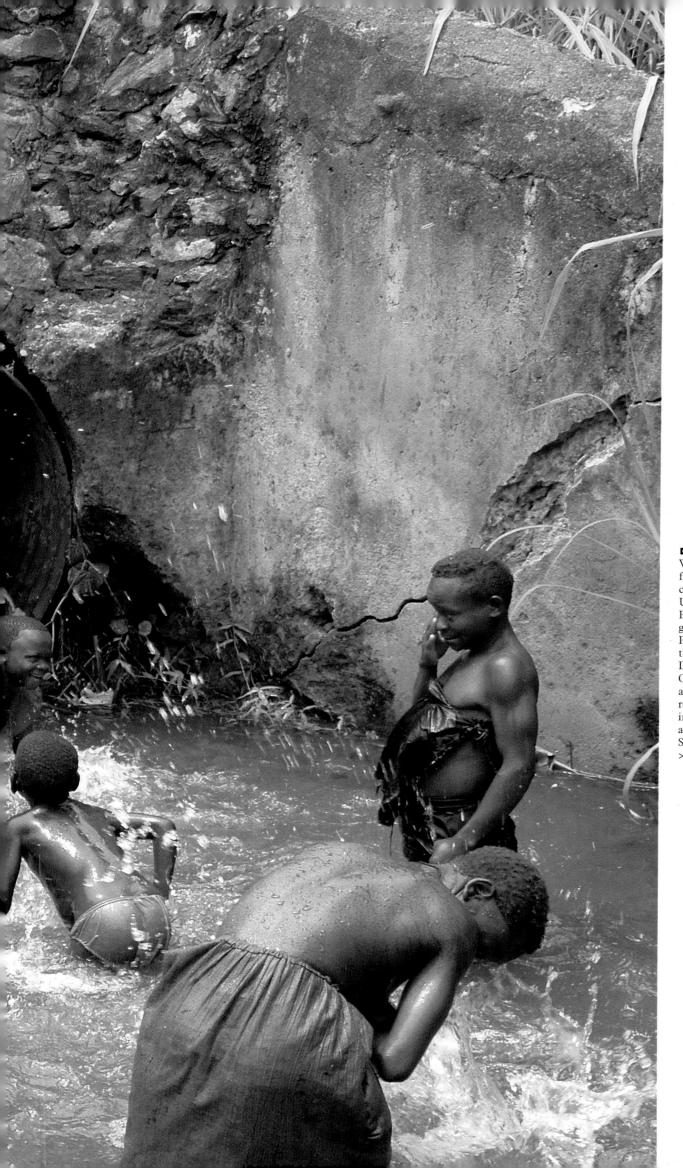

■ **Left**
While their families set up a
fishing camp, BaTwa children
cool off in a culvert in
Uganda's Semuliki National
Park. The BaTwa hunter-
gatherers (also known as
Pygmies) were forced from
their traditional home in the
Democratic Republic of the
Congo by political unrest
and shrinking forests. Now
resettled across the border
in Uganda, the BaTwa fish
and hunt birds in the
Semuliki Forest.
> *Larry C. Price in Uganda*

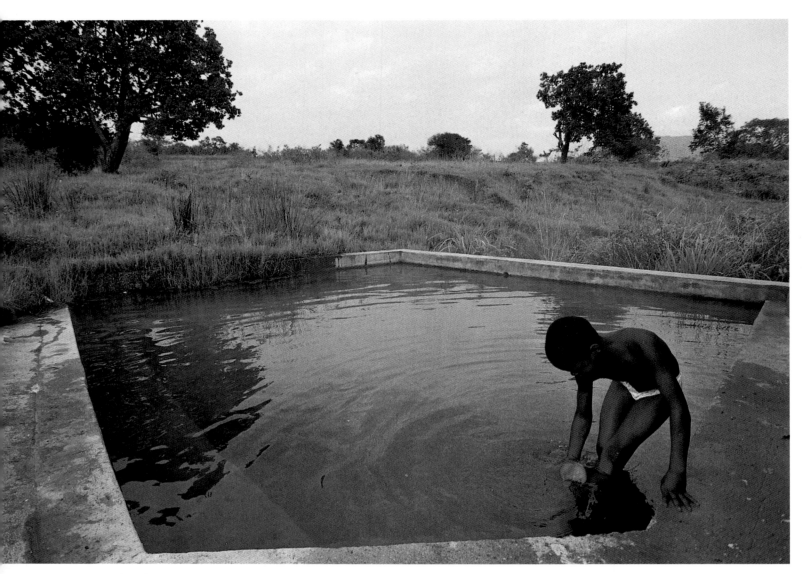

□ **Above**
In the Ezulwini Valley, near the residence of Swaziland's King Mswati III, a young girl stops to bathe in a public hot spring on her way to school.
> *Lori Waselchuk in Swaziland*

■ **Right**
A 16-year-old OvaHimba woman cradles her infant in the remote homestead of Otjekwa, Namibia. Driven from their original home near the Namibia-Botswana border by Nama cattle raiders in the mid-19th century, the seminomadic OvaHimba originally migrated to Angola. After World War I, they resettled in a dry, mountainous region near Namibia's Skeleton Coast. The name OvaHimba means "beggars" in an Angolan dialect.
> *Seamus Conlan in Namibia*

◐ **Following Pages**
Youngsters head out for morning recess at an orphanage in SOS d'Abobo, in suburban Abidjan.
> *Lougue Issoufou Sanogo in Côte d'Ivoire*

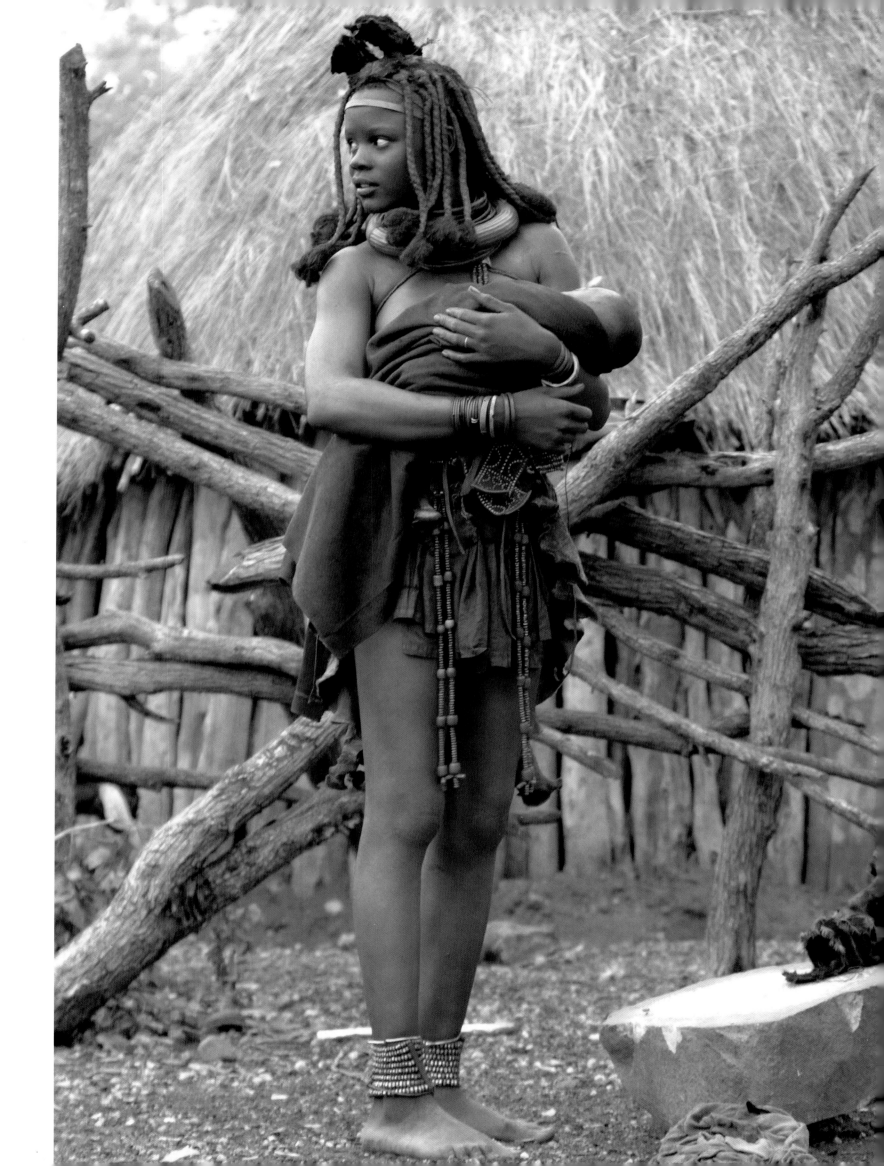

> a runner's heart

**Photographed in Kenya
by Robert Holmes**

The cool highlands of western Kenya, in the fertile heart of Africa's Great Rift Valley, have long been home to the fastest distance runners on the planet—elite athletes who consistently dominate Olympic and world championship track and marathon events. The father of Kenyan distance running is Kipchoge "Kip" Keino, a running legend who has fostered far more than a championship legacy.

Over the course of three decades, the Olympic gold-medalist and his wife, Phyllis, have adopted more than 100 orphaned and abandoned children. The Keinos raise these children on two Kenyan farms, Kazi Mingi ("A Lot of Work") and Baraka ("Blessing"). Over the years, these farm compounds near the highland town of Eldoret—with their dormitory-style bunkhouses, vegetable gardens, and Holstein dairy cows—have become nearly self-sufficient. In 1999, the couple opened the Kip Keino School near Baraka. The school is attended by all of the Keinos' adopted children in grades one through eight, as well as fee-paying students from the surrounding area.

When Day in the Life photographer Robert Holmes visited Baraka farm, Keino had just returned from the 2002 Olympic Games in Salt Lake City. "It was quite moving," said Holmes. "The kids all ran up to Kip, hugging him and calling him 'Daddy.'" Even with seven children of their own, the Keinos find it hard to turn any youngster away. "I came into this world with nothing," explains Keino, a Nandi tribesman whose mother died when he was three. "These children need food. They need clothing. They need shelter, and most of all, they need love."

Morning assembly at the Kip Keino School.

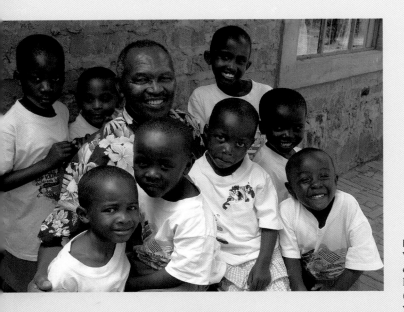

Left and Right
While his school-age children practice their lessons *(right)*, Kip Keino *(top)* takes a break with the younger kids. Preschoolers *(bottom)* eat lunch at Kip Keino's Baraka Farm.

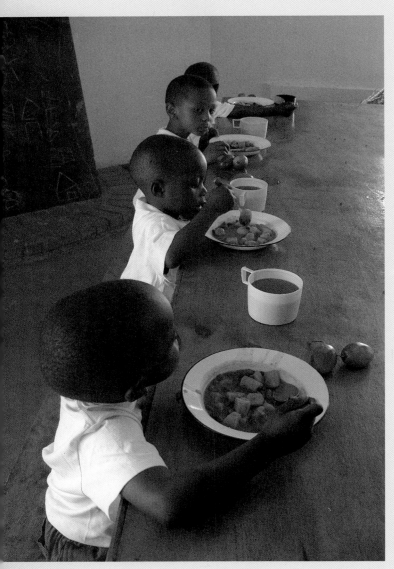

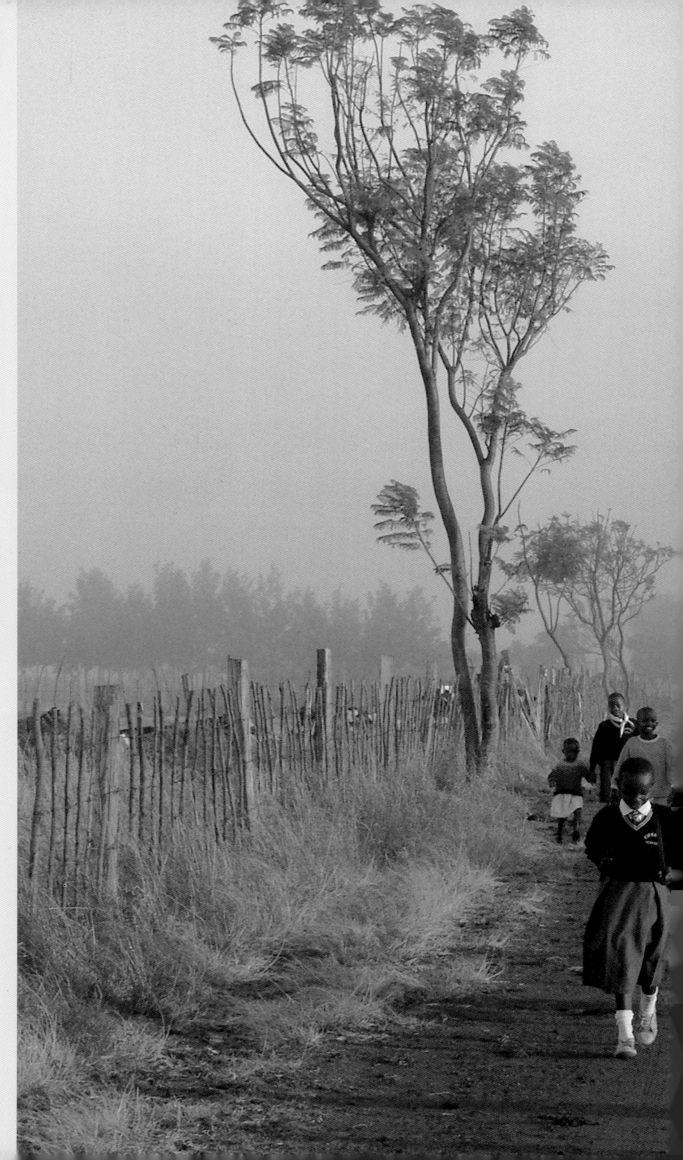

Right
For the Keinos' many adopted children, school is a quick walk down the road from Baraka Farm. Other, fee-paying students travel to the Kip Keino School from the town of Eldoret, 10 miles away.

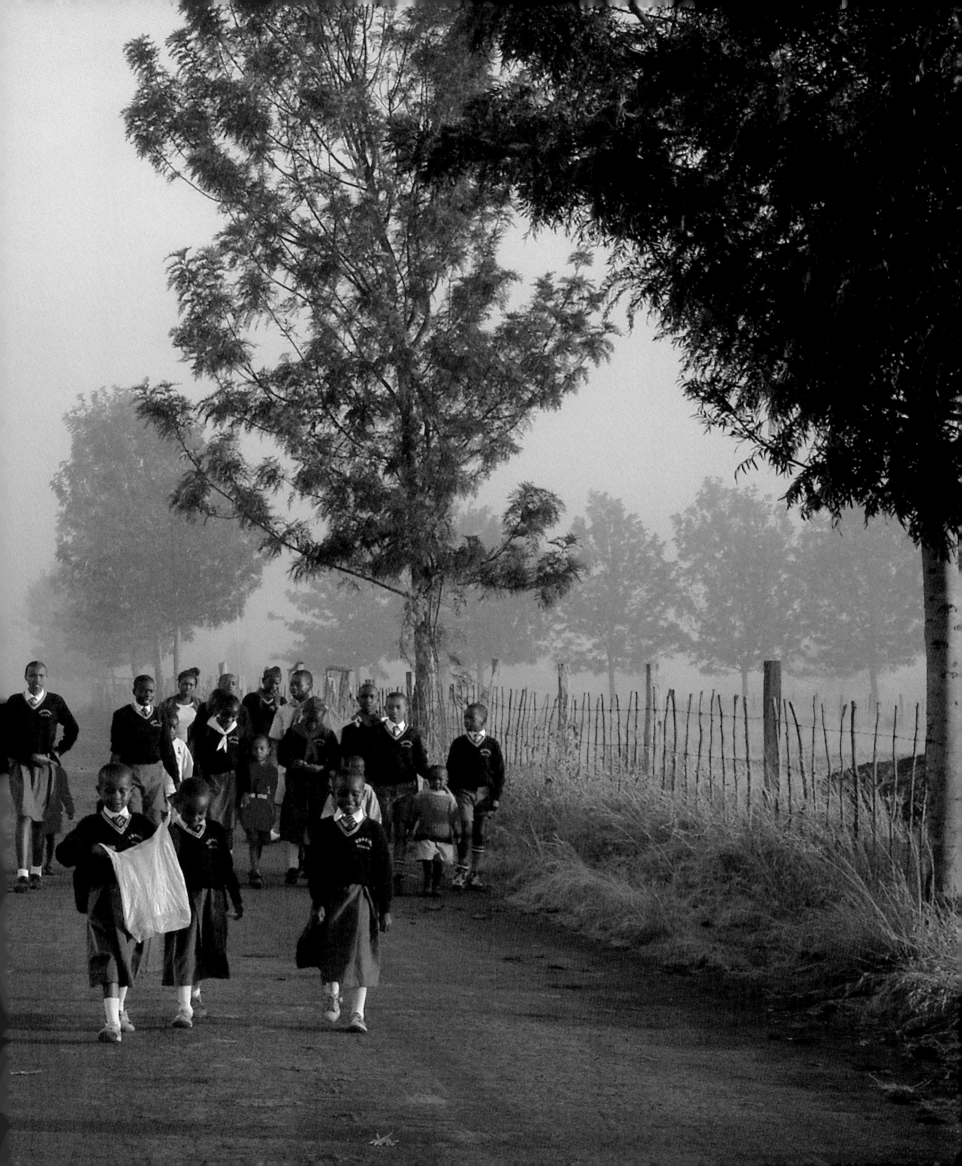

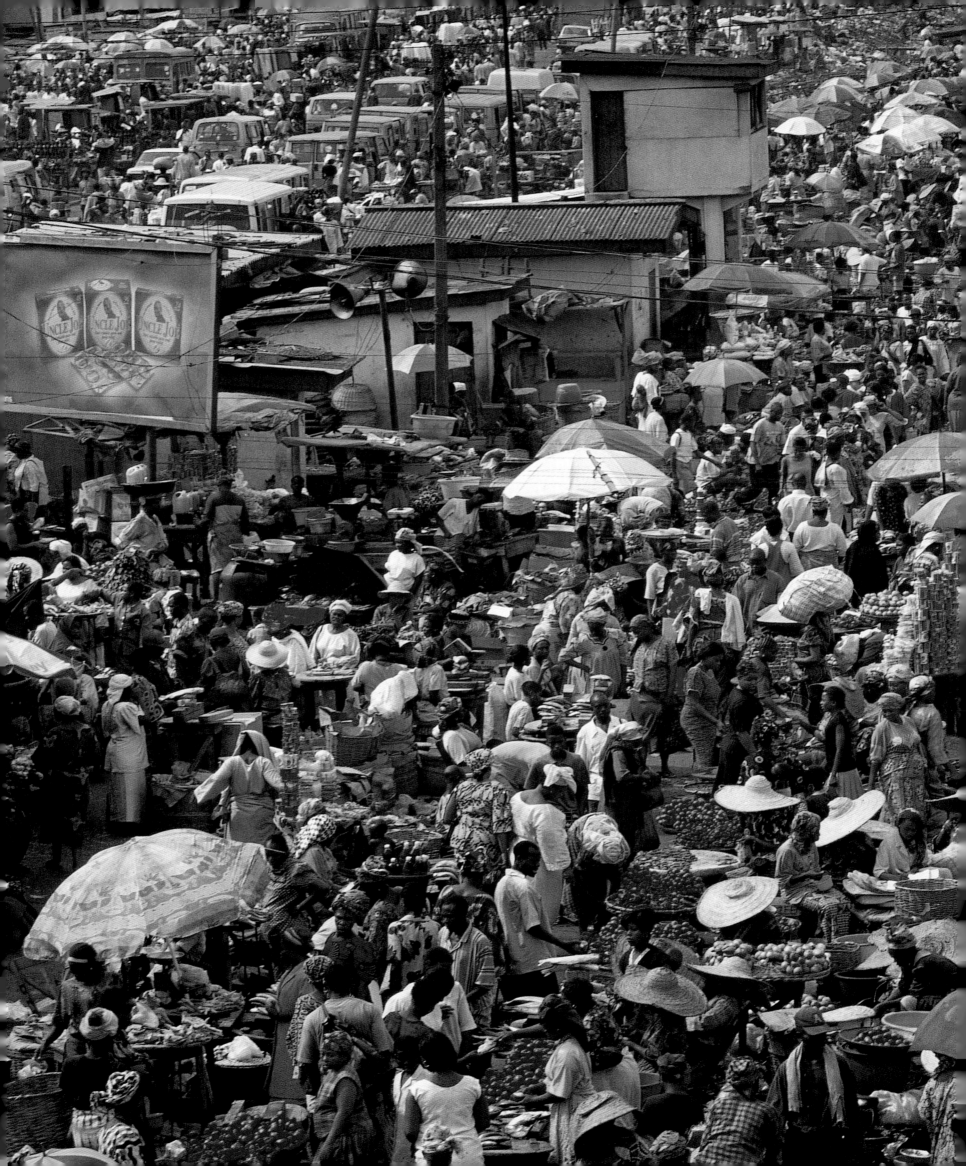

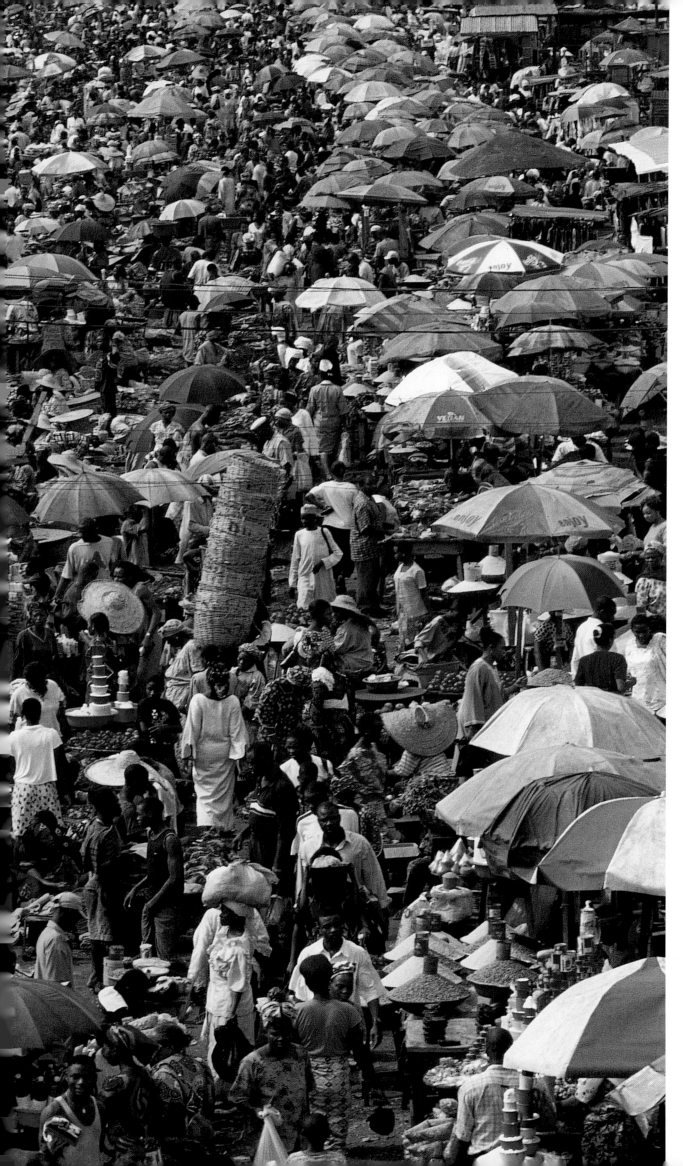

□ **Left**
The massive Oshodi Market in Lagos, Nigeria, is a sea of buyers and sellers trading a vast variety of goods and services. Every day, up to 4 million people pass through the area, located at the congested crossroads of several bus and rail lines in the Nigerian capital, one of the most populous cities on earth.
> *James Marshall in Nigeria*

■ **Following Pages**
In many African rural towns like Bongor, in southern Chad, women play a central role in bringing crops to market—in this case, tomatoes.
> *John Isaac in Chad*

65

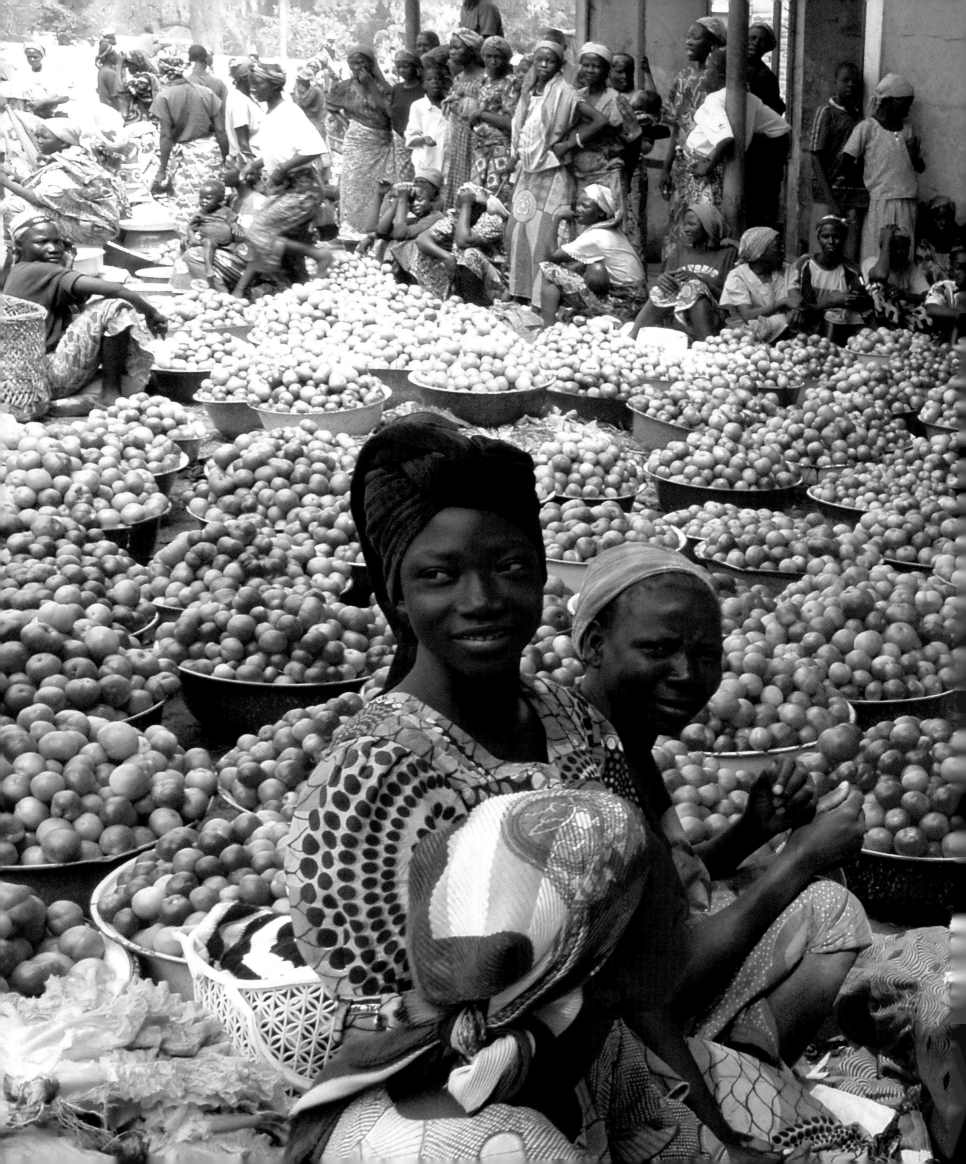

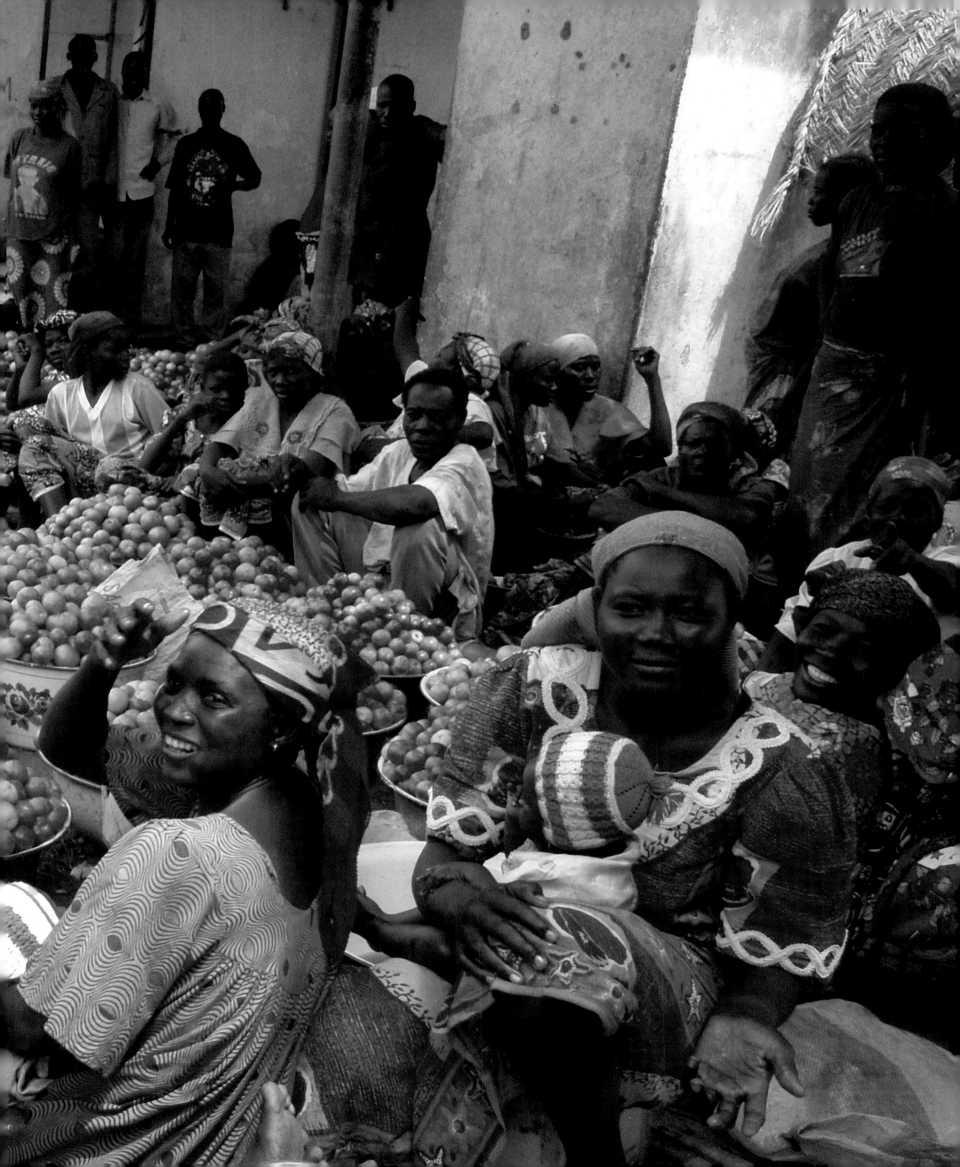

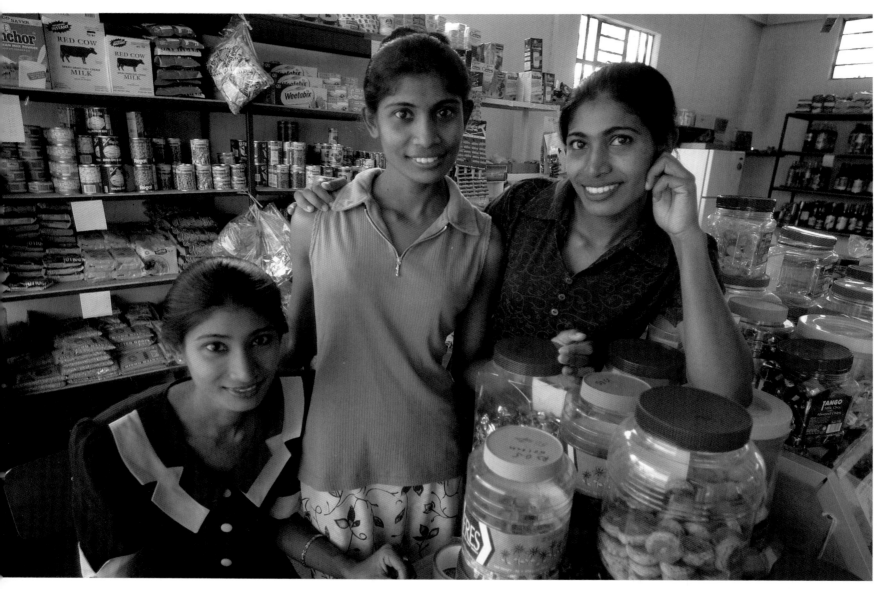

On the island nation of
Mauritius, off Africa's
southeastern coast, sisters
Rekha, Rajshree, and Ranjeeta
staff the family general store
near the fishing village of
Grand Gaube. Like most
Mauritius residents, the girls
are of Indian descent.
> *Kevin T. Gilbert in Mauritius*

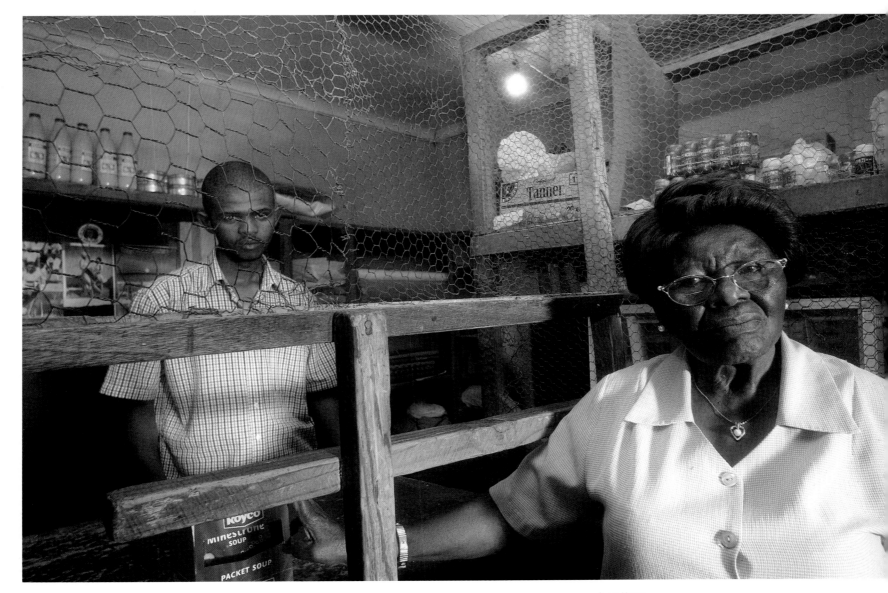

■ Above
Eighty-six-year-old Epainette
Mbeki—mother of President
Thabo Mbeki—tends a tiny
shop in the remote village of
Idutywa in South Africa's
Transkei region. Epainette and
her husband, Govan, were
both teachers and committed
Communists. Govan, a
longtime leader of the African
National Congress, was jailed
for several years with Nelson
Mandela. Like mothers
everywhere, the outspoken
Mrs. Mbeki never hesitates to
ring her son the president
whenever she has something
important on her mind.
> Pedro Meyer in South Africa

■ **Right**
In the vast Kejetia Market in Kumasi, Ghana, women pick their way past an assembly line where shoes are crafted from old automobile tires. Sprawling across 25 dusty acres in the ancient Ashanti capital, Kejetia is one of the largest market-places in West Africa. The eclectic assortment of items for sale ranges from agricultural products to consumer goods and religious icons.
> *Frank Fournier in Ghana*

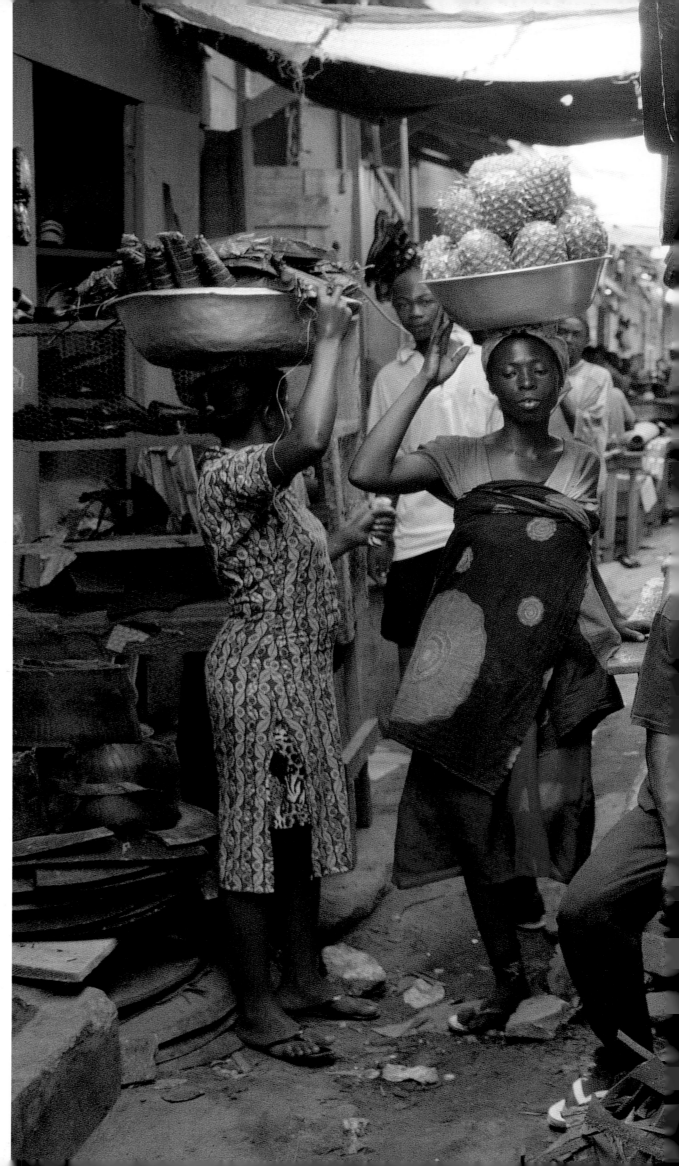

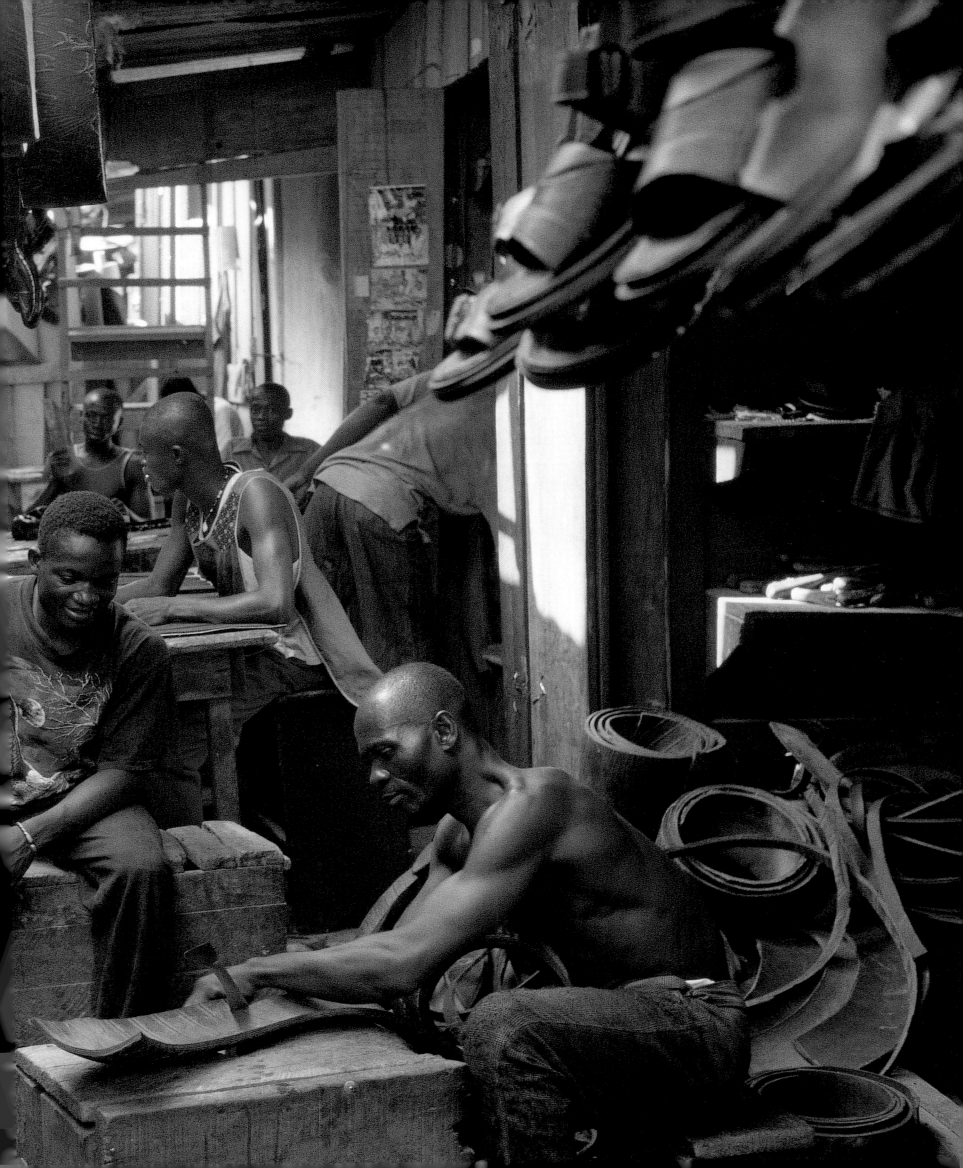

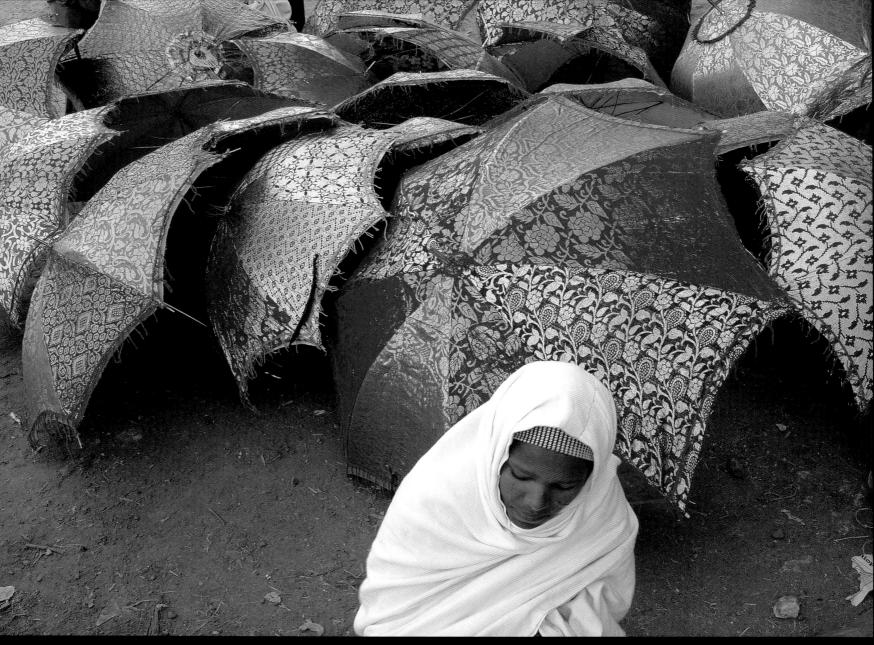

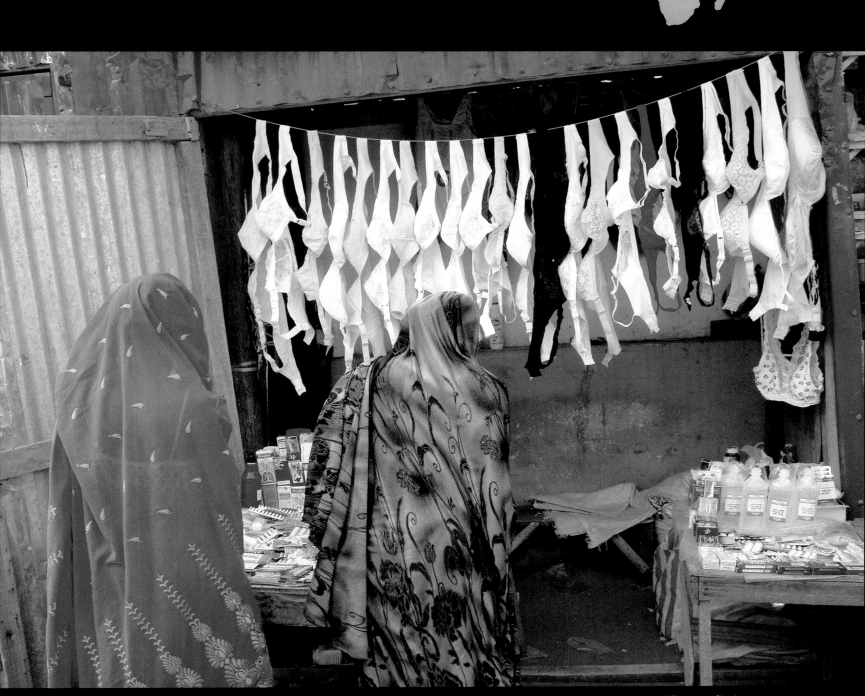

■ *John Isaac > N'Djamena, Chad*

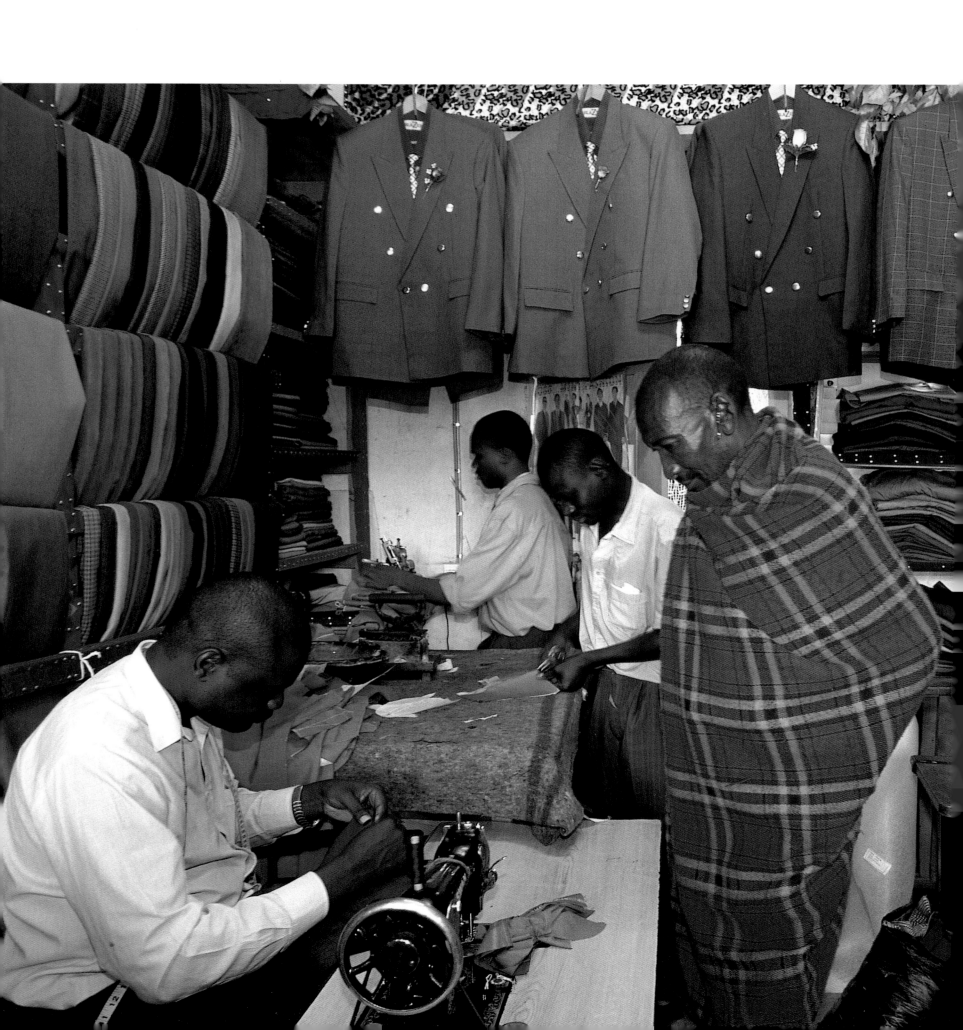

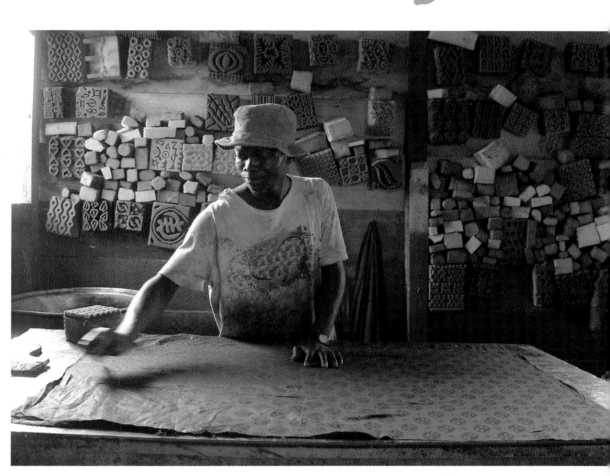

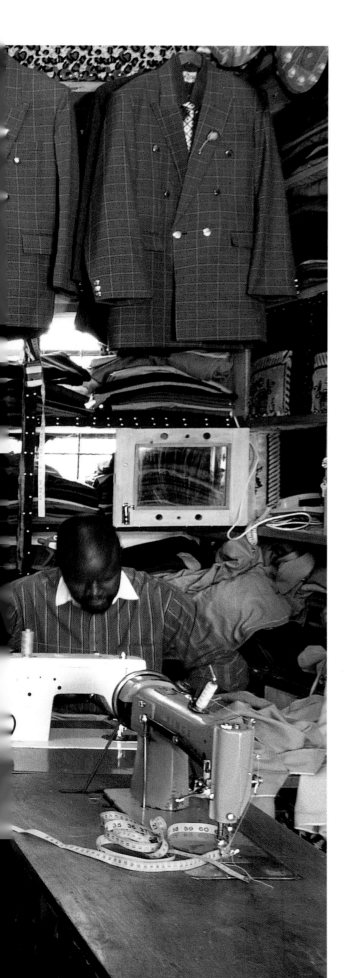

■ **Above**
A worker makes wood-block prints at a textile company outside Ghana's capital, Accra.
> *Jeffrey Henson Scales in Ghana*

■ **Left**
In the Fitwell Tailor Shop in Narok, Kenya, a man in traditional Maasai garb considers his options.
> *Liz Gilbert in Kenya*

■ *Themba Hadebe > Mukinge, Zambia*

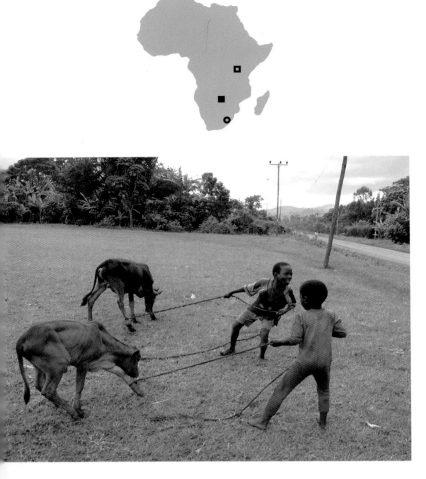

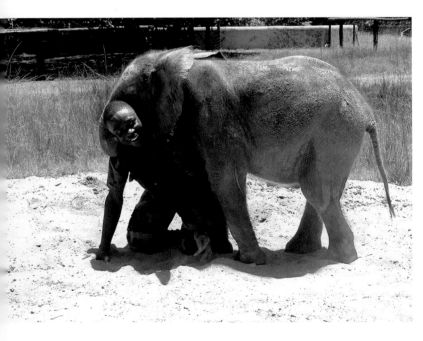

□ Top Left
Lassoing calves on a country road outside Kampala.
> *Jeffery Allan Salter in Uganda*

■ Bottom Left
Phoenix, a baby elephant orphaned by poachers, plays with her keeper at the Munda Wanga Wildlife Sanctuary near Lusaka, Zambia. Phoenix has two attendants who keep her company around the clock.
> *Tom Stoddart in Zambia*

○ Right
In South Africa's KwaZulu-Natal province, rangers test a cape buffalo for bovine tuberculosis. The deadly infection spreads swiftly to other species, particularly lions, which prey on the buffalo. Rangers inject each animal in the reserve with a powerful narcotic. Then they hold its head upright to prevent choking while a veterinarian takes a blood sample and injects an antidote. The buffalo is back on its feet in a few minutes.
> *Jay Dickman in South Africa*

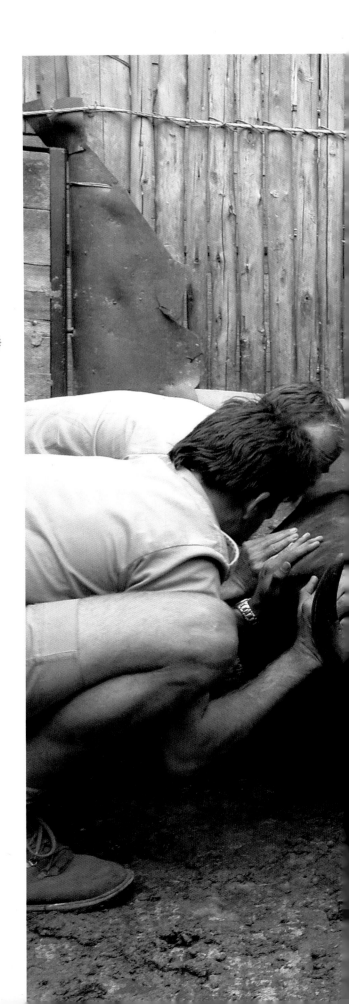

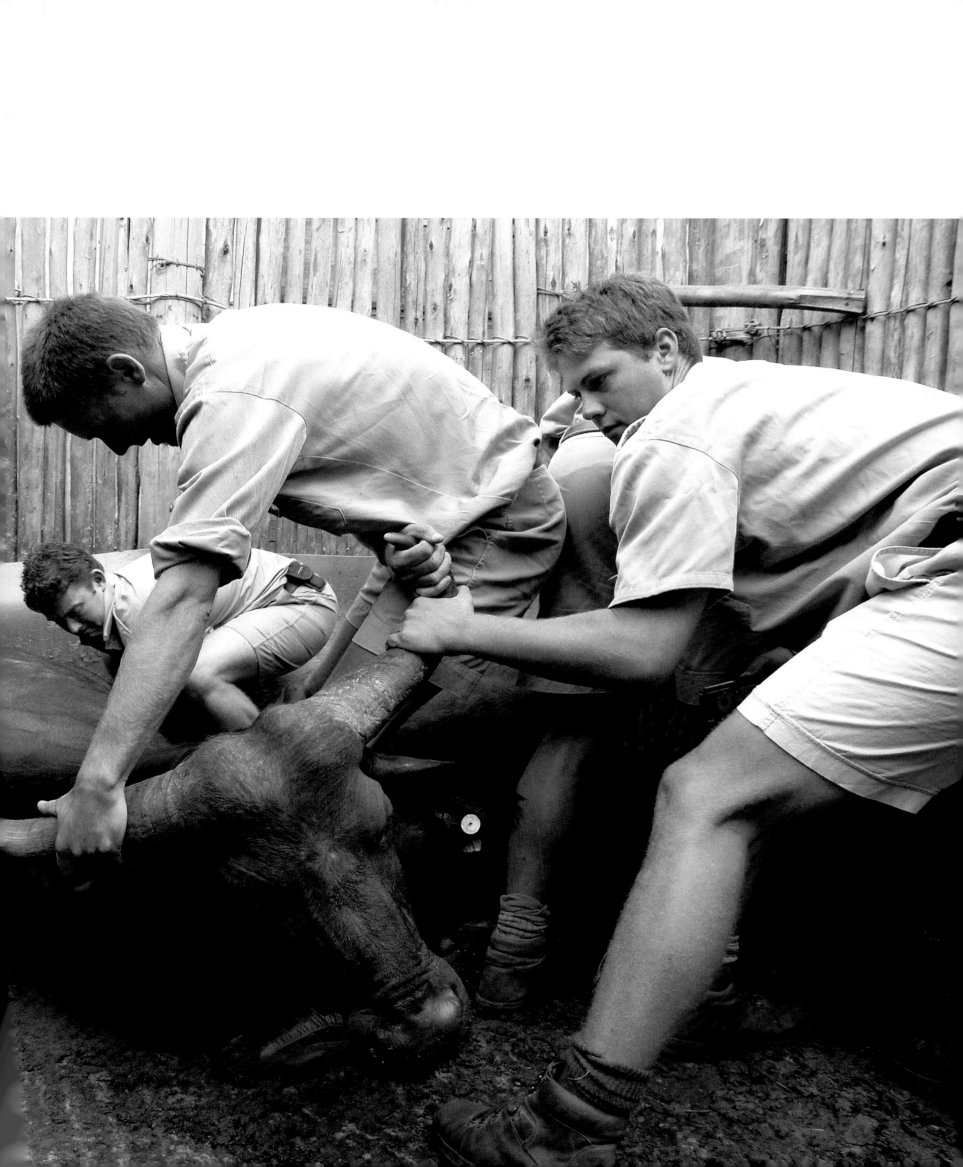

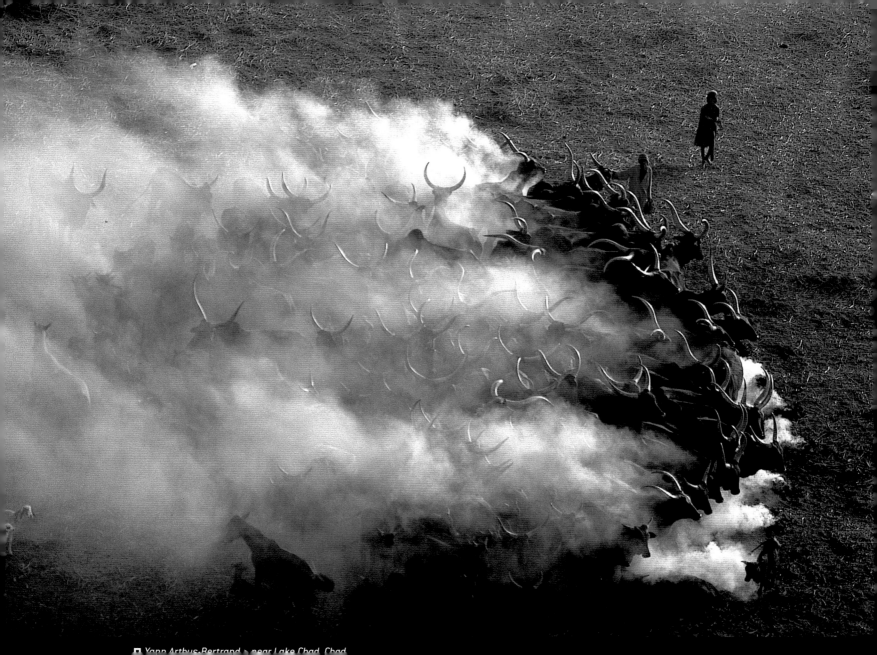

■ François Lagarde > Cape Fria, Namibia

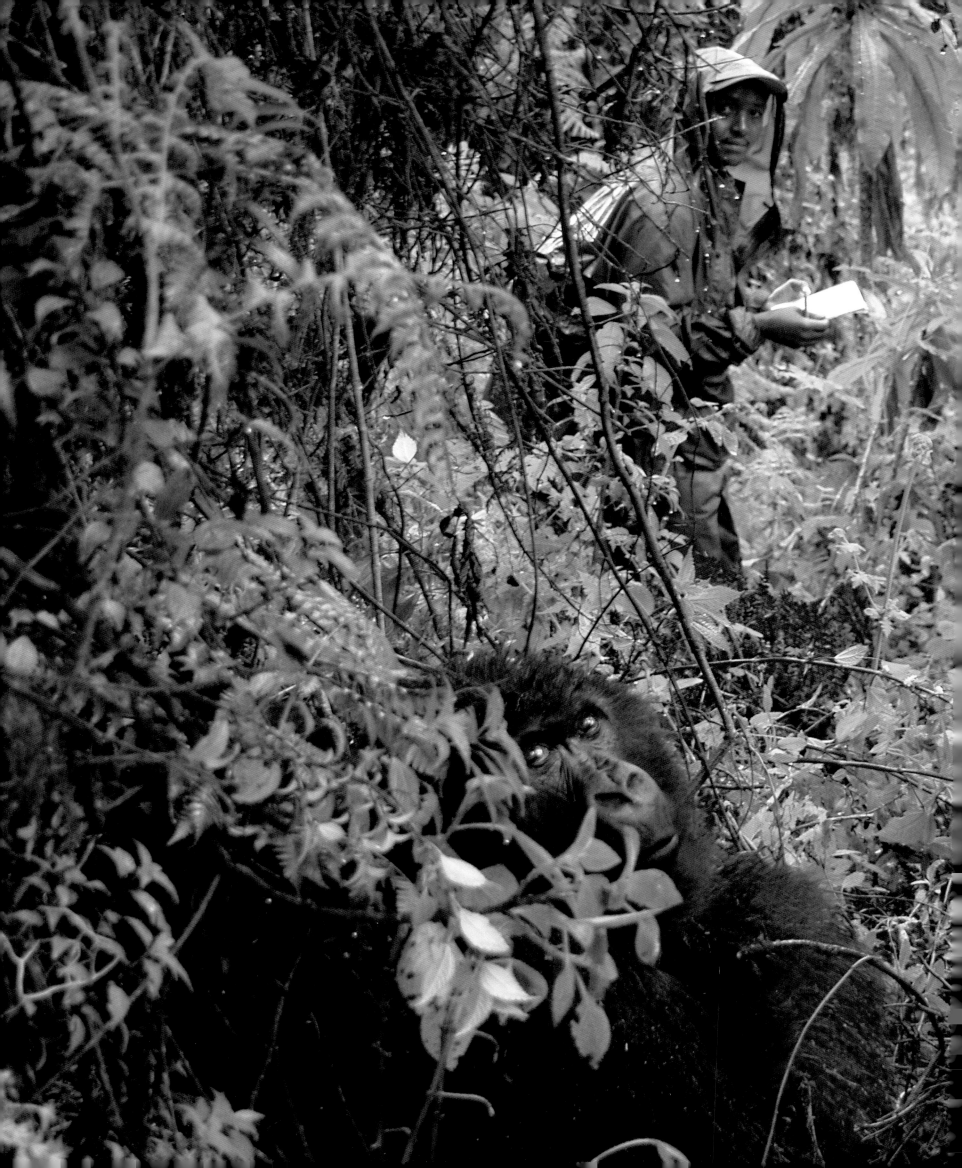

▫ Left
A mountain gorilla gazes at photographer Kristen Ashburn through the dense foliage of Virunga National Park. Threatened by warfare, poachers, and deforestation, the gentle mountain gorillas are among the most endangered species on earth. The late researcher Dianne Fossey publicized their plight in her book, *Gorillas in the Mist*. Today, Rwandan field staff at the Karisoke Research Center, where Fossey worked, strive to protect the remaining mountain gorillas.
> Kristen Ashburn in Rwanda

■ Following Pages
A cattle herder drives his *kuri* longhorns to the Chari River in southwestern Chad. Native to the Lake Chad region, the kuri, with their distinctive lyre-shaped horns, are prized dairy cattle.
> John Isaac in Chad

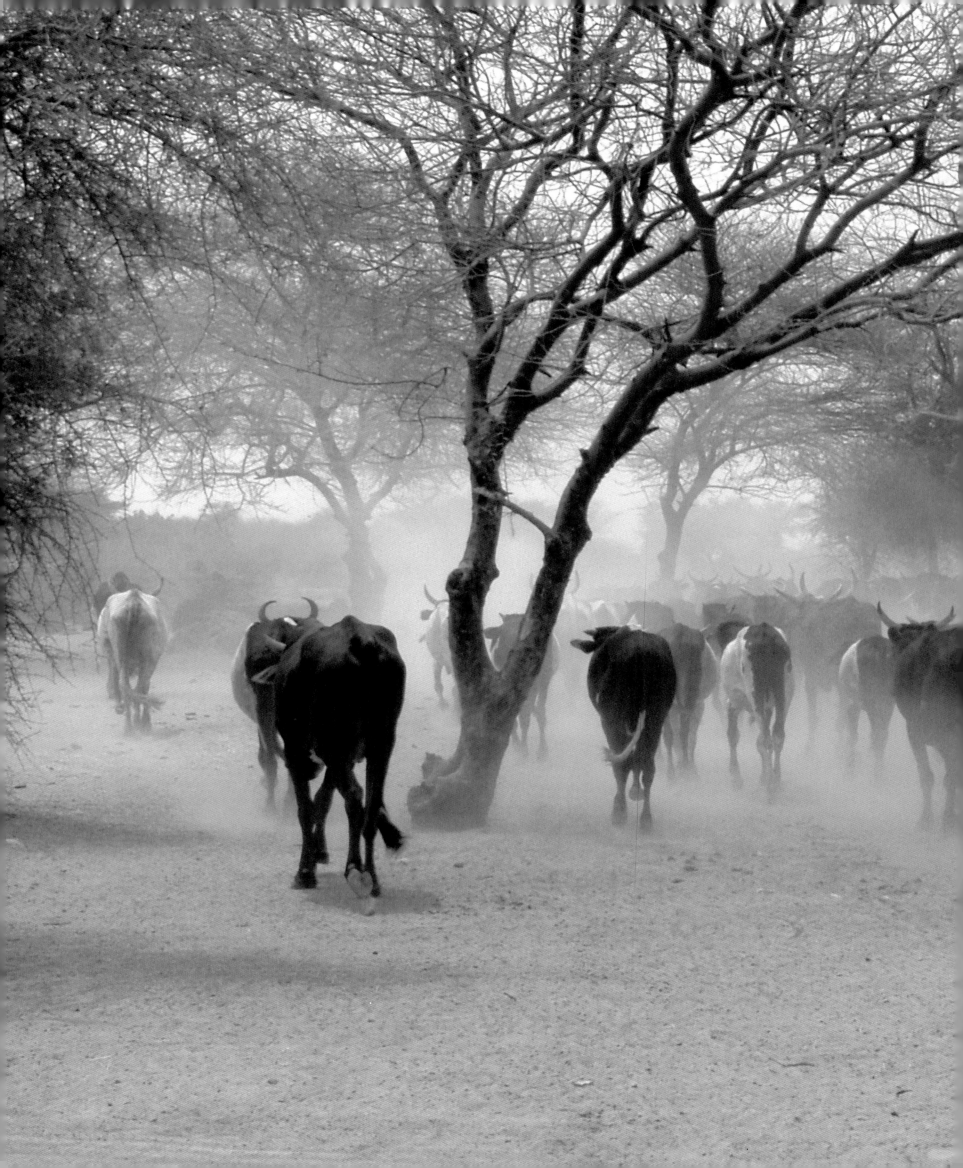

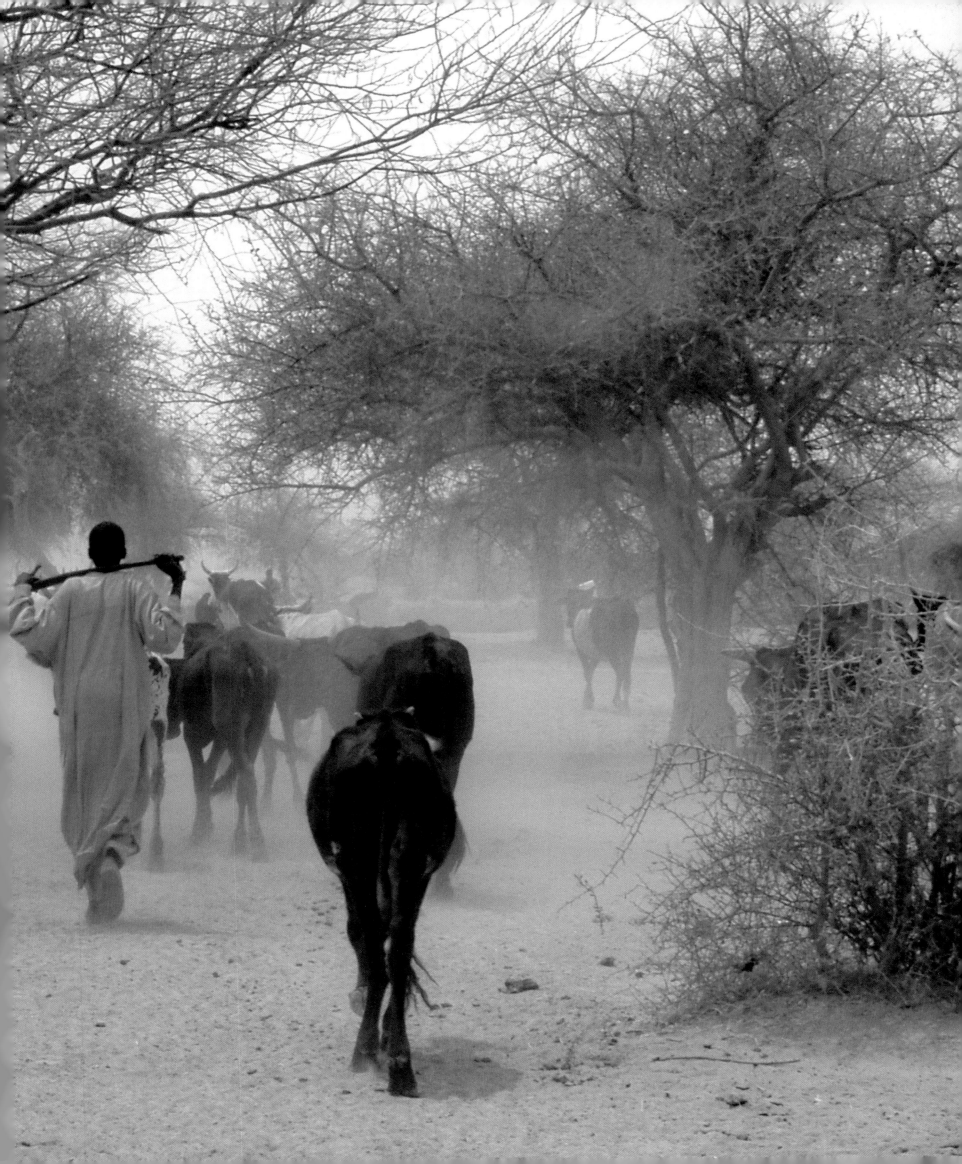

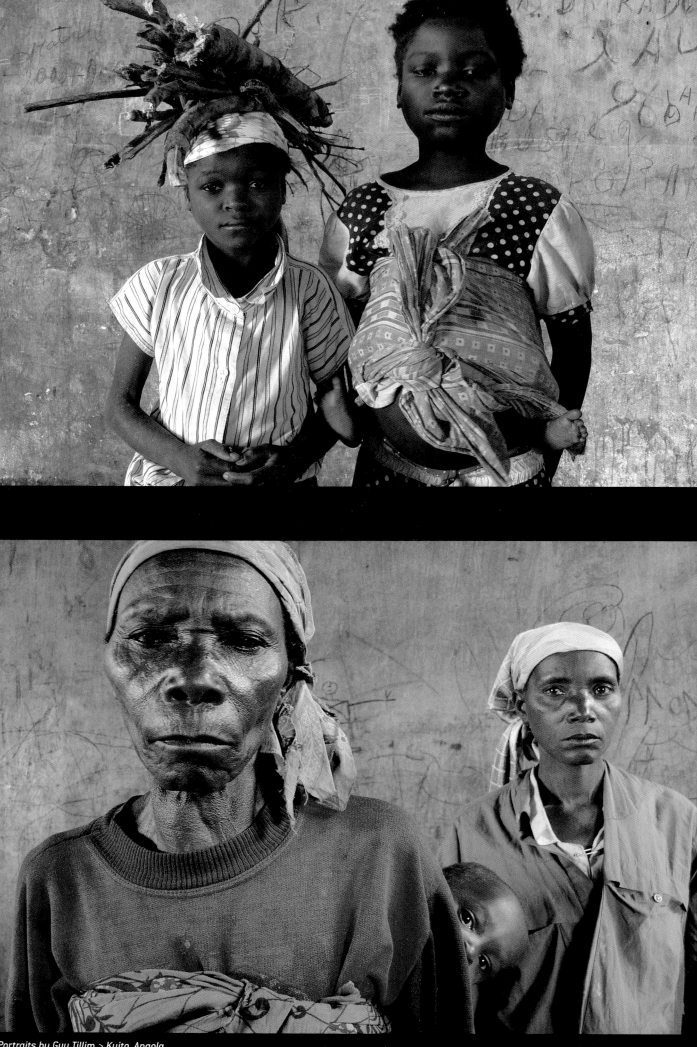

Portraits by Guy Tillim > Kuito, Angola

> the scourge

**Photographed in Zambia
by Tom Stoddart**

A mile from Freedom—a huge, desperately poor suburb of Zambia's capital, Lusaka, ravaged by HIV/AIDS—Polish nun Sister Leonia Kornas offers dignity and comfort to end-stage AIDS patients. At her Mother of Mercy Hospice in the village of Chilanga, south of the Zambian capital, Sister Leonia and her staff struggle to provide food, shelter, and palliative care for some 350 patients. The task is often overwhelming. "It's getting worse every day," says Sister Leonia, who has run the hospice since 1992. "We can't help everybody, and we are now at our limit."

When *A Day in the Life of Africa* was shot, on February 28, 2002, more than 12 million Africans had already died from AIDS, and Zambia was one of the worst-afflicted nations. In early 2002, as many as 300 Zambian men, women, and children were dying each day from AIDS-related causes, and as many as 600,000 children had been orphaned by the epidemic. Poverty, desperation, and denial make it difficult to slow the spread of a disease that is killing one in five Zambian adults.

Freedom lies beside a busy truck route, and despite the enormous risk of contracting HIV, the virus that causes AIDS, many area women feel they must turn to prostitution with long-distance truck drivers in order to economically survive. The drivers, in turn, spread the disease throughout the region. Day in the Life photographer Tom Stoddart of London devoted his shoot day to Africa's AIDS epidemic, recording scenes of compassion and despair at the Mother of Mercy Hospice and nearby Mapepe Cemetery.

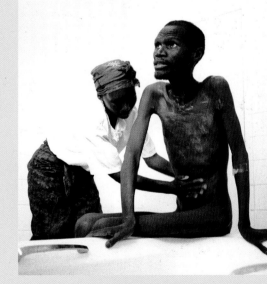

Thirty-two-year-old Mother of Mercy Hospice patient Godfrey Malama is gently bathed by his wife, Cecile.

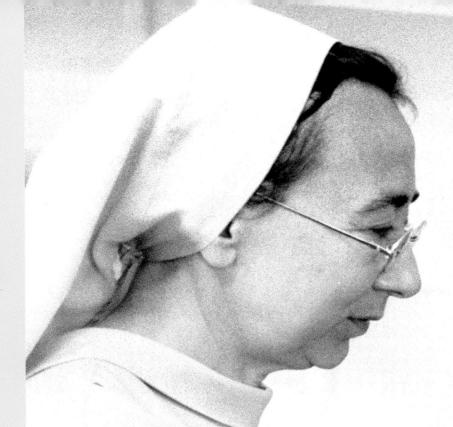

Right
Sister Leonia Kornas
comforts a frail patient on her
morning rounds at the Mother
of Mercy Hospice. Since she
came to Zambia in 1992,
Sister Leonia has provided
hospice- and home-based care
for hundreds of dying AIDS
patients in the villages around
the capital, Lusaka.

Following Pages
Too weakened by AIDS to sit
up or raise her head, 18-year-
old Josephine Mudenda is
given her morning bath by a
hospice nurse.

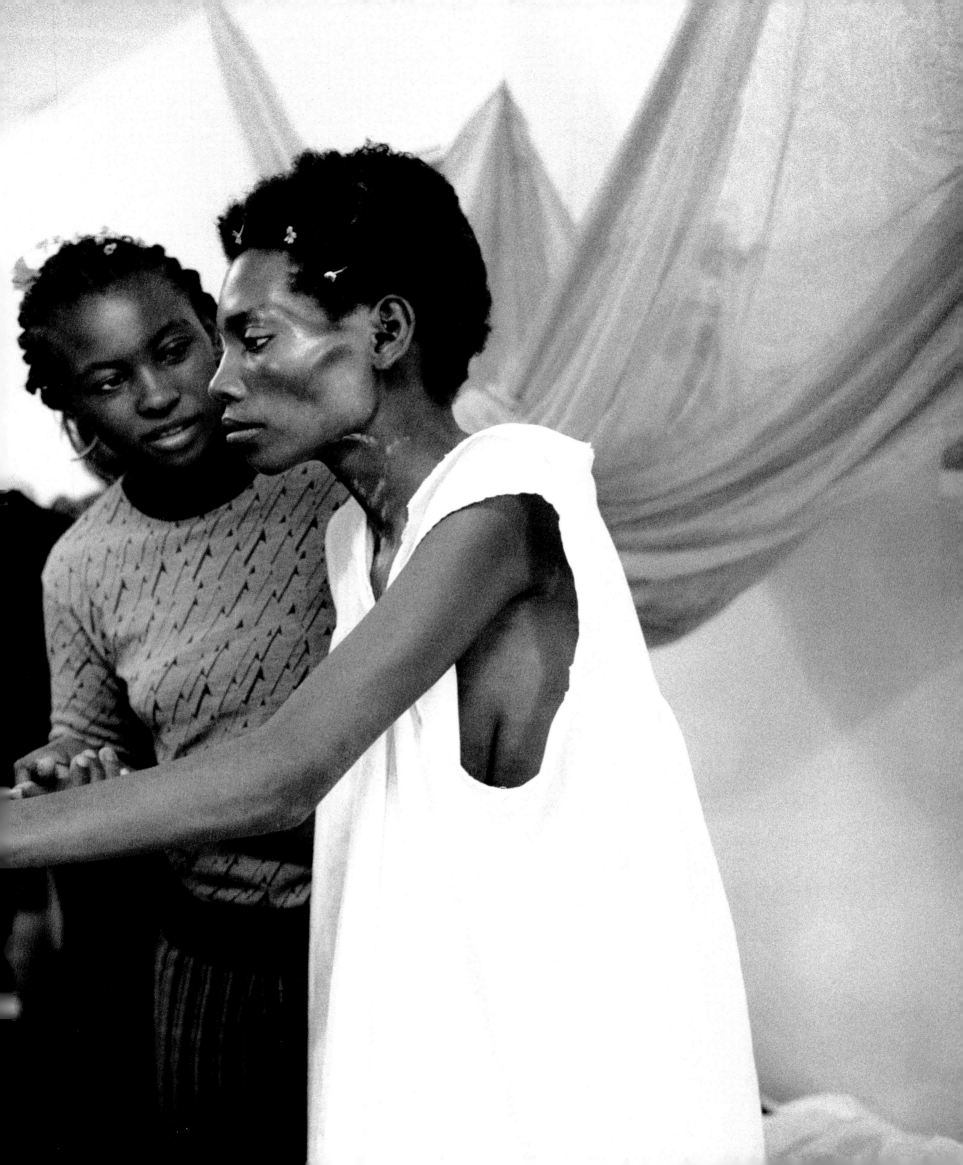

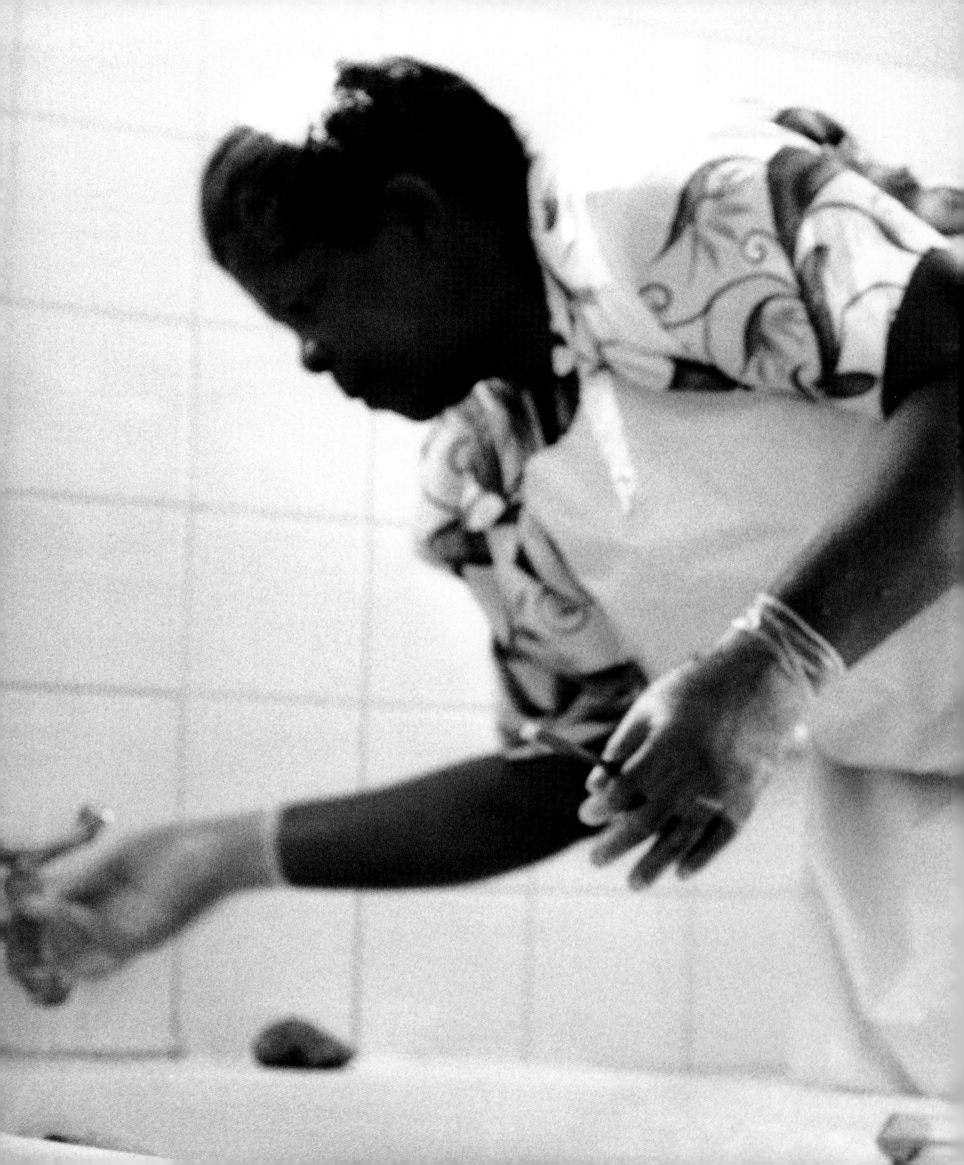

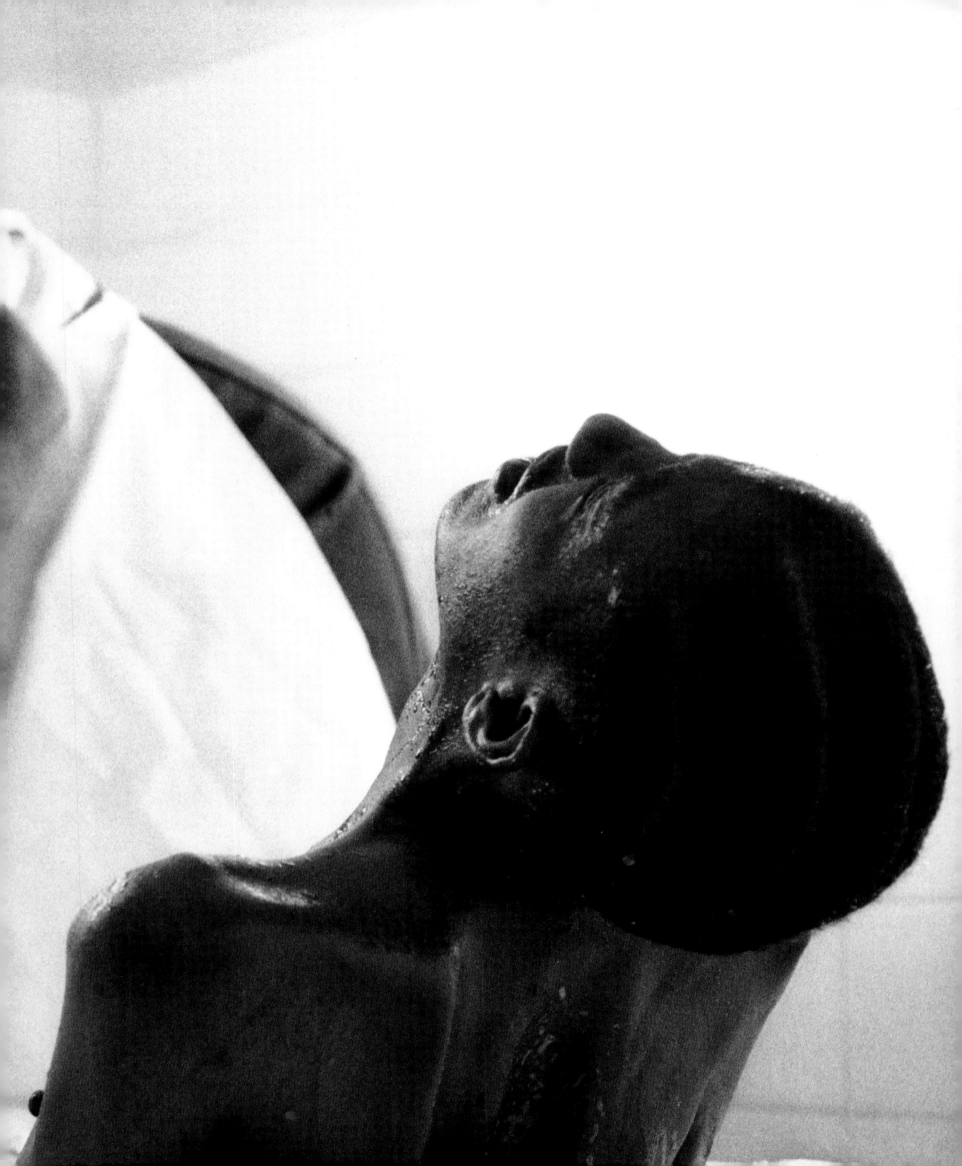

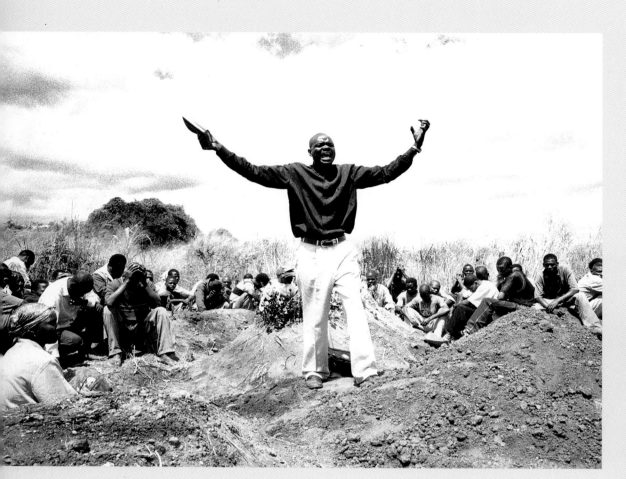

Above
Amid mounds of fresh-turned graves, a pastor preaches to crowds of mourners at Beauty Makwete's funeral in Mapepe Cemetery, near Chilanga.

Right
Relatives grieve by the open coffin of Beauty Makwete, a young child who died at Chilanga's Mother of Mercy Hospice. On average, the hospice loses four or five of its AIDS patients every day.

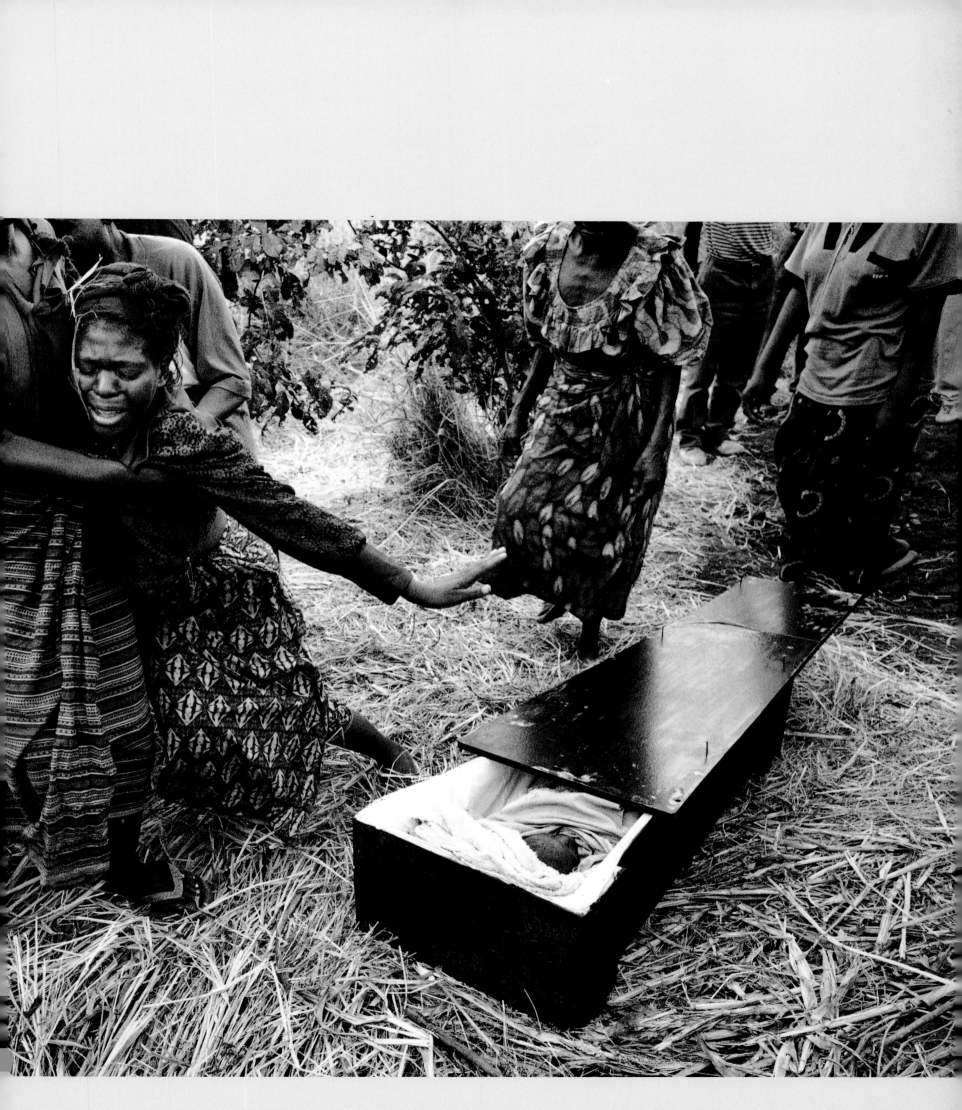

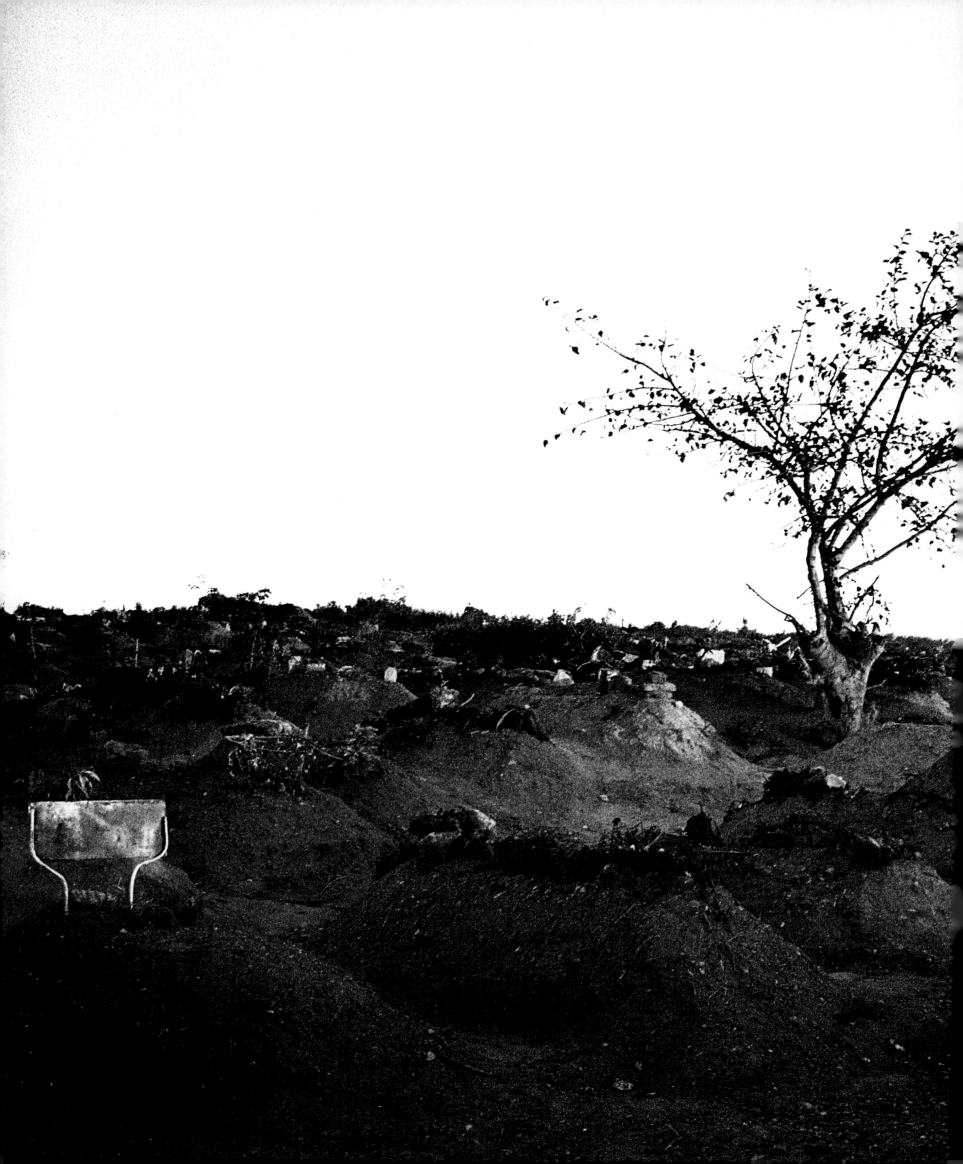

Left
A moonscape of new graves
stretches as far as the eye can
see at Chunga Cemetery in
Lusaka, a grim testament to
the decimation wrought
by Zambia's AIDS pandemic.
According to photographer
Tom Stoddart, gravediggers
bury as many as 50 bodies in
this cemetery alone every day.

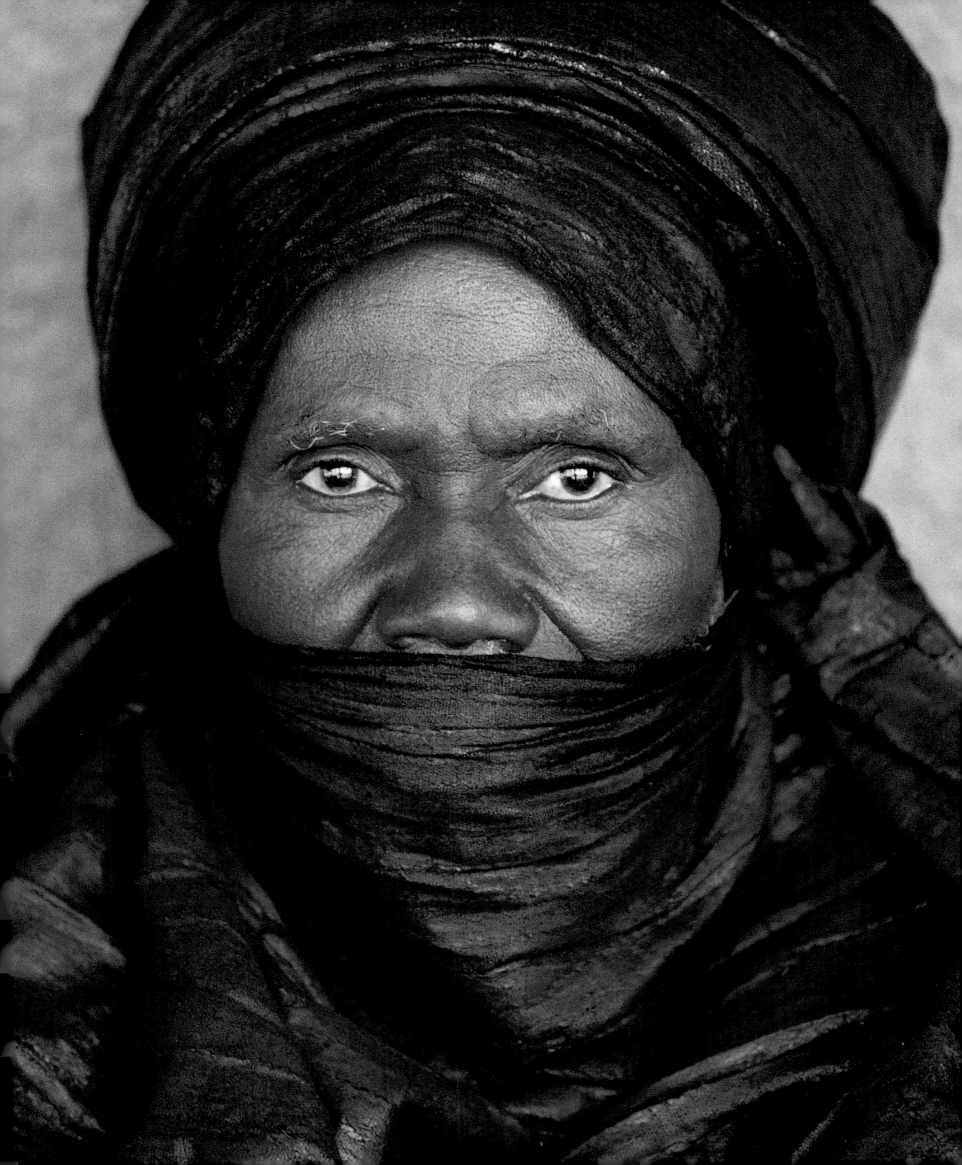

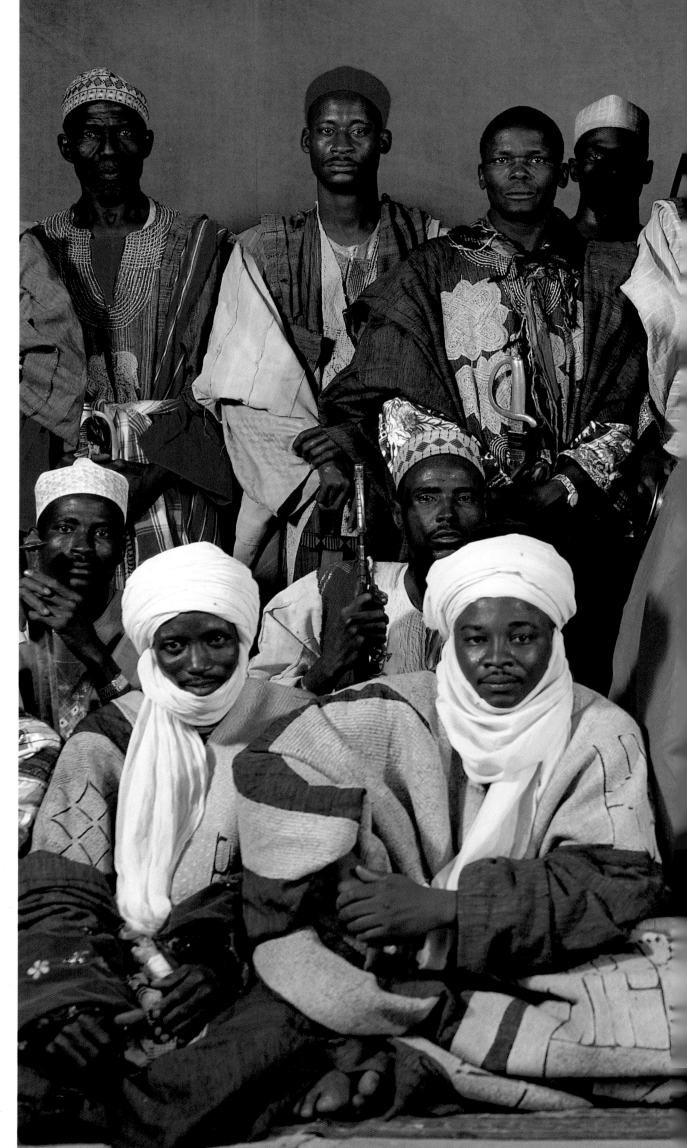

□ **Right**
A *lamido*, or traditional ruler, poses with members of his court in Mindif, a village near the Mandara Mountains of northern Cameroon. As a symbol of power, the lamido presents his dignitaries with horses that they ride in equestrian displays known as fantasias. To help pay for the costly upkeep of their mounts, the nobles of Mindif often perform fantasias for tourists.
> *Yann Arthus-Bertrand in Cameroon*

■ **Following Pages**
A worker adjusts an aging cacao-bean processor on the small Atlantic island of São Tomé. Cacao plantations in the former Portuguese colony—once worked by slaves—brought both wealth and infamy to the so-called "Chocolate Island." Although it is still a cocoa exporter, many of São Tomé's cacao plantations have been abandoned since the island and its neighbor, Príncipe, gained independence in 1975.
> *Benoit Gysembergh in São Tomé*

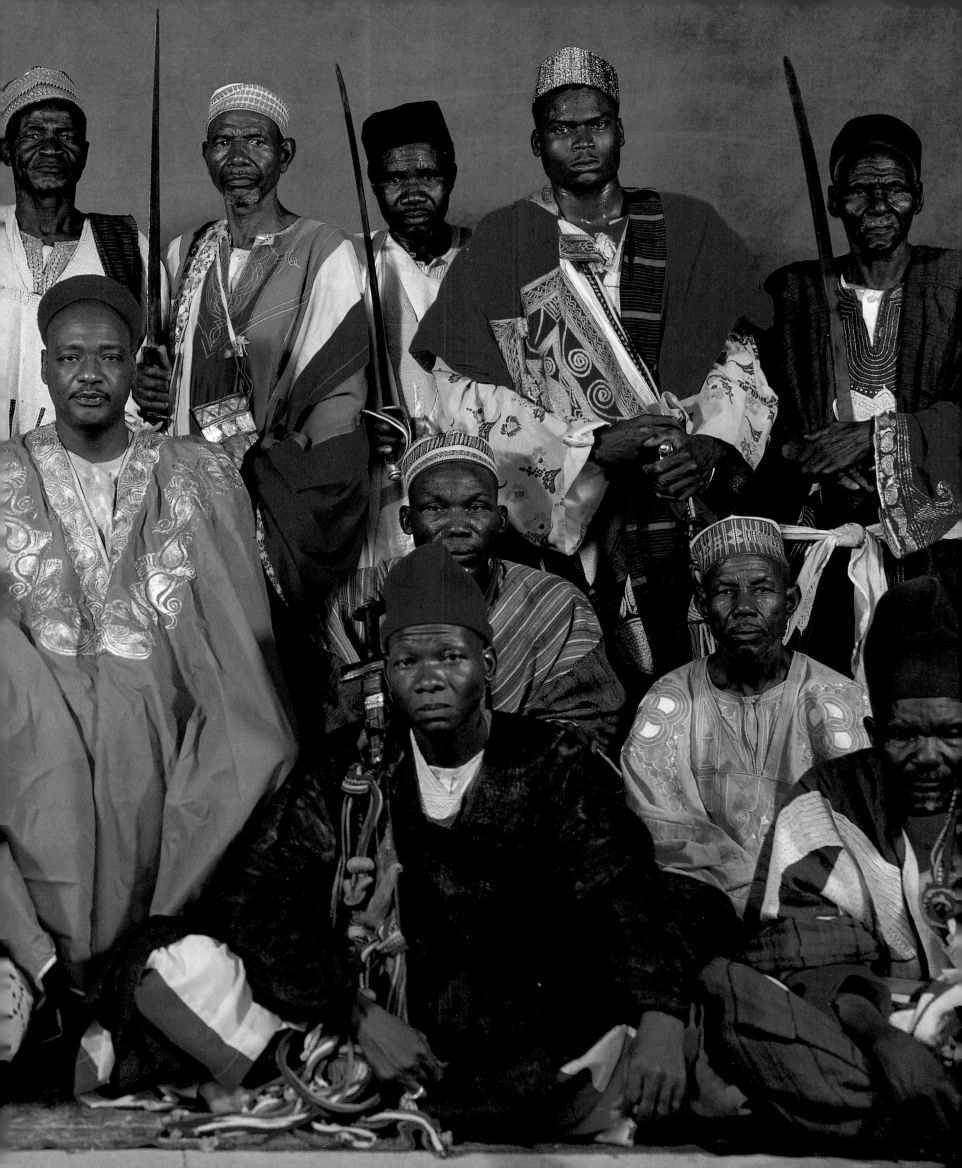

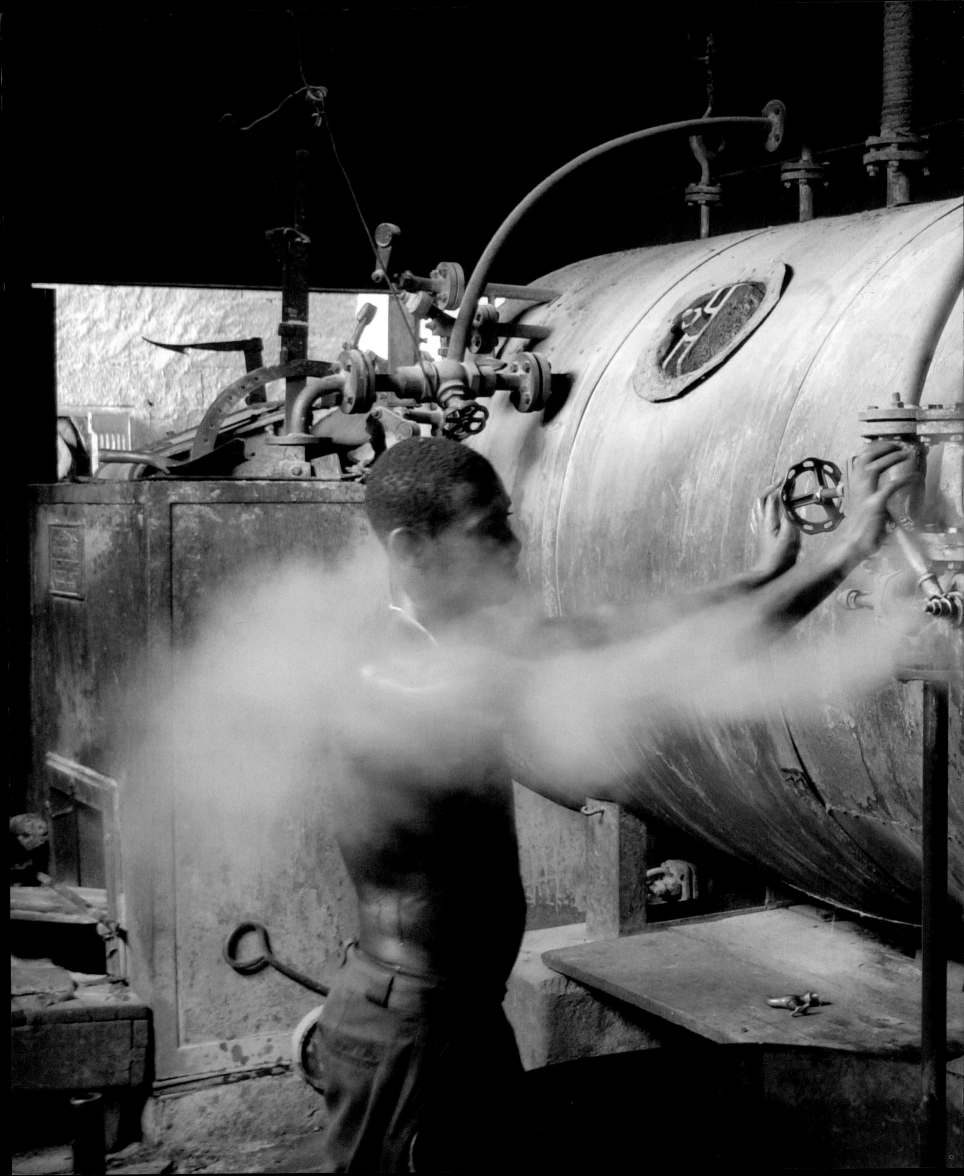

□ **Above and Right**
During *A Day in the Life of Africa*, French photographer Françoise Huguier visited the train station at Beira on Madagascar's central coast. She made portraits of some of the workers in the station's repair shop. "The shop looked like a museum," says Huguier. "Many of the locomotives and rail cars were originally built in the early 20th century, but these men somehow kept

Portraits in Beira, Mozambique, by Françoise Huguier

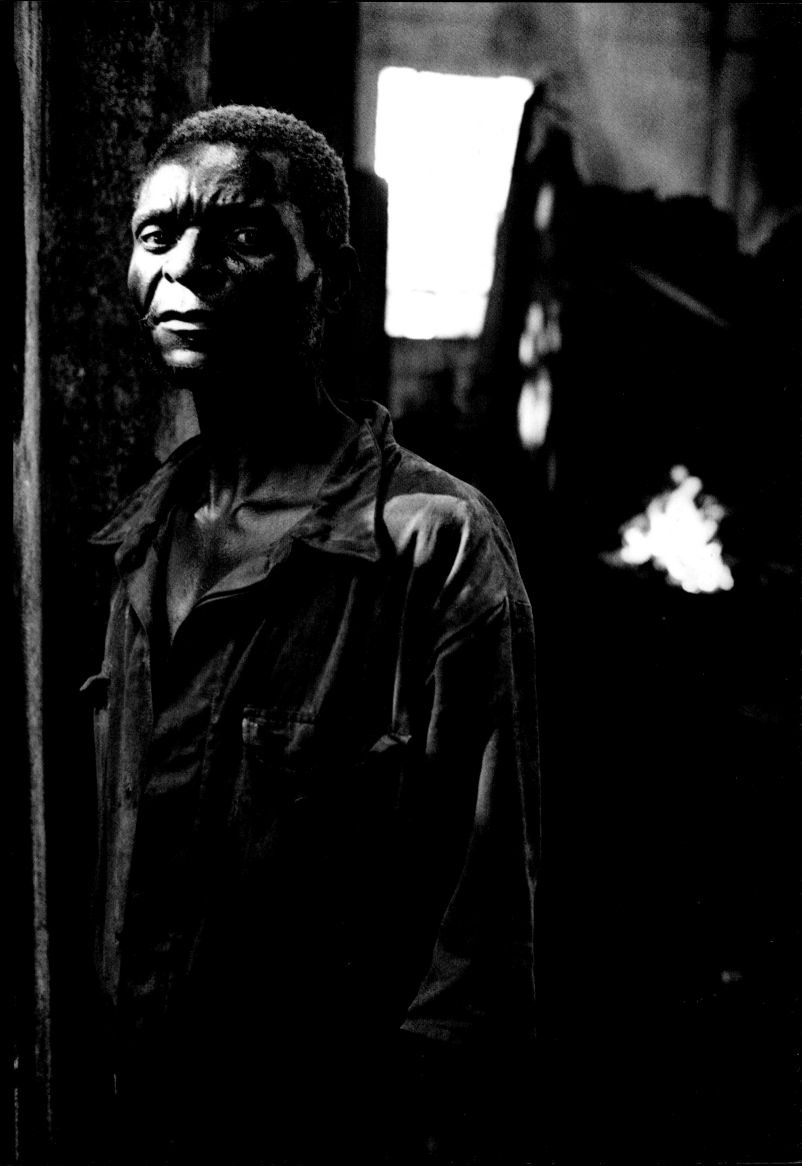

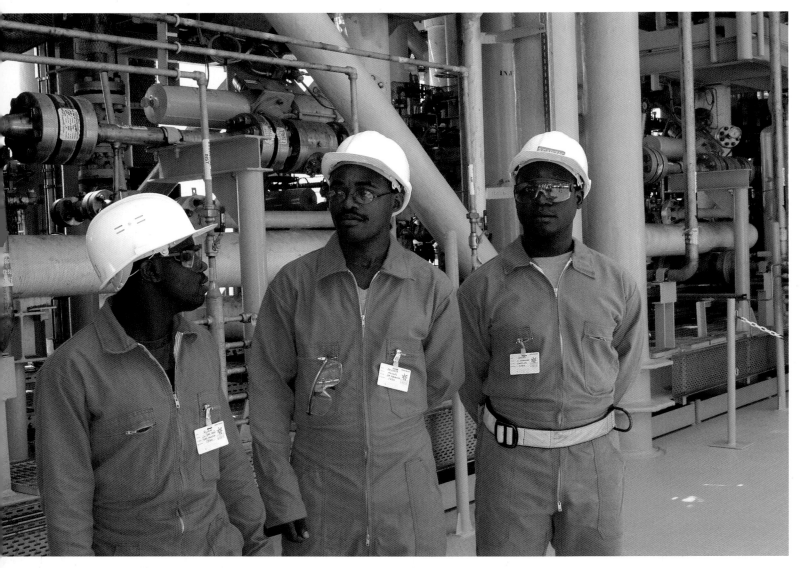

☐ **Above**
Oil workers in Angola.
Petroleum production is vital
to the Angolan economy,
accounting for some 90% of
its exports.
> Quintilhano dos Santos in
Angola

■ **Right**
A brickmaker in Bangui,
Central African Republic,
poses in front of his fiery
ovens. The bricks are made
from a cement-like mixture
harvested from termite
mounds.
> Nick Kelsh in the
Central African Republic

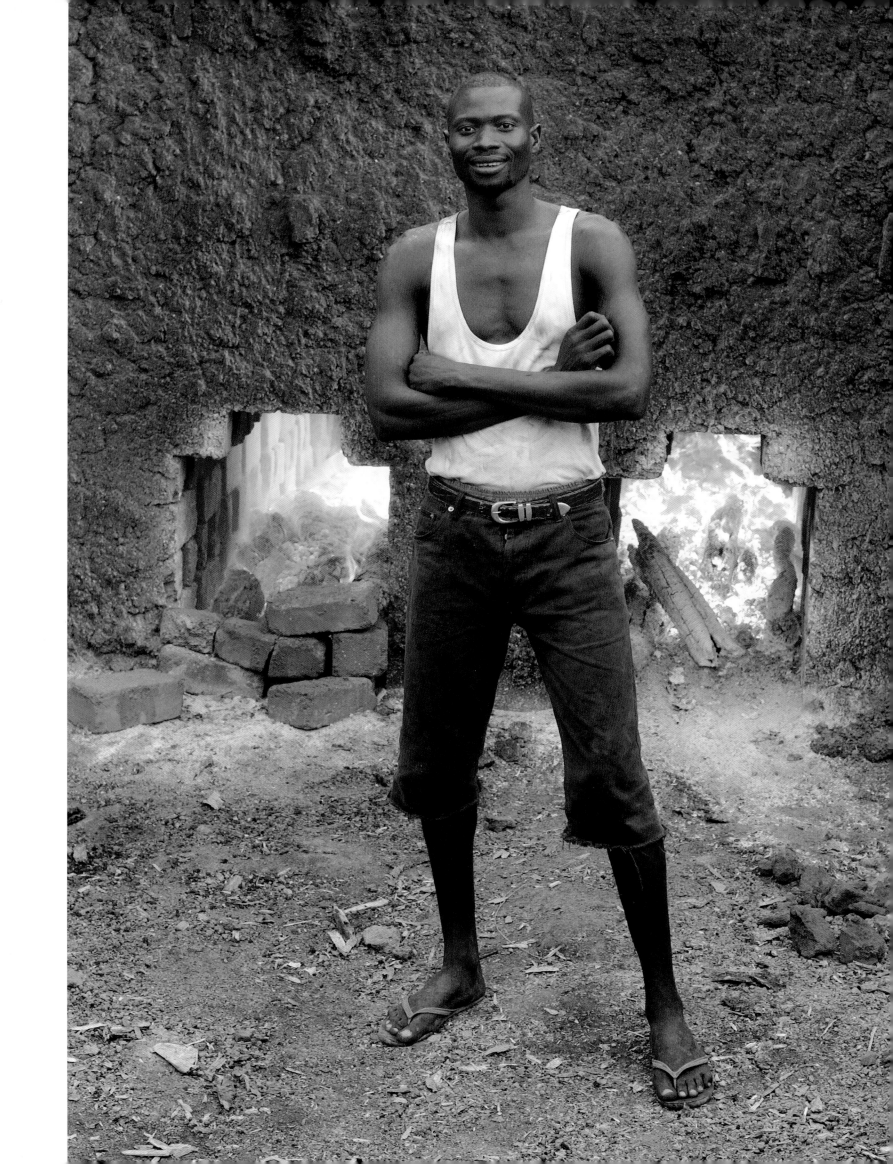

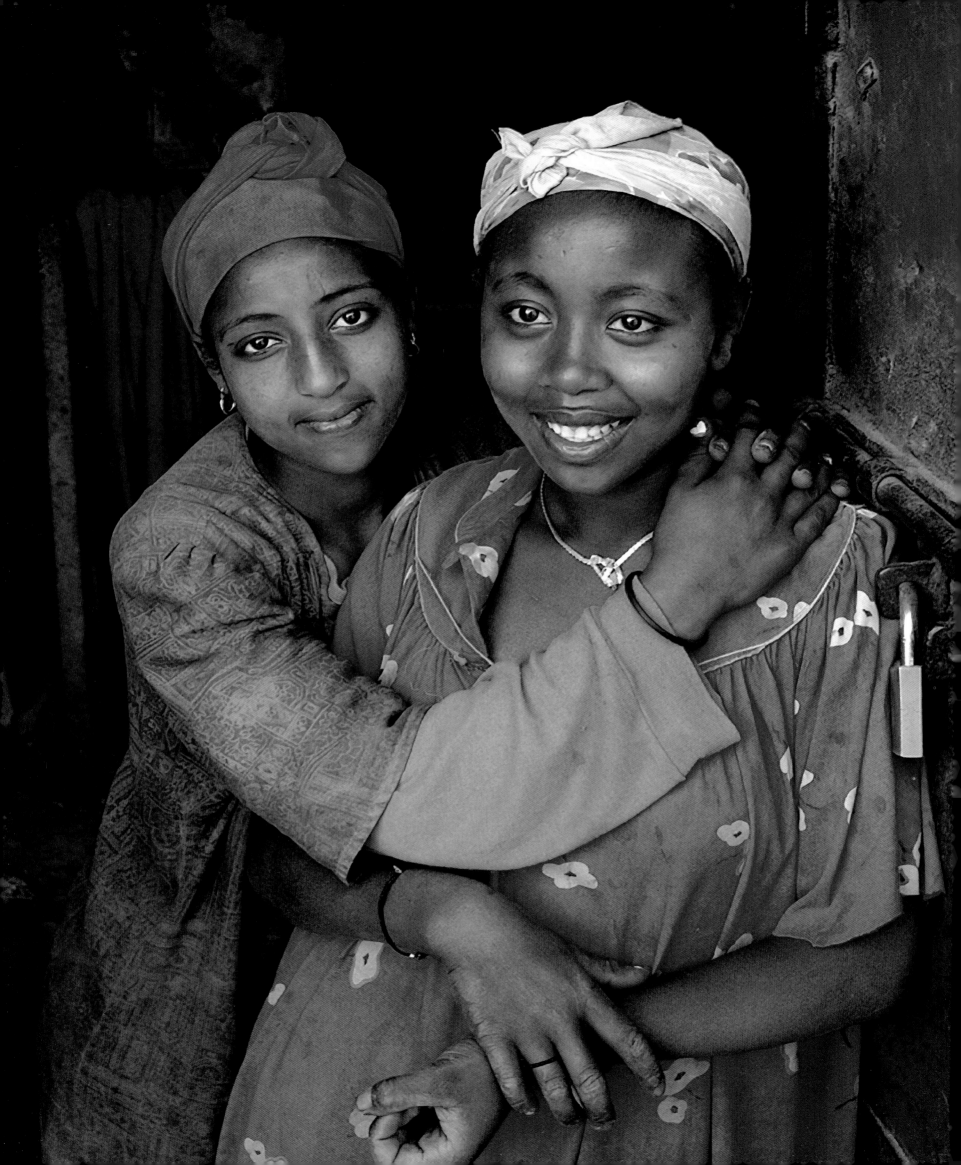

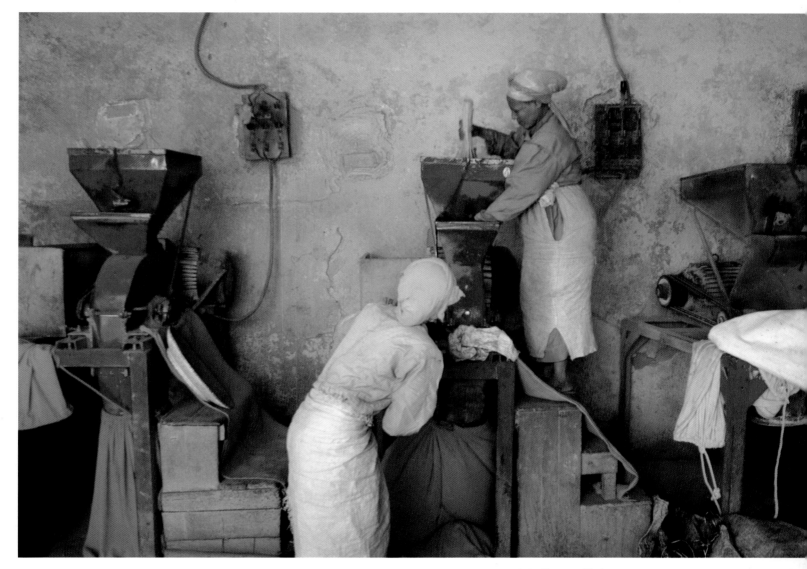

■ **Above and Left**
Toiling over large, dust-spewing grinders, workers in the Eritrean capital of Asmara make *shiro,* a food staple manufactured from chickpeas. The legumes are processed into a powdery, protein-rich flour traditionally boiled, spiced, and mixed with butter or oil. At left, two young workers break for a portrait.
> *Peter Turnley in Eritrea*

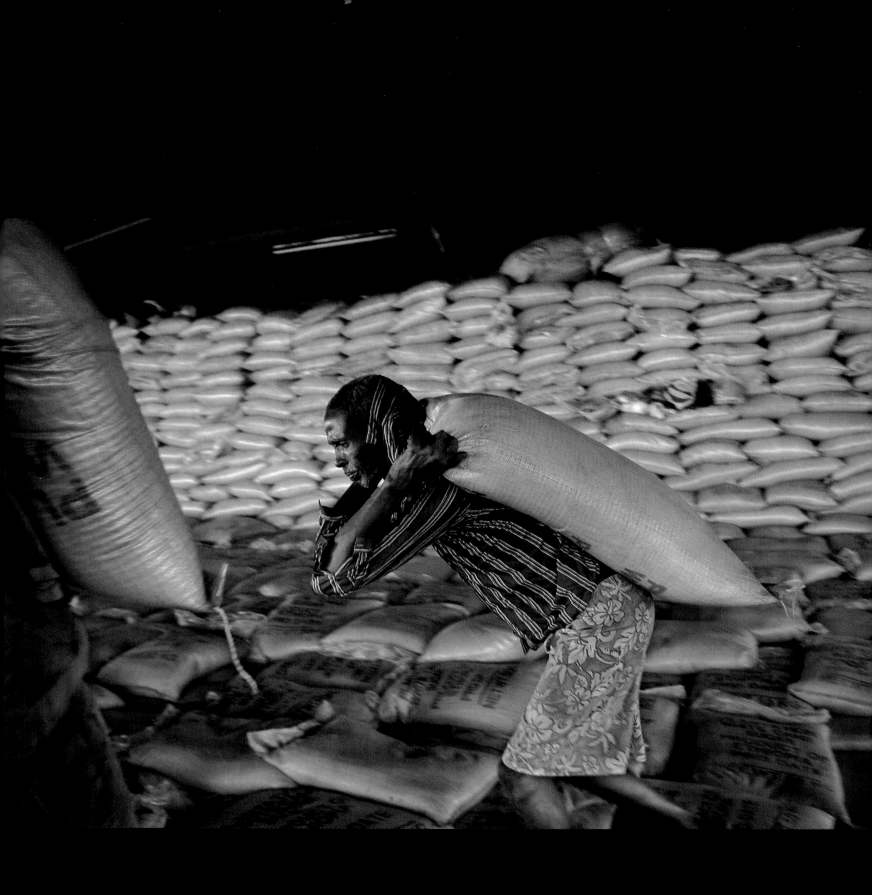

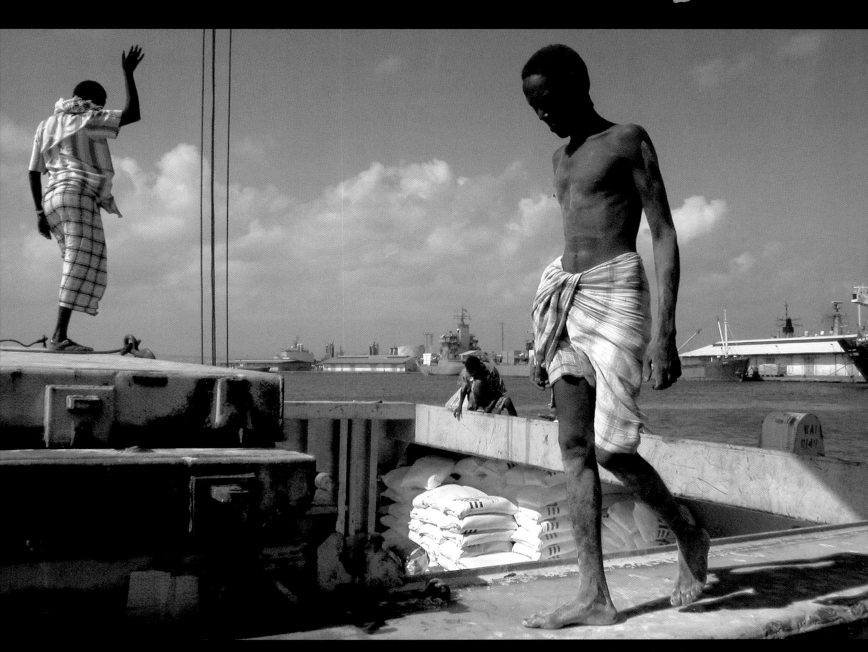

Images of Djibouti by Alex Majoli

◻ **Left, Above, Following Pages**
Day in the Life photographer
Alex Majoli spent shoot day in
the east African harbor of
Djibouti, a sweltering cross-
roads and gritty gateway to the
Gulf of Aden and the Red Sea.
Using one small Olympus
C-4040 camera, Majoli captured
these digital images of a vibrant
city-state on the continent's
eastern edge.

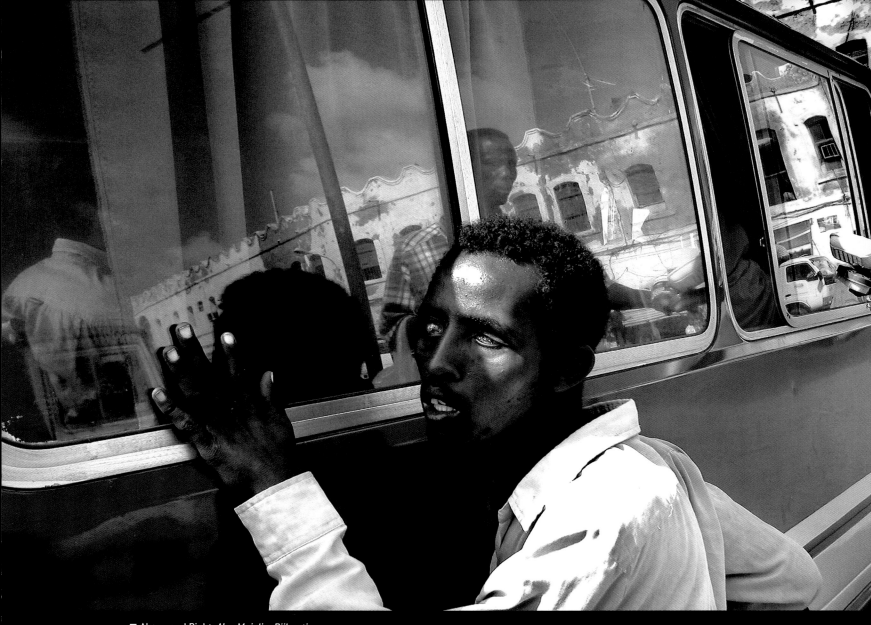

❑ Above and Right, *Alex Majoli* > *Djibouti*

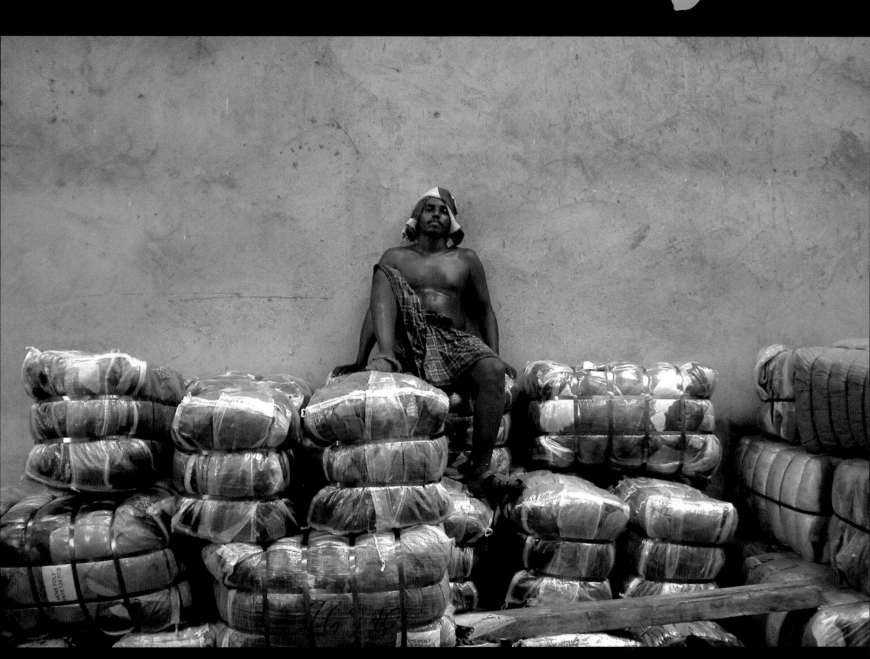

■ **Following Pages**
The parched skeletons of
500-year-old camel-thorn trees
stand in the dry lake bed of
Dead Vlei, Namibia. The
Tsauchab River once ran
through here, nourishing their
gnarled roots. Then the
spreading Great Sand Sea of
the Namib Desert blocked the
river's course. But every
decade or so, enough rain falls
so that the river again courses
over the huge dunes and
floods the dry clay pan.
> *George Steinmetz in Namibia*

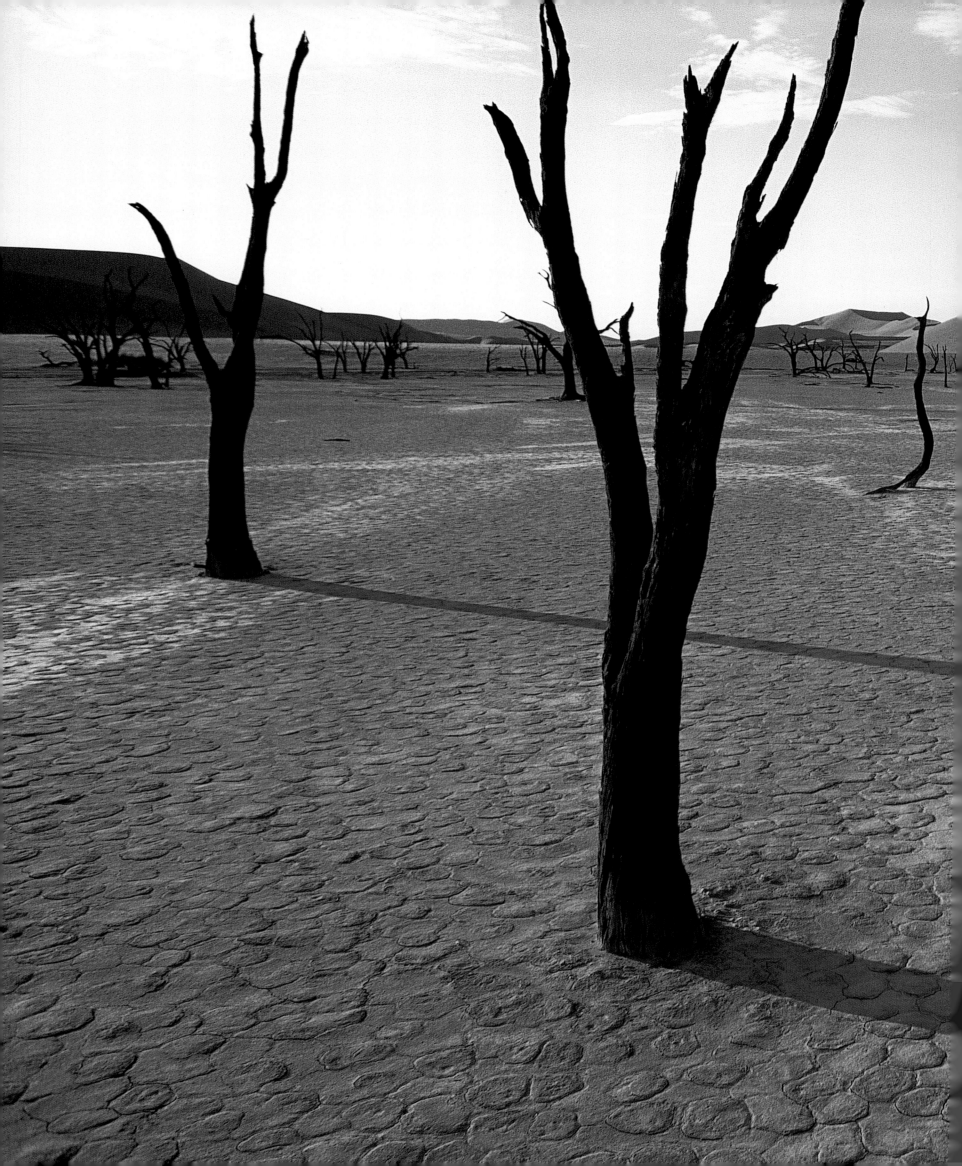

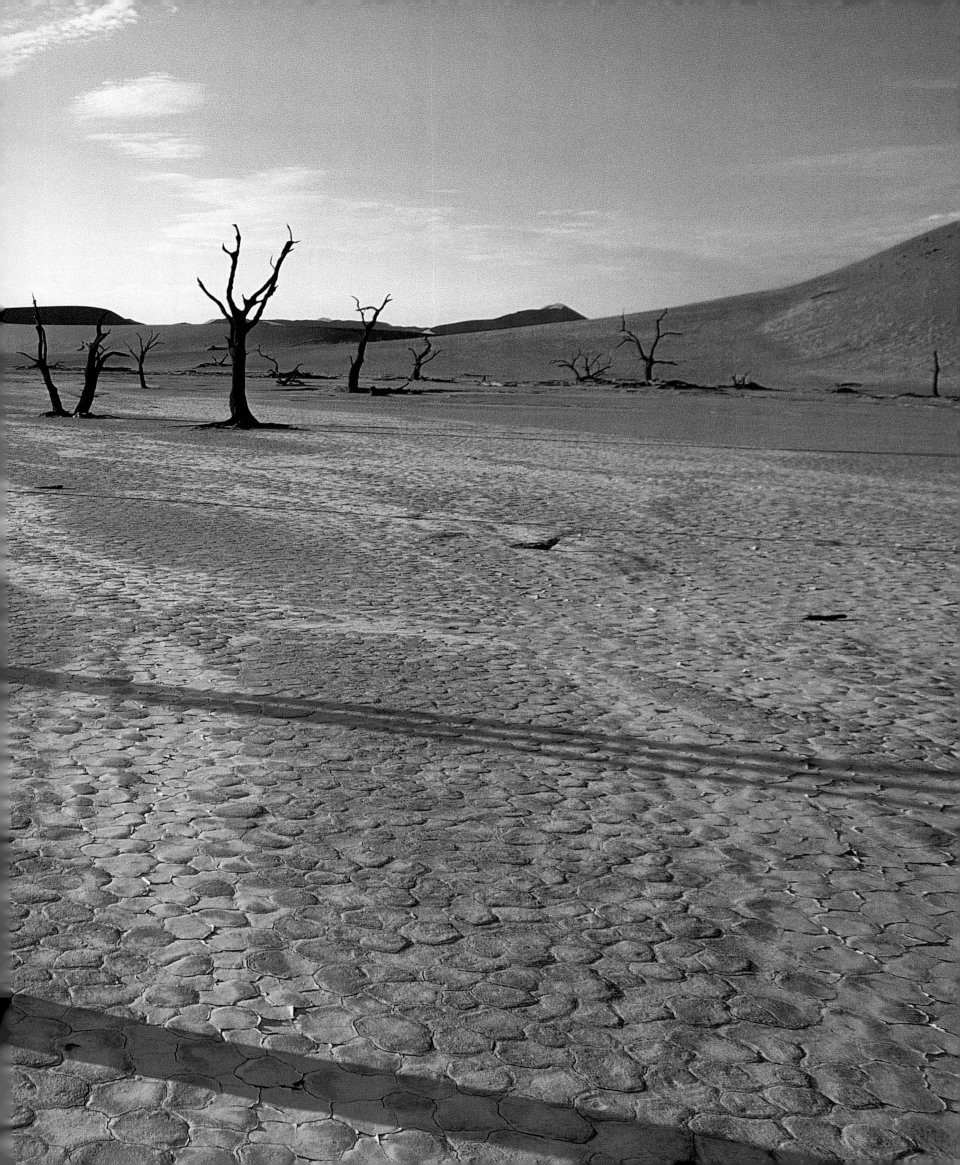

Jeffery Allan Salter > Kampala, Uganda

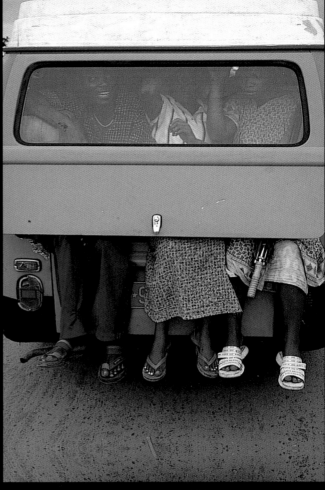

Xavier Desmier > Marara, Guinea

Per-Anders Pettersson > Kinshasa, Congo-DRC

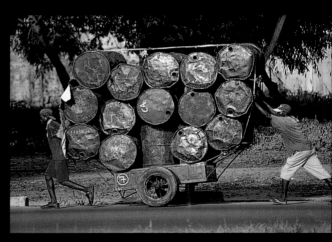

Noël Quidu > Matadi, Congo-DRC

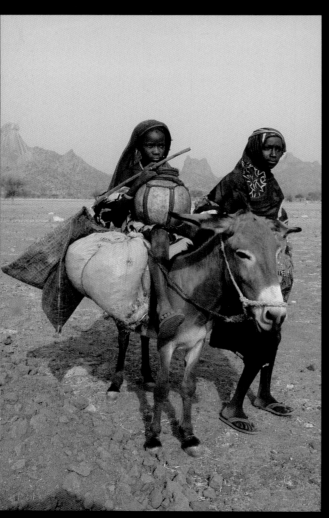

John Isaac > Misserie, Chad

Daniel Laîné > Lomé, Togo

> iron and sand

**Photographed in Mauritania
by Pascal Maitre**

The great Sahara Desert stretches hundreds of miles across Mauritania, a sparsely populated land of sand dunes, rocky outcroppings, and low-lying scrub. With few passable roads, inland travel from the Mauritanian port of Nouadhibou can be treacherous. So many travelers hop a ride on one of the world's longest trains—a huge mineral freighter that shuttles between the Atlantic coast and the rich iron mines of Zouerate. Most passengers ride free of charge in open cars atop the ground iron ore. The more affluent pay 2,200 uguiyas (eight U.S. dollars) to ride first class or 1,000 uguiyas to jam into the train's second-class car.

For his *A Day in the Life of Africa* assignment, French photographer Pascal Maitre boarded the two-mile-long ore train in Nouadhibou and rode more than 450 miles past scattered campsites, startling rock formations, and isolated desert villages. On his 18-hour trek, Maitre chronicled the thin thread of life that lines the tracks east from Nouadhibou to Choum—a Saharan crossroads town—then northward to the red and black Adrar Mountains, home to some of the world's richest iron deposits. Hauling goods, supplies, and people into some of the most remote areas on earth, the ore train is a mobile shopping center, a social link, and an iron lifeline through the harsh desert landscape.

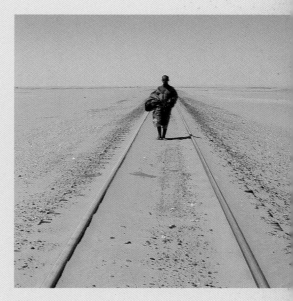

A lone traveler walks the tracks in Mauritania.

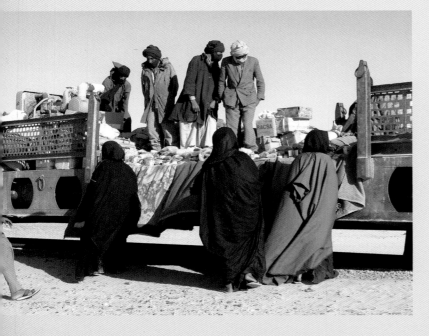

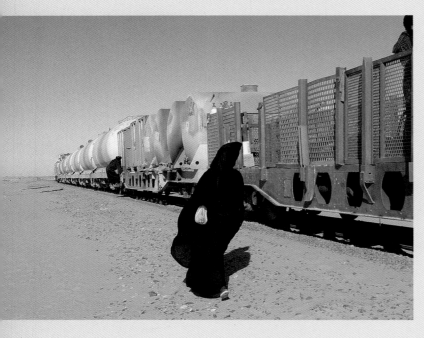

Left and Right
In Mauritania, the iron ore train's service car is a rolling marketplace that serves isolated desert settlements strung along the 450-mile line. Customers buy food, clothing, manufactured goods—even water—from the train's mobile vendors.

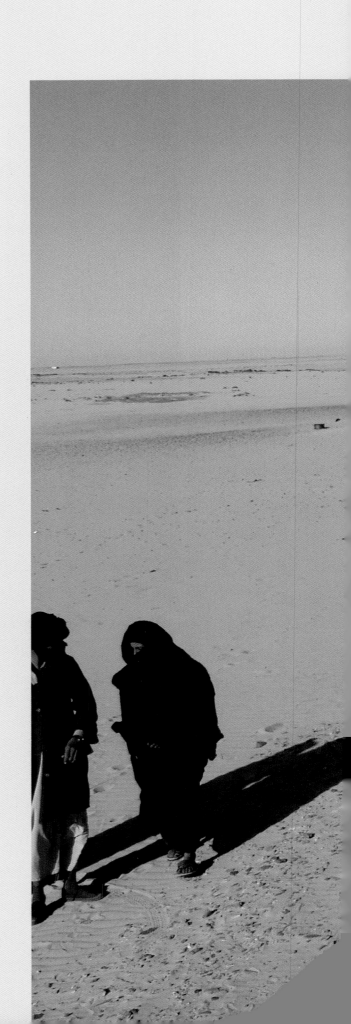

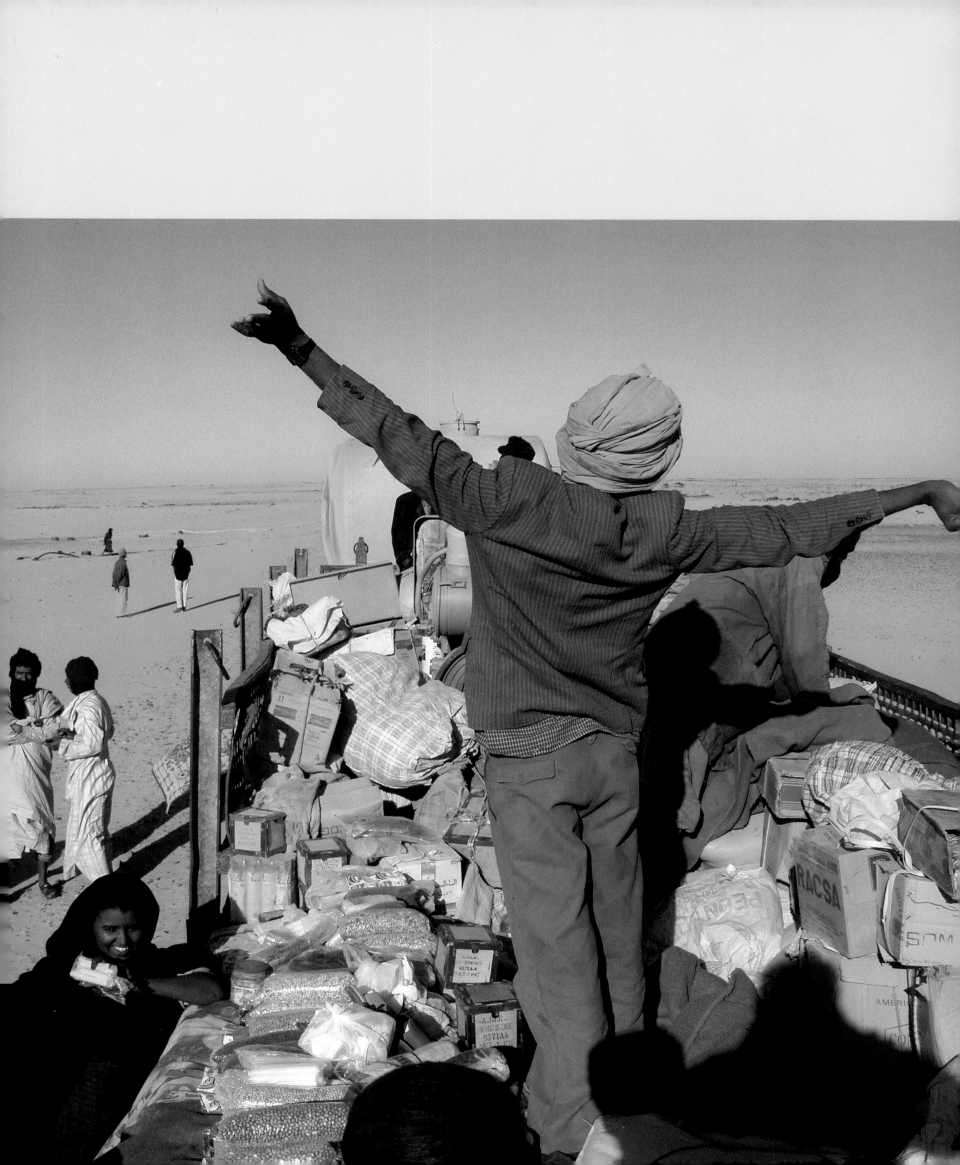

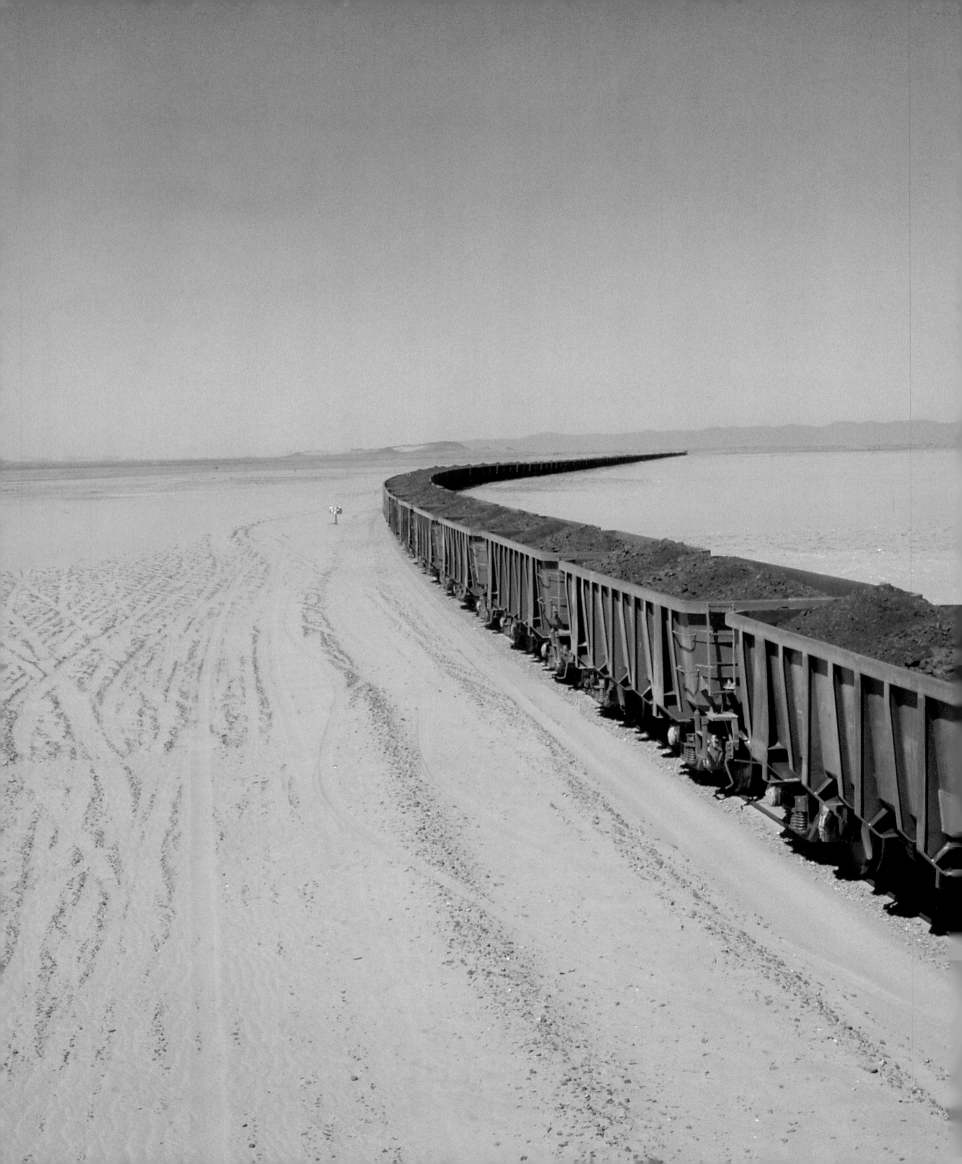

78186

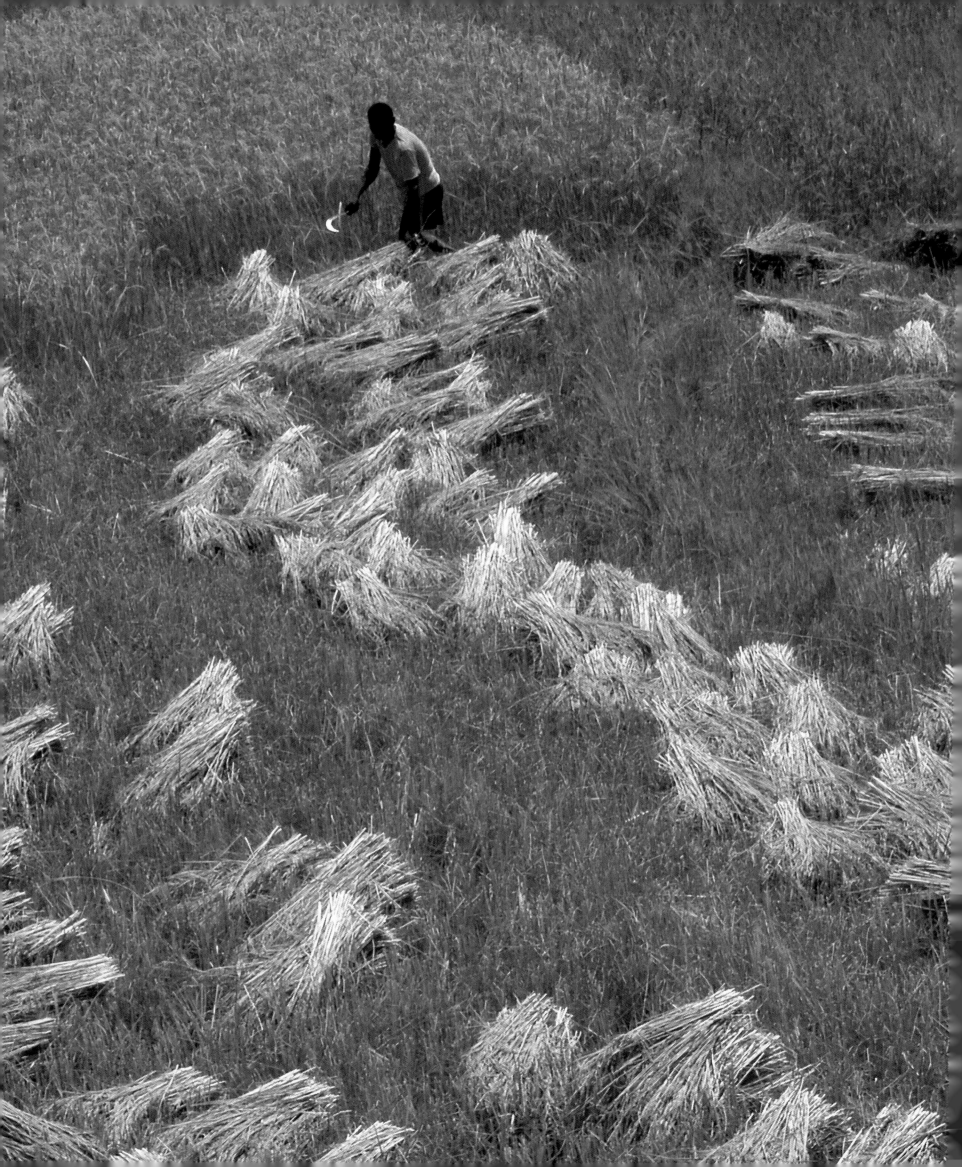

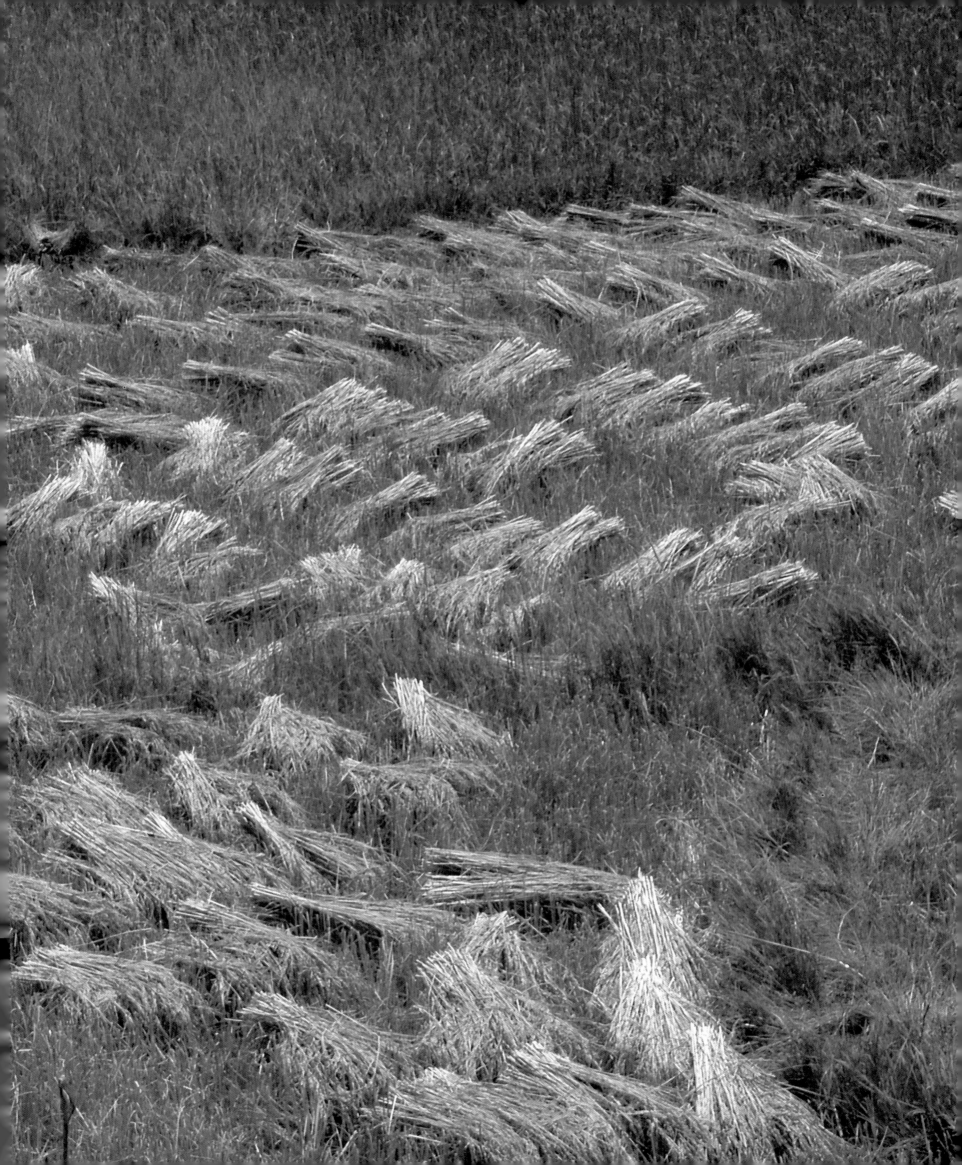

◻ **Right**
In a driving rain, field workers
harvest tea on the Kiamara
Estate in the fertile foothills
of Uganda's Rwenzori
Mountains. Tea grows year-
round in Uganda's humid
climate, and is picked, dried,
and packed on the estate.
During Uganda's years of
terror and political upheaval
in the 1970s, the tea plant-
ations went untended. Many
reverted to towering forest.
> *Larry C. Price in Uganda*

◼ **Previous Pages**
A villager harvests rice on
the high plains of Madagascar.
Per capita, the people of
Madagascar are among the
greatest rice consumers on
earth, but because of wide-
spread deforestation and
consequent soil erosion, the
country must now meet its
needs with Asian imports.
> *Pierrot Men in Madagascar*

◐ **Following Pages**
An elegant islander visits his
son's general store on São
Tomé, the former Portuguese
colony in the Gulf of Guinea.
> *Benoit Gysembergh in São Tomé*

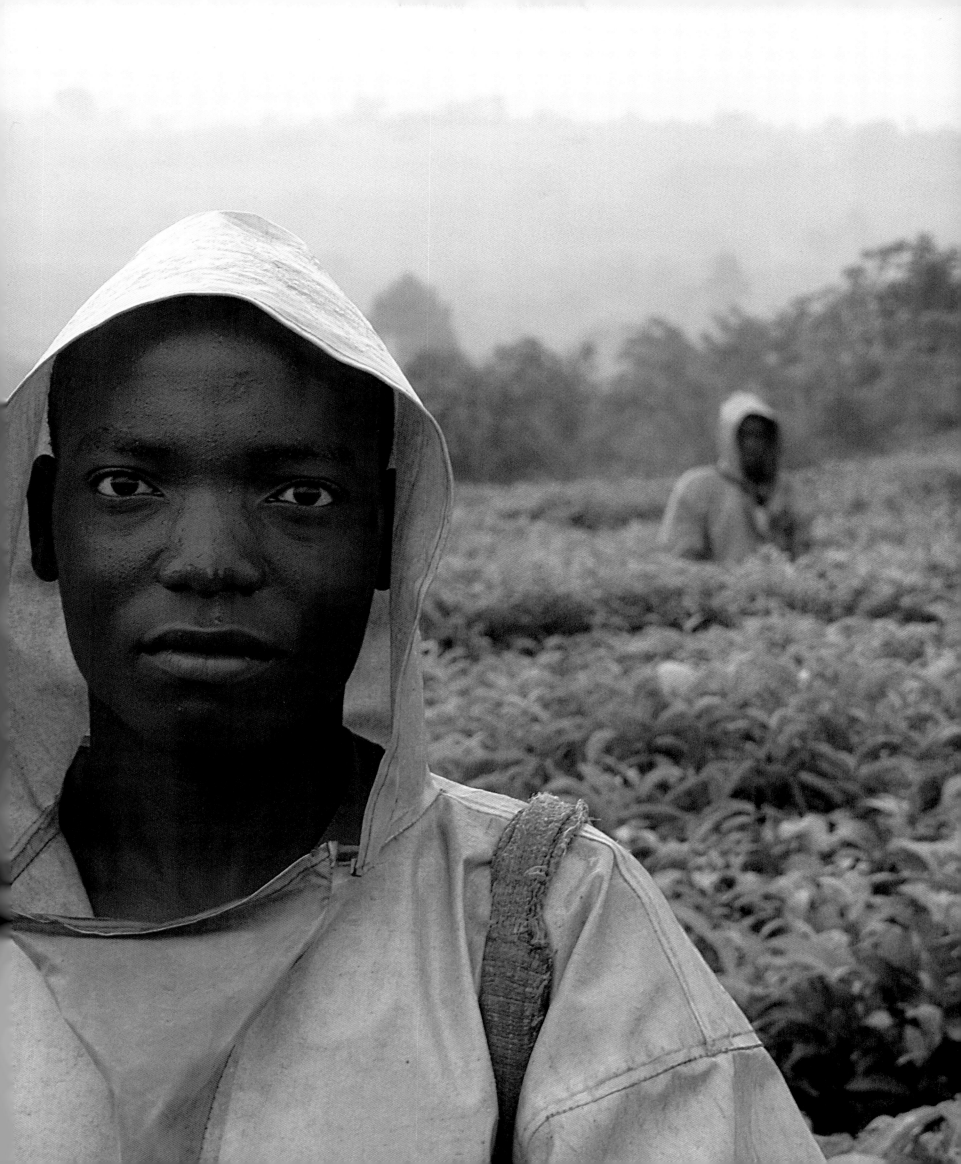

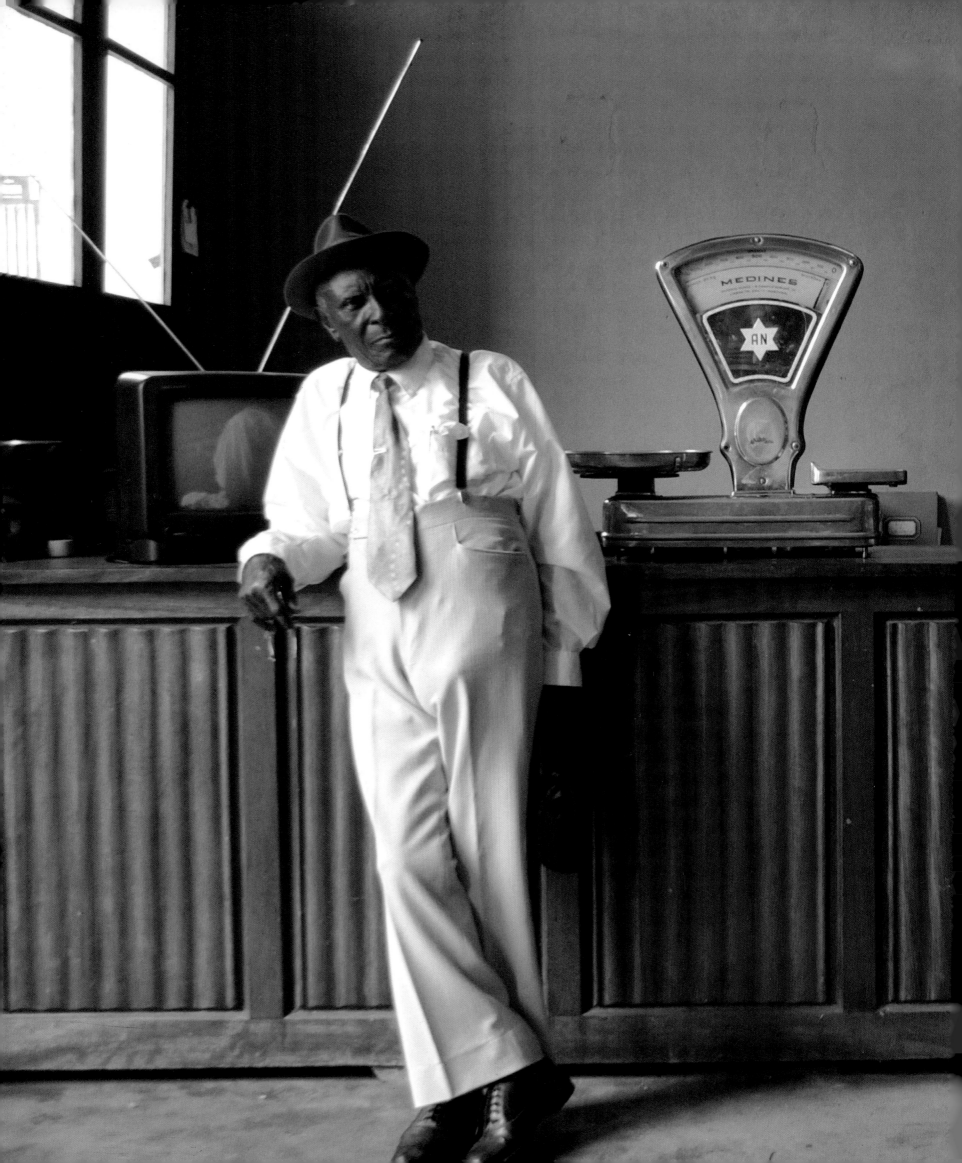

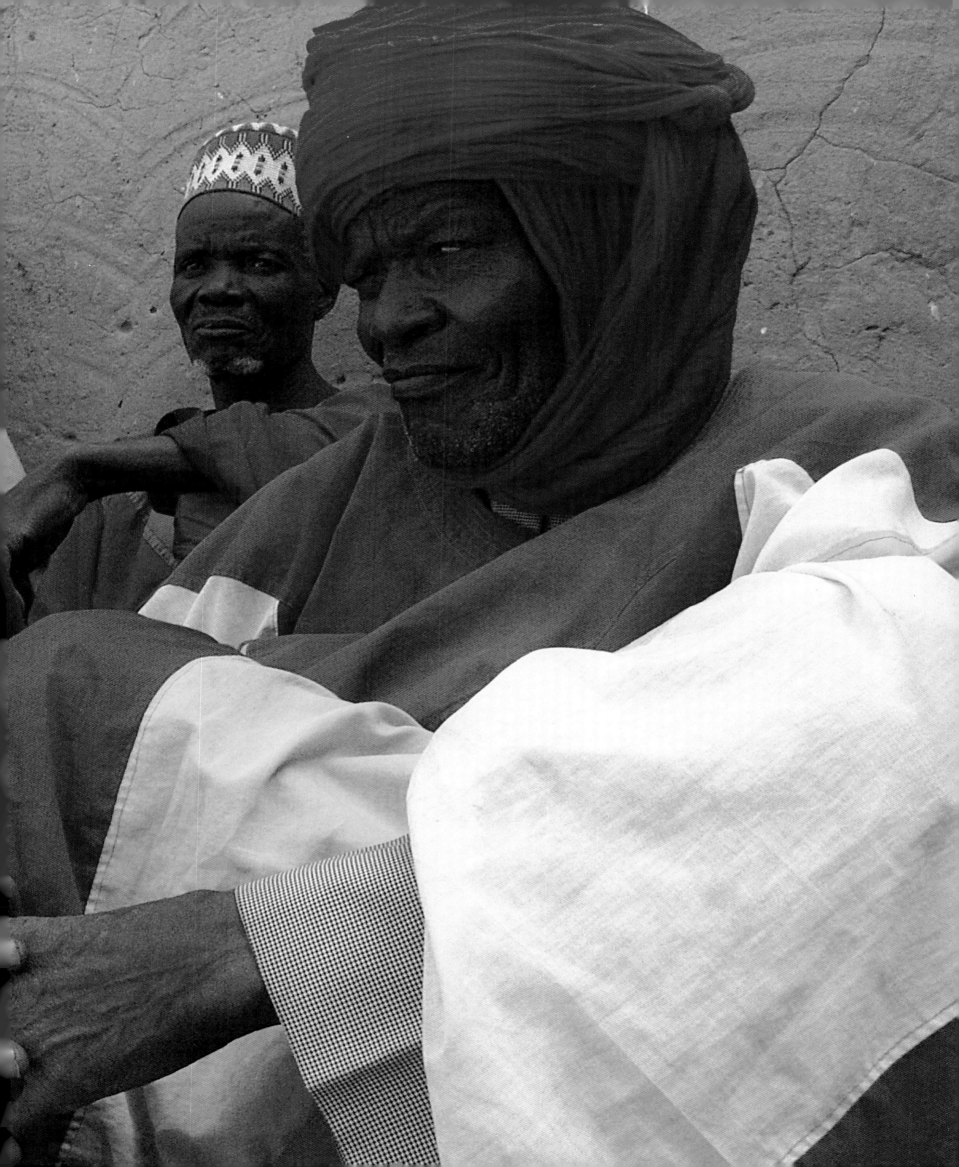

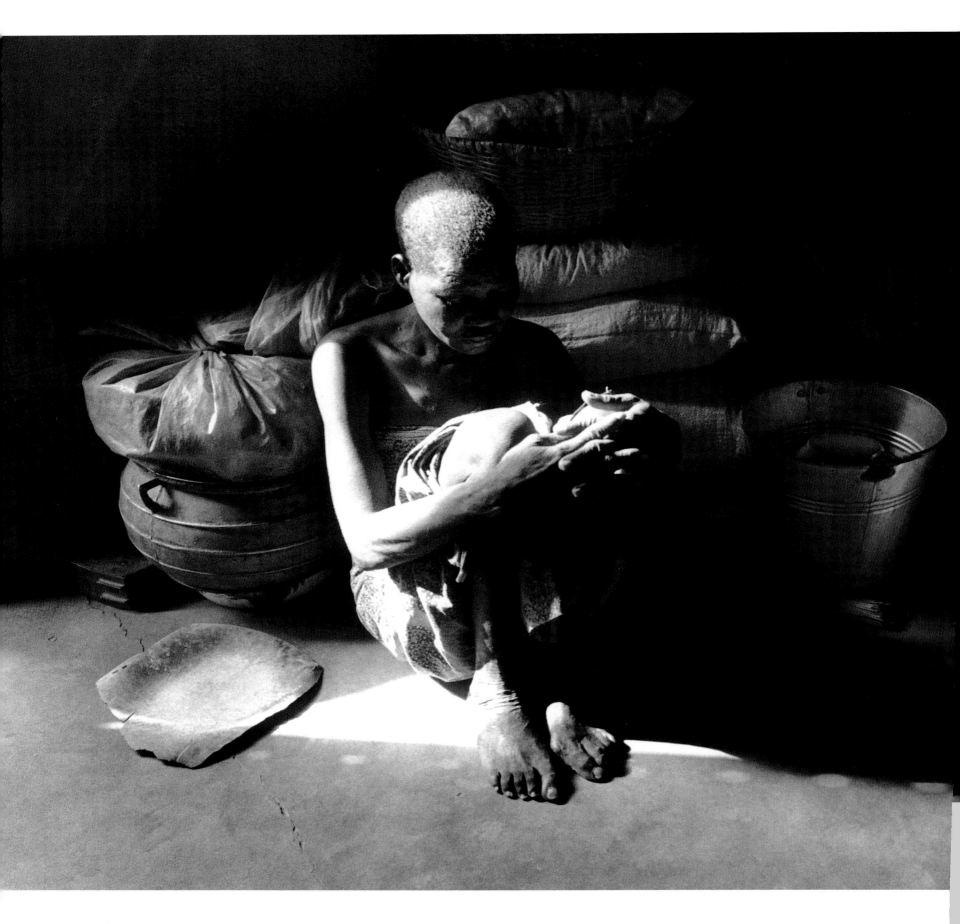

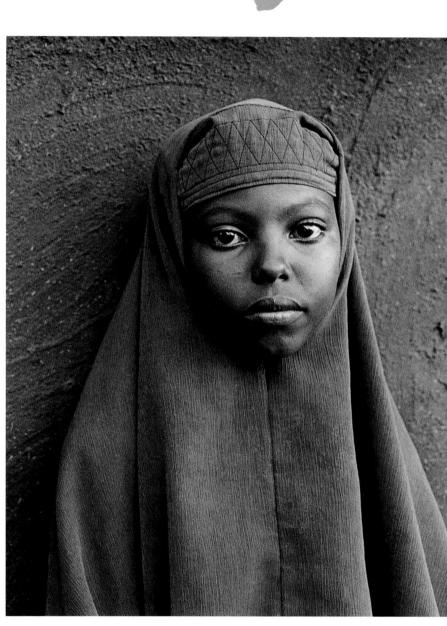

■ Left
A reputed *mangeuse d'âmes* or
"soul-eater." Perceived as a
possessor of uniquely
malevolent powers, this
woman in Ouagadougou,
Burkina Faso, is ostracized by
her community. Mangeuses
d'âmes are usually post-
menopausal women held
responsible for tragic deaths.
> *Patrick Zachmann in
Burkina Faso*

◻ Above
World-renowned photo-
journalist Sebastião Salgado
made this portrait in
Jamaame, in the lower Juba
region of Somalia. Salgado,
a Day in the Life veteran,
was unable to shoot in
Africa on February 28, 2002,
but wanted to participate in
the project, so he donated
recently shot photographs.
> *Sebastião Salgado in Somalia*

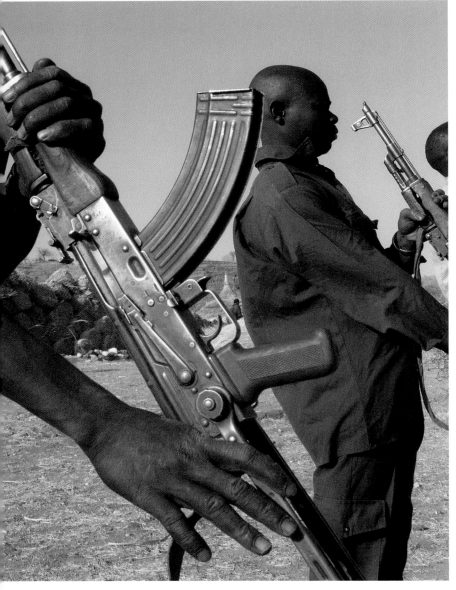

◻ Above
Soldiers drill in the village of Kerker, in the central Sudanese mountains. For decades, civil war has raged between the Sudan's Islamic government in the north and its mainly Christian and animist population in the south. It is estimated that up to 2 million people have died in this conflict.
> *Francesco Zizola in Sudan*

■ Right
At an interim care center run by the International Rescue Committee, a child in Sierra Leone's Kono district gazes at United Nations peace-keepers stationed next door. The children at the center were captives of the Revolutionary United Front, a rebel army that kidnapped them for use as child soldiers during Sierra Leone's horrific 10-year civil war. Since a May 1999 cease-fire accord, the center has reunited more than 300 former child soldiers with their families.
> *Andre Lambertson in Sierra Leone*

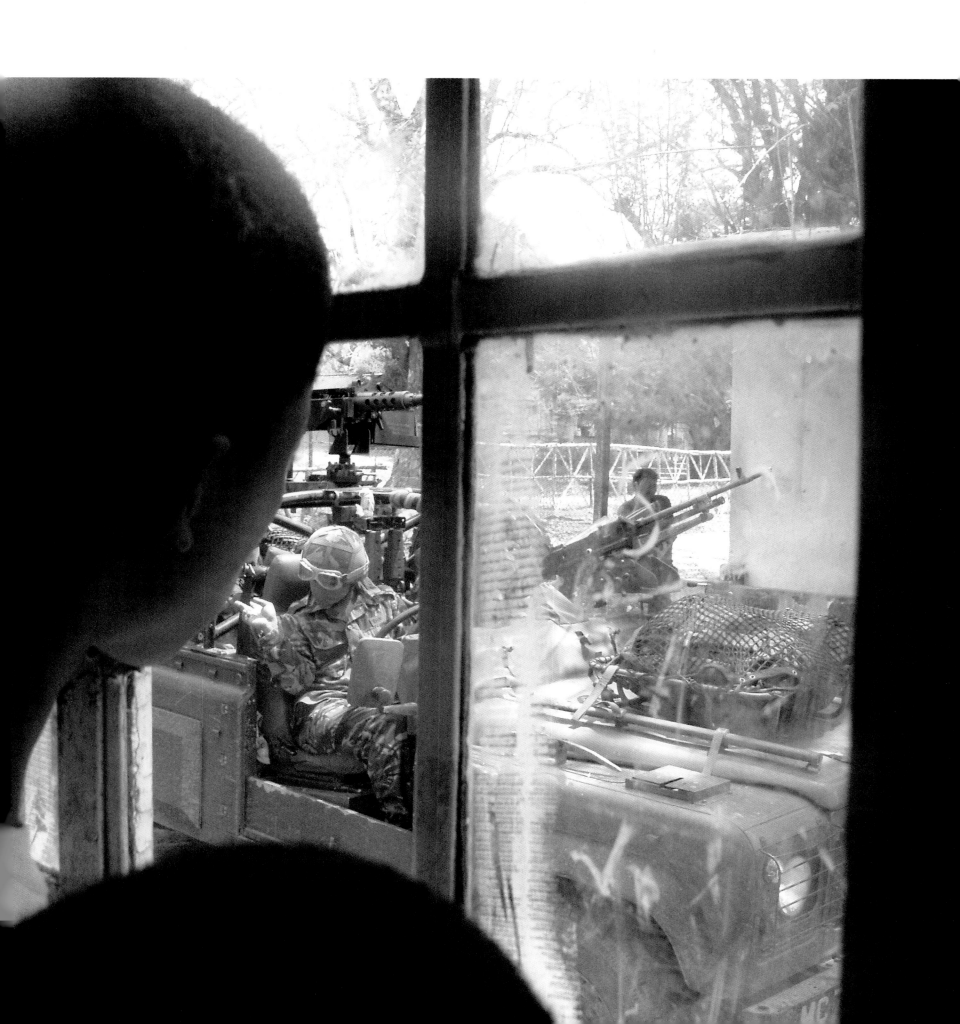

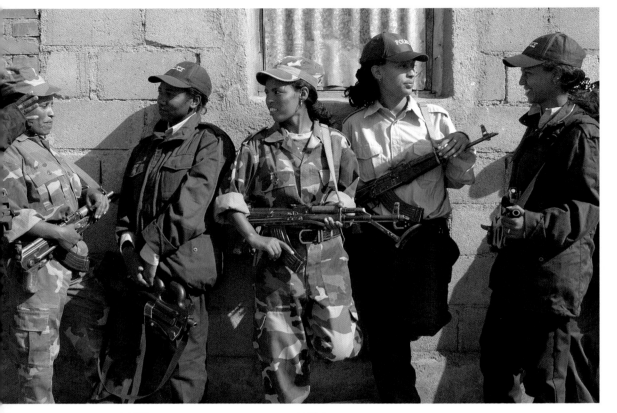

■ **Above**
In Asmara, Eritrea, female police officers—all army veterans—gather before evening patrols. Women were front-line combatants during Eritrea's war of independence, and now hold prominent posts in the government, police, and military.
> *Peter Turnley in Eritrea*

■ **Right**
Seven-year-old Mussa Tamba greets his mother for the first time in two years. Mussa was kidnapped and employed as a child soldier by rebel forces in Sierra Leone. Workers from this International Rescue Committee interim care center in Sierra Leone's Kono district drove Mussa 60 miles back to his village in order to reunite him with his family. "No one in the village had any idea Mussa was coming," says Day in the Life photographer Andre Lambertson, who accompanied the child on his journey home. When the IRC jeep stopped outside the village of Waiyor, Lambertson says, surprised residents ran out to greet the boy and escort him home. "His mother was so happy, she was dancing. She didn't believe it could possibly be true."
> *Andre Lambertson in Sierra Leone*

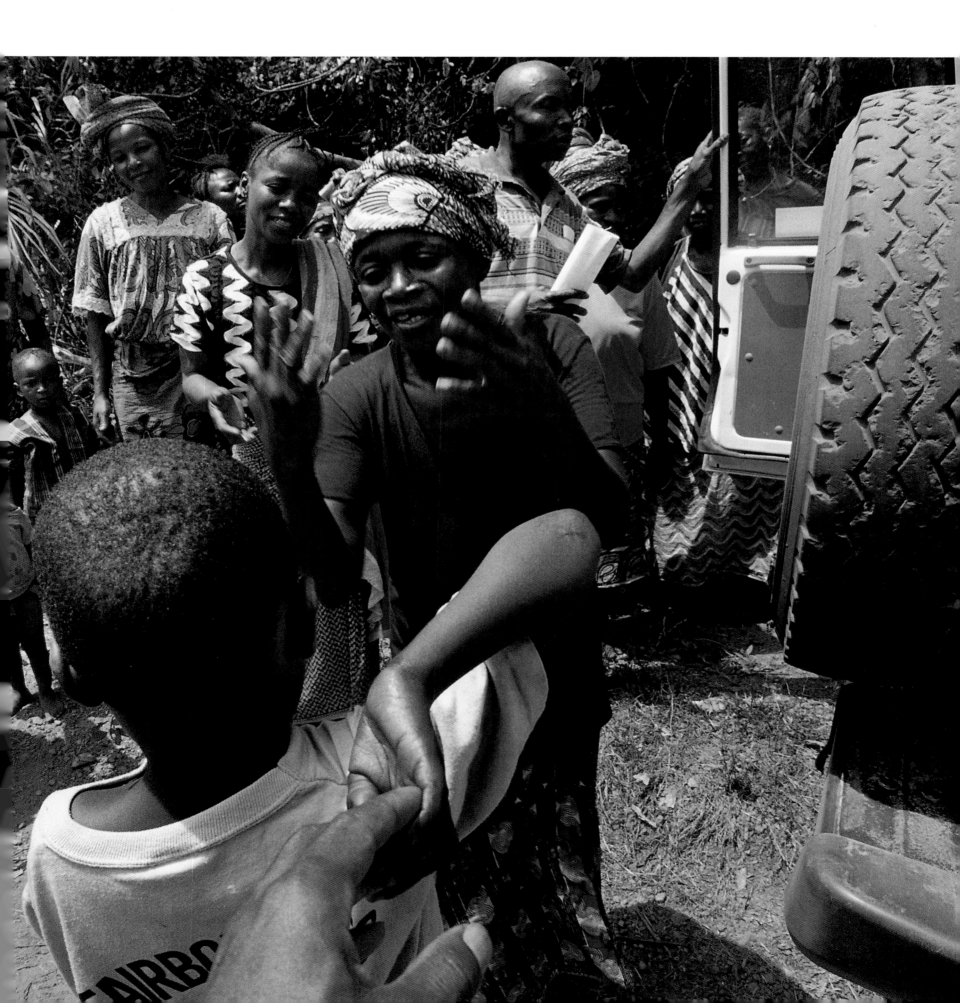

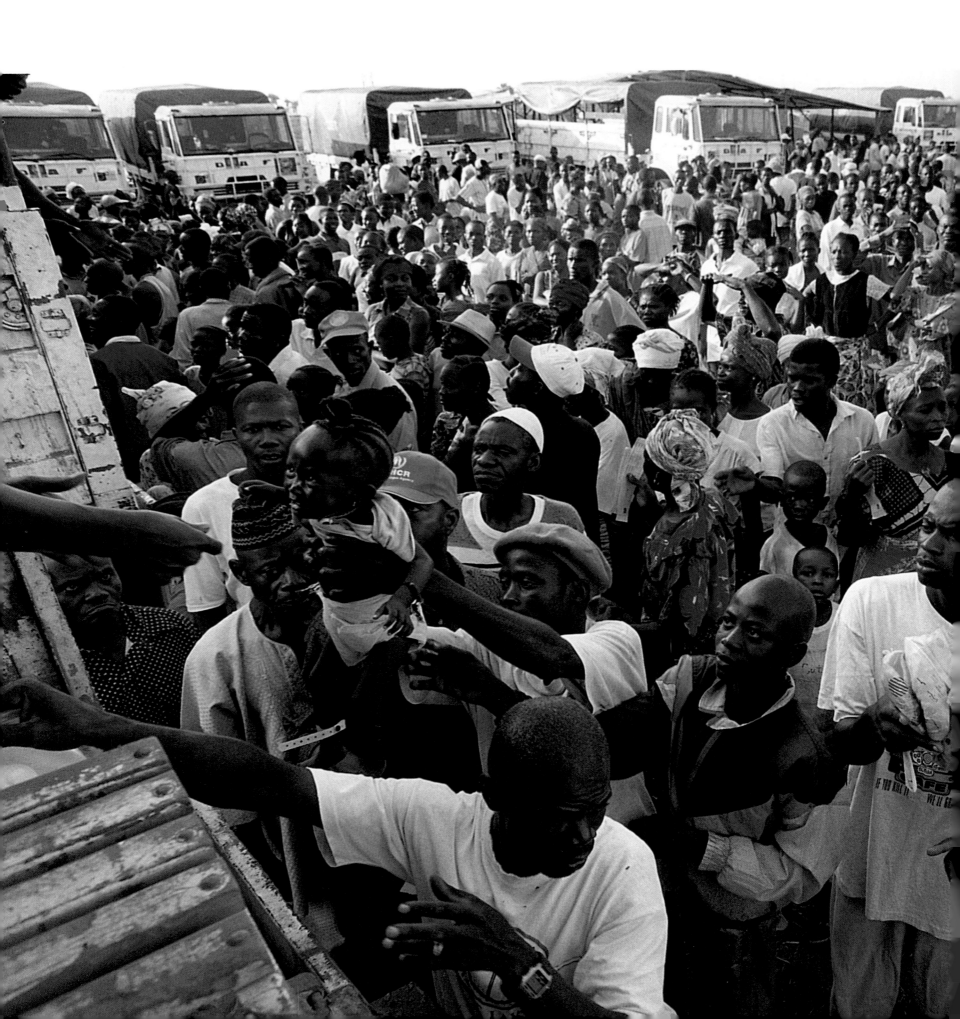

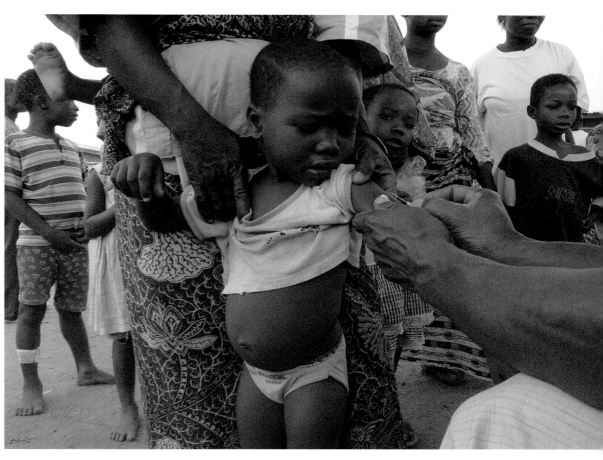

■ **Above**
In the remote Côte d'Ivoire village of Guianle, government health workers vaccinate children against cholera, polio, and yellow fever.
> *David Turnley in Côte d'Ivoire*

■ **Left**
At Samukai Town, a camp in Liberia, refugees displaced for years by Sierra Leone's civil war crowd United Nations trucks they hope will carry them back to their homes.
> *Paul Fusco in Liberia*

141

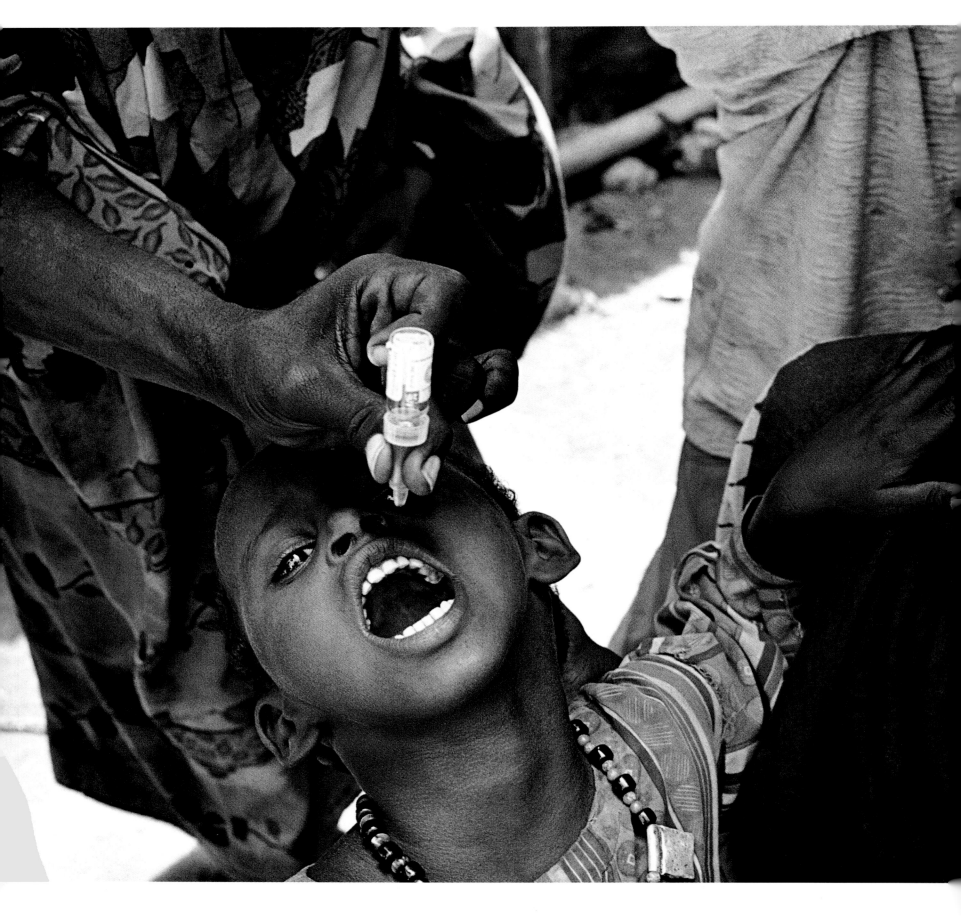

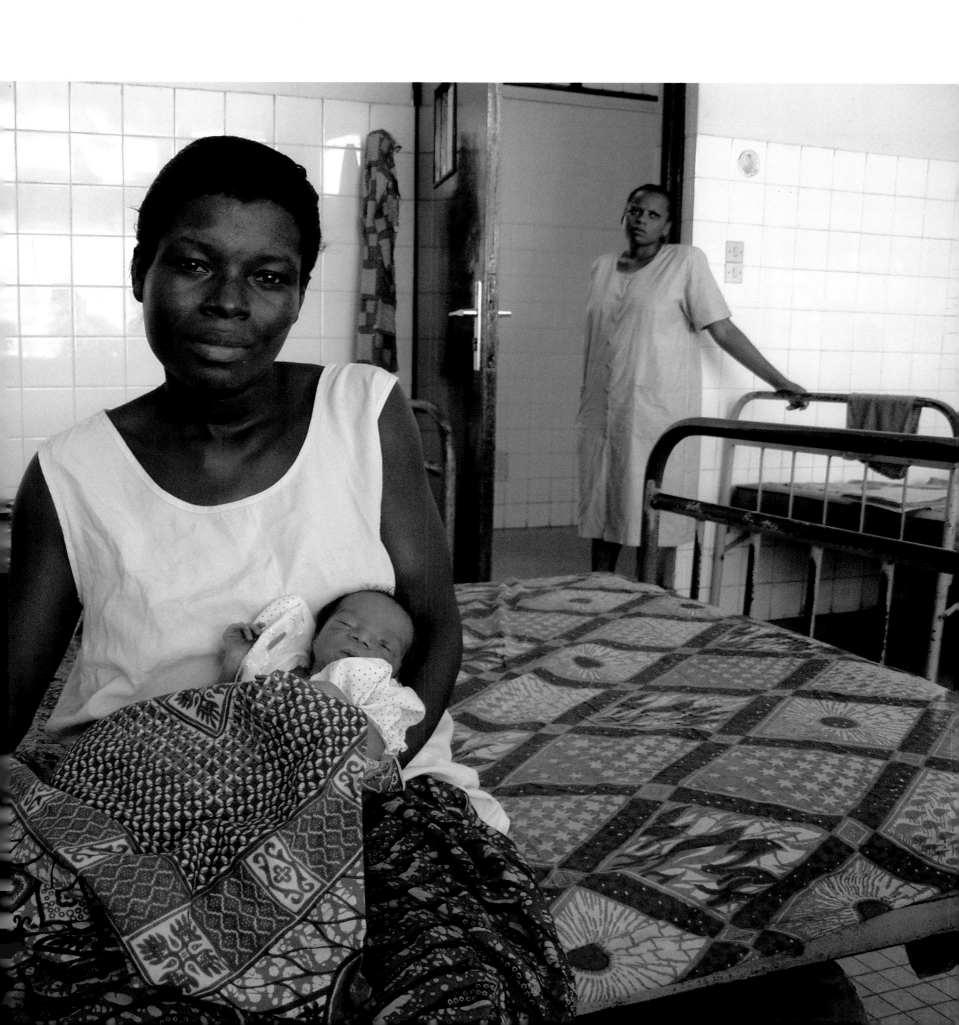

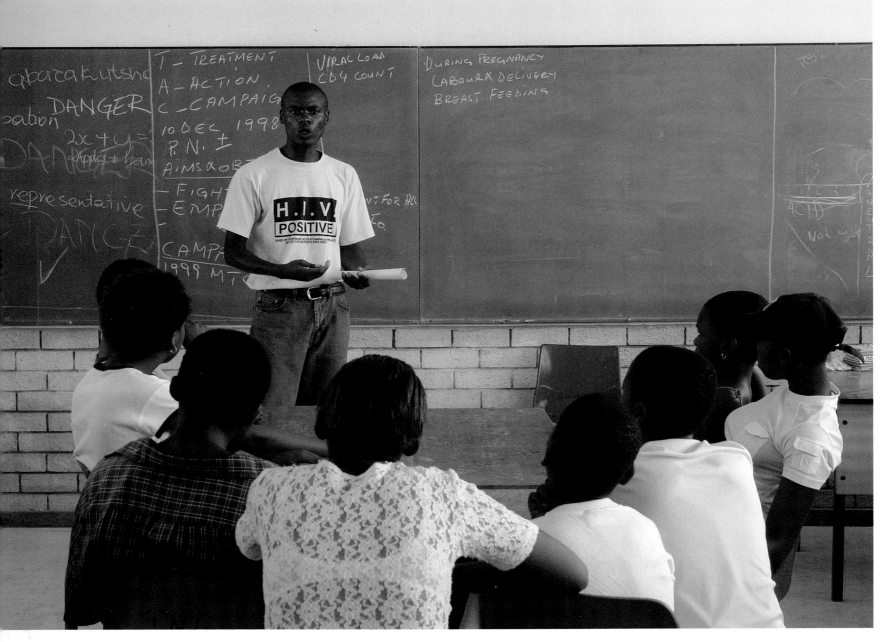

□ Above

In a Cape Town suburb, Bonile Peter trains volunteers for the Treatment Action Campaign, a South African AIDS advocacy organization. The group works toward affordable treatment for all South Africans living with HIV/AIDS. According to the government health department, by the turn of the millennium, 4.7 million South Africans—one in every nine—were infected with the virus, more than any other nation on earth.

> *Gideon Mendel in South Africa*

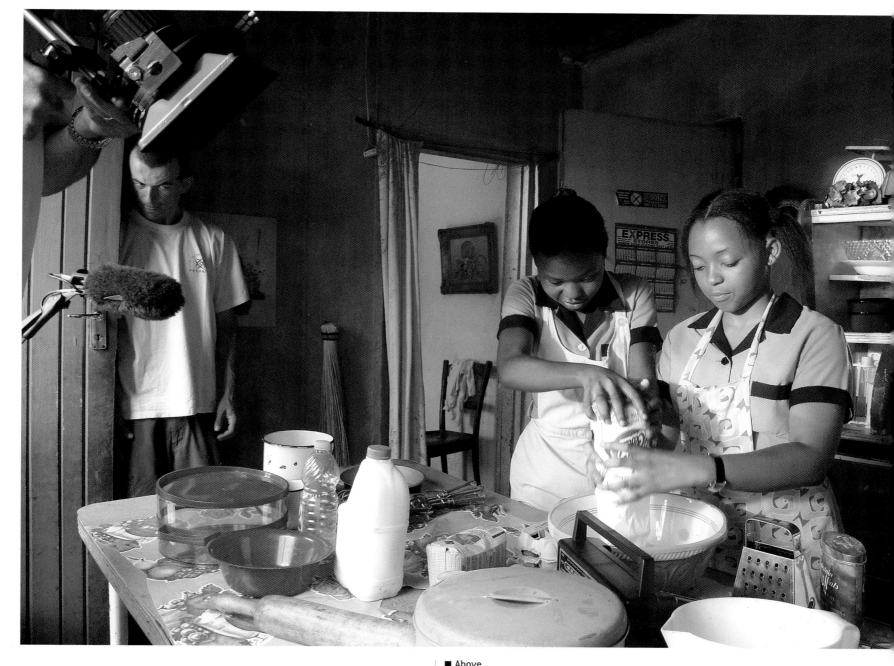

■ **Above**

A South African TV crew films *Soul Buddyz*, a children's show that tackles difficult issues—from AIDS and sexuality to physical and mental disabilities—in a frank, straightforward fashion. The program was spun off from *Soul City*, South Africa's award-winning soap opera that reaches 12 million teenagers and young adults with useful information about issues affecting their lives— particularly HIV issues.

> *Louise Gubb in South Africa*

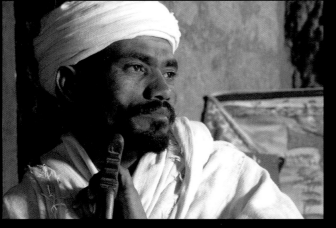

Michael S. Lewis > Lalibela, Ethiopia

Kim Ludbrook > Ghanzi, Botswana

John Isaac > Mongo, Chad

Tim Georgeson > Awasa, Ethiopia

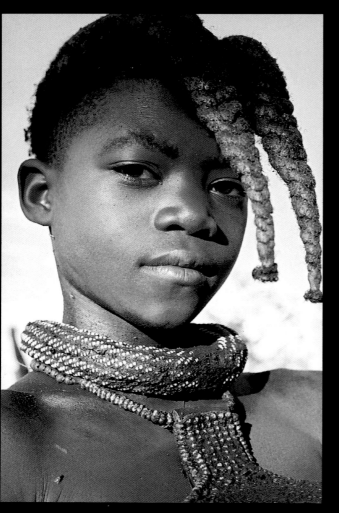

Greg Marinovich > Opuwo, Namibia

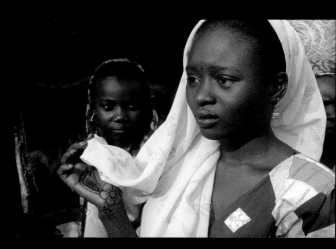

Lori Grinker > Zinder, Niger

> second sight

**Photographed in Tanzania
by Doug Menuez**

Blindness caused by the highly infectious trachoma bacteria is a catastrophic problem in Africa, where 10 percent of the population is at risk. Most often, trachoma causes blindness in adults, particularly women, leaving them unable to care for their families. Children are often forced to leave school to earn a living or care for younger siblings, perpetuating a cycle of poverty.

Recent medical advances, however, have made trachoma more easily treatable, with a single annual dose of an antibiotic called Zithromax (azithromycin). The International Trachoma Initiative (ITI)—a partnership founded by Pfizer and the Edna McConnell Clark Foundation—distributes free Zithromax and initiates community-based health strategies in trachoma-affected areas. The initiative's mission is to support the World Health Organization (WHO) goal of eliminating blinding trachoma worldwide by 2020. Pilot projects in Morocco and Tanzania—involving more than 2 million people—have already cut the severe infection rate in children by more than 50 percent in just over a year.

ITI-trained health workers travel to rural villages and employ a strategy of prevention as well as treatment developed by the WHO called SAFE—an acronym for Surgery, Antibiotics, Face-washing, and Environmental change. Day in the Life photographer Doug Menuez accompanied an ITI team on a nine-hour car trip from Dar es Salaam to the rural community of Maweni, in the Manyoni district of Tanzania. The team dispensed hundreds of doses of Zithromax, helped build a new school cistern to provide clean face-washing water for village children, and performed outdoor eye surgery under a baobab tree. "It was an emotional roller coaster," says Menuez. "We saw these beautiful children going blind. At first everyone was afraid to take the pills, but when the head man took it, everyone else did, and we knew these kids would have a future."

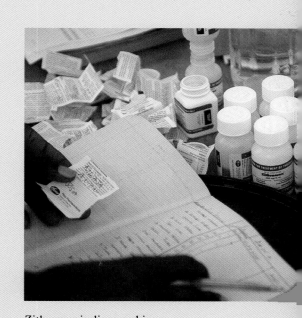

Zithromax is dispensed in rural Tanzania to cure and control trachoma-related blindness.

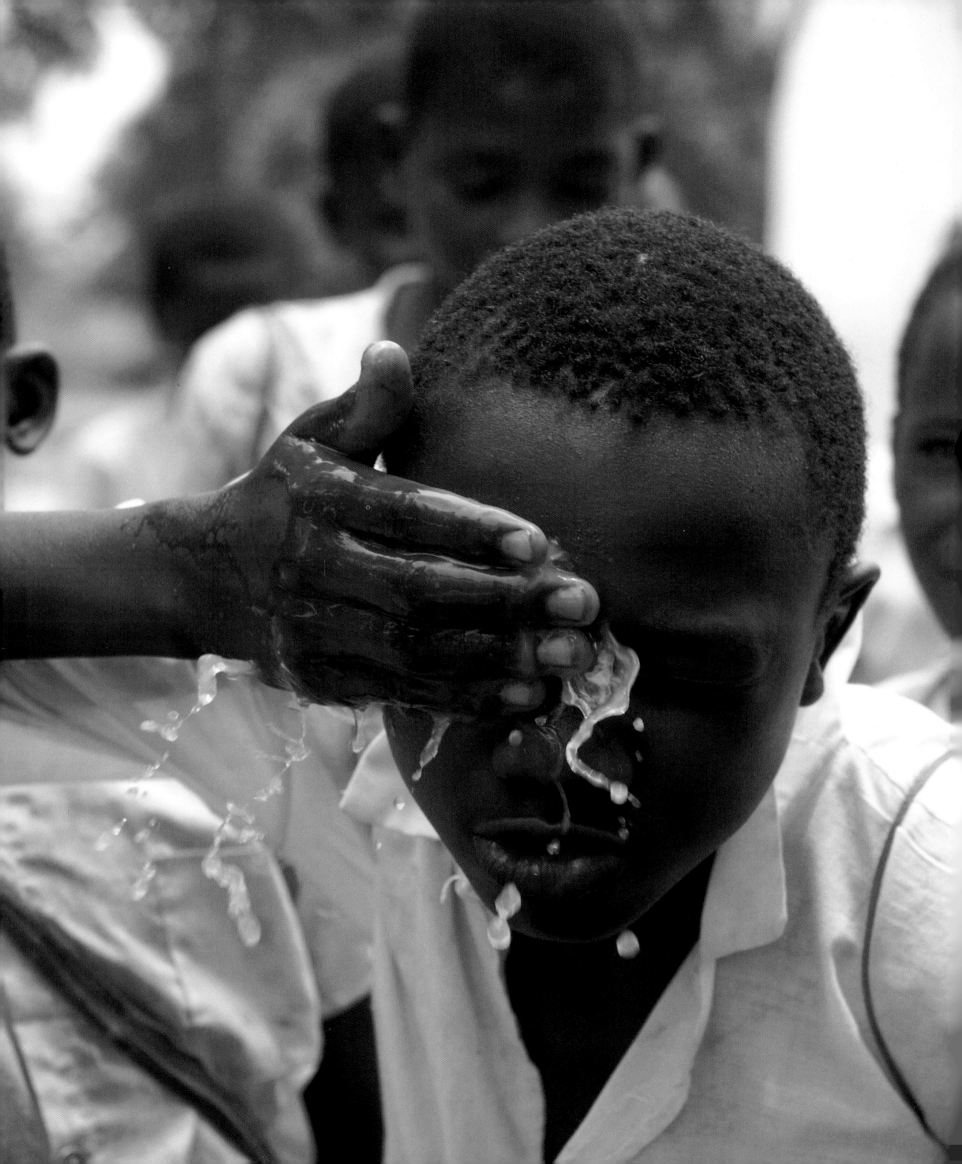

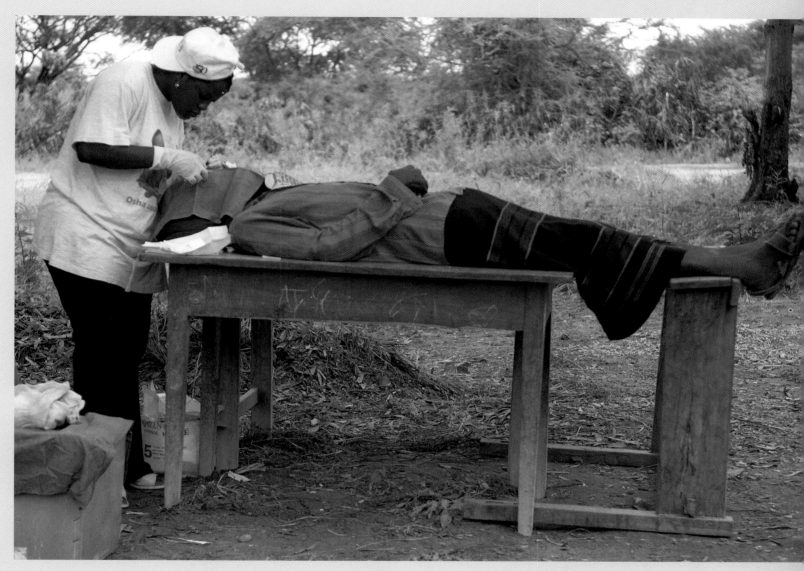

Left
Daily face-washing with clean water helps prevent trachoma-related blindness. Caused by the bacterium *Chlamydia trachomatis*, the disease often begins in early childhood and is easily transmitted from the eyes of an infected child to other family members.

Above
A health worker performs surgery on a patient with an advanced case of the disease. Untreated, trachoma causes eyelashes to turn inward, scratching and eventually damaging the cornea. The simple 15-minute procedure rotates lashes away from the eye, preventing blindness and relieving pain.

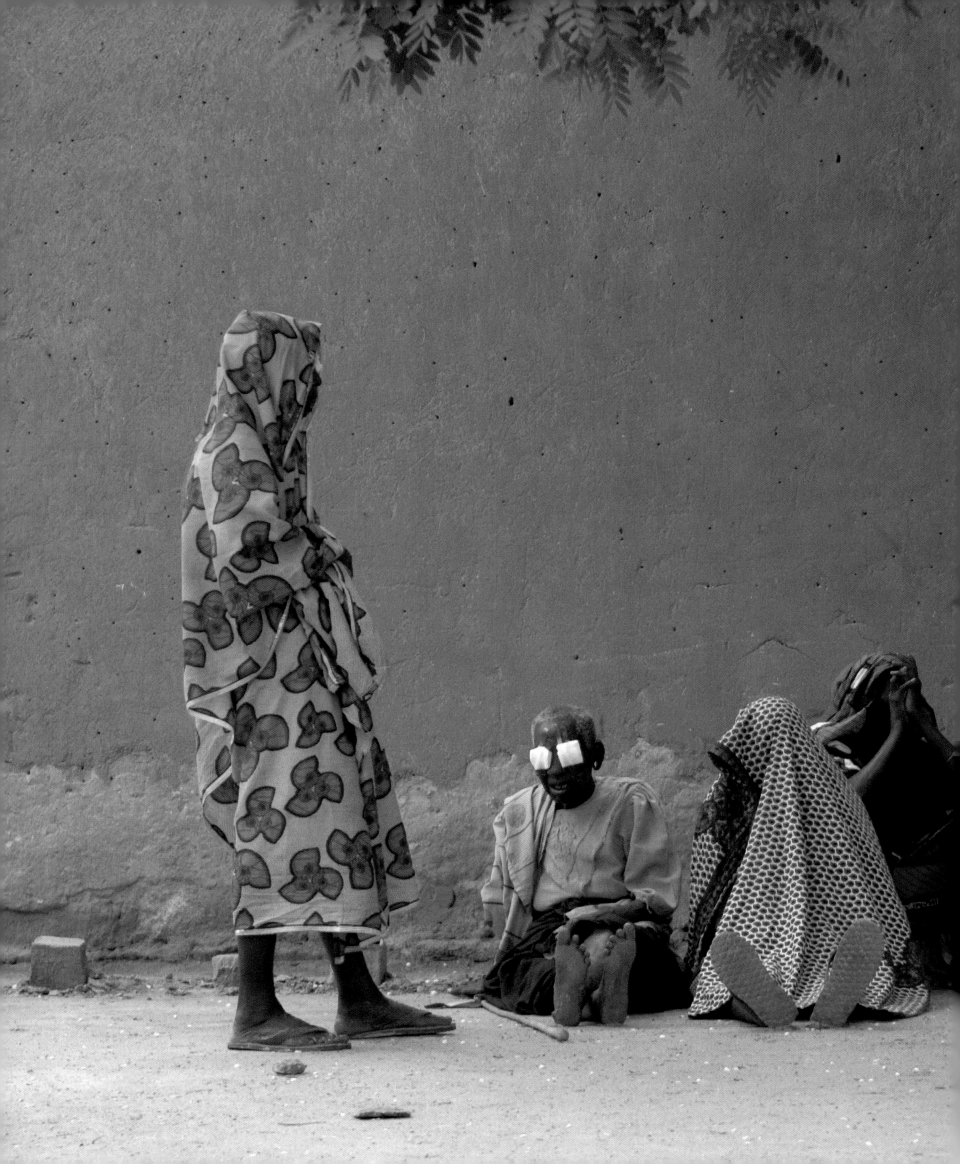

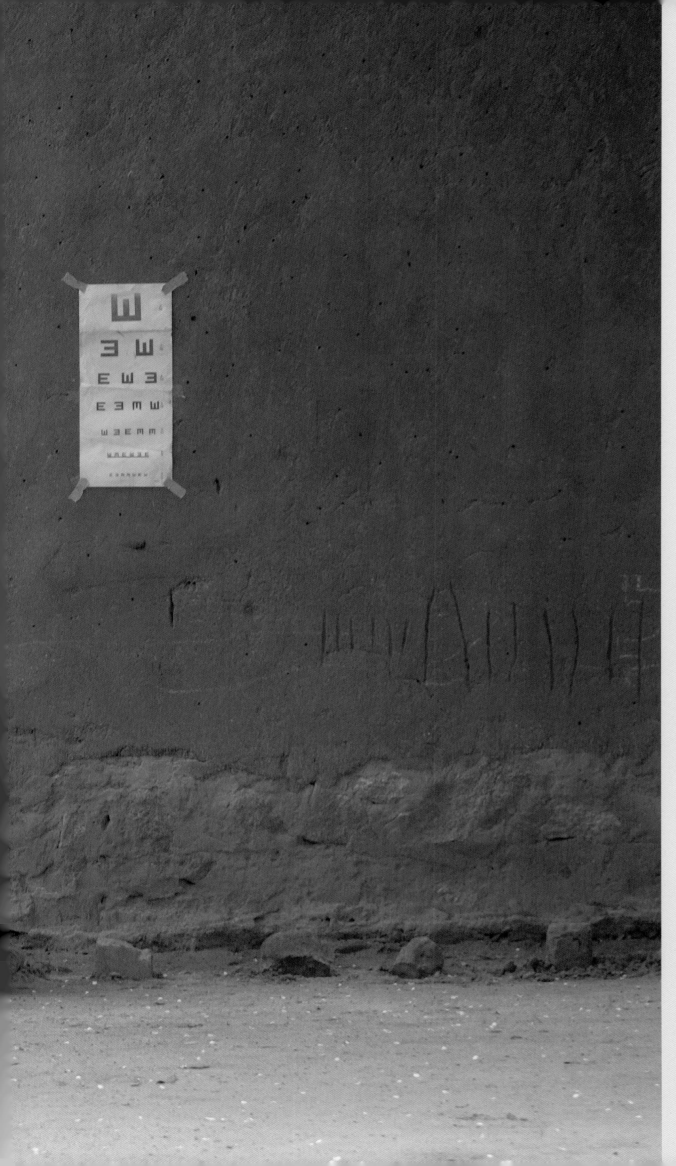

Left
Patients in Maweni
immediately after eye surgery
to correct trachoma-related
blindness. Preventing the
spread of the disease "is quite
a challenge," acknowledges
Peter Kilimam, the
International Trachoma
Initiative's Coordinator for
Anglophone Africa in
Tanzania. "It is hard," he says,
"for people in rural villages
to understand the connection
between a mild eye disease
in children and the blindness
of their mothers. But with
the SAFE strategy, we make
the connection understood."

153

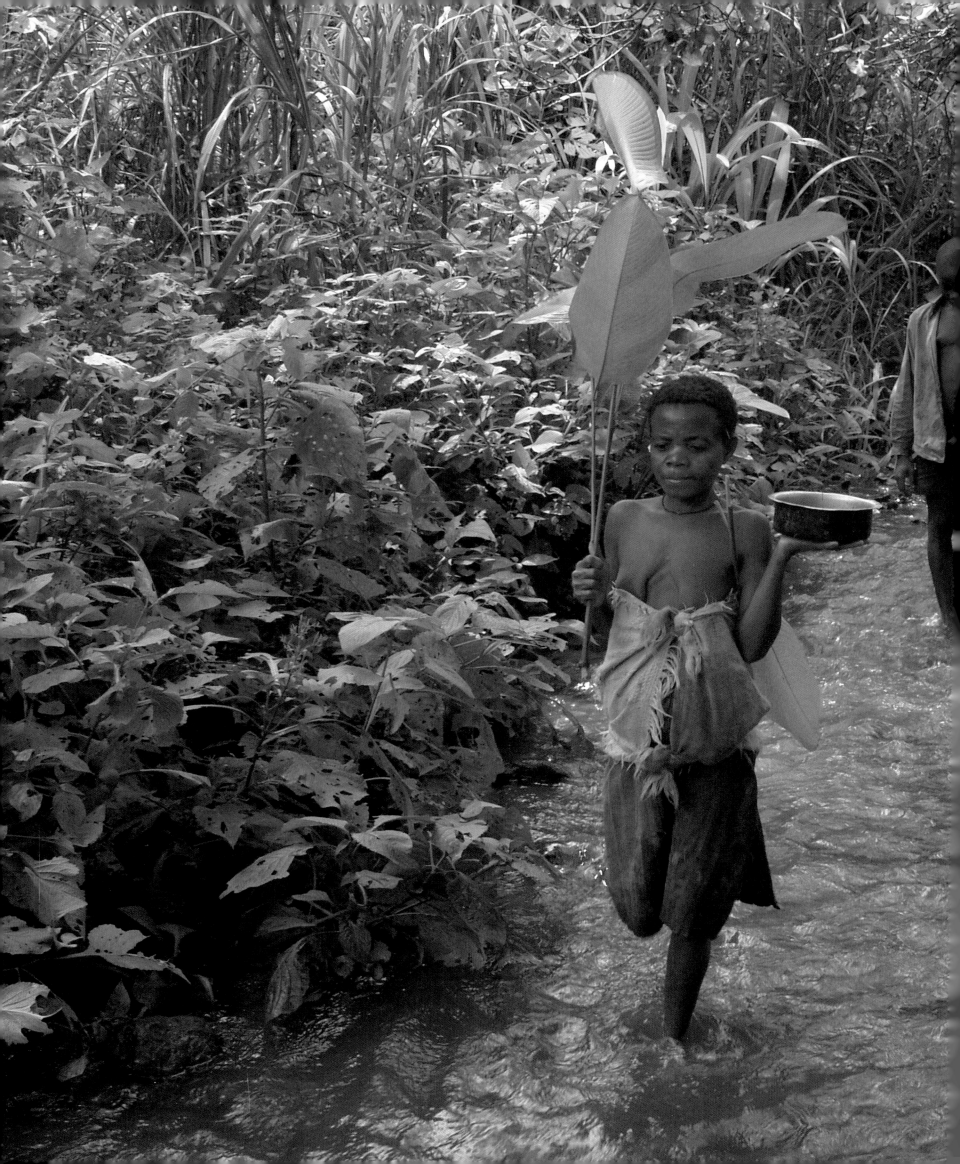

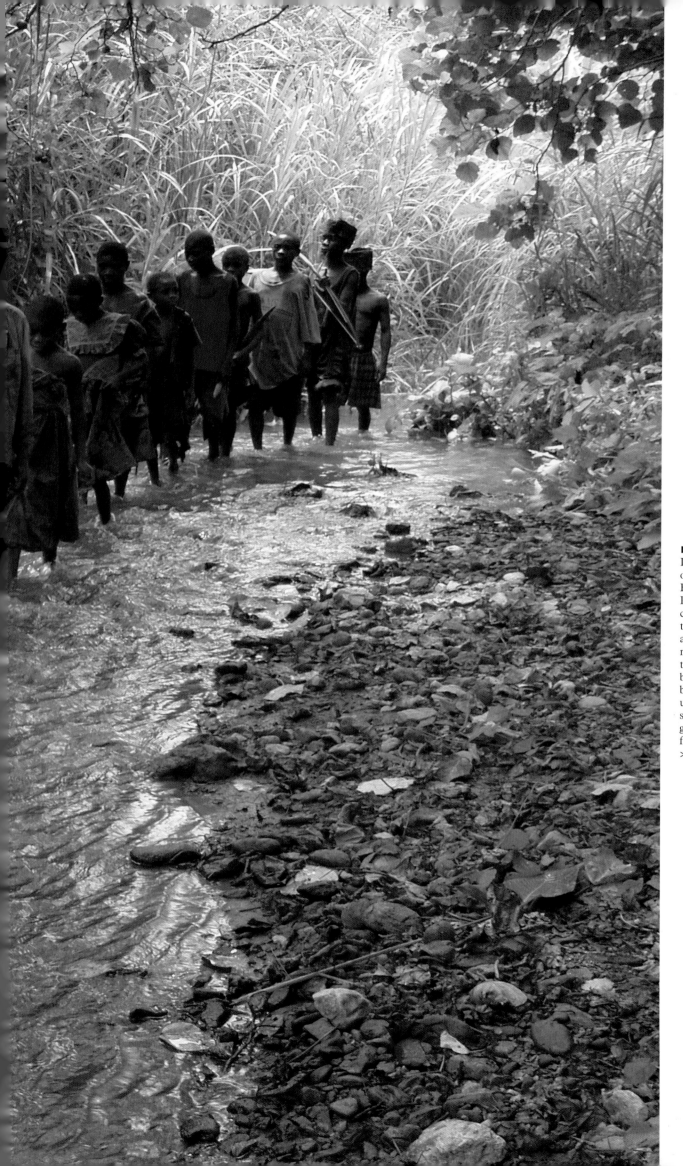

■ Left
In the dense equatorial forest of Semuliki National Park, BaTwa people (also known as Pygmies) move to a new campsite upstream, tending traps and collecting plants along the way. The semi-nomadic BaTwa are traditionally forest-dwellers, but most have been displaced by deforestation and political upheaval, and can no longer survive by hunting and gathering leaves, tubers, fungi, and honey.
> *Larry C. Price in Uganda*

155

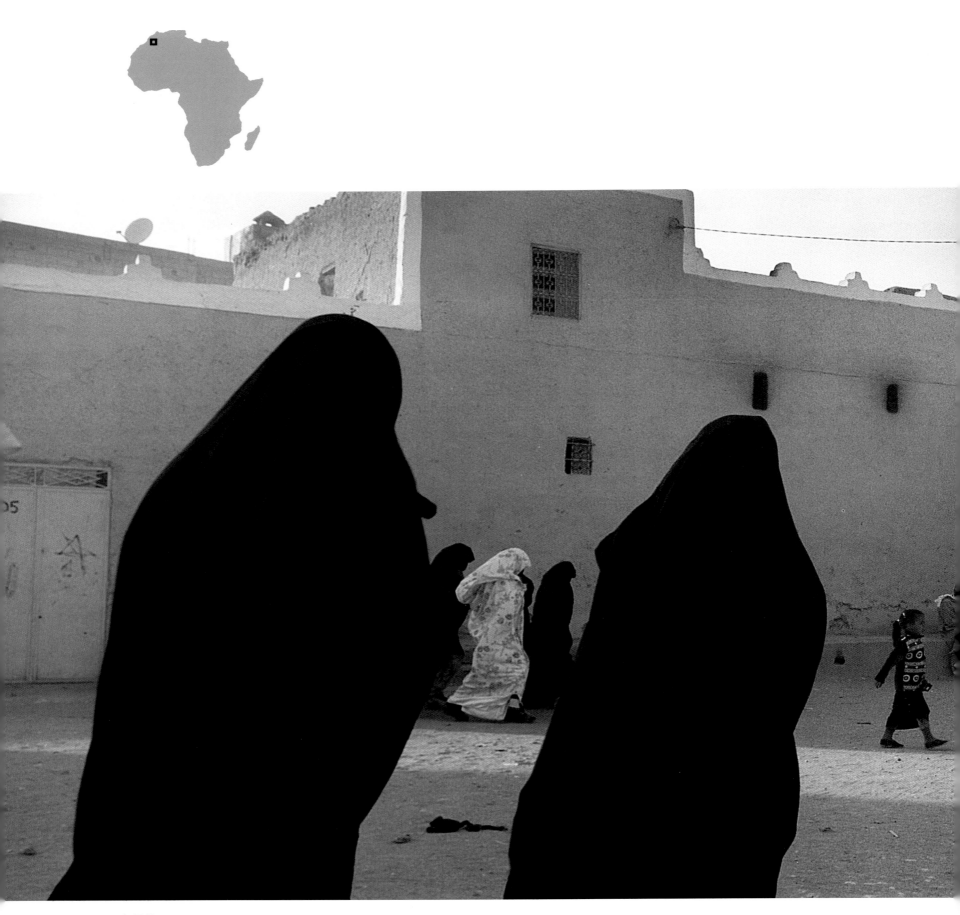

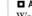 **◻ Above**
Women pass through a
courtyard in Zagora,
southern Morocco.
> *Bruno Barbey in Morocco*

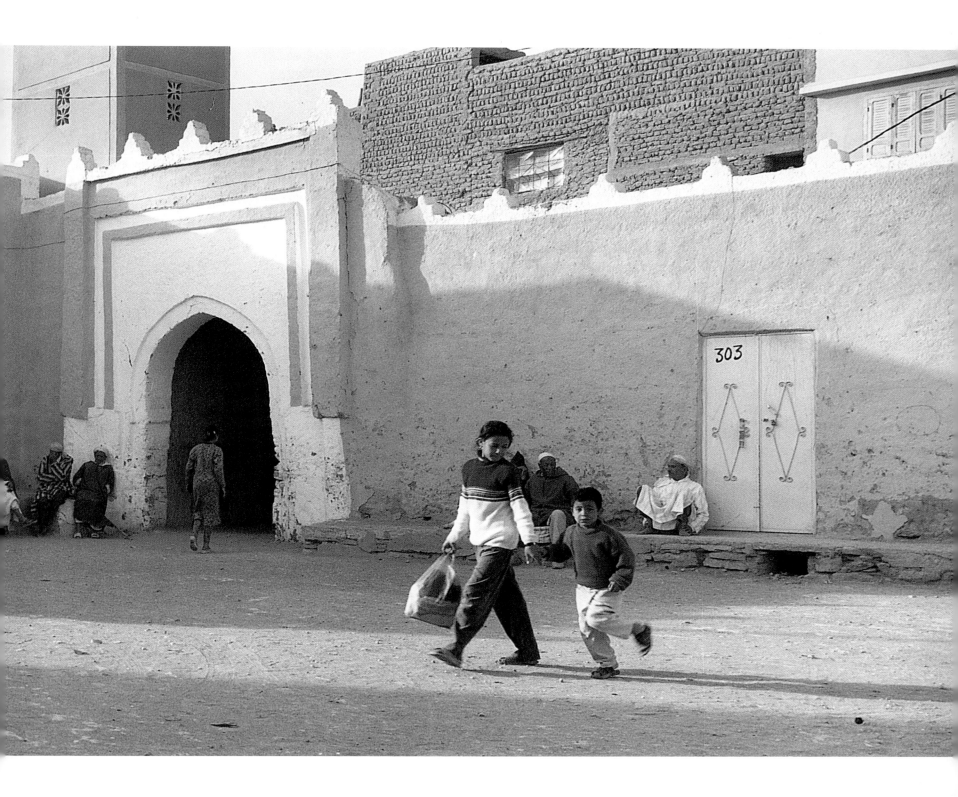

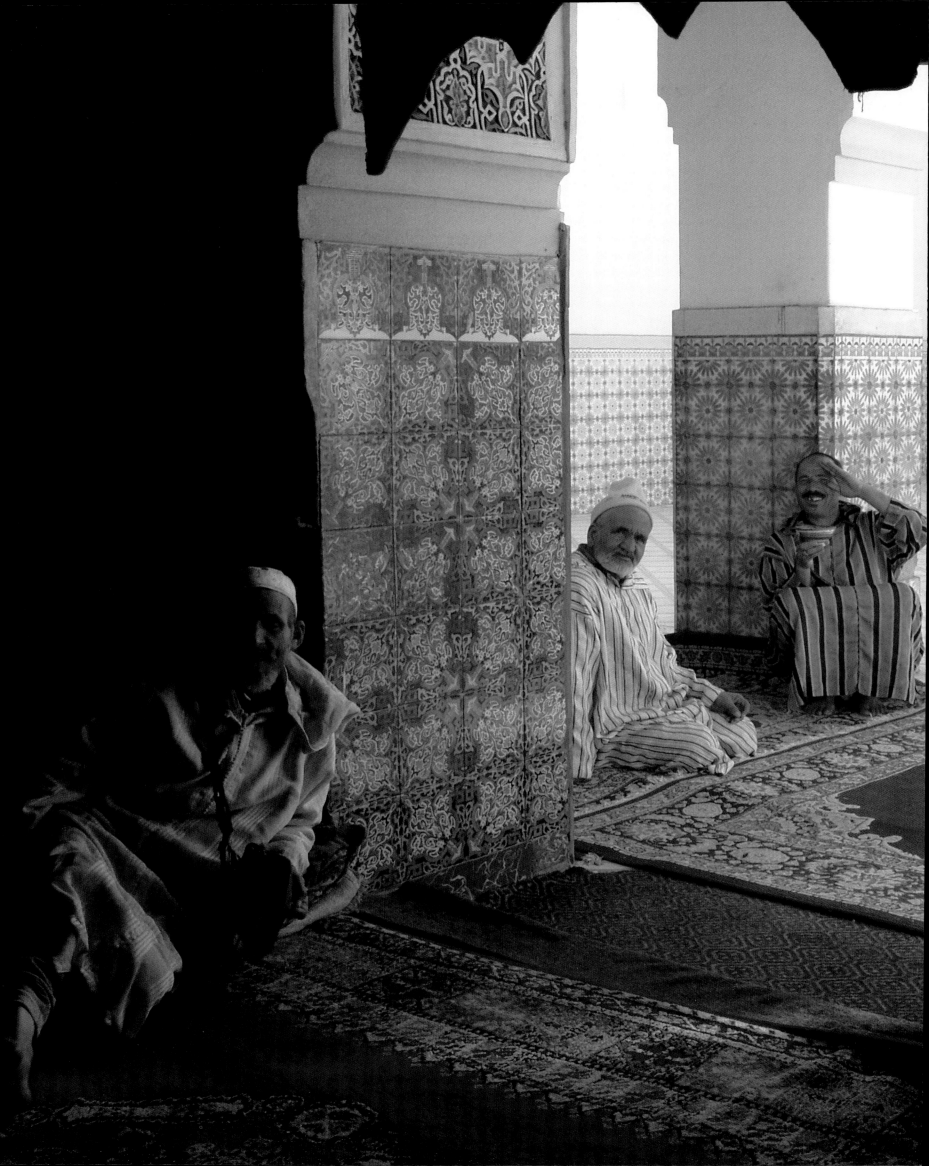

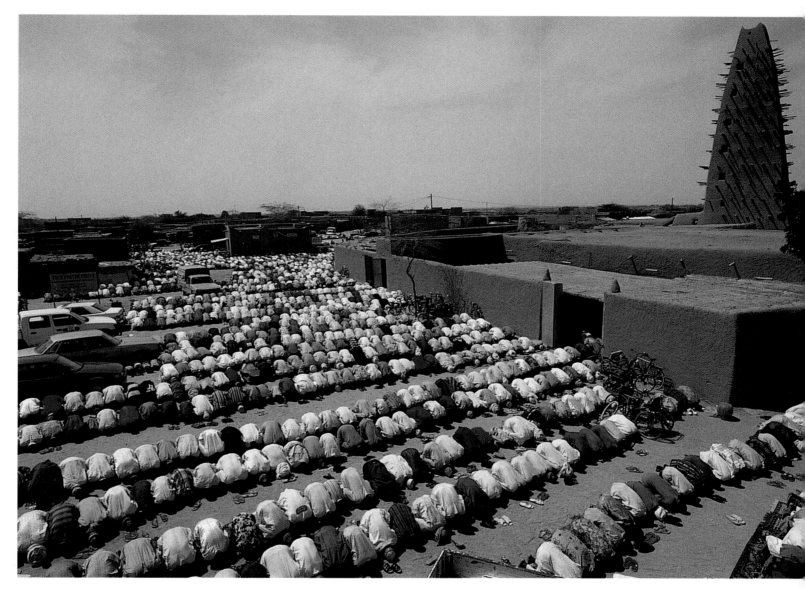

□ **Above**
Worshippers outside the
15th-century mosque of
Agadez, a sanctuary too
small to hold their numbers.
> *Jean-Luc Manaud in Niger*

■ **Left**
In the village of Tanselot, near
Marrakech, men gather at the
shrine of a Muslim saint.
> *Bruno Barbey in Morocco*

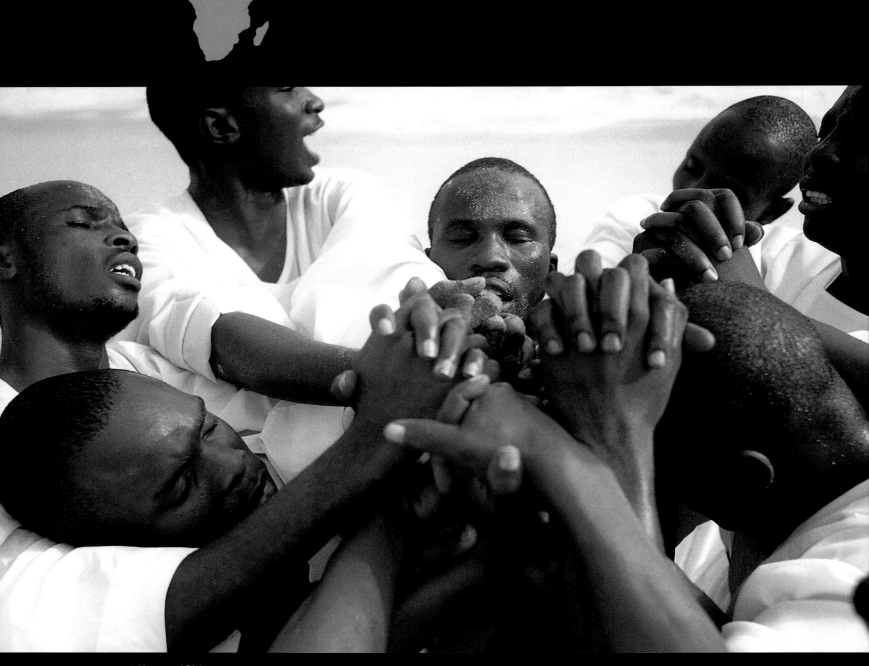

□ Above and Right

In Lagos, where Christian
ministries are multiplying
rapidly, worshippers gather
by the seashore. On Bar
Beach, above, most famous
for its nightlife, the Celica
Church of Christ Most
Glorious offers prayers for
peace, unity, and the glory
of Nigeria. At right, on
Lagos' Badagry Beach, the
faithful pray for an ailing

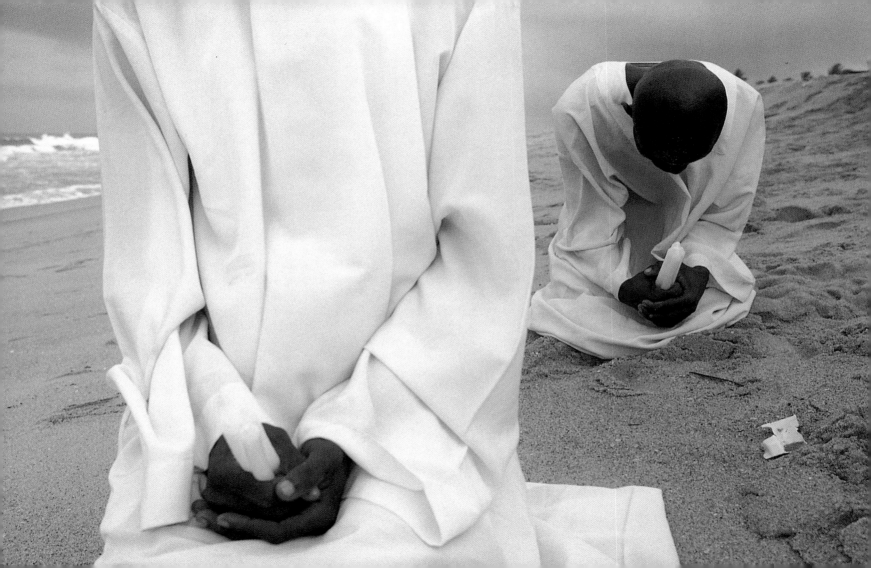

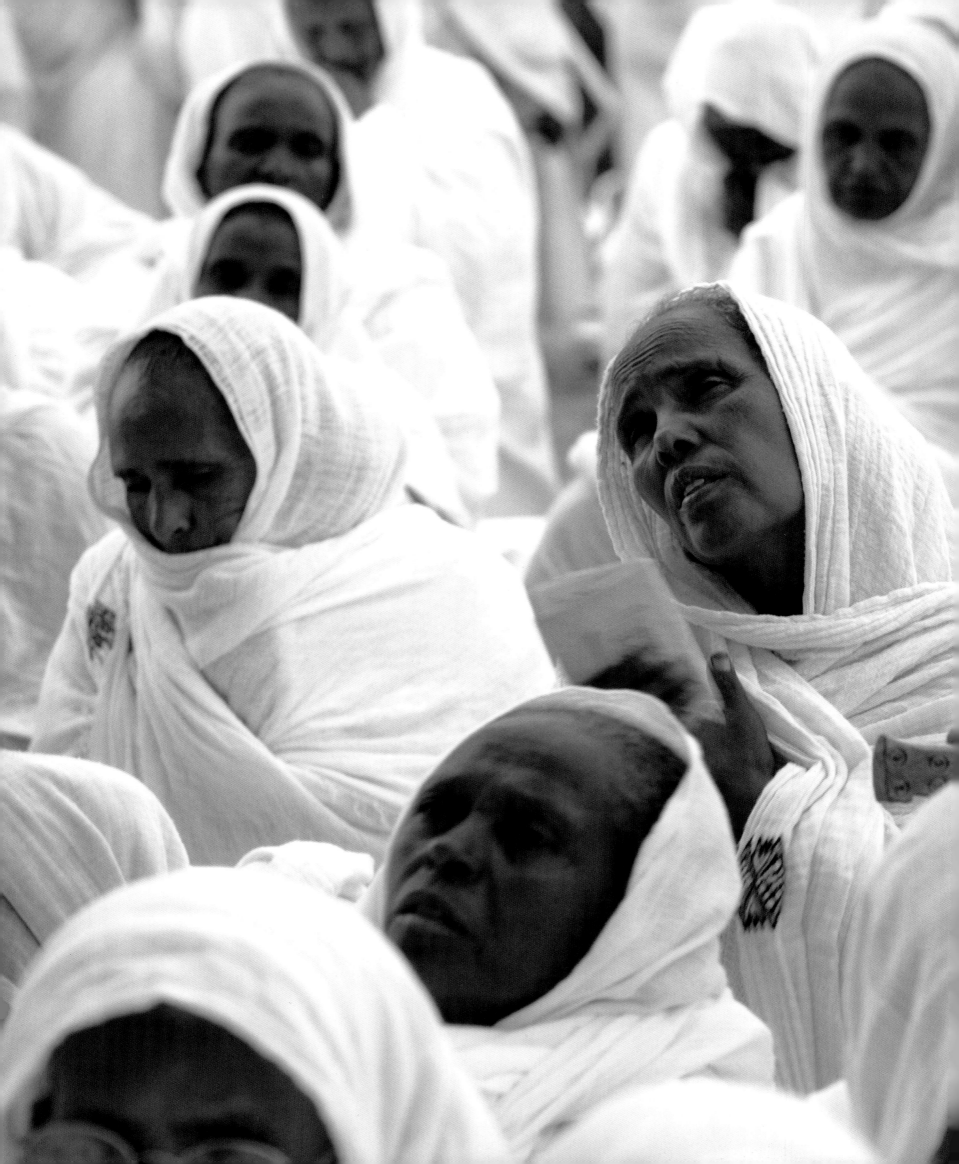

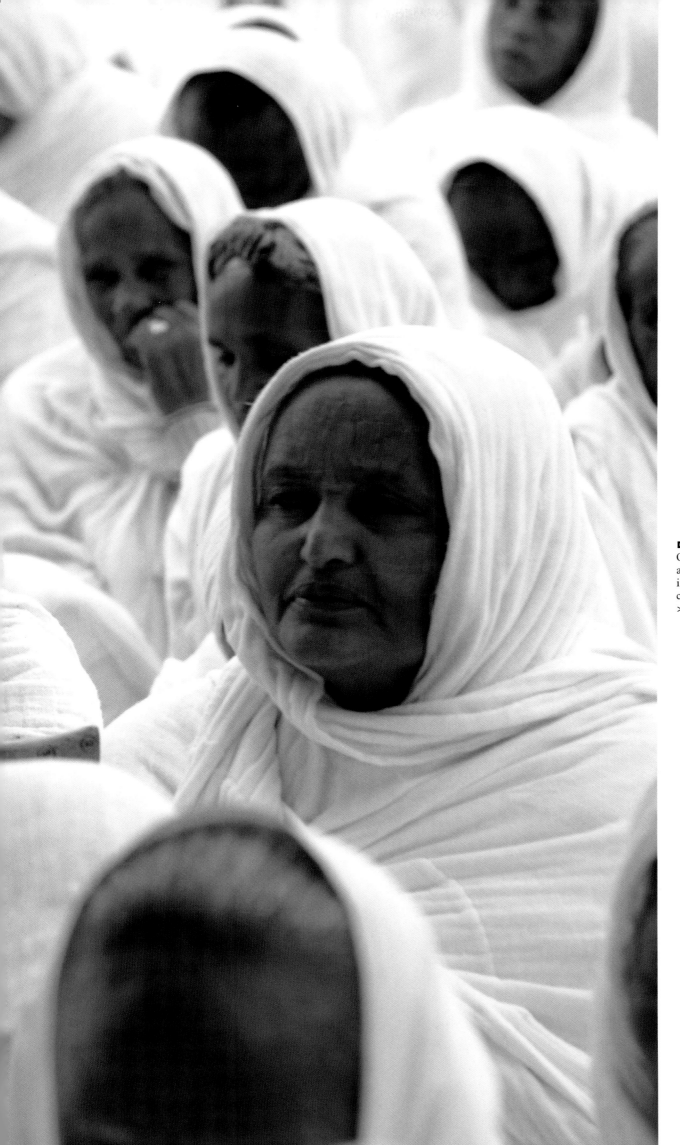

163

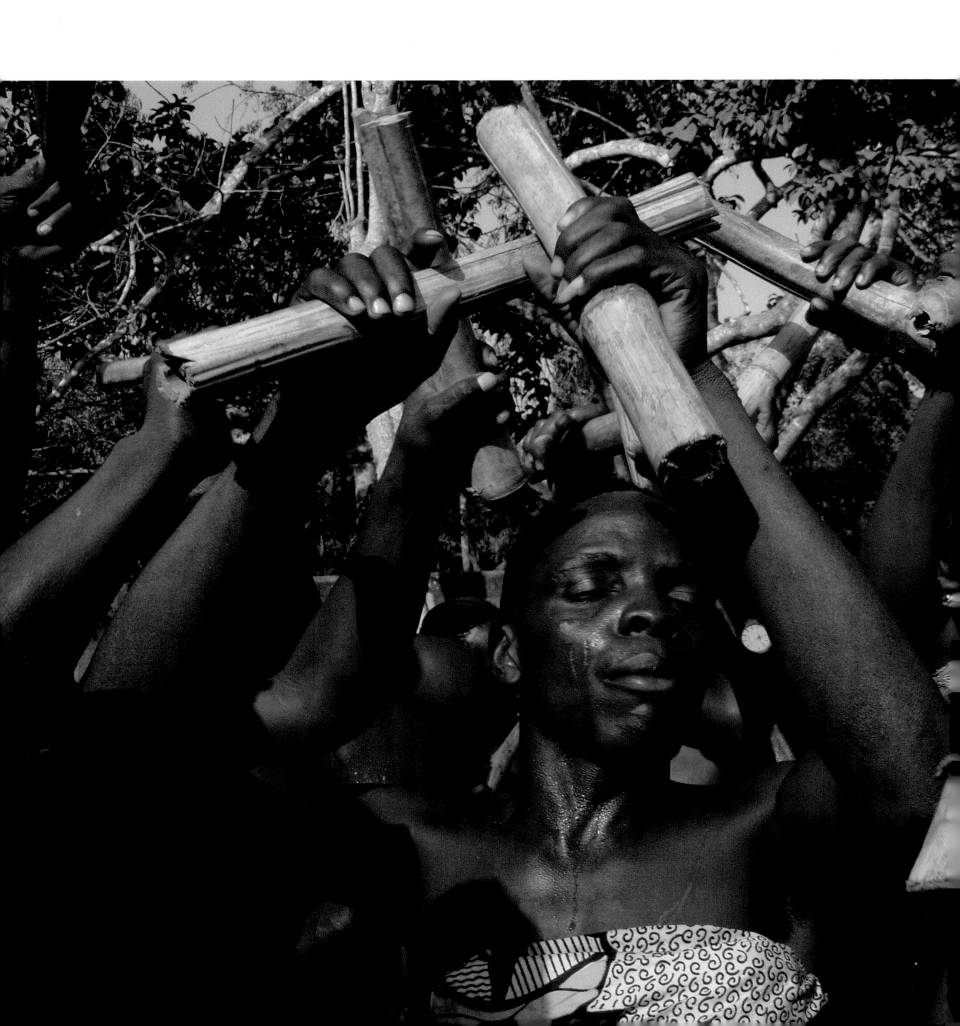

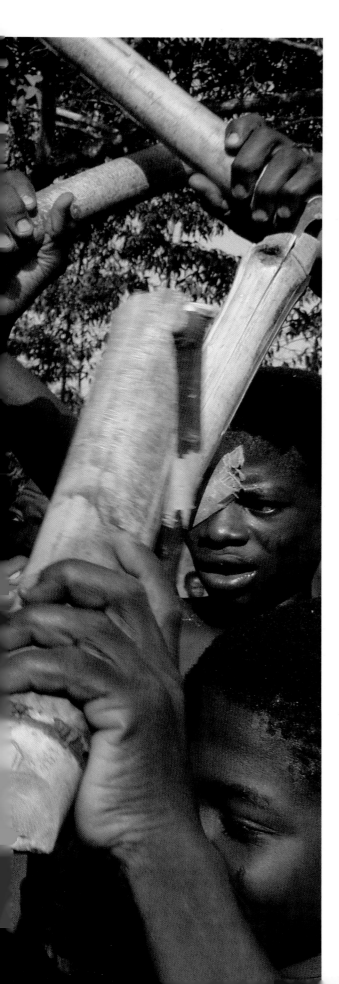

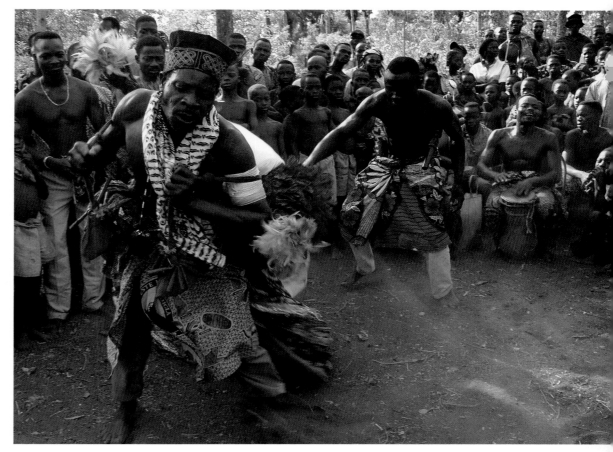

■ **Above and Left**
Vodun or "voodoo" originated
in the west African countries
of Benin, Togo, and Nigeria.
In Aglogbe-Vedo, near Benin's
capital of Porto-Novo,
villagers take part in an
annual celebration in honor
of Hligbo-Agodowe, a deity
that helps protect their
community. Represented by a
fetish made from a sack of
white cloth and red feathers
(above), Hligbo-Agodowe is
believed to heal fevers and
protect children and pregnant
women. To the rhythmic
beating of bamboo sticks
(left), a celebrant carries the
heavy fetish to a sacred wood,
where young goats will be
sacrificed.
> *Jean-Claude Coutasse in Benin*

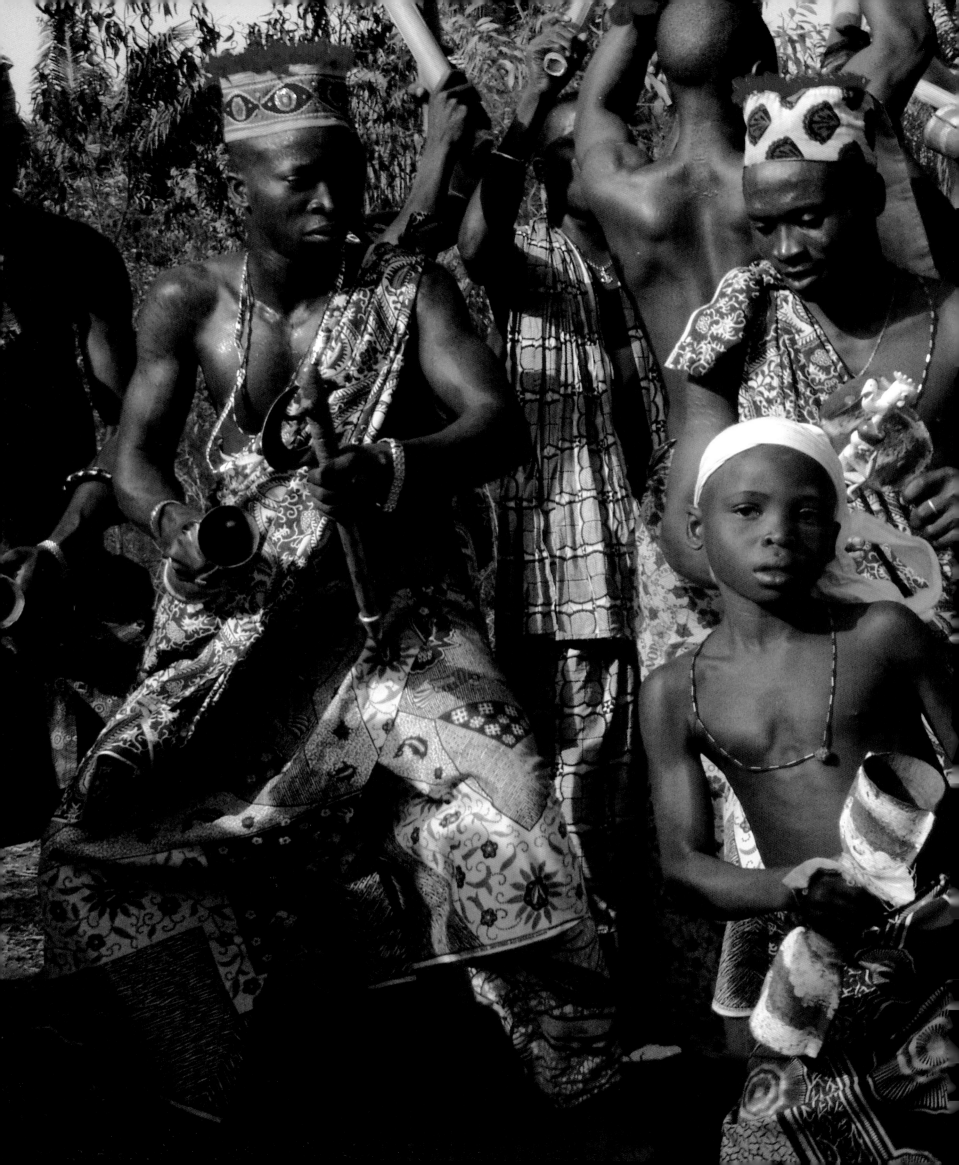

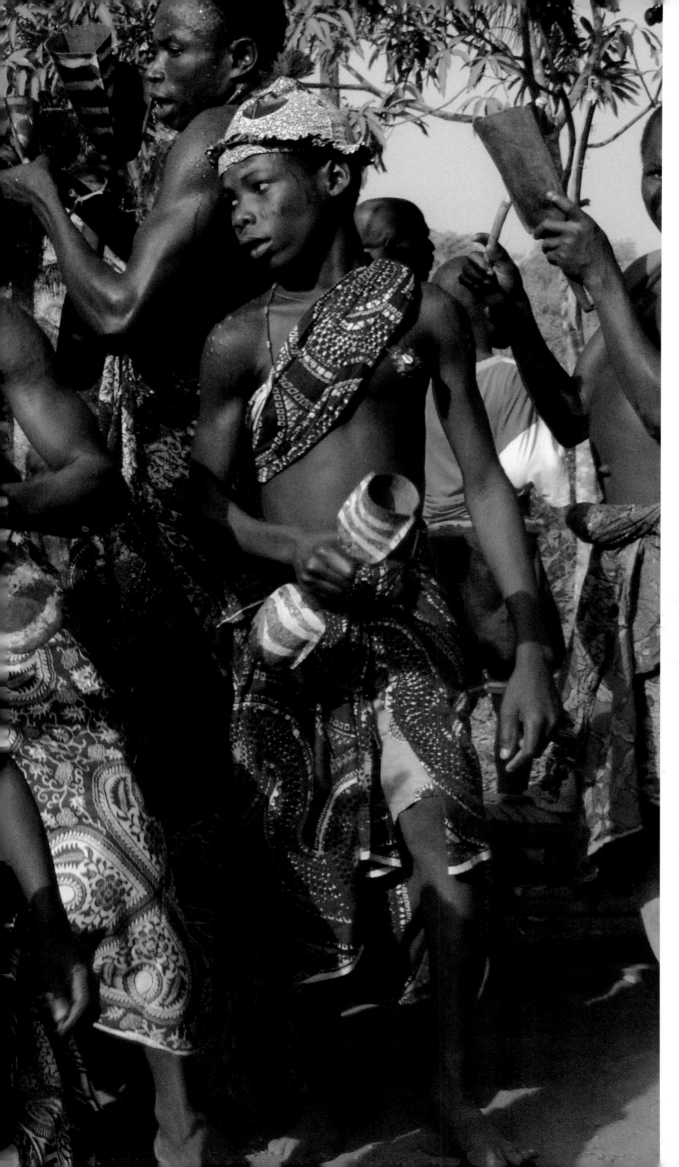

◻ **Left**
Celebrants dance to honor
the deity Hligbo-Agodowe
in a sacred wood near
Aglogbe-Vedo, Benin.
> *Jean-Claude Coutasse in Benin*

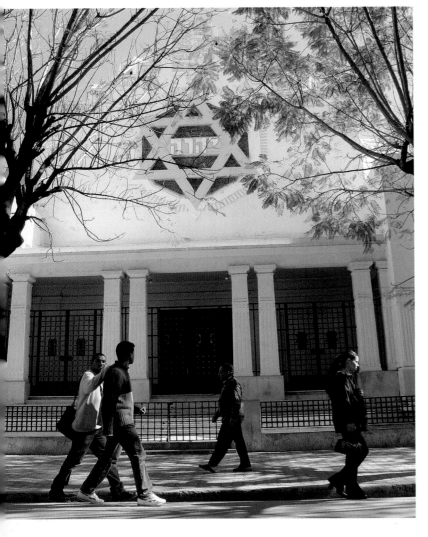

□ **Top Left**
Pedestrians stroll past one of the 14 synagogues on the island of Djerba. Home to half of Tunisia's 2,000 Jews, Djerba dates its Jewish population to the destruction of Solomon's temple in 586 B.C.
> *Emmanuel T. Santos in Tunisia*

■ **Bottom Left**
In the desert of northern Kenya, Father Tony Barrett celebrates mass with his Turkana congregants. Barrett, an Irish priest and anthropologist who has lived among the Turkana for 28 years, wrote a dictionary of the Turkana language.
> *Chris Steele-Perkins in Kenya*

○ **Right**
A priest leads his packed congregation at Armée de Victoire, one of the largest, most popular Gospel churches in Kinshasa.
> *Per-Anders Pettersson in Congo-DRC*

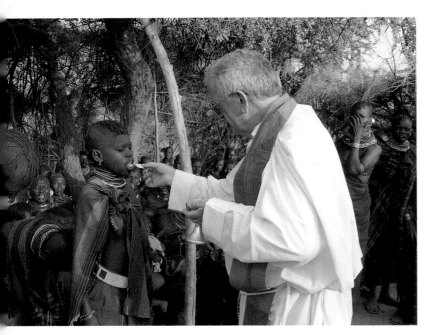

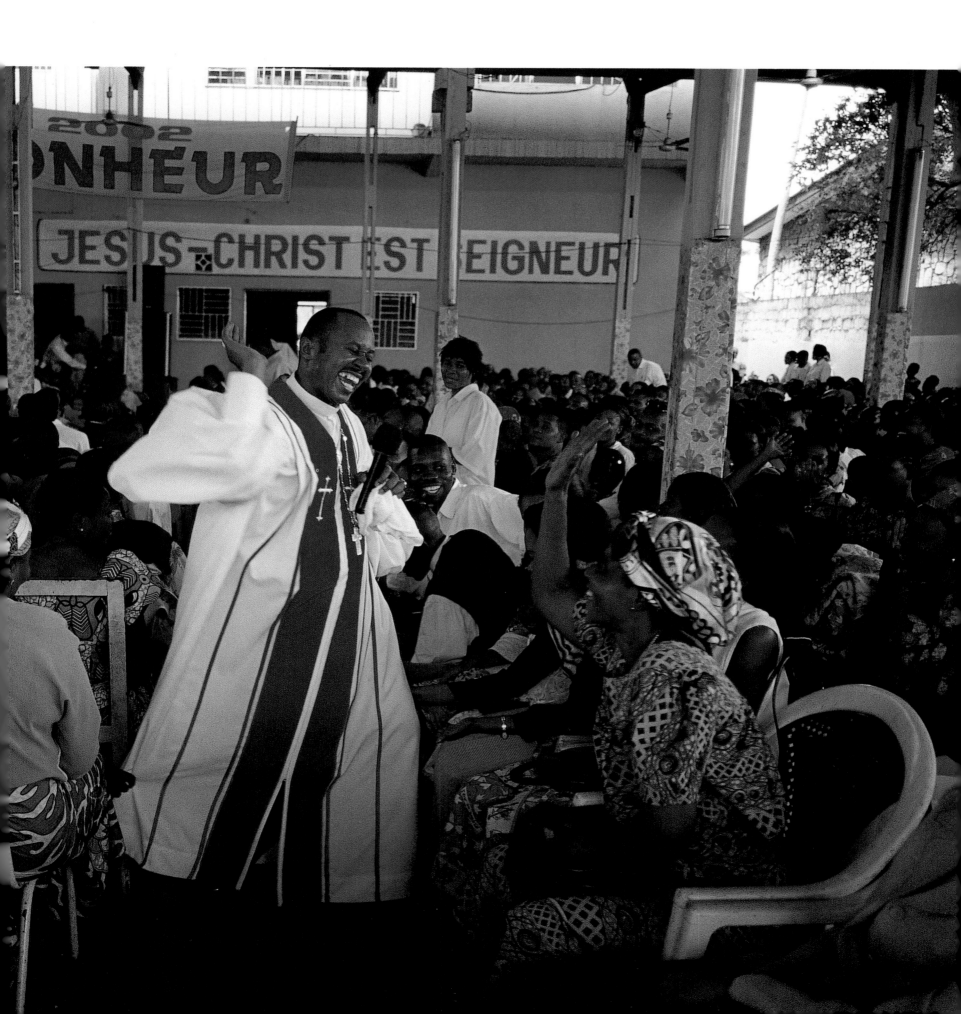

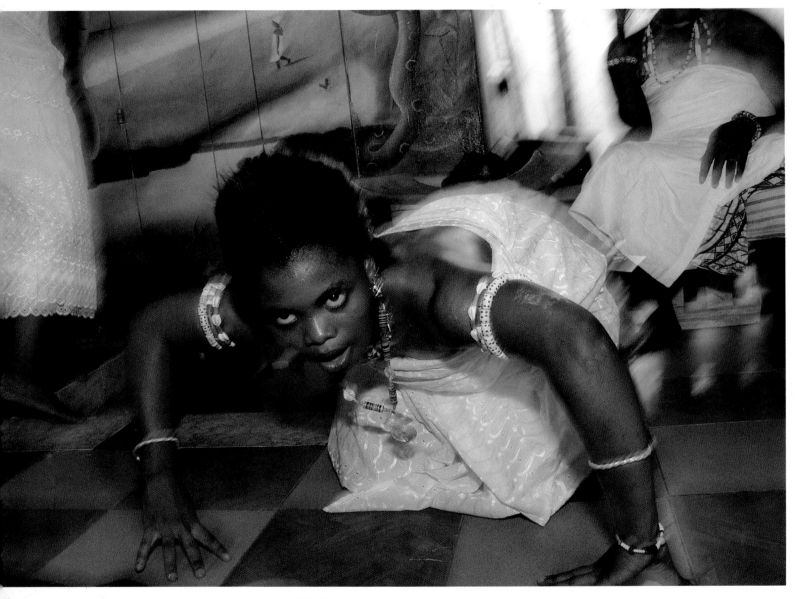

▫ Above
In Cotonou, Benin, a young
woman performs a ritual to
honor the ocean deity
Mamywata. Falling into a
trance state, she is possessed
by the crocodile god,
Adjakpassi.
> *Jean-Claude Coutasse in Benin*

■ Right
Only women are allowed to
attend the circumcision of this
young Maasai girl in her
family's calf pen in the Narok
district, south of Nairobi.
When the procedure is finished,
cow's milk will be poured onto
the 13-year-old's wound.
According to Maasai tradition,
all women must go through
female circumcision—removal
of the clitoris—before they
can be married. Some modern
Maasai women as well as
anti-clitoridectomy activists
worldwide are campaigning to
end the ritual cutting.
> *Liz Gilbert in Kenya*

■ **Left and Right**
Mahou villagers in Douelala, western Côte d'Ivoire, gather at a Muslim funeral for Diamond Soualid. The 39-year-old died after falling from a palm tree while harvesting palm nuts. During the ceremony, men and women mourn separately. Soualid's body lies in the community's only casket, reused for every village funeral.
> *David Turnley in Côte d'Ivoire*

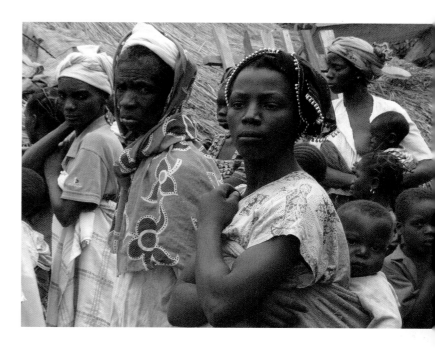

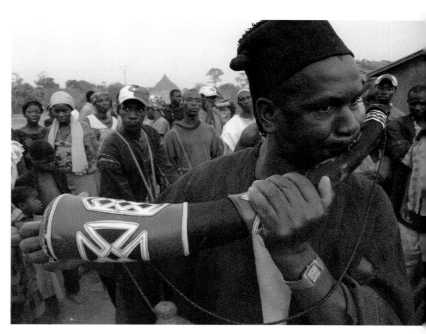

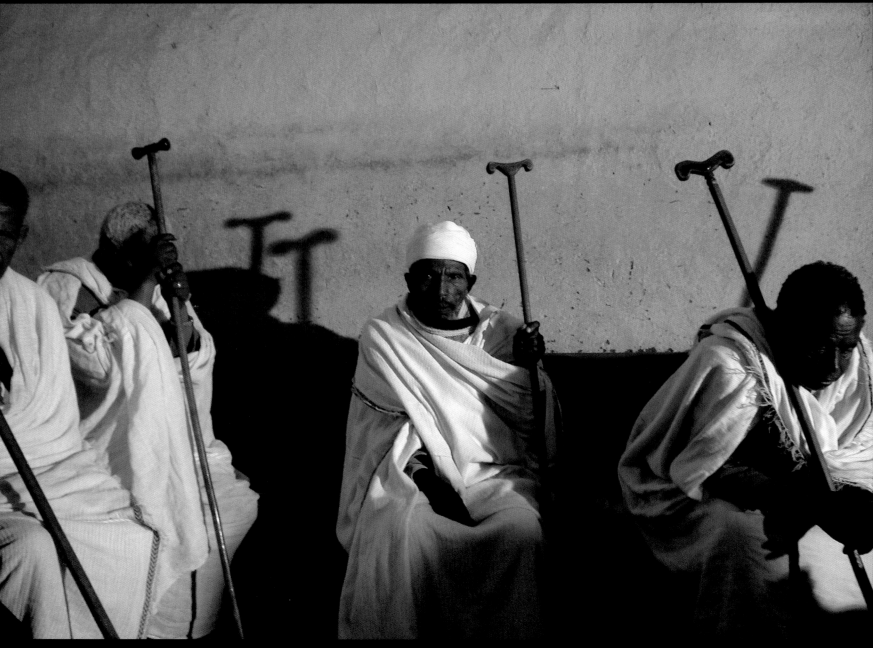

□ *Tim Georgeson > Awasa, Ethiopia*

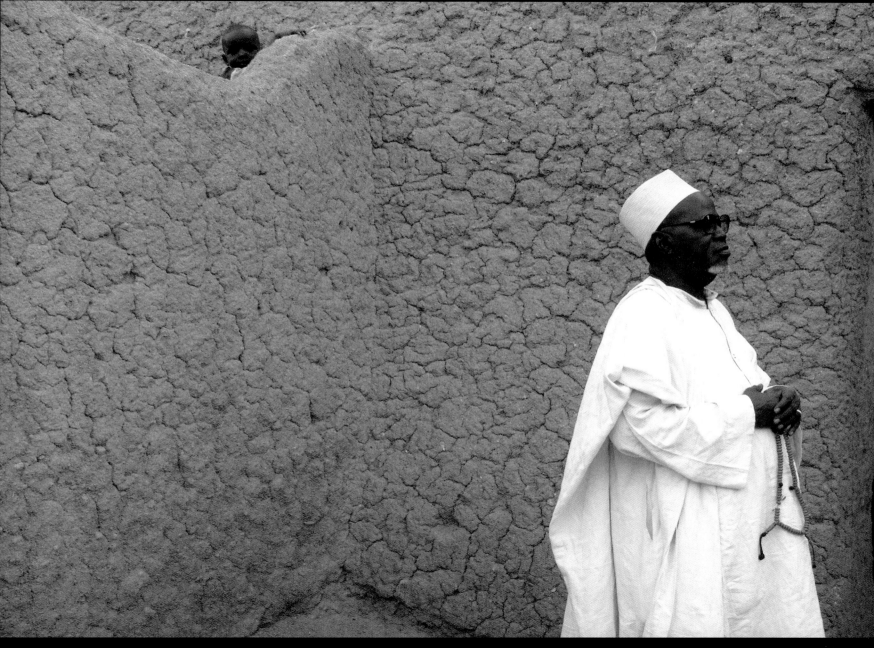

■ *Lori Grinker > Zinder, Niger*

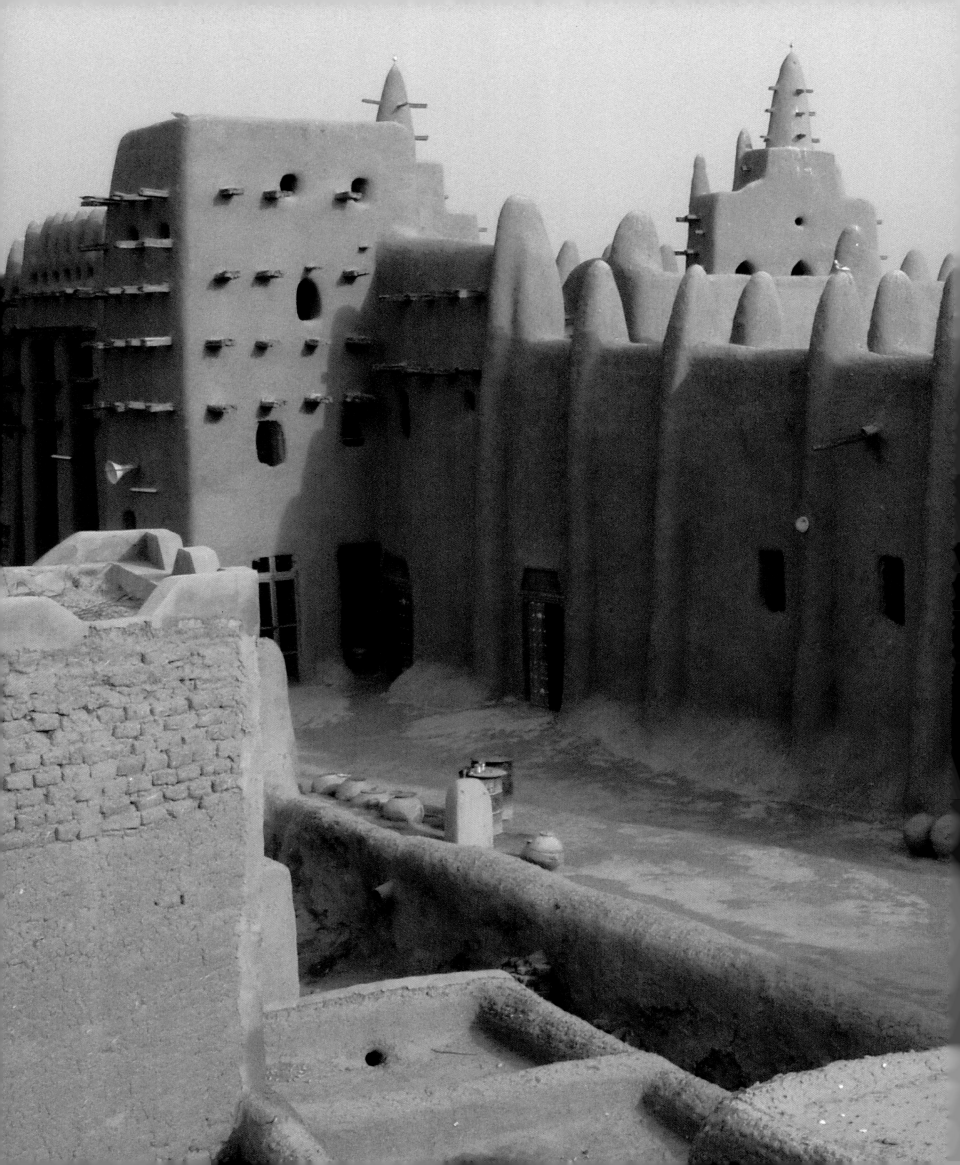

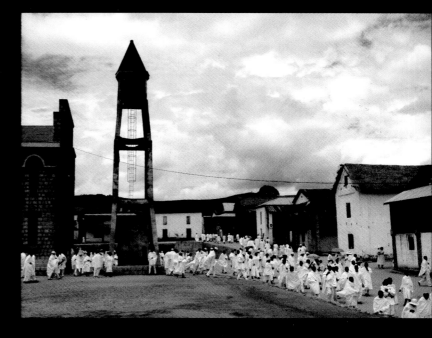

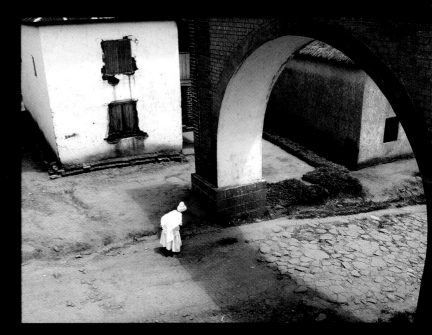

□ **Left and Right**
Photographer Pierrot Men
spent *A Day in the Life of
Africa* in the high plains
town of Soatanana in his
native Madagascar.
Soatanana's pious residents
dress only in white, to
symbolize their purity.
Residents greet visitors by
washing their feet in a
biblical ritual of welcome.
Pierrot Men's photographs
capture the interplay of
light and shadow in this
"white village," which has
inspired much of his
creative work.
> *Pierrot Men in Madagascar*

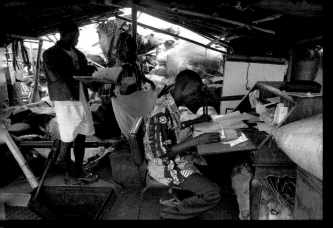
Patrick Robert > Congo River, Congo-DRC

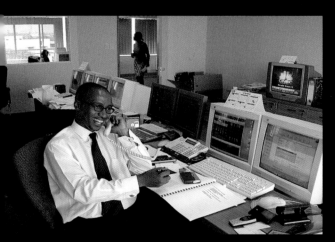
Louise Gubb > Rosebank, South Africa

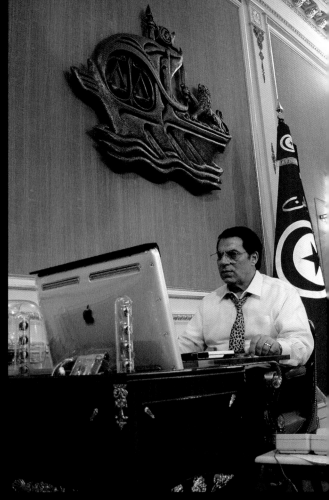
President Zine el-Abidine Ben Ali of Tunisia, by Emmanuel Santos

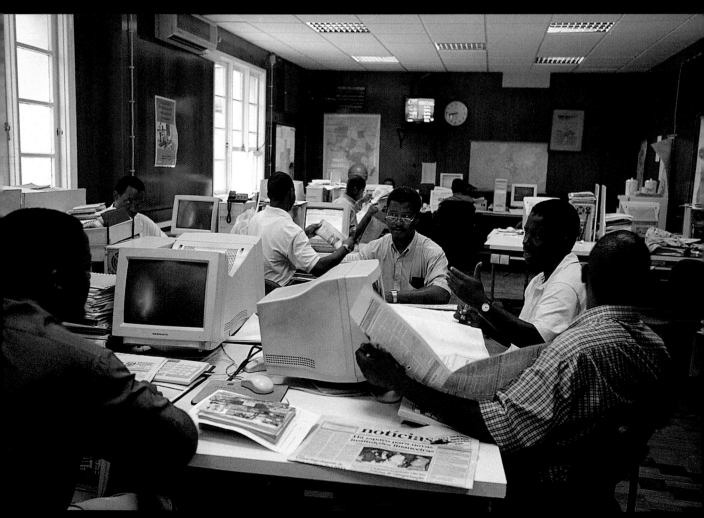
Laurent Van der Stockt > Maputo, Mozambique

> phoenix

**Photographed in Angola
by Guy Tillim**

Life is slowly but inexorably returning to Kuito, an Angolan city practically destroyed by that country's nearly three-decade-long civil war. When South African photographer Guy Tillim first visited Kuito in 1994, government troops had just liberated the town after a nine-month siege by rebel forces. "The town was shattered. People were starving," he recalls. "I've never seen such total devastation in my life. The front line ran right through the center of Kuito, and not a single building in the city was unscathed."

Tillim never forgot the misery he witnessed, and six years later, in 2000, he returned. This time he found that thousands who had fled the city during the war had streamed back. "They were building walls, patching bullet holes, trying to begin to make a life again."

For *A Day in the Life of Africa*, Tillim visited Kuito a third time. Just days after the death of longtime Angolan rebel leader Jonas Savimbi, Tillim found a city where normal life was finally re-emerging. "It was amazing," he says, "to see the changes that had taken place in just one year. Markets, small shops, and hairdressers had opened, and people were out going to restaurants and bars."

With a new cease-fire plan in place, the prospects for Kuito and Angola as a whole are growing brighter. Once roads reopen and trade begins to flow, Tillim predicts, there will be new hope for a nation that has been crippled by years of factional conflict but is rich in natural resources, including oil. "War is the only thing that many people in Kuito have ever known," he adds, "but now there is a chance that things will change."

A café in Kuito, Angola.

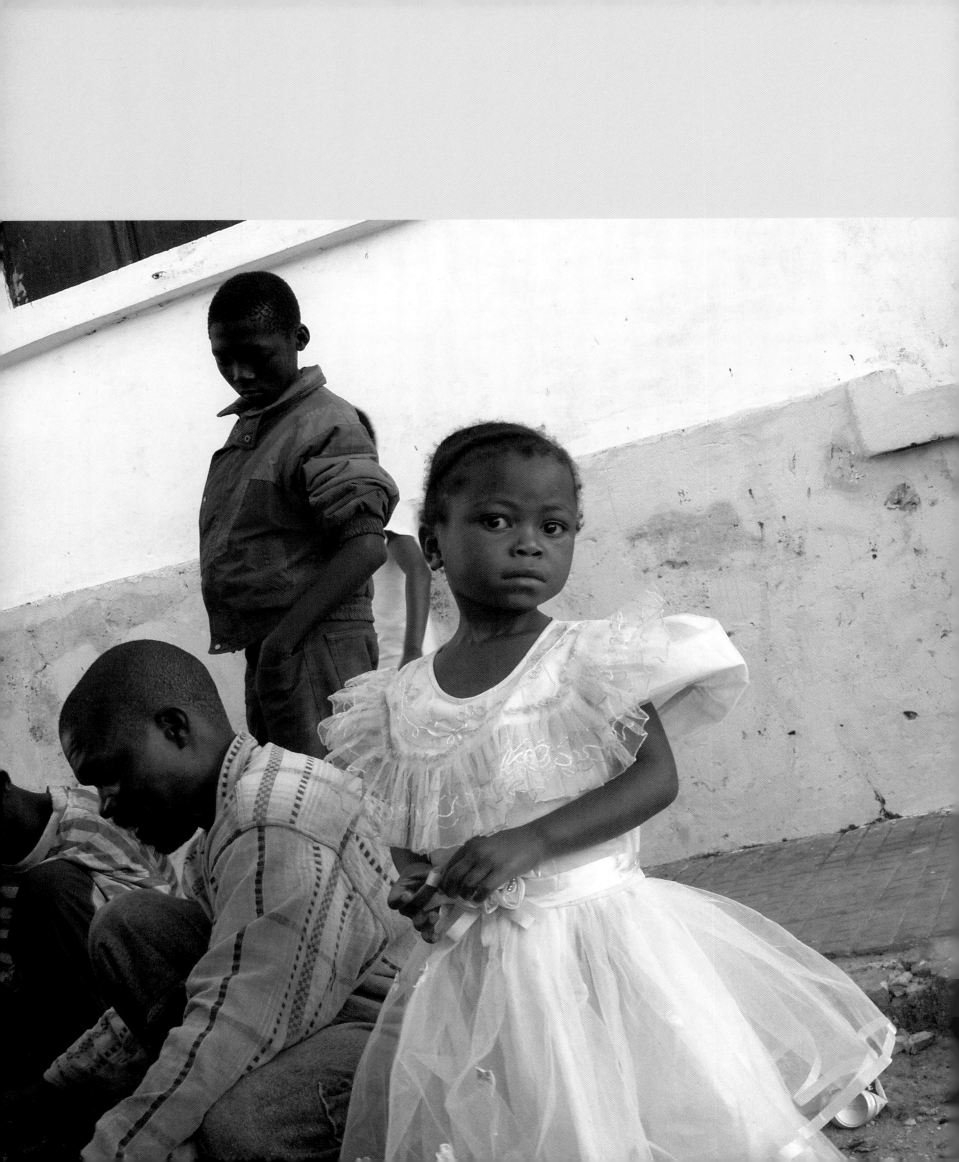

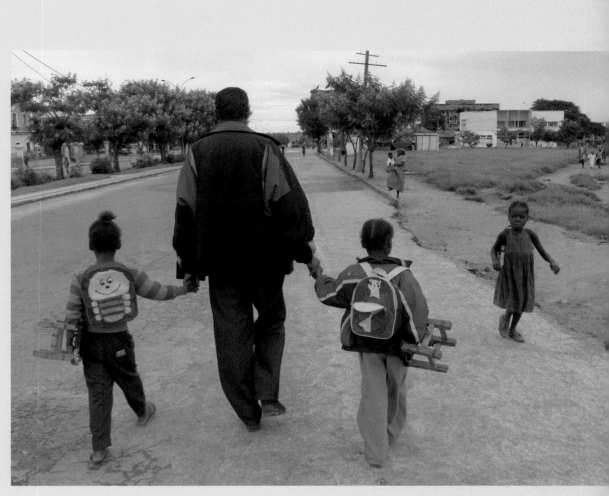

Above
A father walks his two daughters to school. Like all students in Kuito, the children bring their own small benches to class.

Left
A child waits on a quiet street while her father, a mechanic, fixes a truck.

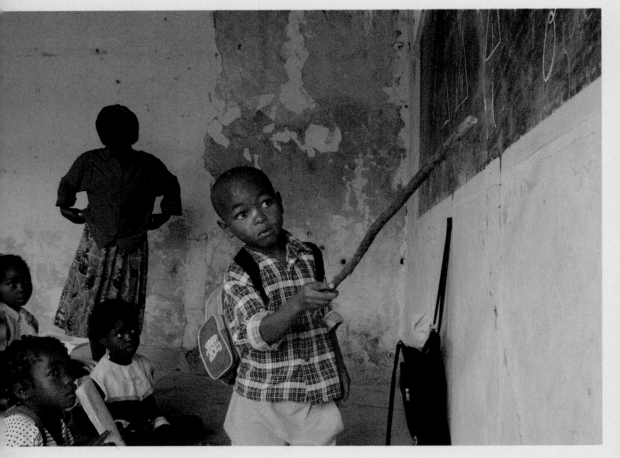

Above and Right
Primary-school teacher Eugenia Amelia instructs her attentive class under a new roof, replacing one destroyed during Angola's long civil war.

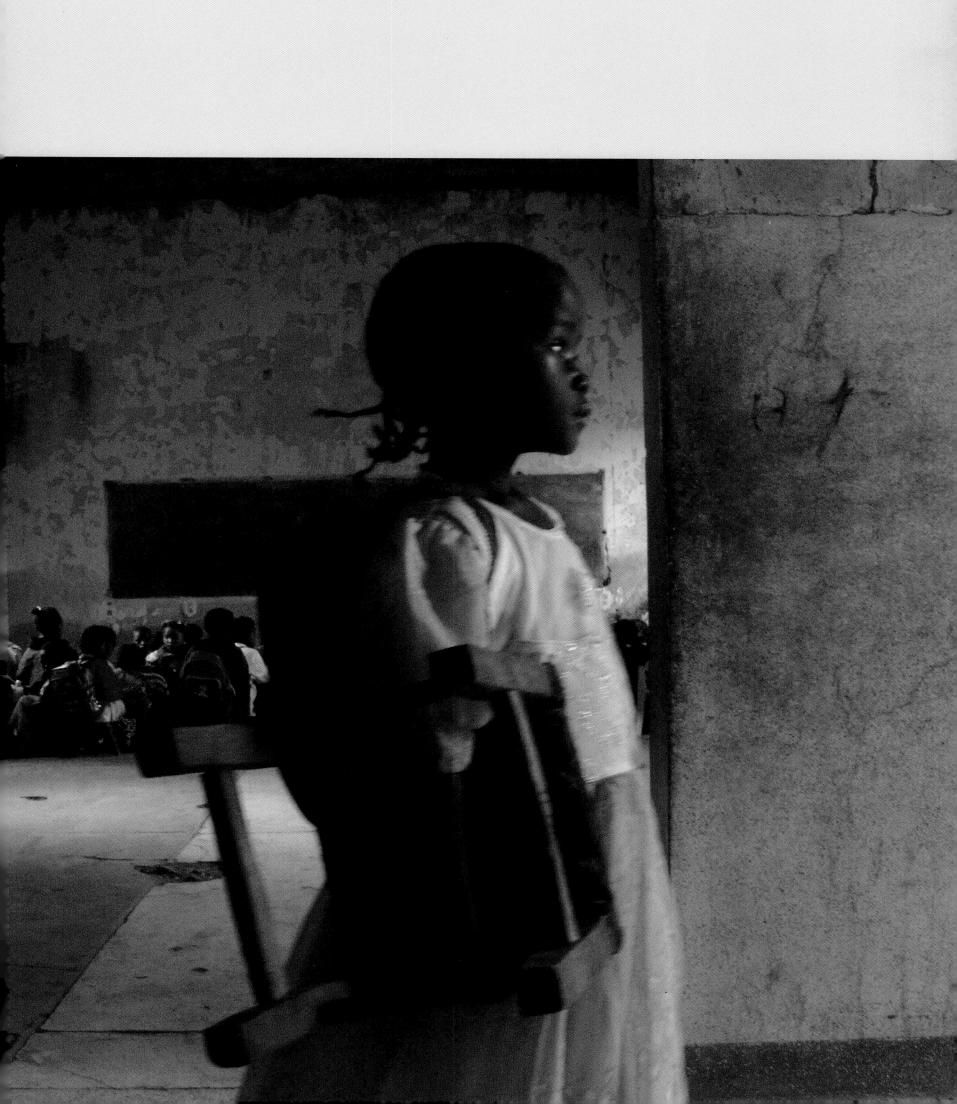

■ Right
Travelers on a dusty road
outside Dar es Salaam.
> *Douglas Menuez in Tanzania*

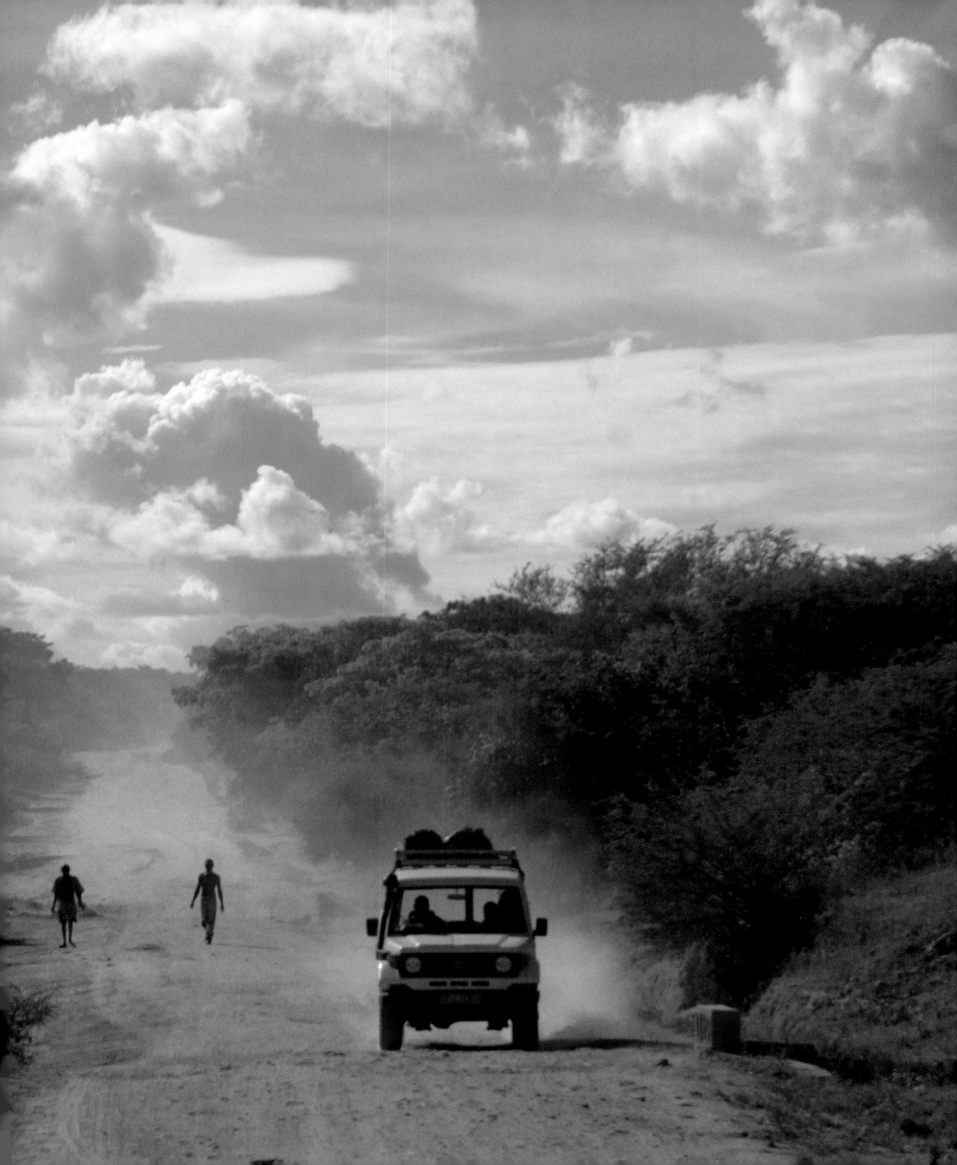

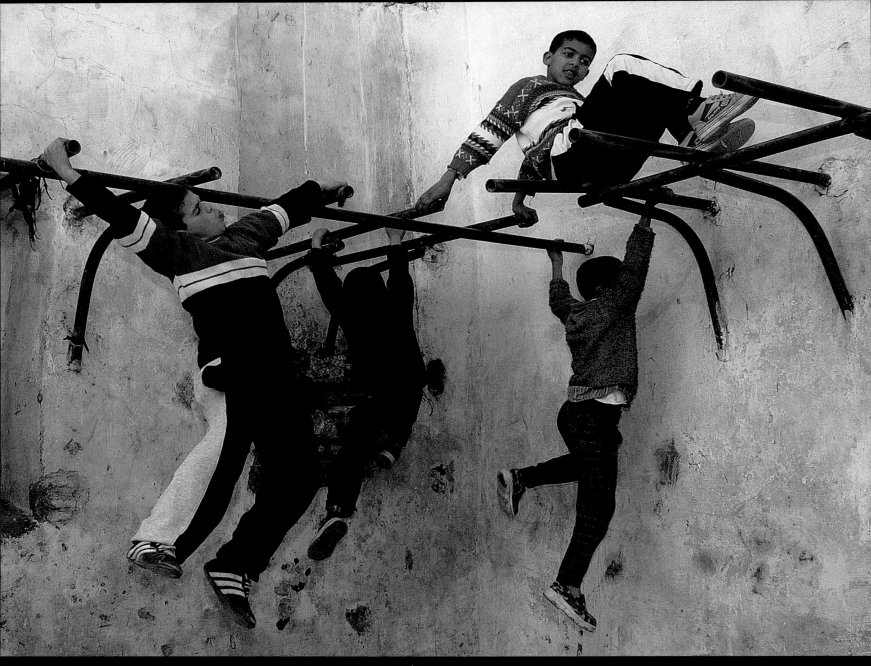

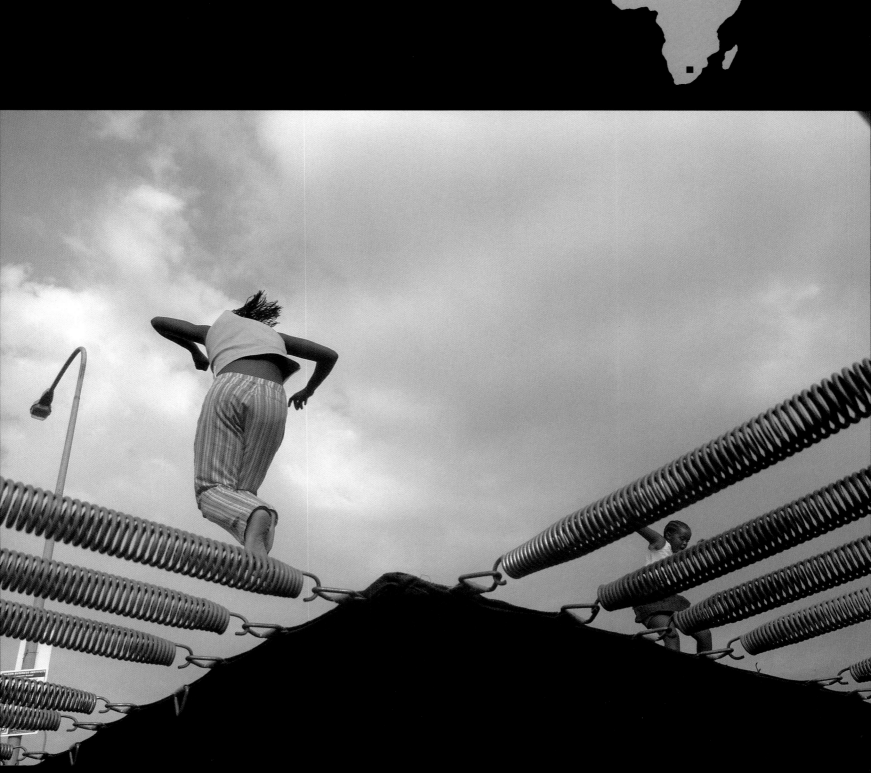

■ *Victor Matom > Soweto, South Africa*

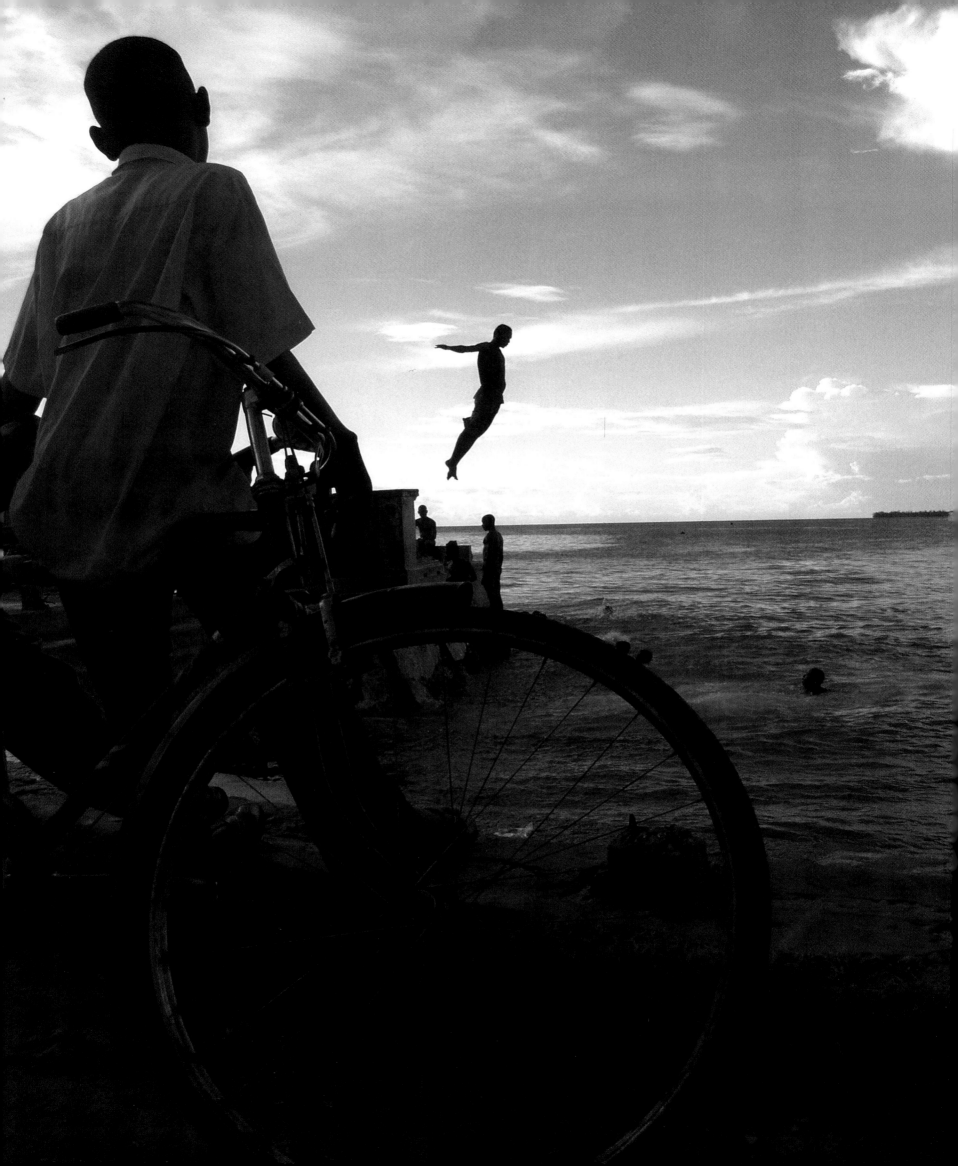

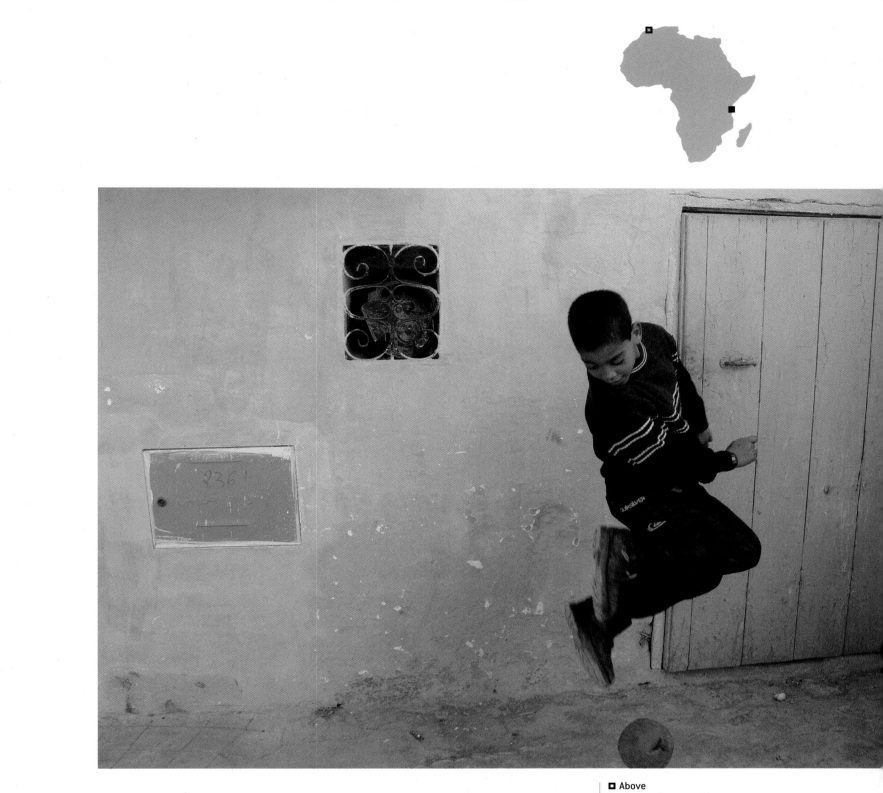

■ Above

In the medina, or old quarter, of Chefchaouene, a boy practices his soccer skills in front of blue-washed walls painted by the town's Jewish residents in the 1930s.

> *Joachim Ladefoged in Morocco*

■ Left

A diver leaps from the carved ruins of a limestone pier into the Indian Ocean on the island of Zanzibar (Unguja), once a rich trading and slaving port off Tanzania's Swahili Coast.

> *Mariella Furrer in Tanzania*

■ **Right**

Kids cool off at the new Olympic-size Khayelitsha Municipal Swimming Pool near Cape Town. The country's amateur swimming federation—Swimming South Africa—offers lessons to children in the township and coaches them for provincial swim meets.

> *Gideon Mendel in South Africa*

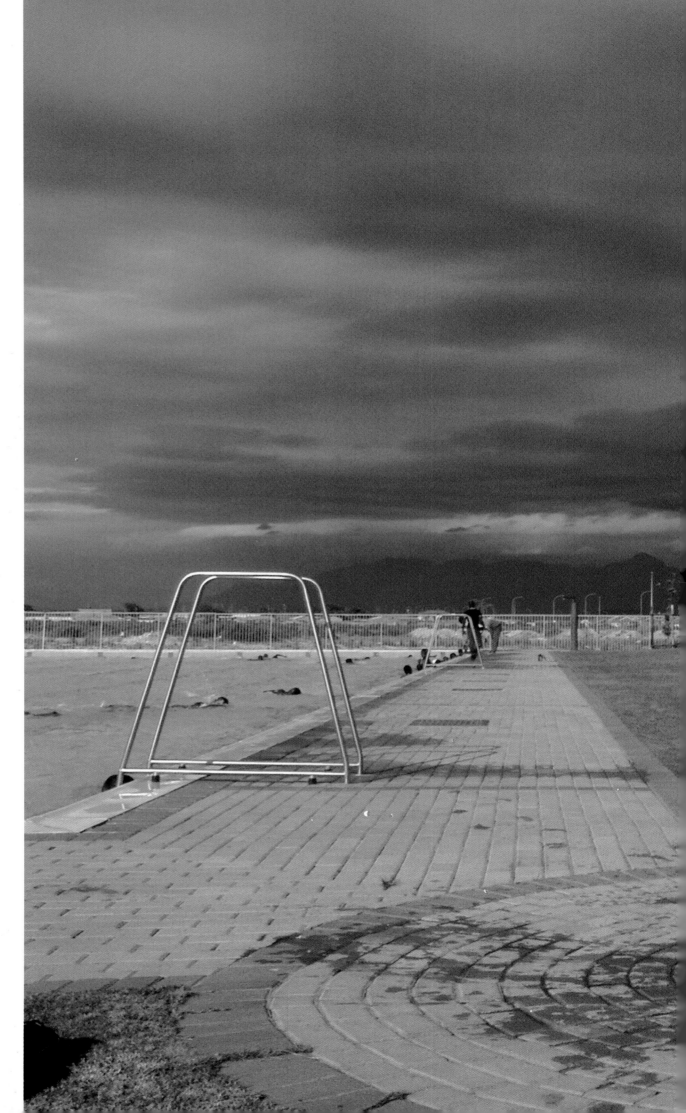

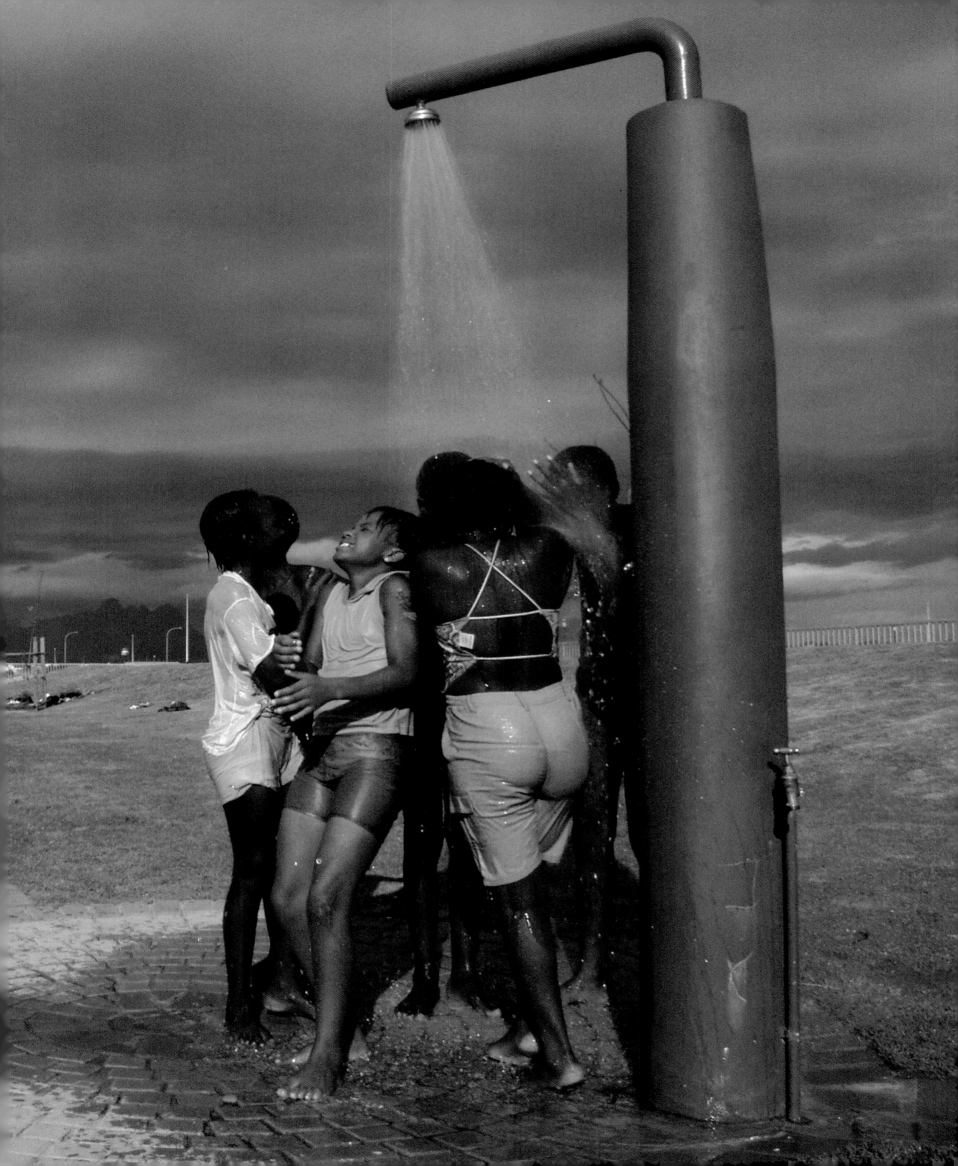

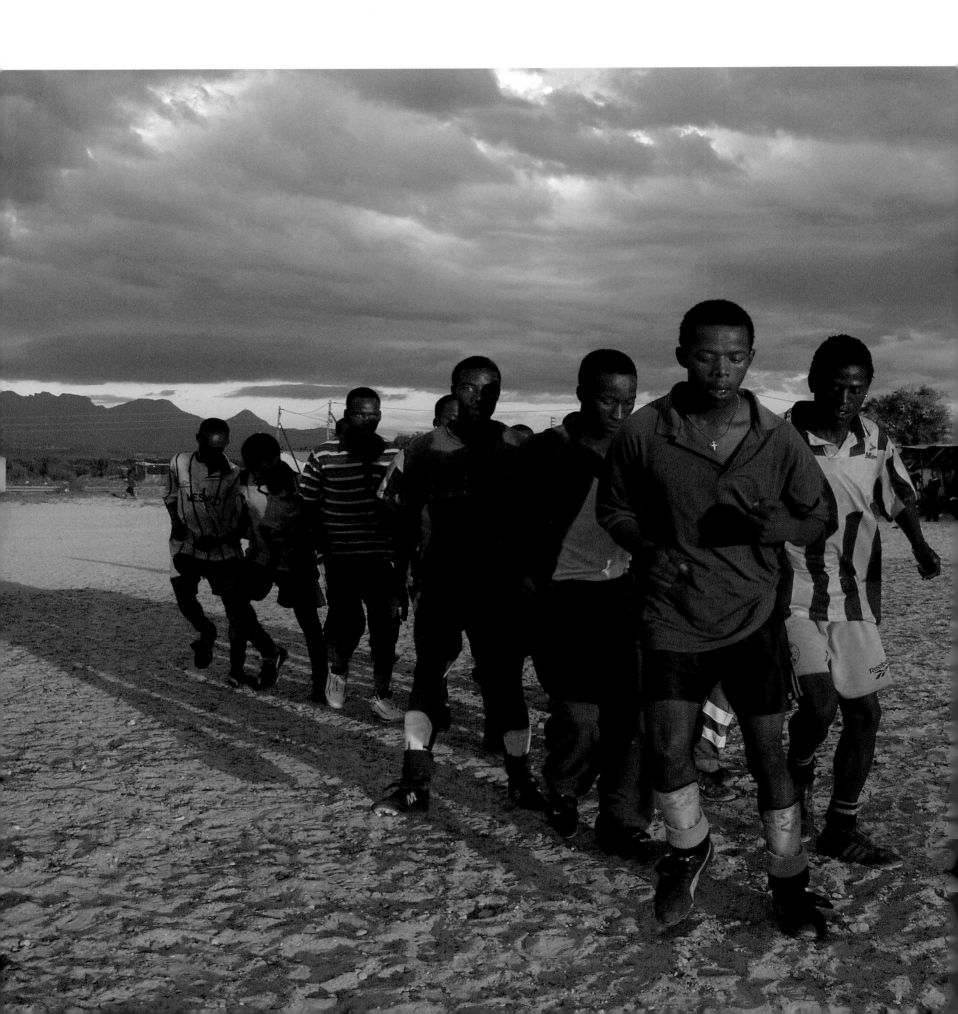

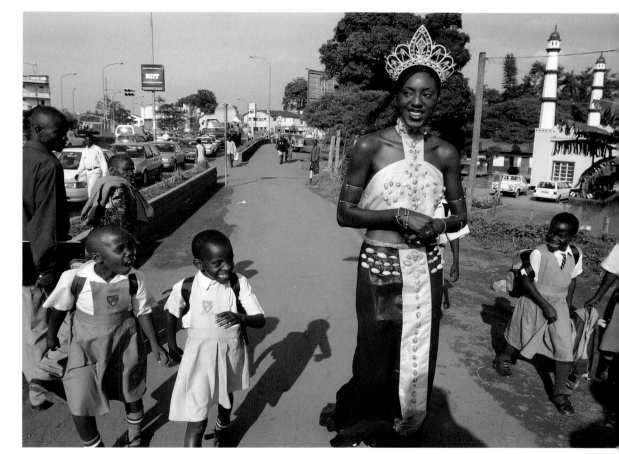

Victoria Nabunya, Miss
Uganda 2001, commands
stares and smiles as she strolls
down a Kampala sidewalk in
full regalia.
> *Jeffery Allan Salter in Uganda*

■ **Left**
Wearing a dress hand-painted
with the likeness of former
South African President
Nelson Mandela, a model
poses under stormy skies in
Lagos, Nigeria. The designer
of the dress, Deola Sagoe, was
pursuing a business career in
Miami when she decided to
return home to Lagos and the
world of fashion. Her award-
winning creations, sold under
the Odua label, blend hand-
loomed African fabrics and
Western designs.
> *Douglas Kirkland in Nigeria*

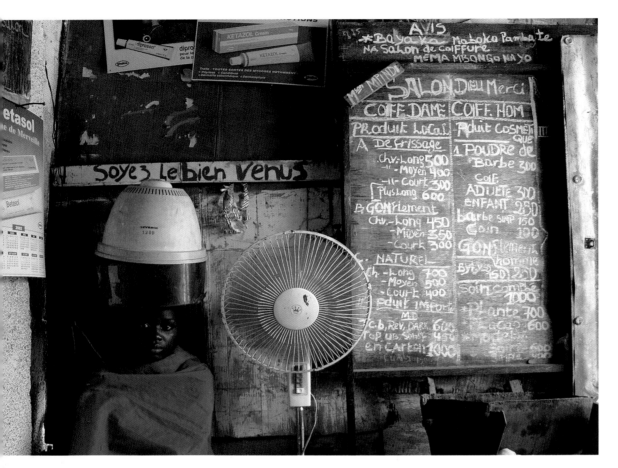

□ **Above**
Fifteen-year-old Perpeture
Tulubeli sits patiently under
the hair dryer at a popular
Kinshasa beauty parlor. The
salon, run by stylist Mpinde
Eariste in a wooden shack
outside his home, charges 300
Congolese francs, or about one
U.S. dollar, for a haircut.
> *Per-Anders Pettersson in
Congo-DRC*

■ **Right**
In Mali's ancient city of
Djénné, a woman plaits her
19-year-old neighbor's hair.
> *Jeffrey Aaronson in Mali*

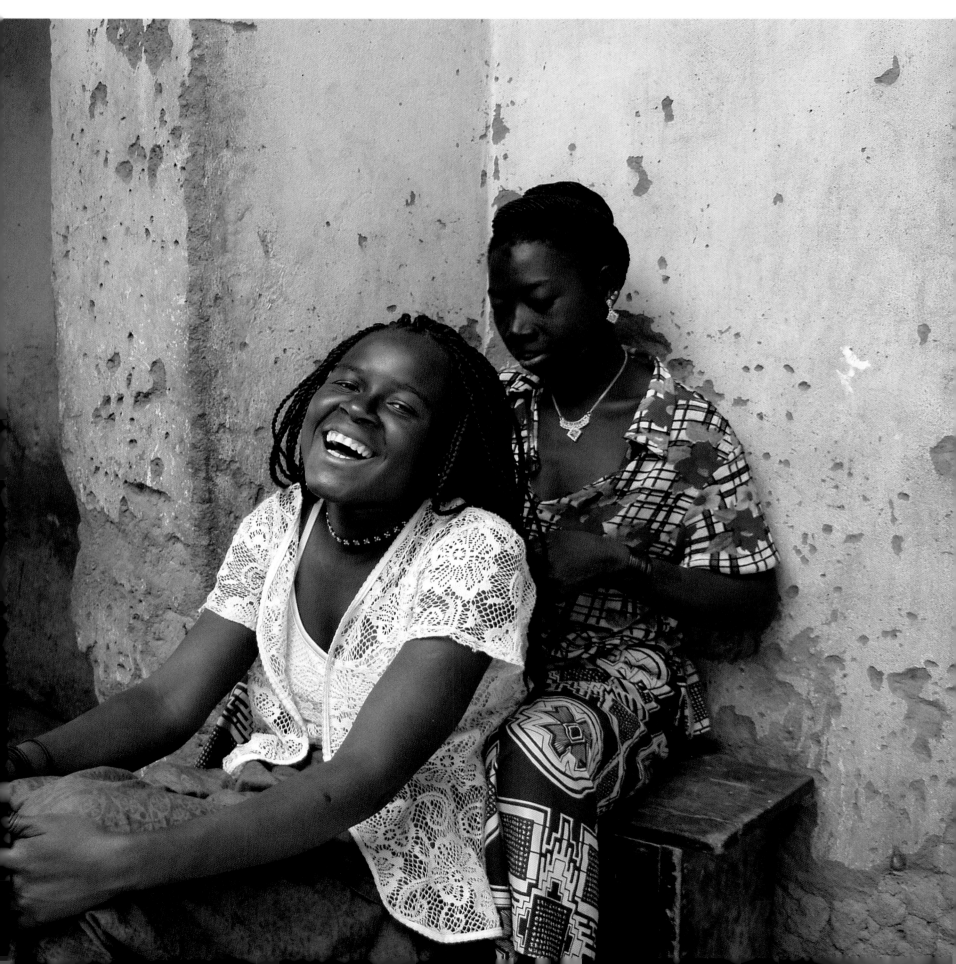

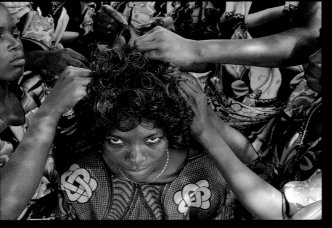

Jean-Claude Coutausse > Porto-Novo, Benin

John Isaac > N'Djamena, Chad

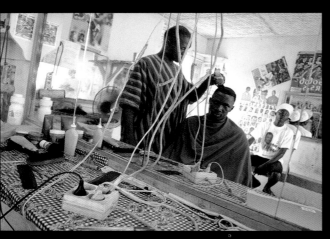

Susan Meiselas > Lambaréné, Gabon

Frank Fournier > Kumasi, Ghana

Jeffrey Henson Scales > Accra, Ghana

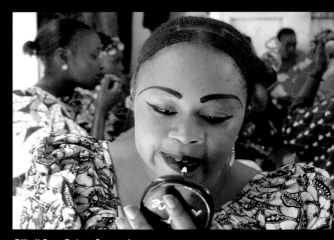

Djibril Sy > Dakar, Senegal

>it takes a village

**Photographed in Burkina Faso
by Gerd Ludwig**

House decoration is more than ornamental to the Gurunsi people of Burkina Faso. It is a communal activity that shapes their social and spiritual life. Known for their elaborately decorated houses, the Gurunsi—one of Burkina Faso's 60 distinct ethnic groups—live in the southern savanna of Tiebélé, near the Ghana border. The Gurunsi grow grain, beans, and yams in village fields, and live in family compounds surrounding a community courtyard and corral.

All of the smooth-walled, mud-brick homes in Tiebélé are circular, except for the dwellings in the chief's large rectangular complex. Most of these houses are covered with elaborate geometric artwork, painstakingly created by village women using straw, feathers, and small stones.

When Day in the Life photographer Gerd Ludwig visited Tiebélé, the village was in the midst of a celebration—an annual art and culture festival that included painting and archery competitions, soccer matches, and non-stop musical performances. Encouraged by gifts of locally brewed beer, the women of Tiebélé vied to create the most beautiful designs, stopping only to sing and dance joyously as bands of musicians and drummers paraded through the narrow streets. Photographer Ludwig was moved by the warm, close-knit community spirit of Tiebélé—a spirit not always evident in his own home town of Los Angeles.

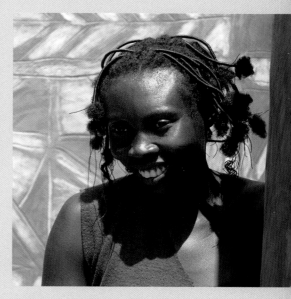

In the chief's compound in Tiebélé.

Right
In a field outside Tiebélé, a Gurunsi man pours water into brick molds that contain a mixture of clay and straw. The bricks are used to construct houses that will later be decorated by the women of the village.

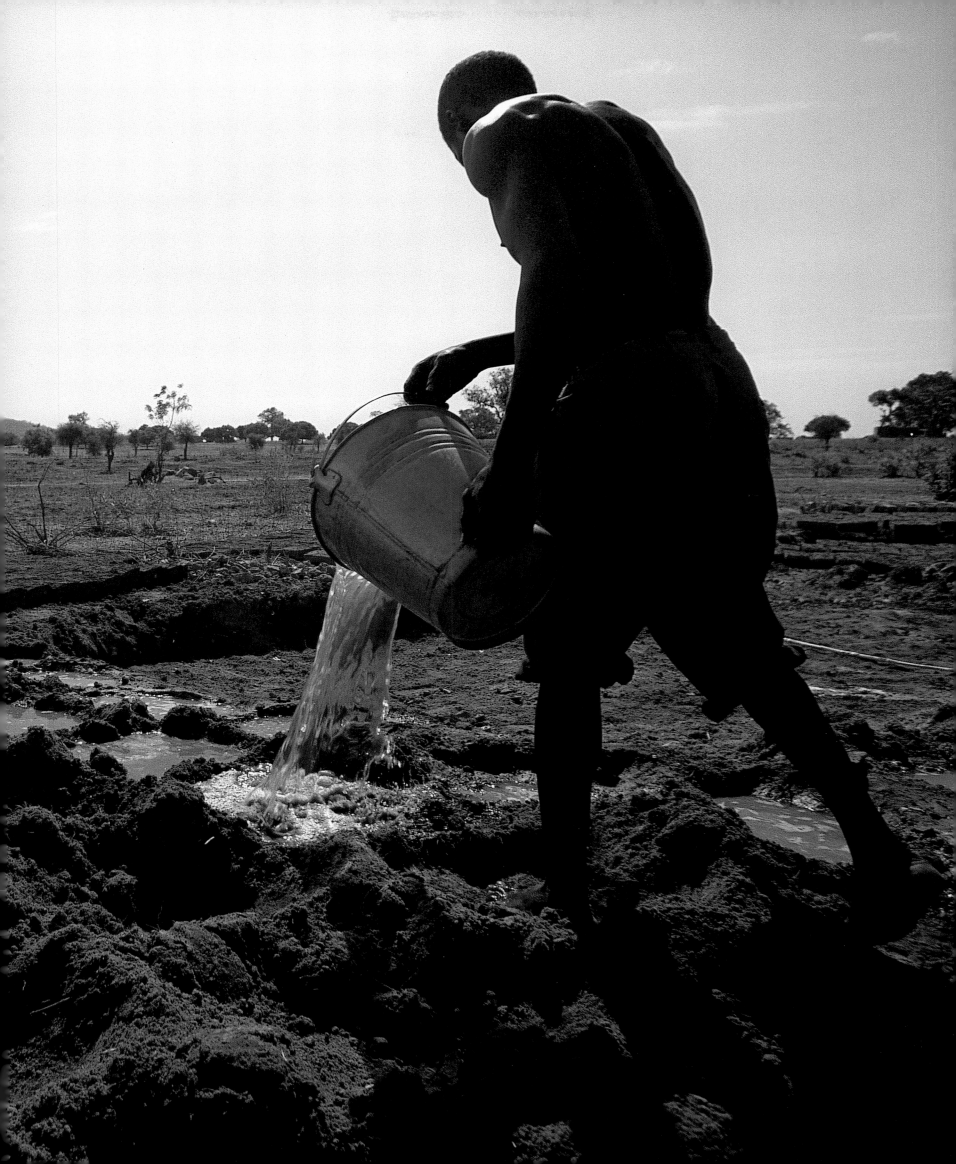

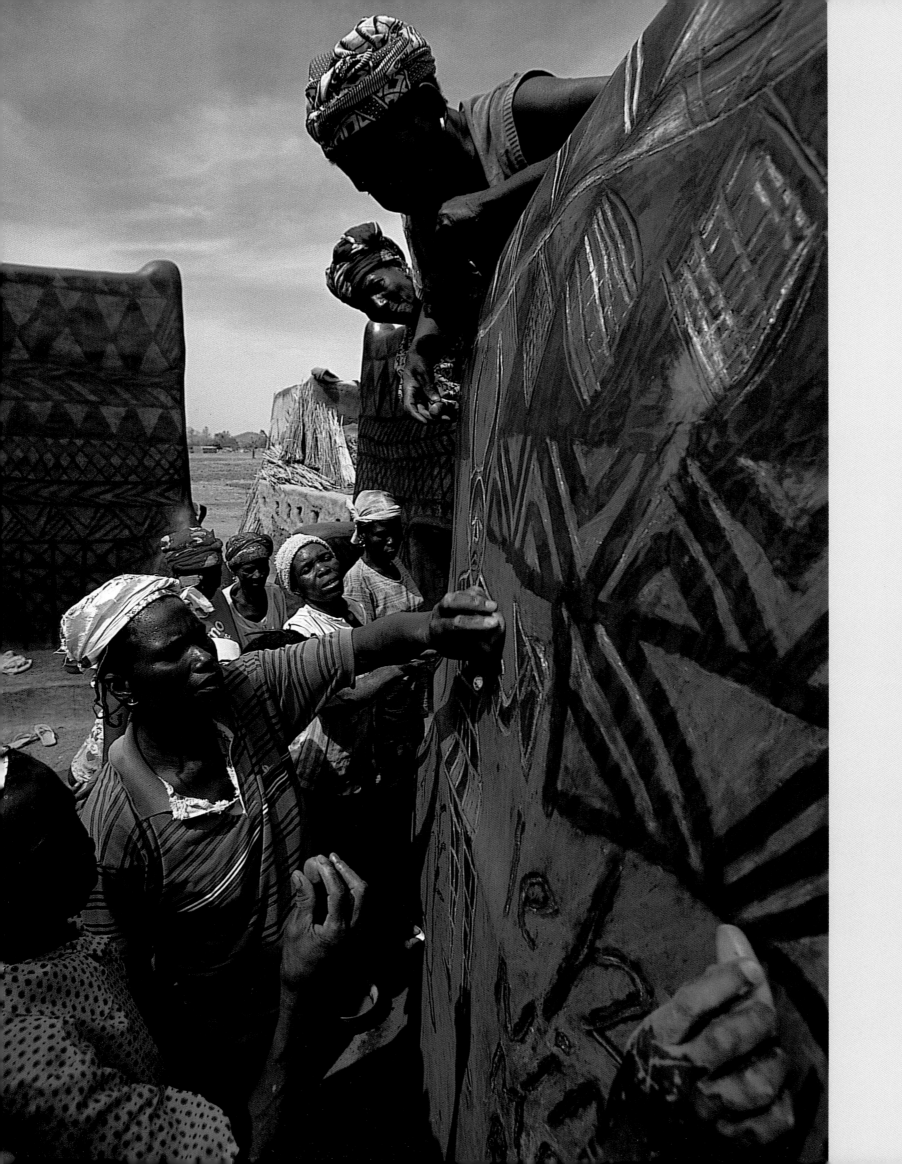

Above
A tender moment in the chief's compound, home to some 400 villagers.

Left
A family group of Gurunsi women creates a geometric mural during Tiebélé's annual art and culture festival.

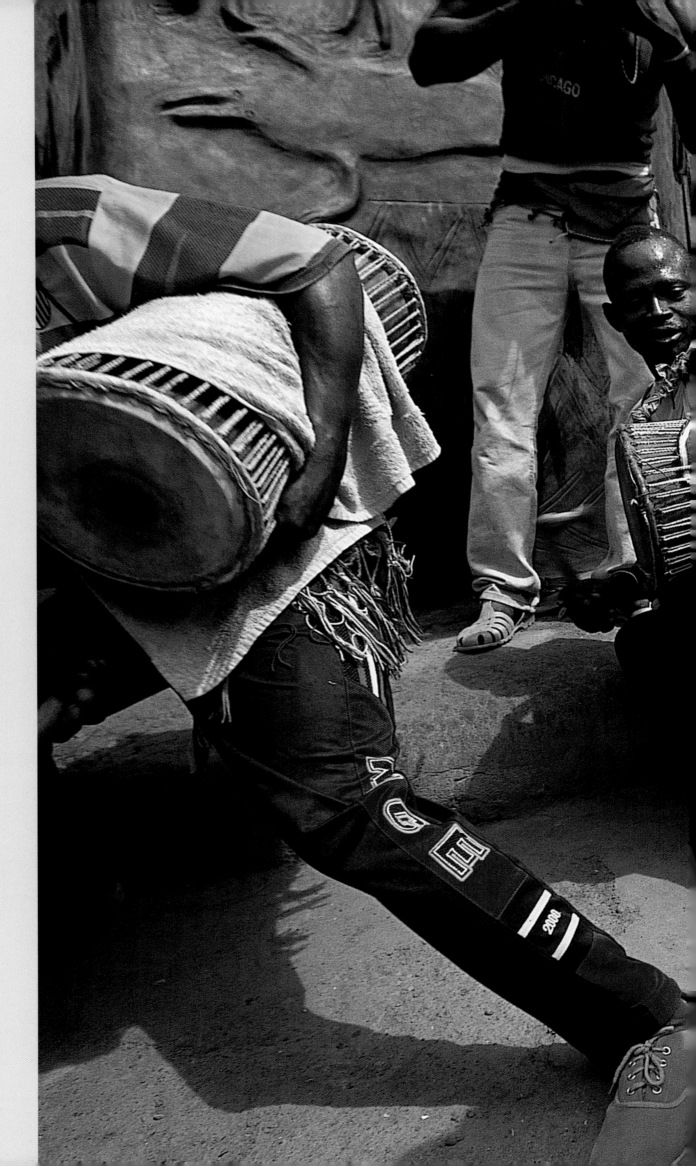

Right
Gurunsi drummers give
a highly charged street
performance during the
Tiebélé arts festival.

Following Pages
During the mural competi-
tion, painters take a break
to dance, sing, and bump.

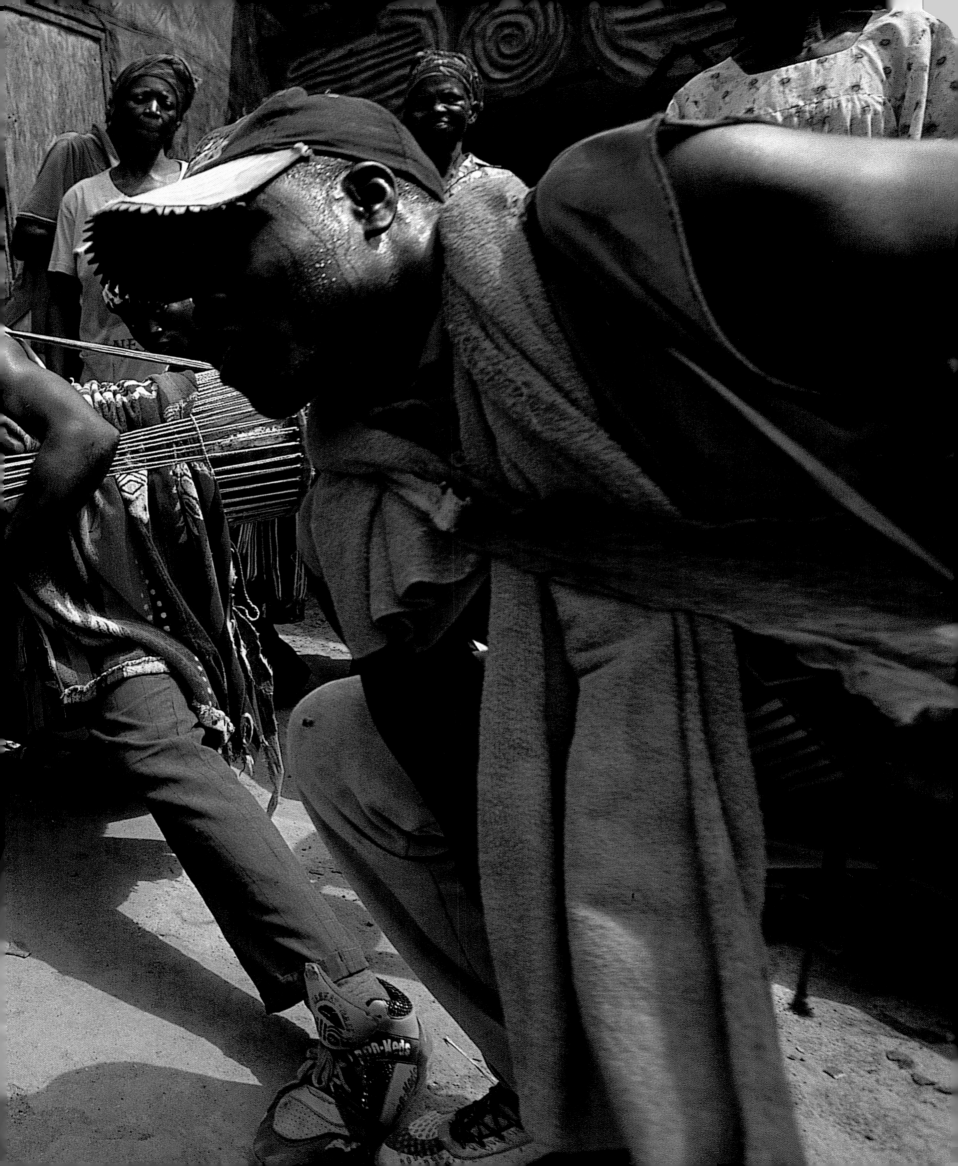

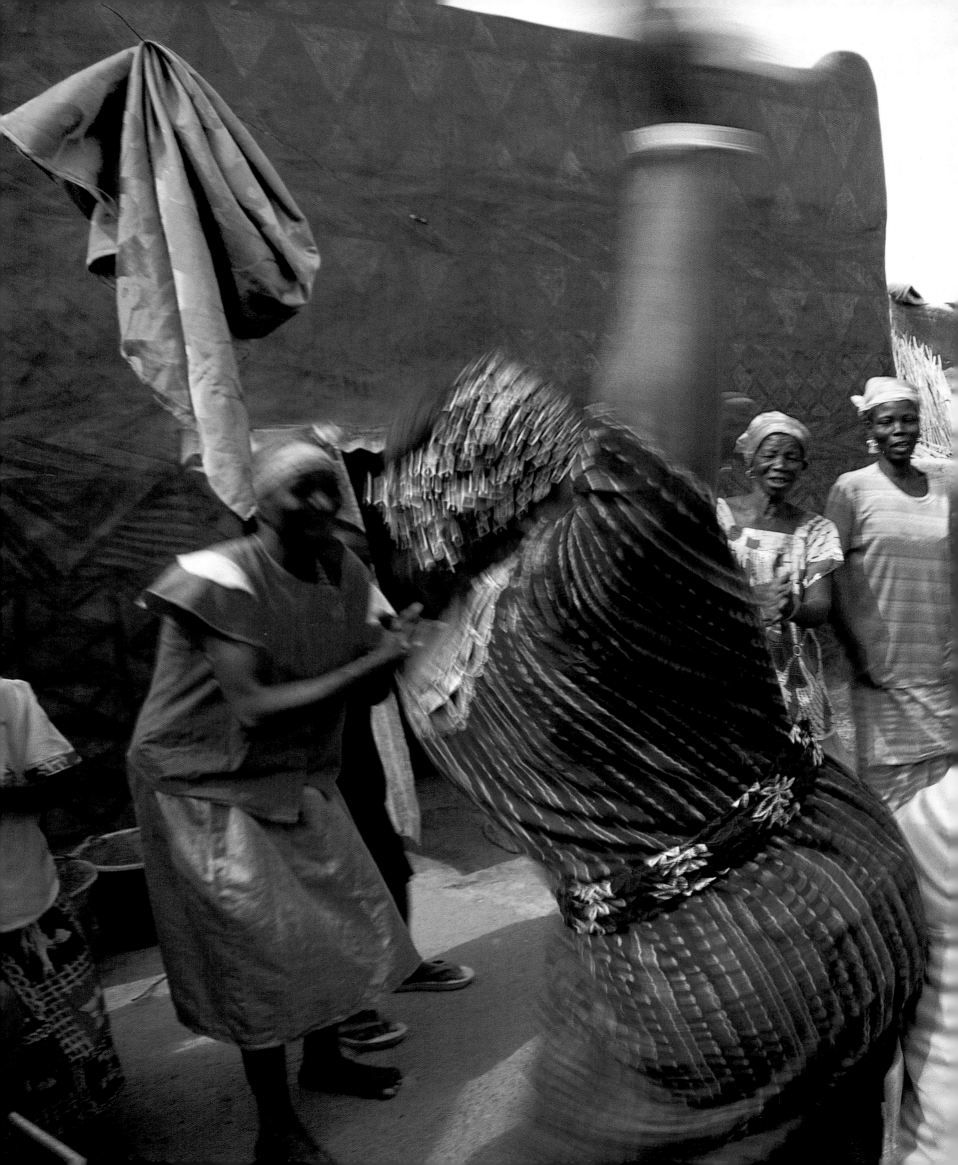

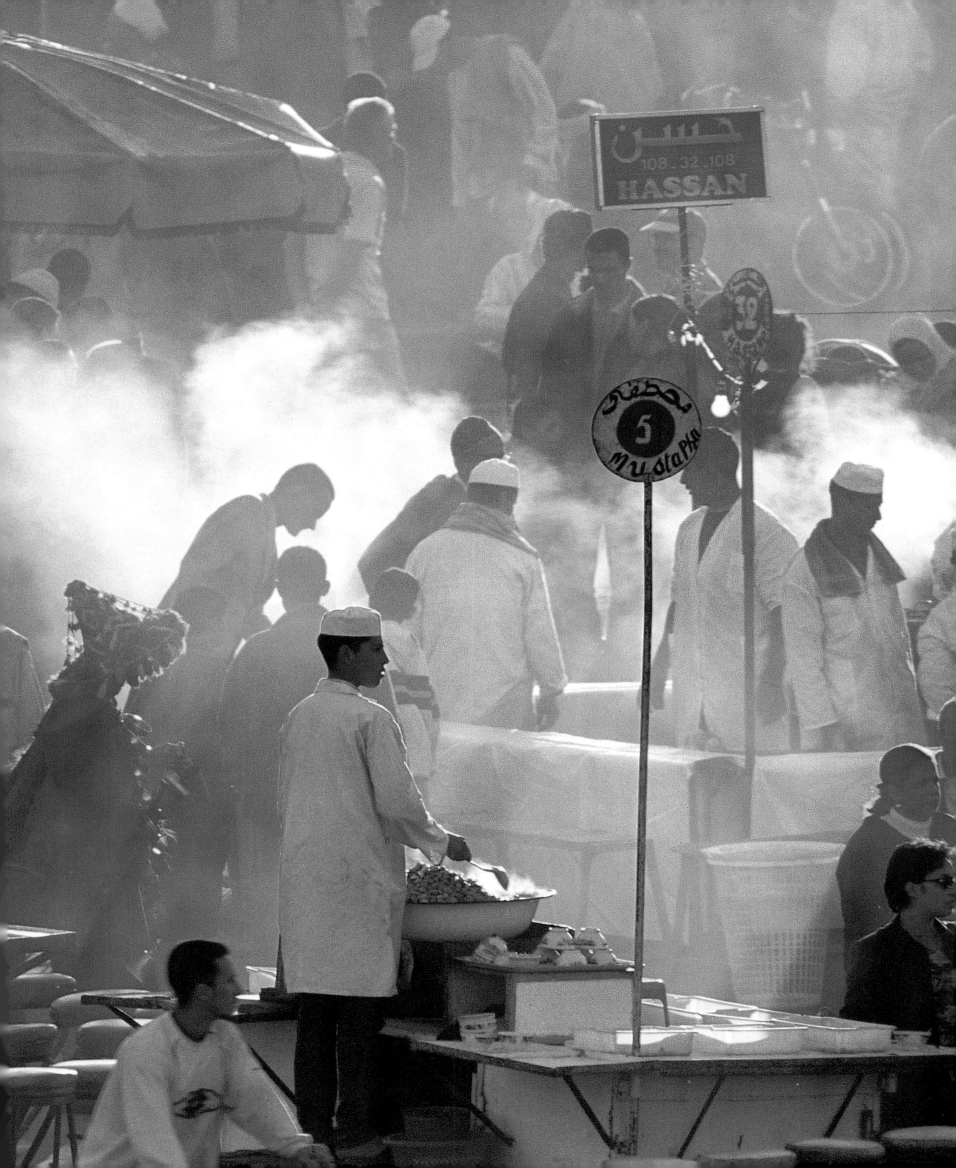

 Right
In bomb-blasted Hargeysa,
Somaliland—a breakaway
territory in northern
Somalia—the fighting has
stopped, but recovery comes
slowly after 14 years of civil
war. Photographer Ed Kashi
shot this eerie scene
through the windshield
of a truck.
> *Ed Kashi in Somalia*

■ **Previous Pages**
As the sun sets over
Marrakech, steam wafts from
food stalls in the huge Djemaa
el-Fna market.
> *Paul Chesley in Morocco*

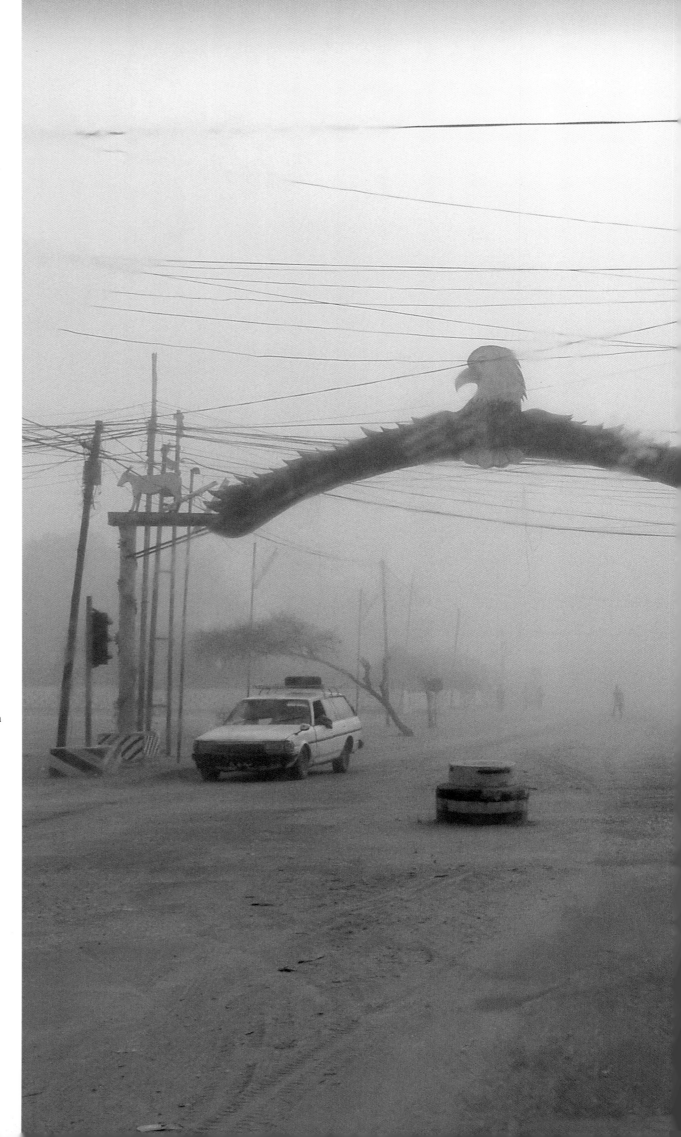

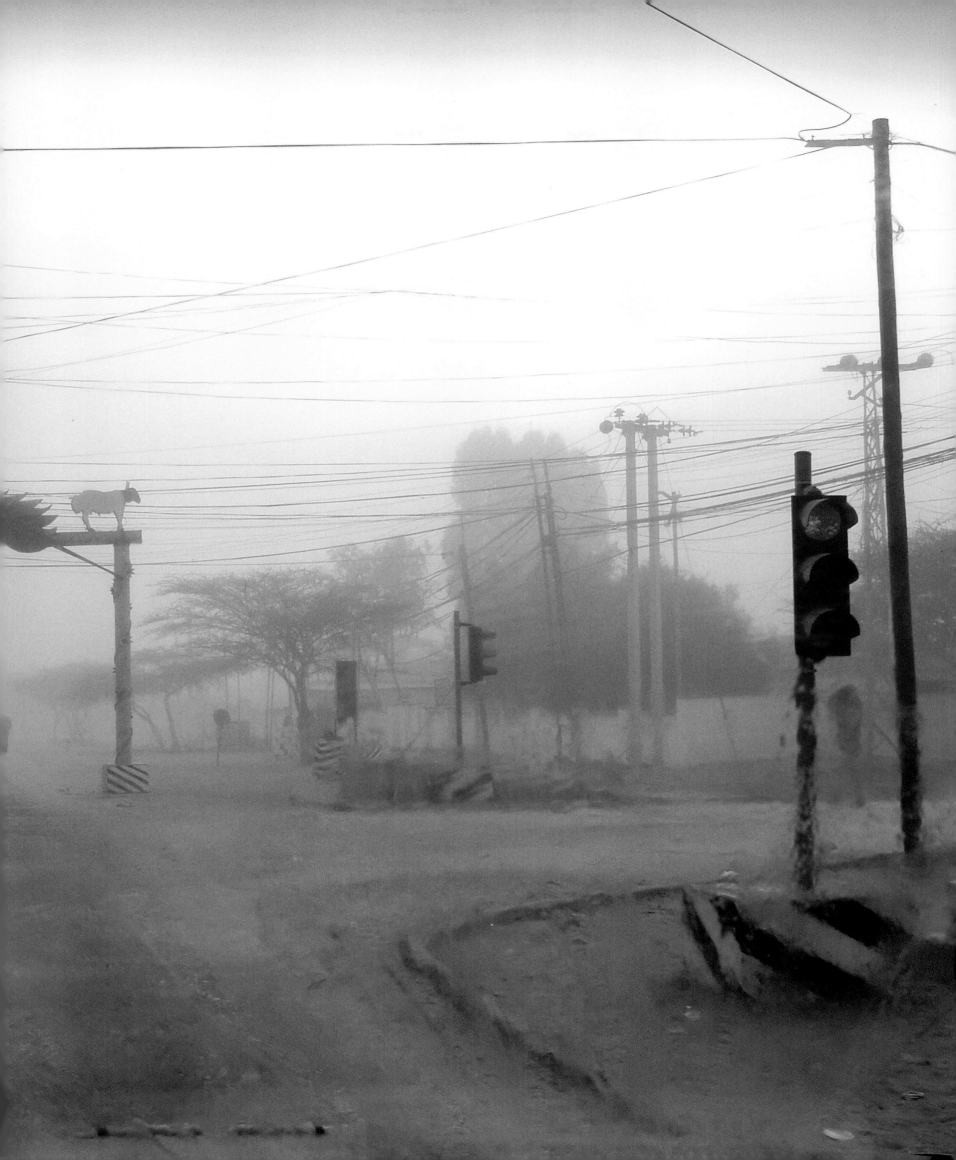

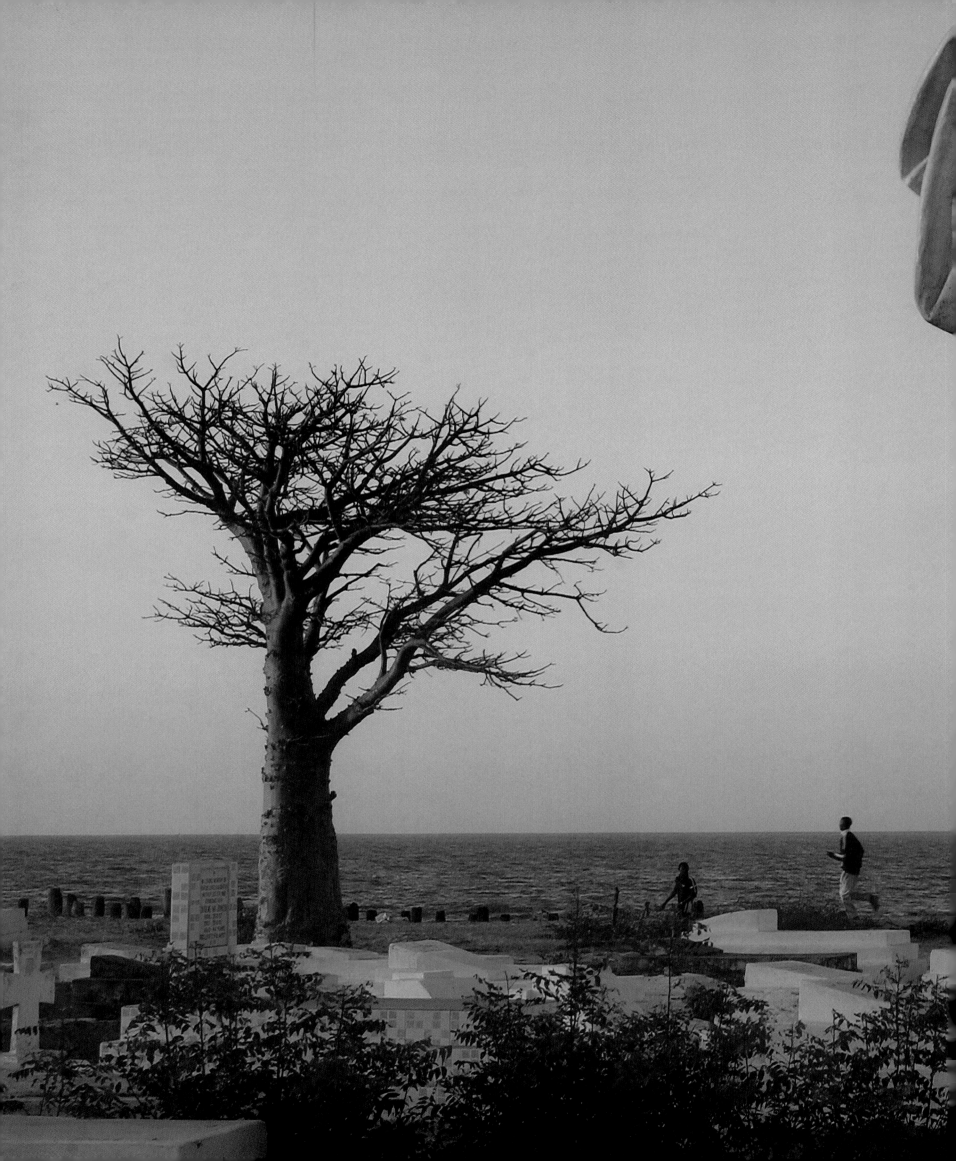

■ Left
The Christian cemetery in Banjul, island capital of Gambia. Bound by the Atlantic Ocean and the 700-mile-long Gambia River, Banjul lies just a few feet above sea level. The tide has gradually eroded the shoreline cemetery, washing many grave sites out to sea.
> *John Stanmeyer in Gambia*

233

□ **Right**
In the mountains of central Sudan, near the village of Gidel, Nuba children gaze across the granite range where their people have been isolated by decades of civil war.
> *Francesco Zizola in Sudan*

■ **Following Pages**
The pyramids of Meroë, in Sudan, are tombs of ancient Nubian kings who ruled for more than 900 years. Although smaller than the Egyptian pyramids at Giza, the Meroë tombs are far more numerous, recalling an important dynasty that reached its peak in the first century A.D.
> *Chris Rainier in Sudan*

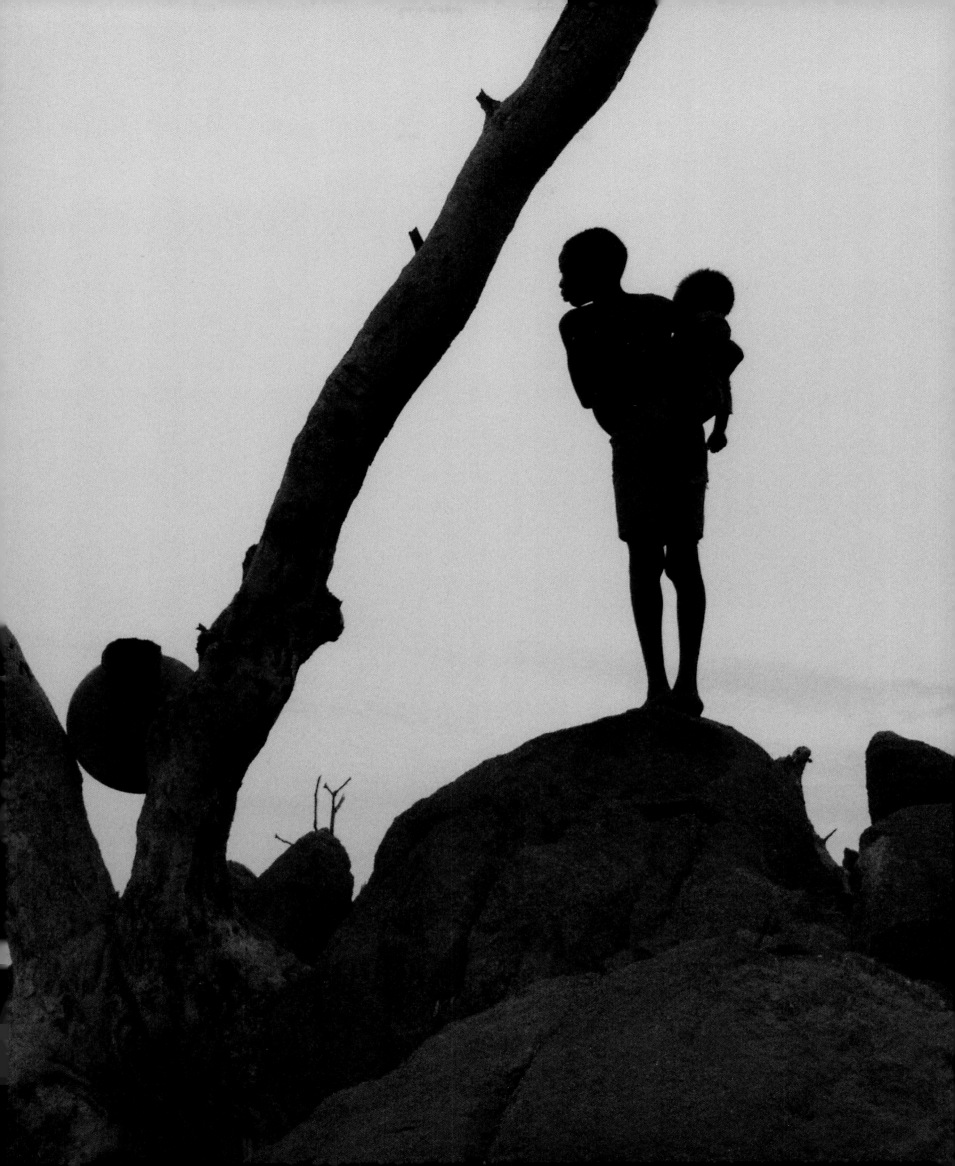

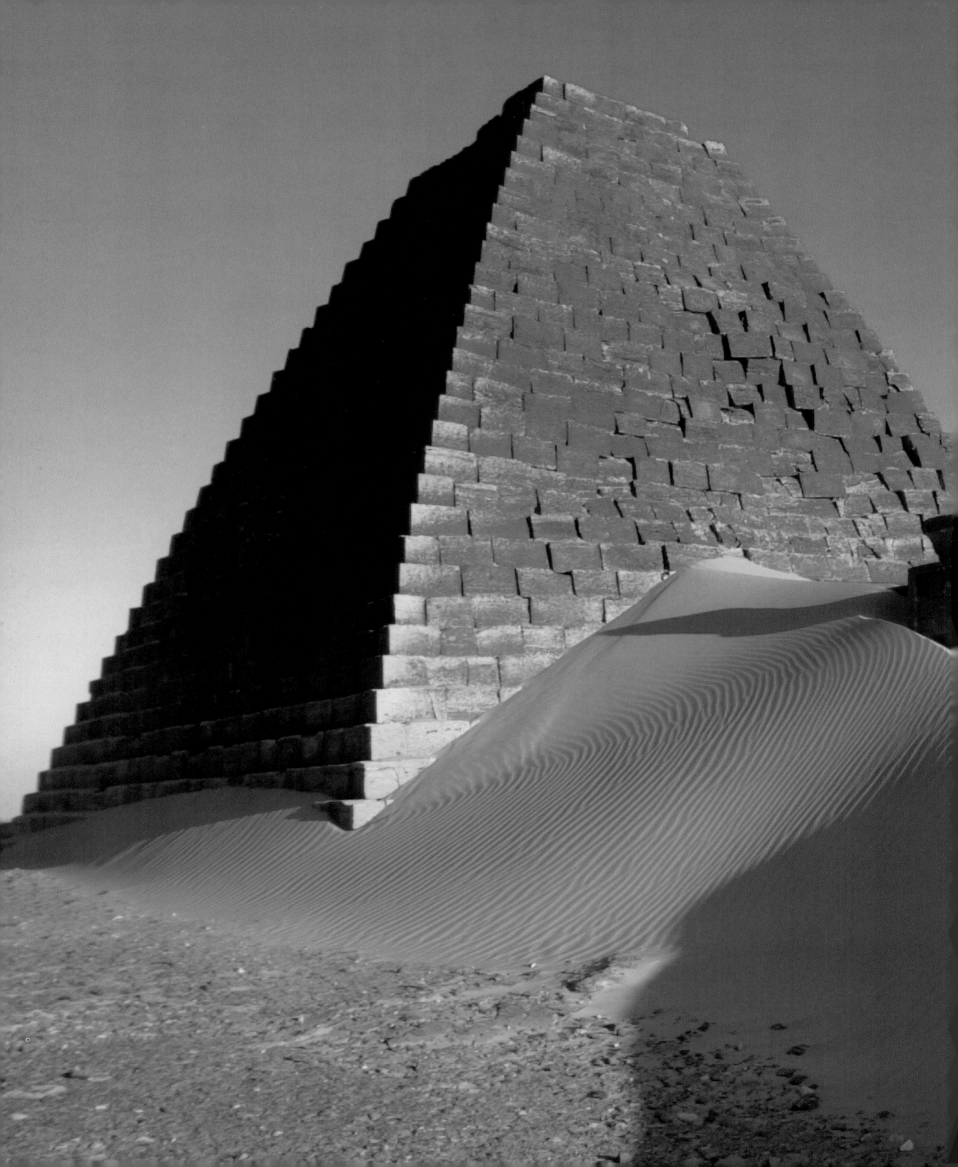

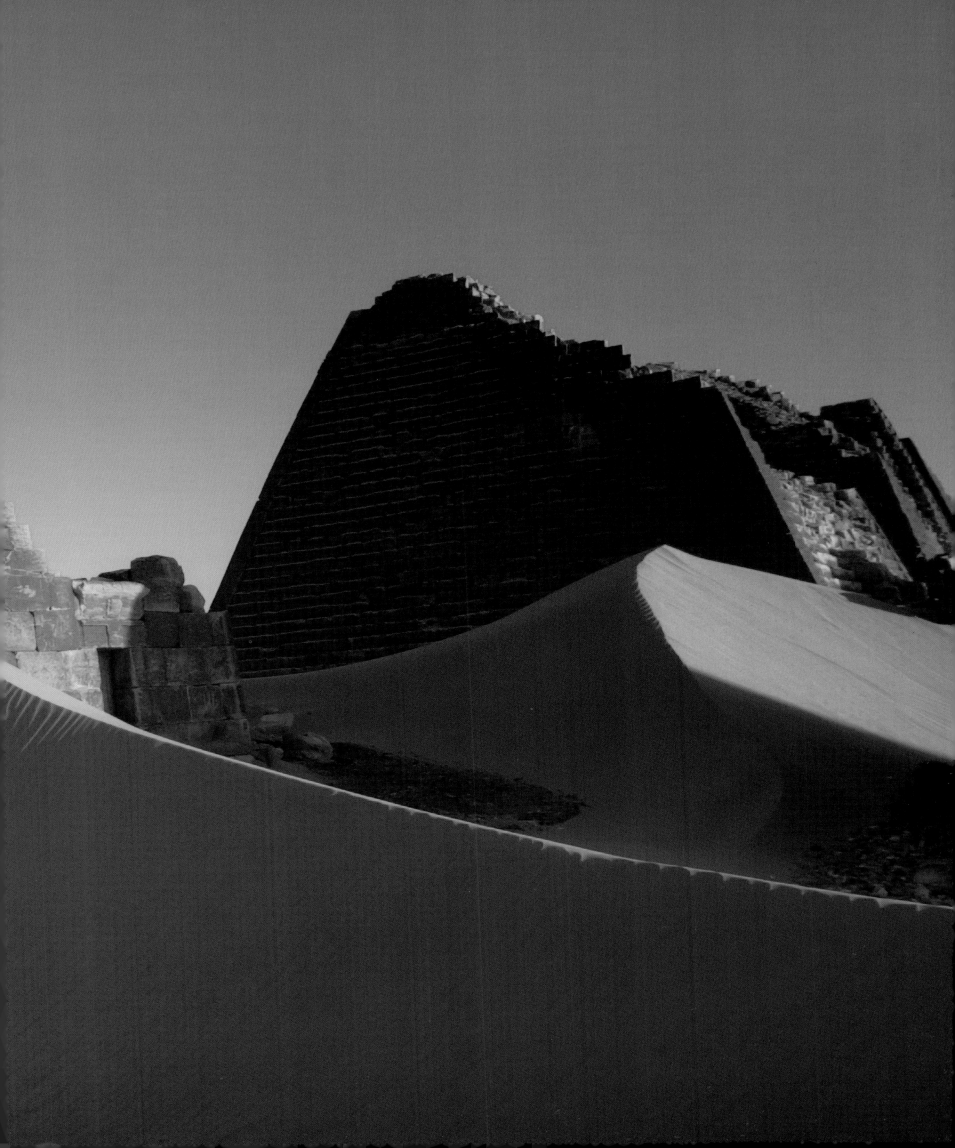

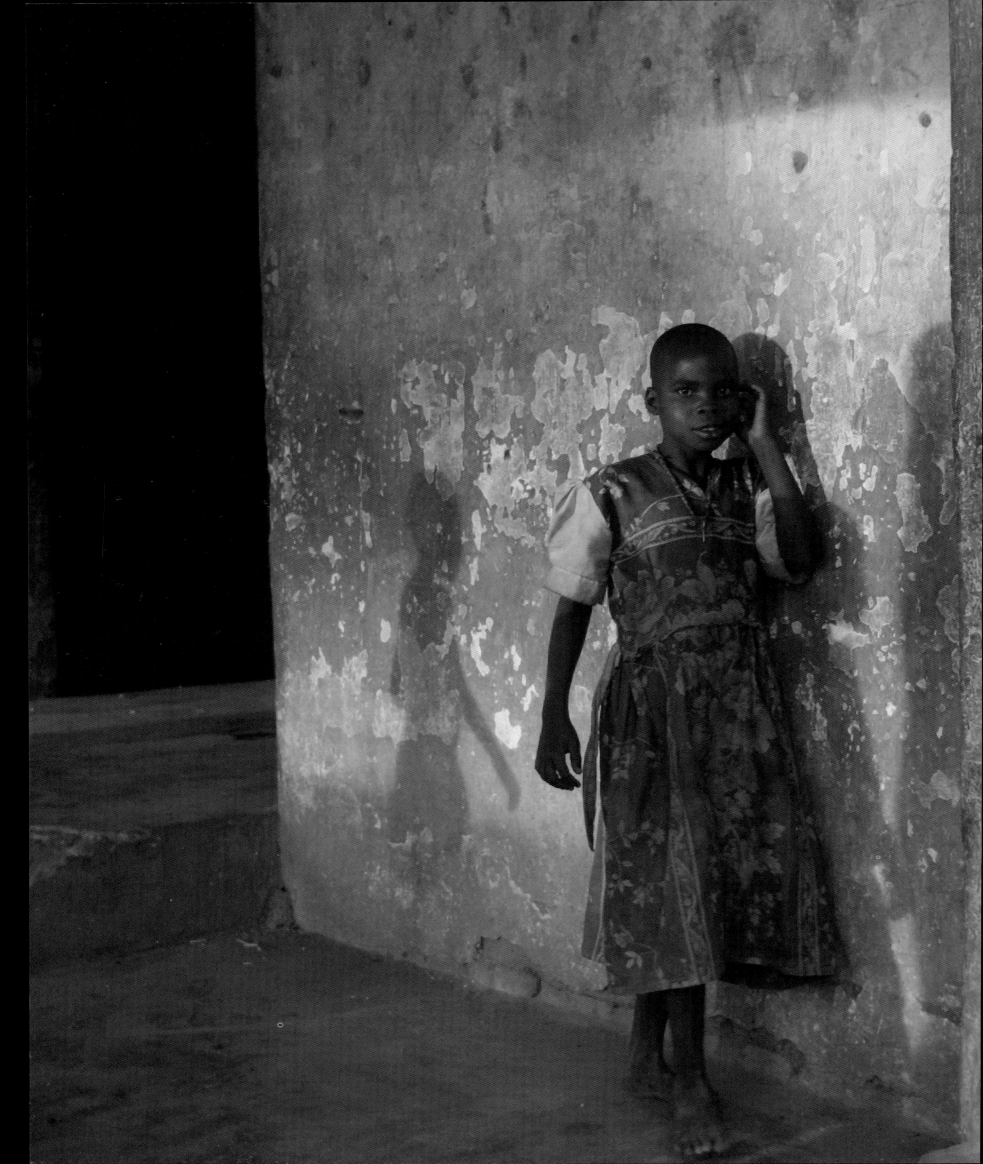

▫ Left
A young girl in Pabbo,
a camp for Ugandans
displaced by rebel fighting
in the north. Children have
been particularly victimized
by the rebel raids. During
the last decade, the Lord's
Resistance Army (LRA),
based in neighboring
Sudan, has captured more
than 10,000 Ugandan
children, abducting them
for use as servants and
soldiers. As a result, many
families have fled their
villages for camps like
Pabbo, where some 50,000
refugees live in crowded
conditions under the
protection of Ugandan
soldiers. Since March 2002,
Sudan and Uganda have
cooperated to fight the LRA
and return abducted
children to their homes.
> Ron Haviv in Uganda

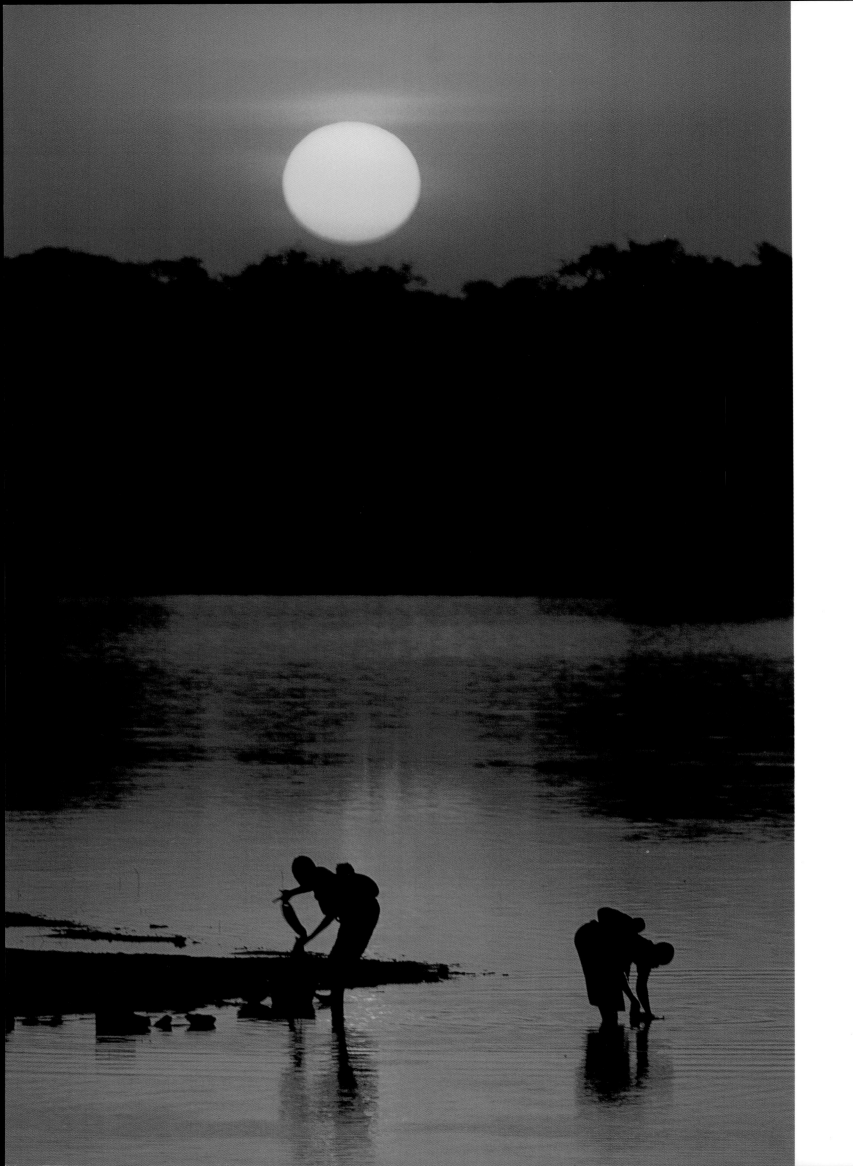

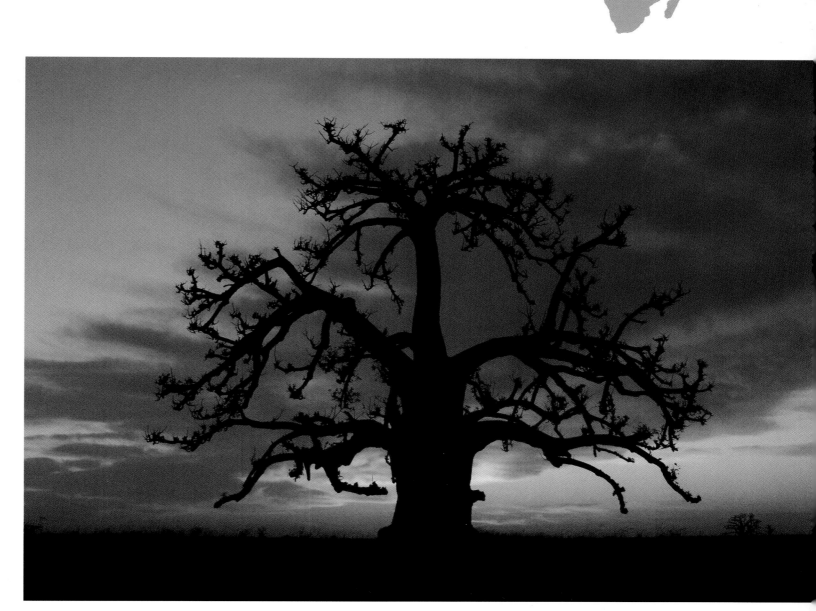

□ Above
Near the Senegalese towns of Joal and Fadiout, a solitary baobab tree spreads its branches above a field. Considered national symbols in Senegal, baobab trees often mark burial sites.
> *Anthony Barboza in Senegal*

■ Left
In the golden evening light, village women do their daily wash in the Nazinon River near Burkina Faso's capital, Ouagadougou.
> *Gerd Ludwig in Burkina Faso*

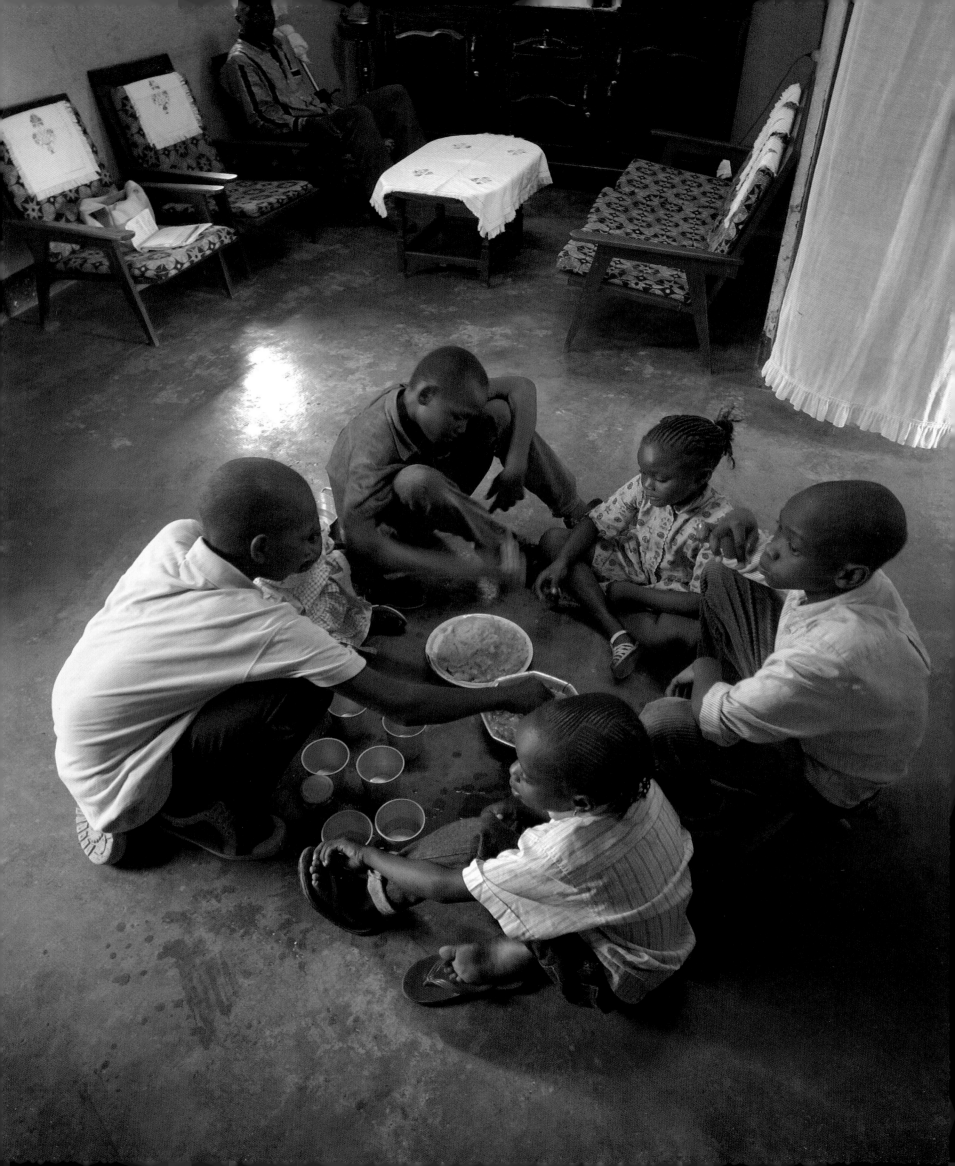

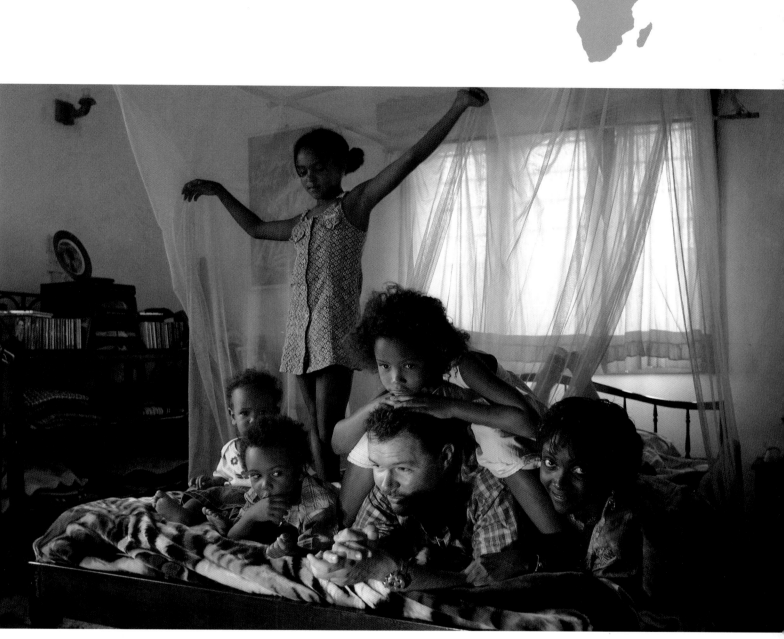

◻ **Left**
Julien Bini's six children eat
supper on the paved floor of
their comfortable home in
Bangui, capital of the Central
African Republic. Bini is an
English teacher and translator.
> *Nick Kelsh in the*
Central African Republic

◼ **Above**
After dinner, Belgian-born
Alain Burie *(center)* and his
Ugandan wife, Rita Burie
Nakiwala *(far right)*, curl up
with their kids in their
comfortable, four-bedroom
Kampala home. Burie, who
works for a non-governmental
organization called the
German Development
Cooperation, regularly travels
to Congo-DRC, where his
organization provides support
to women's groups.
> *Jeffery Allan Salter in Uganda*

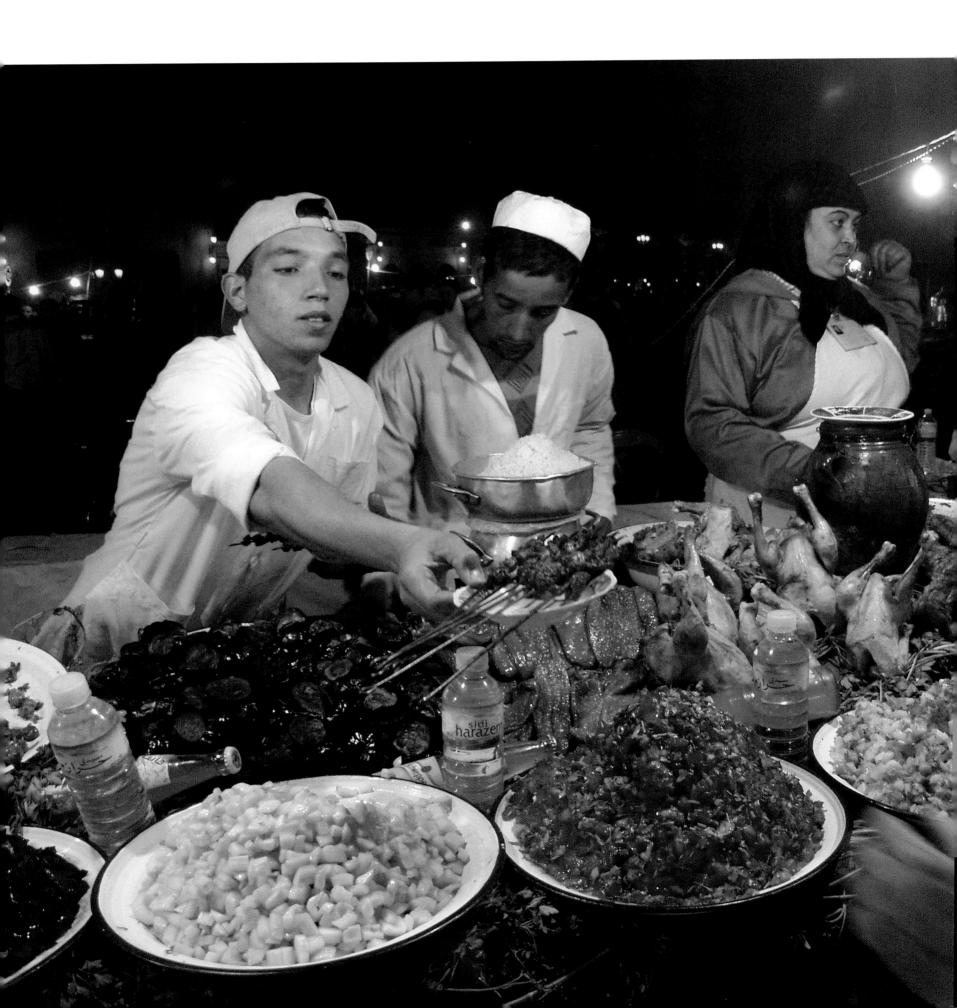

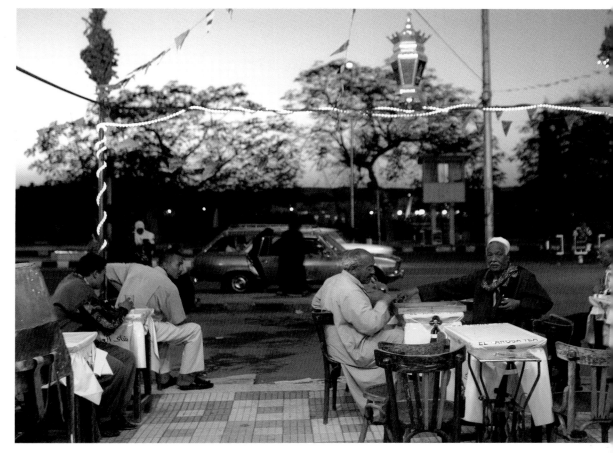

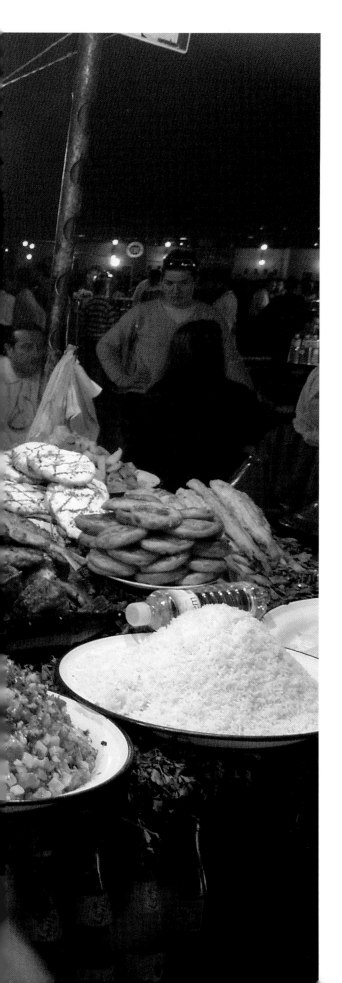

■ Above
By the Nile River in Aswan,
customers cluster at cafés on
the stylish Corniche el-Nile.
> *Alexandra Boulat in Egypt*

■ Left
Succulent food displays,
throngs of storytellers,
musicians, even snake-
charmers draw evening diners
to the Djemaa el-Fna plaza
in Marrakech.
> *Bruno Barbey in Morocco*

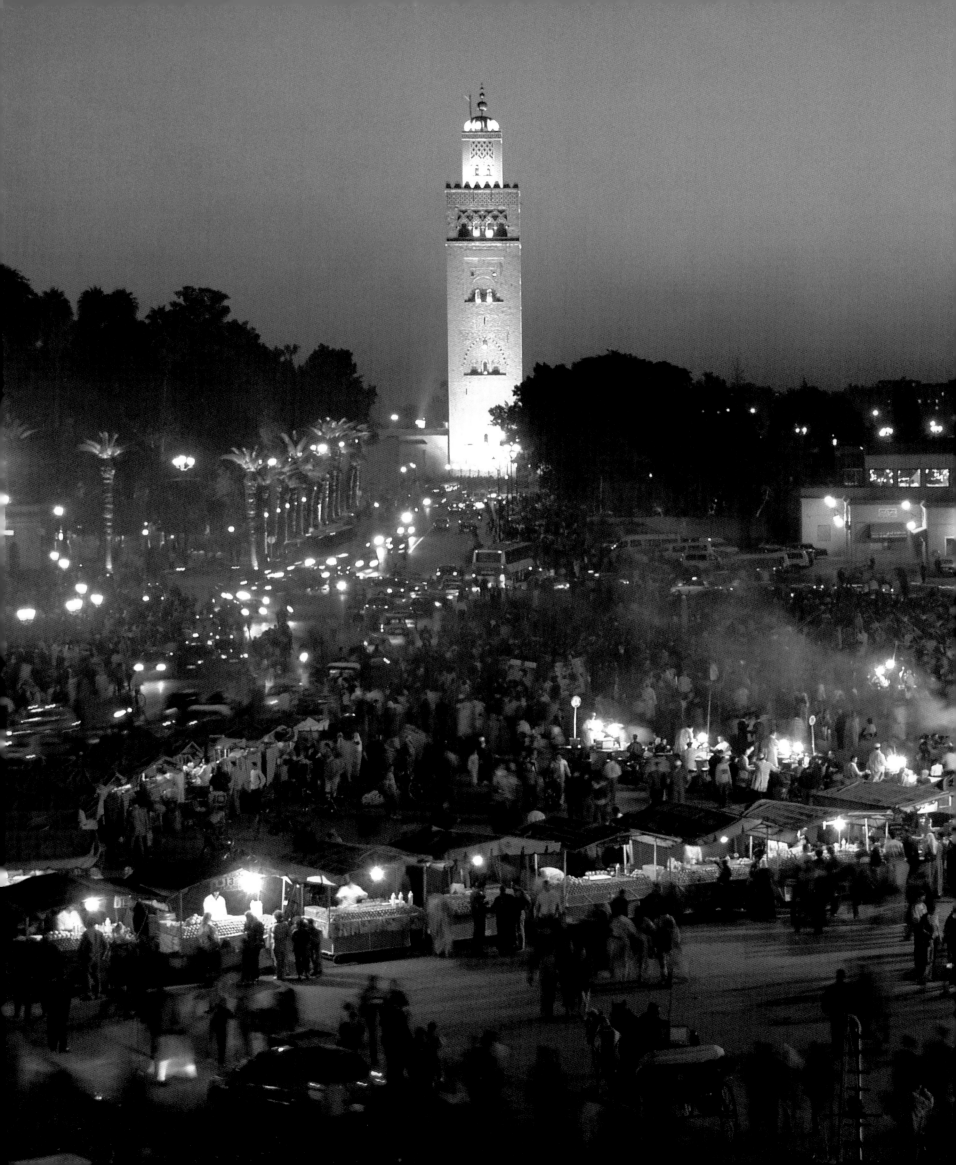

□ **Left**
In the old city of Marrakech, the 12th-century Koutoubia Mosque towers over throngs of traders and tourists in the Djemaa el-Fna market.
> *Bruno Barbey in Morocco*

■ **Following Pages**
On Mali's harsh Bandiagara Plateau, the moon rises over a cliffside Dogon settlement, a cluster of mud-brick dwellings and granaries. Dogon have inhabited this escarpment for 600 years.
> *Jeffrey Aaronson in Mali*

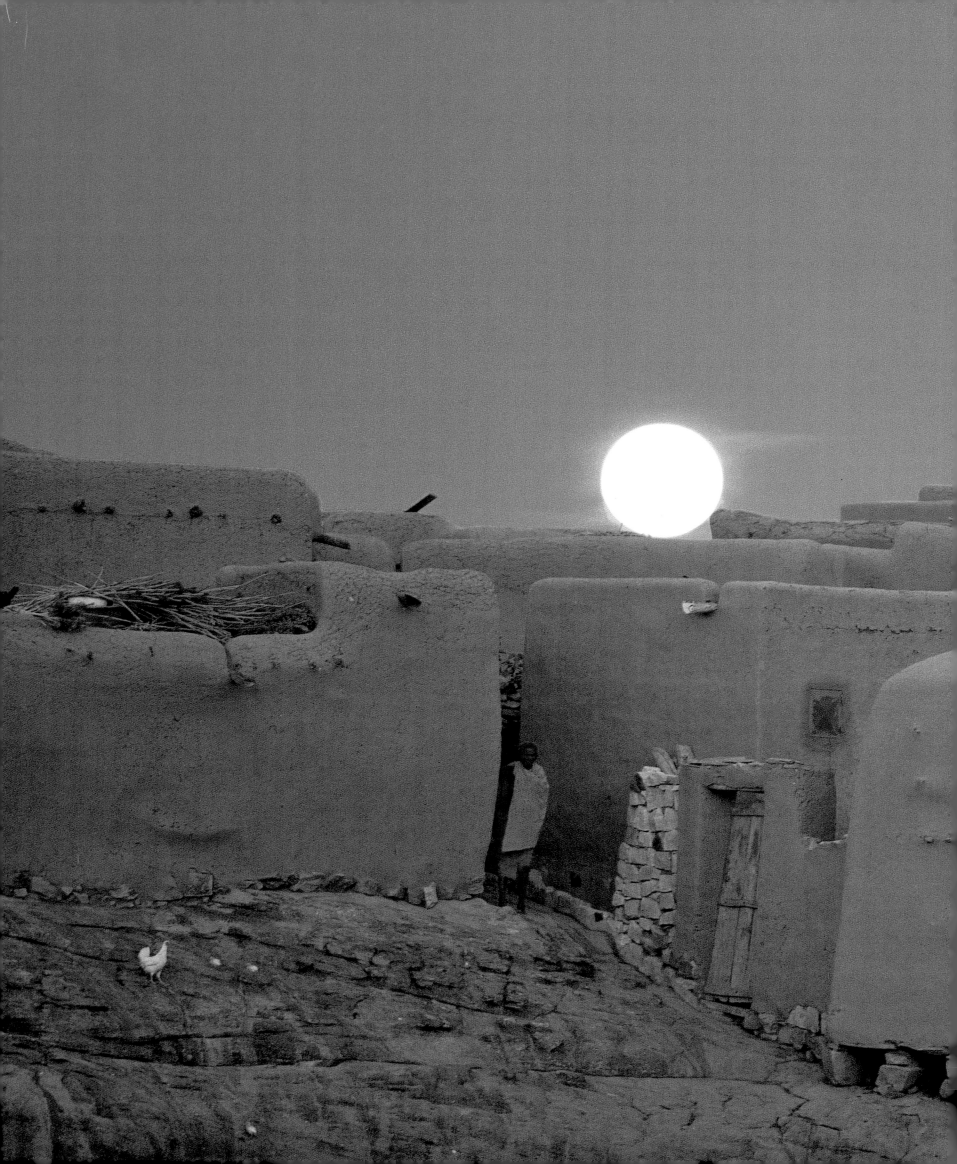

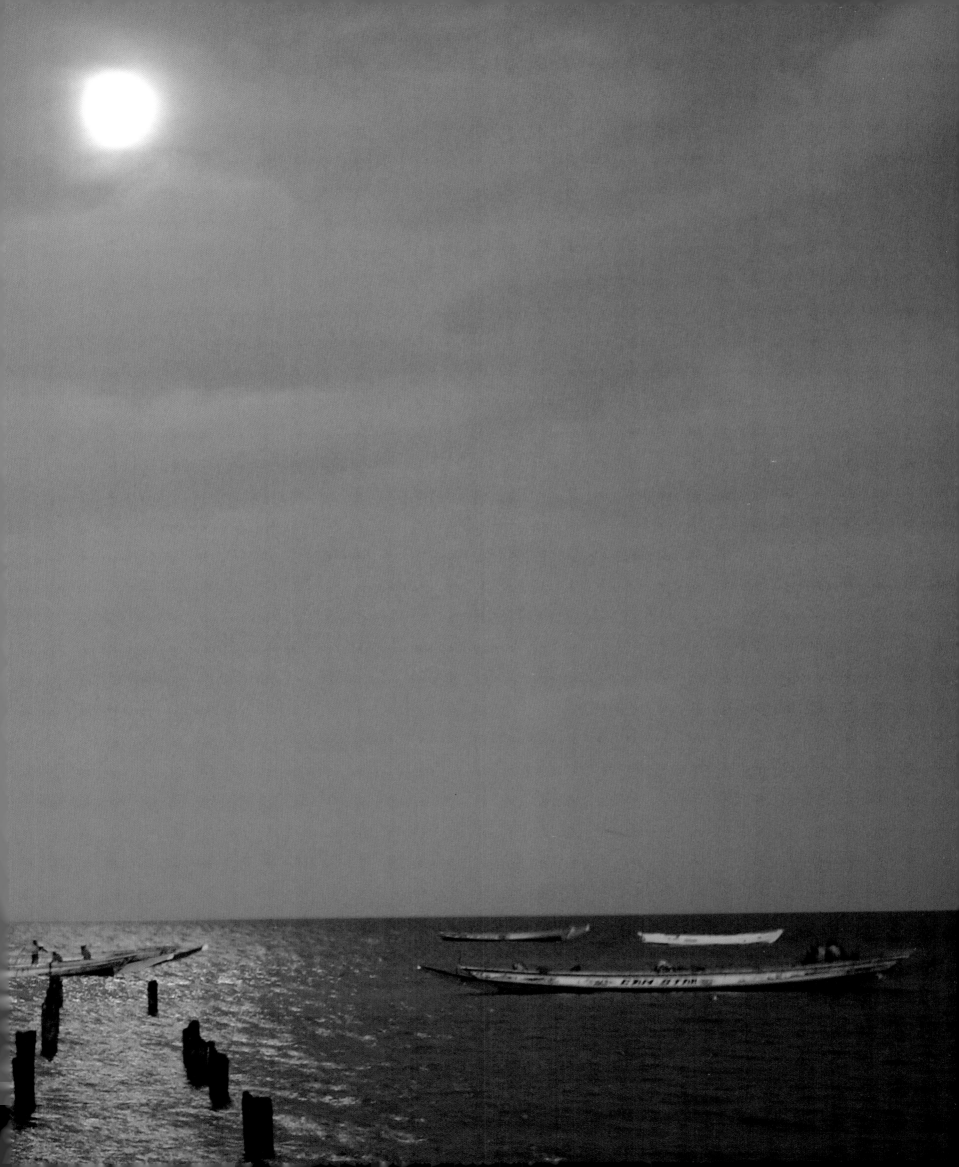

■ Left
As *A Day in the Life of Africa* winds to a close, a winter moon peeks out from behind the Great Pyramid in Giza, Egypt.
> *Dilip Mehta in Egypt*

Africa in Perspective by Howard French, Senior Writer, *The New York Times*

The many perspectives of Africa presented in this book dare to open the reader to an entire continent. This is a challenging goal. Clearly, an understanding of the African continent cannot be reduced to a few pages in a book. Neither can contemporary Africa be summarized without mentioning its past or the many factors that have shaped the continent—its vast geography, extreme climates, and the diversity of its cultures, languages, and religions.

As human beings, Africa is mother to us all, the place where human history began. It is a continent with a noble and heroic past, boasting such great kingdoms as Mali, Zulu, Kongo, Ashanti, Dahomey, and the incomparable civilizations of ancient Egypt, where 5,000-year-old pyramids still stand as testament to a rare genius. Throughout history, Africa has surprised the world. This is the continent of Hannibal, son of Carthage in North Africa, who crossed the Alps with 37 elephants and a large infantry in the second century B.C. and routed Rome's mighty legions in their own backyard. Nine centuries later, Moors repeated the Carthaginians' feat, bringing an enlightened age of learning and religious tolerance to the Iberian Peninsula, ruling over Spain and Portugal from 711 until the 12th century.

Africa's modern era, though, began with an unhappy collision. In 1491, Europe and sub-Saharan Africa came into sustained contact for the first time, and for both, nothing would ever be the same again. This fateful meeting occurred in the region we now call the Congo. And though few teach the history of this encounter today, it would set the course of history for most of sub-Saharan Africa for the next half millennium: a promise of salvation and material betterment giving way to a reality of subjugation and dispossession.

When Portuguese explorers disembarked from their caravels and came ashore in the late 15th century, leaders of the Kongo Kingdom were awed by the many novel goods the foreigners possessed—from sturdy iron utensils to glittering mirrors. The Portuguese, too, were impressed with the order and gentility that seemed to prevail, and set about creating a Christian mission to convert the Africans to Catholicism.

With Portugal's colonization of Brazil in the early 16th century, however, the focus of European zeal in Africa switched virtually overnight from "saving souls" to capturing and selling them. A huge pool of field labor was needed to work the vast tropical commodity plantations being carved from the Brazilian forest, and with remarkable speed, the heinous Triangle Trade was born.

Africans held in chains were shipped to the New World. Lucrative commodities including sugar, coffee, cotton, and tobacco were sent from the New World to Europe. Then guns, textiles, and metal goods were shipped down the coastlines of western and central Africa to slaving stations, where they were exchanged for more captives. Thus began in earnest the African slave trade that would either kill or transport from the continent at least 20 million people.

As the Kongo Kingdom turned into a slave-hunting state, order quickly broke down. When its leaders tried to repudiate the trade, appealing to Christian ethics, Lisbon armed rival tribes who hunted slaves among the Kongolese. This signaled the demise of the Kongo Kingdom, and of any hope for stability and progress wherever the trade took hold. For more than three centuries, Europeans siphoned away slaves from forts on the coastline, scarcely venturing inland. It was these slaves who helped build the New World.

In the 19th century, the golden age of global imperialism, Europeans simply decided to take Africa over, and their fast-improving technologies from weaponry to medicine gave them the means to do so. But Africa would not prove so easy to topple. Across the continent, well-developed kingdoms skillfully blended war and diplomacy for decades, fending off the incursions of the better-armed Europeans. Rapids and waterfalls in African rivers, vast deserts, coastal

swamps, and dense forests hindered European conquerors from penetrating the continent's heartland. Tropical diseases and parasites felled many who tried.

It took Britain—then the world's most powerful nation—most of the 19th century to finally declare victory over the Ashanti. The vanquished people's crown was destroyed. Its king was exiled. Its institutions—African creations that could have been the foundation for a stable, modern state—were wiped out. European colonizers sought to impose their own civilizations, and showed contempt for African ways. Under colonial rule, Africans were given little responsibility, and in the space of a generation local traditions of self-administration and governance were eradicated.

Then, little more than a half century after they had eliminated or distorted sub-Saharan Africa's indigenous societal structures and formative nations, Europe embarked on the process of decolonization. African-led independence movements often met repression and violence for advocating self-rule. But in 1957, Britain granted Ghana independence, and other countries throughout the continent quickly followed. After destroying Africa's indigenous institutions, Westerners made little effort to initiate Africans in the practicalities of self-rule, and left behind infrastructure without the resources to maintain it. Geopolitical boundaries were drawn up with little regard for the ethnic boundaries the Europeans found when they arrived. Today, as independent nations, African countries face the significant challenges of these legacies.

Just as Africa's geography and climate defied the European colonizers, it now challenges contemporary African nations and their peoples. The Sahara Desert takes up a third or more of the continent and drought, deforestation, and overgrazing has reduced agricultural potential even further. In central and southern Africa, particularly, diseases associated with tropical climates and the AIDS scourge pose crippling public-health problems.

> *The Cape Coast Slave Castle, Ghana, by Jeffrey Henson Scales.*

What is remarkable, considering all these factors, is that so many African countries are now beginning to thrive and develop their own home-grown democracies, to operate the mechanisms of responsible government and revive their economic engines. As you can see within the pages of this book, Africa is increasingly surmounting the legacy of its colonial past, its internecine wars, government corruption, and geographical and climactic limitations. Africans are now starting to spread the gospel of education, accepting the duties of environmental stewardship, mastering the responsibilities of self-determination, and in doing so, harnessing their vast potential.

Africa's genius for creation and survival, for grit and adaptation, has made this possible. It is the same genius that sustained Nelson Mandela's victory over South African apartheid and gave rise to no fewer than six Africans who have been awarded the Nobel Prize for Peace.

Africa will need all of its varied genius to utilize the wealth of its natural and human resources. In so doing, Africa will assume its rightful place in a shrinking and increasingly interdependent and connected world. In many ways, the continent's fate is the fate of humankind, and with a new international partnership, Africa will surprise the world again.

Behind the Scenes
of *A Day in the Life of Africa* by Susan Wels

To capture an entire continent in 250 images, shot on a single day, is an improbable concept—particularly in a land as limitless as Africa, with 720 million people, 53 countries, nearly 1,000 languages, and millions of square miles of dramatic, sometimes hostile, often inaccessible landscape.

The logistical scale alone would be confounding, along with the costs, risks, and sheer scope of the challenge. But then—as project director David Elliot Cohen and producer Lee Liberman saw it—that was the point. It would take a project this big, they thought, to bring public attention to a problem as huge as the AIDS plague that is decimating Africa, ravaging families and communities.

It was in February 2001—when they first read *Time* magazine's sentinel reporting on the catastrophe of AIDS in Africa—that, Cohen remembers, "we knew we had to do this book." They saw a chance, Liberman adds, "not only to present Africa with a human face, but to help create global awareness of a continent at risk."

Six years earlier, the two had partnered to produce *A Day in the Life of Israel,* the most recent book in the best-selling Day in the Life series, launched two

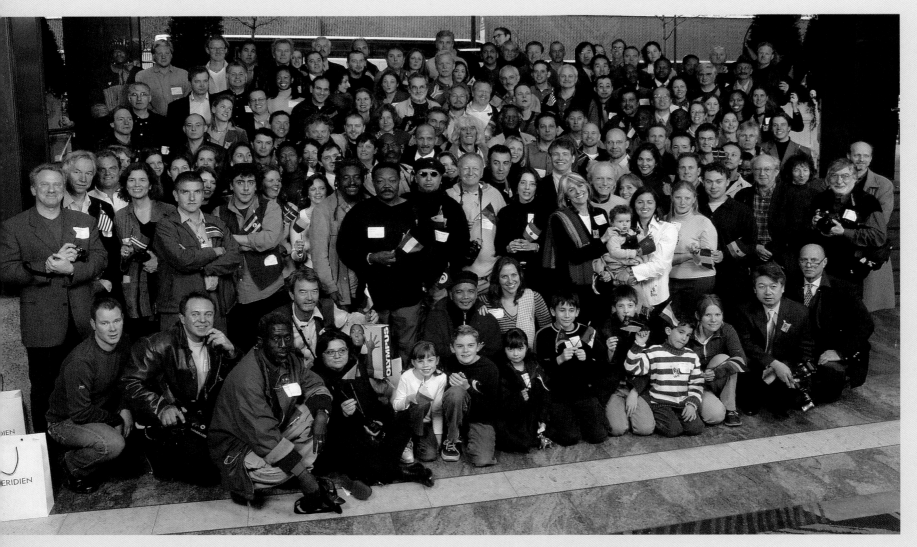

> A Day in the Life of Africa *photographers, staff, sponsors, and friends gather, pre-shoot, at Le Méridien Montparnasse.*
By James Marshall and Mark Greenberg in Paris

decades ago. Cohen, who directed 11 Day in the Life titles, had taken an extended hiatus from the series—one that included a 16-month trip around the world with his wife and children. During their travels, the family spent more than a month in southern Africa. "We fell in love with Africa," he says, "but we had no idea how bad the AIDS situation really was. We didn't know—even Africans didn't know at the time—the extent of the problem." Now, he and Liberman decided that the time was right to do another Day in the Life book, which would tackle the biggest challenge the series ever attempted—to shoot not a country but an entire continent and donate the publishing profits to support crucial AIDS-education programs in Africa.

The first step was to raise the $2 million in sponsorship money necessary to pay for the project. But crisscrossing the globe through the summer of 2001—from London, Paris, and New York to South Africa and Australia—they found little support for the idea. Africa simply wasn't a corporate priority. But everything suddenly changed following the shock of the September 11 terrorist attacks on the World Trade Center and the Pentagon.

"We were in London when it happened," Liberman recalls. "And almost immediately, attitudes began to change. People wanted to join and support us, and corporations wanted to do something compassionate."

With seed funding from the LJCB Investment Group of Melbourne, Australia, and sponsorship from Olympus and South African Airways, the ball began to roll. By December, major sponsors including Anheuser-Busch, ChevronTexaco, Le Méridien hotels, Air France, and the World Bank Group signed on, thanks in part to the persuasive efforts of Day in the Life of Africa team members Ariane de Bonvoisin, Heather King, Chuck Collins, and Lael Weyenberg.

A key supporter was South Africa's Eskom, the fourth largest utility company in the world. "I'm a very busy man," Eskom's chairman, Reuel Khoza, told

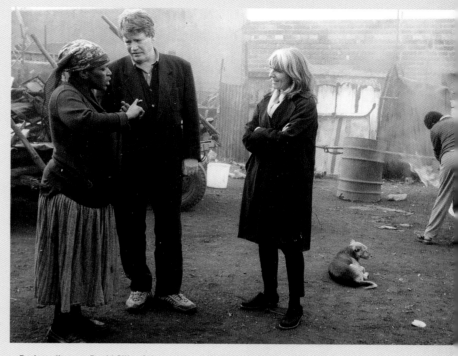

> Project director David Elliot Cohen and producer Lee Liberman listen to a local point of view in Soweto. By Louise Gubb in South Africa

Cohen in Johannesburg, "but it is my friends who are dying from AIDS. I'll do whatever I can to help." By the end of the year, A Day in the Life of Africa had a green light. And with shoot day—February 28, 2002—only two months away, planning and logistics went into overdrive.

A key task was to locate world-class photographers willing to drop everything and fly to the far corners of Africa. Cohen had been out of the photography world since his last Day in the Life project in 1995, so he turned to Eliane Laffont, worldwide editorial director of Hachette-Filipacchi Media Group, for assistance. Invitations were sent to an extraordinary group of photographers selected by Laffont. The list ranged from Pulitzer Prize and World Press Photo winners to up-and-coming talent. "Our standard was simple," Cohen states. "We wanted the very best photojournalists working in the world today." But the list—which included more than 20 African and African-American photographers—was also limited by another criterion:

previous on-the-ground experience in Africa, an environment, Cohen adds, "that is no place for amateurs or first-timers."

Invitees also had to be willing to shoot digital photography. Not only was *A Day in the Life of Africa* the most ambitious book ever attempted in the series, it would also be the first to rely on digital cameras. Actually, the idea of shooting digital—proposed early on by project sponsor Olympus—"scared the hell out of me," Cohen admits. But after talking to photojournalists, including digital experts Mark Greenberg and Douglas Kirkland, he was persuaded. The decision meant, for one thing, that photographers would need intensive pre-shoot training on the Olympus E-20 and C-4040 digital cameras. "More than half of the photographers had never shot an assignment with digital equipment," Cohen recalls. "Asking them to use digital cameras for the first time on a highly competitive one-day shoot was like handing a top tennis star a new type of racquet for the first time at Wimbledon."

> *Photographer Tom Stoddart at the Mother of Mercy Hospice near Lusaka, Zambia.*

Dozens of top photojournalists signed up for digital training sessions in New York, Paris, and Johannesburg—led by project photographer and senior advisor Mark Greenberg—to get as comfortable as possible with their new tools before the shoot. Fortunately (a silver lining of the dot-com collapse) an incredibly talented digitally enabled team was available at a moment's notice to organize training sessions and the complex logistics of a digital shoot. Most were also willing to move from Boston, New York, and San Francisco to Paris, where *A Day in the Life of Africa* was headquartered, in the Left Bank offices of Les Editions du Pacifique.

While a stateside staff, including Day in the Life veteran Carole Bidnick and attorney Phil Feldman, firmed up sales and distribution of the book, the editorial team in Paris—led by Louise Gubb of South Africa and *Newsweek* veteran Spencer Reiss, former managing editor of *A Day in the Life of America*— worked with photographers to pinpoint locations and subjects for the shoot. For the first time in the series' 20-year history, photojournalists were invited to suggest their own assignments. "We were working with 100 photographers who already knew Africa well," Cohen explains. "It was clear that they had a larger knowledge base than any small group of assignment editors in Paris."

Whatever simplicity was gained in the assignment process, however, was lost in the logistical maze of getting photographers to 100 different locations around Africa and, more importantly, back again safely. The plan was to have the photojournalists assemble in Paris before leaving for their African assignments, then return to the French capital for a media drop and debriefing before heading home. Corinne Nagy and Peter Goggin deftly handled the endlessly complicated travel arrangements. Despite scaled-down airline schedules after the September 11 attacks, and an unexpected Air France strike at the end of February,

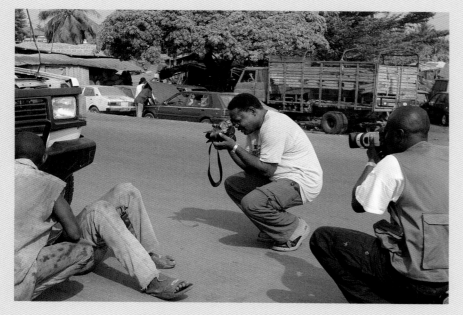

> *While shooting in Abidjan, Côte d'Ivoire, C. W. Griffin becomes a subject himself for the* Day in the Life of Africa *video project.*

From Cairo, where Nina Berman shot the city's belly-dancing culture after dark, to the dune-swept Namib Desert—where George Steinmetz lugged his own motorized paraglider and 200 pounds of gear, including spare propellers—Day in the Life photographers fanned out across Africa. Though only one nation, Libya, actually denied access to the Day in the Life team, across the continent, photographers coped with bureaucratic mazes and delays, camera-shy subjects and worse. In Togo, Daniel Laîné called the Paris office, slightly panicked, as he watched the body of a thief burning outside his hotel window. Larry Price had a close call driving in Uganda, when a wheel suddenly flew off his four-wheel-drive, plunging him into a ditch near the Congolese border. In Congo-DRC, Swedish photographer Per-Anders Pettersson was held for two hours by security forces, who nearly confiscated his photographs. And in Morocco, police briefly held Joachim Ladefoged as a spy, until he showed them digital images of his shoot on his E-20's LCD display.

the two managed to get everyone where they needed to go without major mishaps.

Finally, on Friday, February 22, ninety-five photographers assembled en masse in the French capital. While they picked up their assignments and plane tickets and posed for a "family portrait" on the steps of Le Méridien Montparnasse, publicity director Gina Privitere organized crews from ABC, CNN, Reuters, BBC, Agence France-Presse, and RFI Radio France Internationale to capture the event. Two days later—after more training, robust quantities of wine, and a kick-off party at Le Méridien—they took off for Africa.

In addition to digital cameras, each photo-journalist was equipped with gear including Lexar Media's 256-megabyte CompactFlash cards and Minds@Work's MindStor 5-gigabyte portable hard drives, known as "digital wallets," for downloading images in the field. Twenty-seven photographers also carried digital video cameras to capture footage for a DVD documentary of the project, funded in part by Apple.

> *David Turnley and friend in western Côte d'Ivoire.*

269

Despite these obstacles, photographers caught extraordinary glimpses of daily life across the continent, from the !Kung San in Namibia and fishing villages in Côte d'Ivoire to the charms of café life in Asmara, Eritrea, and the beach scene in Lagos, Nigeria. Best of all, Cohen adds, is the fact that every photographer eventually made it safely home again. Heavy rains stranded Antonin Kratochvil in a remote area of the Congo for 20 days, and a few others were lost for shorter periods of time—Liz Gilbert contracted food poisoning from goat meat in a Maasai village, and Kristen Ashburn and Jean-Luc Manaud also fell ill, delaying their return to Paris. But amazingly there were no arrests, serious injuries, or deaths. "I had a huge sense of relief," Cohen says, "the day we knew every photographer was accounted for. We felt blessed."

At that point, the focus shifted to the Sisyphean task of editing 50,000 digital photographs (and a few rolls of film) into a book, orchestrated by post-production director Dawn Sheggeby and digital advisor Kevin Gilbert of Blue Pixel. Seven photo editors—Guy

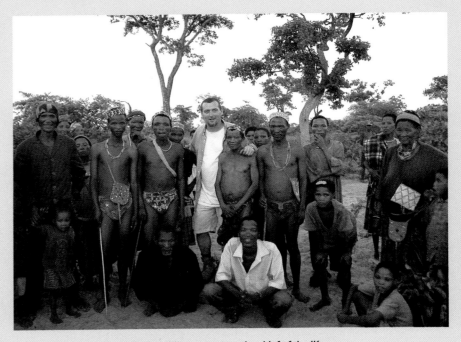

> *Seamus Conlan in Namibia. By !Alli!, secretary to the chief of the !Kung*

Cooper, former director of photography for *Newsweek*; Michele McNally, picture editor of *Fortune*; project design director Tom Walker; Robert Pledge of Contact Press Images; *Washington Post* photo editor Michel DuCille; former *San Jose Mercury-News* photo chief Sandra Eisert; and French photo editor Zohra Mokhtari—crammed into the crowded Paris office to screen images. Using Photo Mechanic editing software from Camera Bits, as well as advanced equipment donated by Apple (including G4 computers and active-matrix, flat-panel displays, color-corrected by Gretag-Macbeth) the team worked night and day to winnow thousands of photos down to the 250 extraordinary pictures in this book.

For many of the editors, the digital process was a revelation. "Like all Day in the Life projects," Walker says, "this book pushes the technology envelope. Using digital this way is like witnessing the birth of a whole new medium. The images," he adds, "have an entirely new look and sensitivity. The depth and detail are truly incredible."

> *Kevin Gilbert on the Indian Ocean island of Mauritius.*

270

Cohen, for one, is now a true convert to the digital process. "It was a wonderful surprise when we actually saw the pictures," he remembers. "We realized that the technology not only worked under difficult field conditions, but that it was really far better than traditional chemical photography in many respects. The pictures are fresher and far sharper than traditional photography."

Together, these pictures present a portrait of life in Africa layered with all the rich detail of struggle, celebration, and hope. "They put a face on Africa," Walker says—one, Liberman hopes, that will encourage people to care about the AIDS epidemic that is sweeping, unstopped, across the continent. Profits from the book will be distributed by the Day in the Life of Africa AIDS Education Fund, to programs that will teach people to prevent and treat HIV/AIDS. Administered by San Francisco's Tides Foundation and advised by experts including the directors of the Harvard AIDS Institute and South Africa's Soul City Foundation, the Fund will work to achieve long-term change—saving African lives through a celebration of African life. This book, Liberman says, "will help us discover not just what Africa is, but what it needs, and how we can possibly help."

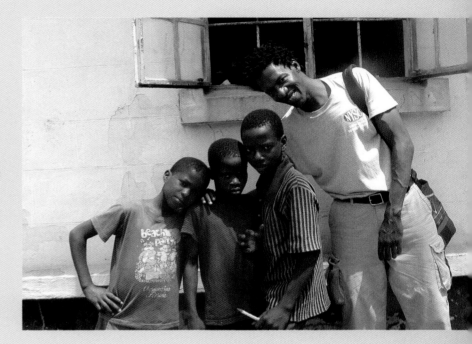

> Top: Andre Lambertson at the International Rescue Committee's interim care center in Sierra Leone.
> Bottom: A Day in the Life of Africa winds to a close in Tunis.
By David Elliot Cohen in Tunisia

271

Photographers

Jeffrey Aaronson
American/Aspen, Colorado
After a brief career as a research biochemist, Jeffrey Aaronson has spent the last 22 years venturing to the farthest reaches of the globe (including 60 trips to China) on assignment for clients including The National Geographic Society, *GEO*, *Smithsonian*, *Time*, *Newsweek*, and *Vanity Fair*. He has won many honors for his photography including awards from Communication Arts, Graphis, American Photo, PATA, and Lowell Thomas and Roger Tory Peterson.

Abbas
Iranian/Paris
An Iranian transplanted to Paris, Abbas' work covering political and social movements has put him at the heart of most major events in Africa, Asia, the Middle East, and Latin America since 1970. A member of Magnum photo agency, his photographs have appeared in leading magazines worldwide. After spending the last decade covering Christianity and the resurgence of Islam, Abbas is currently focusing on animism throughout the world. His books include *Return to Mexico*, *Allah O Akbar: A Journey Through Militant Islam*, and *Faces of Christianity*.

Yann Arthus-Bertrand
French/Paris
A world-renowned aerial photographer, Yann Arthus-Bertrand has been published in international magazines, including *Paris Match, Le Figaro, Stern, GEO, Life,* and *National Geographic*. He has produced more than 70 books, and, under the patronage of UNESCO, has produced the series *The Earth from Above*, featuring aerial shots from every continent to educate and create the sense of responsibility necessary to protect our planet.

Kristen Ashburn
American/New York
Kristen Ashburn's subjects have included neurologically damaged Romanian orphans, AIDS in southern Africa, multi-drug-resistant tuberculosis within the Russian prison system, and genocide survivors in Rwanda. Often combining volunteer work with her photography, Ashburn has created a volunteer organization to aid Romanian orphans. She also taught a photography workshop for Rwandan orphans and created an accompanying exhibit shown in Kigali. Her work has appeared in international

magazines and was published in *Life Magazine: A Year in Pictures*.

Jane Evelyn Atwood
American/Paris
Born in New York, Jane Evelyn Atwood has been living in France since 1971, and working in the tradition of documentary photography, following her subjects for long periods of time. She is the author of five books on subjects including Parisian prostitutes, the French Foreign Legion, the blind, and women in prison. Atwood has won various international prizes including the W. Eugene Smith Award in 1980, a 1987 World Press Photo for *Jean-Louis: Living and Dying With AIDS*, and an Alfred Eisenstaedt Award in 1998 for *Babies Behind Bars*.

Bruno Barbey
French/Paris
For *A Day in the Life of Africa*, Bruno Barbey returned to Morocco, the country of his birth and childhood. After studies at the École des Arts et Métiers in Switzerland, Barbey spent the 1960s in Africa illustrating a number of books and working for *Vogue*. In 1966, at the age of 25, he joined the small but already prestigious Magnum photo agency. His work is regularly published in book form and in international magazines such as *Life*, *National Geographic*, *Paris Match*, and *The Sunday Times* (London). His photographs are included in museum exhibitions in Europe, the United States, and Japan.

Anthony Barboza
American/New York
Anthony Barboza began his 37-year photography career with the Kamoinge Workshop, and is still an active member of this long-running group of photographers. The recipient of numerous grants and awards, including a National Endowment for the Arts grant, Barboza has photographed for *Time, Life, Essence, National Geographic, Vanity Fair, Vogue, Oprah, Cosmopolitan, Playboy, Forbes,* and *Fortune*. He was assistant curator of the Brooklyn Museum's 2001 show "Committed to the Image: Contemporary Black Photographers."

Nadia Benchallal
French/Paris
Born in France and of Algerian descent, Nadia Benchallal studied photography at the International Center of Photography in New York. In 1992, she began a project focused on the daily life of women in Algeria, which

eventually expanded to cover Muslim women worldwide. Benchallal's work has appeared in various publications worldwide, and has been exhibited in museums and galleries in Germany, Belgium, Holland, France, Spain, China, and Japan. A Contact Press Images photographer, she is the recipient of many awards, including a World Press Photo prize.

Nina Berman
American/New York
Nina Berman has won several Pictures of the Year and Communication Arts awards for work documenting the life of Afghan women under the Taliban, the rape of Muslim women in Bosnia, and extremist culture and politics in the United States. Her pictures have appeared in numerous international magazines including *Time, Newsweek, The New York Times Magazine, Fortune, GEO,* and *Stern*.

Peter Bialobrzeski
German/Hamburg
Peter Bialobrzeski's began his career in 1984 as a news photographer for the *Wolfsberger Allgemeine Zeitung*. Since then his work has appeared in major international publications including *GEO, National Geographic, Die Zeit,* and *Telegraph Magazine*. He has published two books, *Transit* and *xxxholy*. Bialobrzeski helped found the website www.photosinstore.com in 2000. He is represented by the Laif agency in Germany.

Jodi Bieber
South African/Johannesburg
A seven-time World Press Photo Award winner, Jodi Bieber covered the first democratic elections in South Africa for Johannesburg's *Star* newspaper. In 2001, she received a gold award from the Society of Publication Designers for her work on the Ebola crisis in Uganda. Her work has appeared in publications including *The New York Times Magazine, GEO,* and *Stern*. Represented by Network Photographers, London, Bieber's work has been shown in exhibitions internationally.

Alexandra Boulat
French/Paris
Paris-born Alexandra Boulat was originally trained in graphic art and art history. She worked as a successful painter until 1989, when she switched to photojournalism. A founder of the VII photo agency, Boulat works regularly for *National Geographic*, *Paris Match,* and *Time*.

Boulat has won several awards for her work on violence in the former Yugoslavia and her story on Yasser Arafat and his family. When not documenting revolution, war, drought, oil spills, and ethnic tension, Boulat also covers the haute couture of Yves Saint Laurent.

Paul Chesley
American/Aspen, Colorado
A freelance photographer with the National Geographic Society, Paul Chesley has participated in all 14 Day in the Life projects. He is a frequent contributor to *Life, Fortune, Time, Newsweek, Audubon, GEO,* and *Stern* magazines, and has worked with *National Geographic* since 1975. His work was exhibited in "The Art of Photography at the National Geographic" at Washington's Cocoran Gallery of Art, as well as in solo shows in London, Tokyo, and New York. His recent works can be seen at www.paulchesley.com.

Stéphane Compoint
French/Paris
A photojournalist since 1986, Stéphane Compoint has produced eight books and nine exhibitions, and has won several awards including two from World Press Photo. Drawn to archeological subjects, Compoint has covered Egyptian mummies, the now-underwater Lighthouse of Alexandria (the seventh Wonder of the Ancient World), and *Australopithecus*, a 3-million-year-old early species of man. He is represented by Witness press agency.

Seamus Conlan
Irish/London
In 17 years as a photojournalist, Seamus Conlan has covered stories in Africa, the Middle East, Europe, and Asia. During the Rwandan war in 1994, he brought together the resources of several international aid agencies, as well as Eastman Kodak and *Life* magazine, to help reunite more than 20,000 lost children with their parents, using photographic images. Conlan received a Directors Club' award for his compilation photograph of the children, and the process he developed is now a standard form of tracing people in developing nations.

Jean-Claude Coutausse
French/Paris
In the early 1980s Jean-Claude Coutausse worked for the Agence France-Presse and the daily newspaper *Libération* on assignment

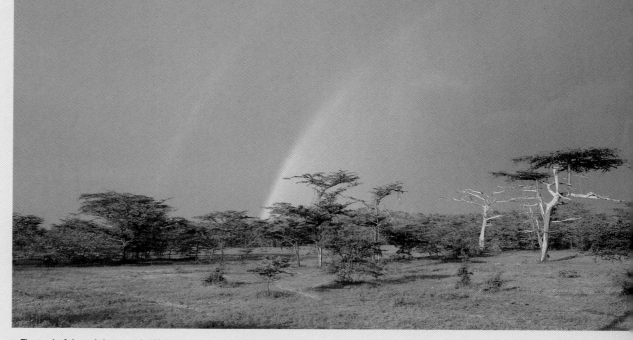

in Libya, Haiti, Chile, Eastern Europe, and Palestine. In 1990 he joined Contact Press Images, and has covered the Gulf War, Somalia, Rwanda, Zaire, and the fall of Yugoslavia for *Time*, *Newsweek*, *l'Express*, *Telerama*, and *The New York Times Magazine*. Coutausse has received five international awards for his project about Haitian Voodoo and currently photographs for the French edition of *National Geographic* and *GEO*.

Anne Day
American/New York
Anne Day is a freelance photographer and writer who covered Namibian independence and the release of Nelson Mandela for Reuters. Her work from Miami, Haiti, South Africa, and the former Soviet Union has appeared in *Time*, *Newsweek*, *The New York Times*, *The Washington Post*, *Fortune*, and *Vogue*. In her other life, she photographed classical American architecture for four books published by W.W. Norton. In real life, she is married to Spencer Reiss, and is the mother of Charlotte, Harry, and George.

Xavier Desmier
French/Paris
A scuba diver with the Jacques Cousteau team from 1982 to 1985, Xavier Desmier participated in various expeditions around the world including the Gulf Stream, the Sargasso Sea, and the Amazon. Desmier has also been an underwater cameraman and photographer for the Jean-Louis Étienne Antarctica mission, and the Canal/Discovery Channel's Titanic expedition. Desmier's work appears in publications including *GEO*, *Figaro*, French *National Geographic*, and *Paris Match*. A World Press Photo first-prize winner, he is a member of the Rapho agency.

Jay Dickman
American/Denver
A longtime contributor to *National Geographic* magazine, Pulitzer Prize–winning photographer Jay Dickman has covered assignments all over the earth. Dickman's work has appeared in nearly all the previous Day in the Life books, as well as in *Life*, *Time*, and *Condé Nast Traveler* magazines. His corporate clients include EDS, Hewlett-Packard, and Nike. Winner of the Golden Eye award from World Press Photo, Dickman is currently a mentor for *American Photo* magazine's Mentor series of international workshops.

> *The end of the rainbow on the Kenyan savannah, by Gary Knight.*

Quintilhano dos Santos
Angolan/Luanda
Quintilhano dos Santos is a well-known Angolan photographer who has worked extensively in the region. His images are widely published, both in Angola and abroad.

George Esiri
Nigerian/Lagos
After serving as a staff photographer for the *Vanguard* and *Guardian* newspapers since the mid-1980s, George Esiri became chief photographer and photo editor of *Prime People*, *Fame*, and *Sport Link* magazines in Nigeria. Now a Reuters photographer, his work has appeared in *The Independent* (London), the *Chicago Tribune*, and *The Washington Post*. He lives in Lagos with his wife and two children.

Frank Fournier
French/New York
Born in France, Frank Fournier now lives in New York with his family. His photographs have been widely published in *Time*, *Life*, *The New York Times Magazine*, *National Geographic*, *Paris Match*, *Figaro*, *Stern*, and *The Sunday Times* (London). His work has included stories on the Rwandan massacres, "The Face of Rape" in Bosnia, and infant victims of AIDS in Romania. He has received multiple World Press Photo awards, and is a member of Contact Press Images.

Mariella Furrer
Swiss/Nairobi
Born in Beirut, Mariella Furrer studied at New York's International Center of Photography. She is now based in Nairobi where she has lived since childhood. Her multinational background—and her ability to speak six languages—have allowed Furrer access into some of the more remote

areas of the world. Her images of Rwanda, Somalia, Sierra Leone, Iraq, and Kosovo have appeared in *Time*, *Newsweek*, *Life*, *Talk*, *Outside*, *U.S. News & World Report*, *Paris Match*, and *Marie Claire* magazines.

Paul Fusco
American/New Jersey
Paul Fusco's career began as a United States Signal Corps photographer in the Korean War. He joined *Look* magazine in 1957 after receiving his B.F.A. from Ohio State University. Fusco is the author of six books, including *RFK Funeral Train* and *Chernobyl Legacy*. While his work has chronicled some of the major social and political events of the second half of the 20th century, including the California grape strike and the spread of the AIDS epidemic, Fusco says his work is about people, "How they live, how they cope with life, how they are treated by their societies."

Tim Georgeson
Australian/Paris
Born 1969 in Singapore, Tim Georgeson is the winner of two World Press Photo awards. His work has been exhibited widely, including the 2000 and 2001 Visa pour l'Image festival in Perpignan, France, and a 2002 exhibition in the Dupont Gallery, Paris. A member of the Paris-based Cosmos agency, his work has appeared in a number of publications including *GEO*, *National Geographic*, *Stern*, and *The New Yorker*. Georgeson is married, and the proud father of a little girl named Nova.

Kevin T. Gilbert
American/Annapolis, Maryland
Kevin Gilbert covered Washington, D.C., for 20 years, primarily as chief photographer at *The Washington Times*. He was five-time president of

the White House News Photographers Association, where he won over 40 photography awards. In 2000, he formed Blue Pixel Digital Experts, a consulting group that trains consumers and professionals to work in the medium of digital photography. He continues to shoot for USA Network, Columbia Tri-Star, Discovery Channel, and other editorial organizations.

Liz Gilbert
American/New York
Liz Gilbert has worked as a photojournalist in Africa for the past 10 years, covering conflicts in Somalia, Rwanda, Sudan, and the Congo. Her pictures have appeared in *Time*, *Newsweek*, and *The New York Times*, as well as many European publications, and have been exhibited at the Visa pour l'Image festival. In 1997 she begin photographing the vanishing traditions of the Maasai of east Africa. Sponsored by Kodak, her images of Maasai ceremonies and portraits have been published worldwide.

Diego Goldberg
Argentine/Buenos Aires
Born in Buenos Aires in 1946, Diego Goldberg has been working as a photojournalist since 1971, mainly with the Sygma (now Corbis) photo agency. His work has appeared regularly in most major news magazines, and he has participated in many book projects, including most of the Day in the Life series. He has received several awards for an ongoing series of portraits of his family called *The Arrow of Time*, begun in 1976. After many years in Paris and New York, he now lives Argentina and is director of photography at the *Clarin* newspaper.

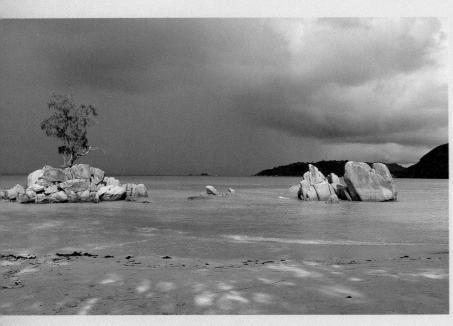

> *A rainy day in the tropical paradise of the Seychelles, by Claude Pavard.*

Mark Greenberg
American/New York
After serving as photo assignment editor for the Associated Press in New York, Mark Greenberg co-founded the New York–based Visions Photo Agency, and is now a principal and director of development for the start-up photo agency World Picture News. He has won World Press Photo awards and was nominated for a Pulitzer Prize for feature photography. His books include *Art of the Masai, Voyager,* and *Amazon Diary: The Jungle Adventures of Alex Winters.* Greenberg lectures on digital photography on behalf of Olympus America, and was a senior digital advisor to *A Day in the Life of Africa.*

Stanley Greene
American/Paris
Greene founded the Camera Gallery in San Francisco in 1975 and received an MFA from the San Francisco Art Institute in 1980. He served as a news correspondent for *Newsweek* magazine in 1986, and is represented today by the VU photo agency, Paris. He has covered international conflicts in Africa, the Middle East, and Europe, with notable coverage of the conflict in Chechnya. His images have appeared in numerous publications, including *Libération, The New York Times Magazine, Stern, Newsweek,* and *Paris Match.* He has won several awards including two from World Press Photo.

C. W. Griffin
American/Miami
C. W. Griffin spent seven years as a special missions combat photographer, including two years on the aircraft carrier U.S.S. America. He was the first black photographer to win Military Photographer of the Year for all branches of the armed forces. In July of 1983 he joined the staff of *The Miami Herald.* His work has appeared on the covers of both *The African Americans* and *Florida*

Hurricane and Disaster 1992. Griffin teaches at the University of Miami, and he has been a mentor to inner-city youth in Atlanta and Miami.

Lori Grinker
American/New York
A Contact Press Images photographer, Lori Grinker began her career documenting the rise of 13-year-old boxer Mike Tyson. She is the author of *The Invisible Thread: A Portrait of Jewish American Women,* and for the last decade she has been documenting the effects of war on veterans from 25 countries. She is the recipient of numerous grants and awards including the W. Eugene Smith Fellowship, the Ernst Haas Grant, the Hasselblad Grant, and a World Press Photo award.

Louise Gubb
South African/Johannesburg
For 10 years, Louise Gubb covered the struggle against apartheid in South Africa, and the advent of democracy under Nelson Mandela's presidency. Her photographs have been featured in two photo books on Mandela, and in a group exhibition, *Shooting Resistance,* at New York's Axis Gallery. Her work has appeared in *Life, Time, Newsweek, Stern, Paris Match,* and *National Geographic,* among others. Gubb has judged the annual South African Ilford Photo Awards several times, and she was assignment editor of *A Day in the Life of Africa.* She is represented by Corbis Saba.

Benoit Gysembergh
French/Paris
Benoit Gysembergh has been a staff reporter for *Paris Match* since 1977. His photographs of Nicaragua, El Salvador, Lebanon, Eritrea, Chad, Rwanda, Somalia, the Persian Gulf, Cambodia, Chechnya, and the Balkans have been published in more that 500 double-page spreads. His books include *Les Derniers Trains de Rêve,*

French Foreign Legion in Guyana, and *La Photo en Première Ligne,* a journal of his experience as a press photographer. Gysembergh also contributed to *A Day in the Life of Australia.*

Themba Hadebe
South African/Johannesburg
Raised in Thokoza, 25 kilometers east of Johannesburg, and the eldest of five siblings, Themba Hadebe says his reason for becoming a photographer mirrors the reason this book was made: "I want to tell a more complete side of our story." He began work at *The Johannesburg Star* in 1995, and in 1999 joined the Associated Press. A 1998 World Press Photo award winner in the spot news category, he now covers southern Africa extensively, and was most recently in the Congo.

Ron Haviv
American/New York
Ron Haviv has covered conflicts and crises in Latin America, the Caribbean, Africa, the Persian Gulf, the Balkans, and Afghanistan. His photographs have earned him several World Press Photo, Pictures of the Year, and Overseas Press Club awards, as well as the Leica Medal of Excellence. His books include *Blood and Honey: A Balkan War Journal,* the result of 10 years of Haviv's work in the Balkans, and *Afghanistan: The Road to Kabul.* Haviv is a contract photographer for *Newsweek* and a founder of the VII photo agency.

Robert Holmes
British/San Francisco
One of the world's foremost travel photographers, Robert Holmes has worked for virtually every major travel magazine, beginning in 1975 when he covered the British Mount Everest Expedition for *Paris Match* and *Stern.* He has searched for snow leopards in Nepal, journeyed with Penan tribesman into the rainforests of Borneo, and crossed the Great Indian Desert on a camel. He has 32 books in print, in addition to being featured in the Day in the Life series and similar publications.

Françoise Huguier
French/Paris
Born in France, Françoise Huguier spent a large part of her childhood in Cambodia and Vietnam, where she was a prisoner of the Vietminh for eight months. A World Press Photo award winner, Huguier has photographed extensively in all parts

of the globe, from Asia, Africa, Siberia, and Europe, covering reports, fashion, and movies. Her work has appeared in publications such as *Libération, Paris Match,* and *Marie Claire,* and she has published several books, including *Sur les Traces de l'Afrique Fantôme* and *En Route pour Behring.*

Taiji Igarashi
Japanese/Tokyo
Born in Japan in 1959, Taiji Igarashi received a B.A. in anthropology from West Virginia University, and then joined the Institute of African Studies at the University of Nairobi in Kenya. After graduating from the Japan Photography Institute in Tokyo, he began work on the "Kilimanjaro Project," conveying the beauty of Mount Kilimanjaro and Africa in general.

John Isaac
Indian/New York
From 1969 to 1998, John Isaac worked for the United Nations, traveling to more that 100 countries, and spending his last years there as the chief of the photo unit. He has also photographed for UNICEF, working closely with Audrey Hepburn, Harry Belafonte, and Liv Ullman. Among his numerous national and international awards is a Lifetime Achievement Award from the International Photographic Council. He was the exclusive photographer of Michael Jackson's first baby, Prince, and has published several books.

Fanie Jason
South African/Cape Town
Fanie Jason began his career as a freelance photographer to supplement his income as a Bible salesman. His photographs have appeared in most South African newspapers as well as international publications such as *Time, The Times* (London), *The Daily Mail, The Observer,* and *The Evening Standard.* Jason is the recipient of the Abdul Sharif Award, and South Africa's Fuji Press Award in 2001.

Alexander Joe
Zimbabwean/Johannesburg
When Rhodesia's black townships became too dangerous for white photographers, Alexander Joe was able to secure his first staff photographer position, with a newspaper that had previously turned him down because of the color of his skin. Overcoming apartheid and prejudice, Joe's work has been published internationally and won

several awards, including one from World Press Photo. His work has been exhibited in Zimbabwe, the United Kingdom, Kenya, Mali, and France, and can be viewed on his website, www.alexjoe.com.

Ed Kashi
American/San Francisco
Since graduating with a photo-journalism degree from Syracuse University in 1979, Ed Kashi has worked in more than 60 countries, been published extensively around the world, and completed nine stories for *National Geographic*. His numerous honors include World Press Photo and Pictures of the Year awards. Kashi is currently working on a seven-year project with his wife, writer Julie Winokur, entitled *Years Ahead: Aging in America,* examining the social impact of the expanding elderly population in the United States. A book from this project will be published in the fall of 2003.

Nick Kelsh
American/Philadelphia
Nick Kelsh's work has appeared on the covers of several Day in the Life books. He co-authored the bestsellers *Naked Babies* and *Siblings* with writer Anna Quindlen, and also wrote and photographed *How to Photograph Your Baby, How to Photograph Your Family, How to Be Santa Claus* and *How to Be Dad*. He lives in Philadelphia with his wife, Anne, and his son, Chaz.

Douglas Kirkland
Canadian/Los Angeles
Working for *Look* and *Life* magazines, and shooting on the sets of more than 100 motion pictures, Kirkland has photographed every significant celebrity and beautiful face of the last 40 years. He has published several books, including *Icons*, and his work is part of the permanent collection at the Eastman House in Rochester, New York. Kirkland is the recipient of several awards, including a Lifetime Achievement Award from the American Society of Operating Cameramen.

Gary Knight
British/London
Gary Knight is currently focusing on war crimes and the application of the Geneva convention, and is working on a book project with writer Anthony Loyd called *Evidence: War Crimes in Kosovo*. Knight's photographs have been widely published by magazines all over the world, and exhibited at the United Nations and in galleries in London and Asia. A founder of the VII photo agency, his many awards include two Pictures of the Year.

Antonin Kratochvil
Czech/New York
Globe-trotting Antonin Kratochvil is known for staying on assignment for as long as it takes to get the right picture. A photographer since 1973, he has received numerous honors, including the Leica Medal of Excellence, the Alfred Eisenstadt Award, and Photojournalist of the Year from the International Center of Photography. He is the author of three books, and is a founder of VII.

Joachim Ladefoged
Danish/Copenhagen
Joachim Ladefoged was a newspaper photographer for seven years before going freelance in 1998. In 2000, he published a book of his pictures from Albania and Kosovo, entitled *Albanians*. He has received two World Press Photo awards, the Visa d'Or news award at the Visa pour l'Image international photojournalism festival in Perpignan, France, and the Eisie award in *Life* magazine for best news photo essay. In 2000 he joined Magnum Photos as a nominee.

François Lagarde
French/Paris
A doctor specializing in tropical and emergency medicine, François Lagarde was a director of scientific films and created one of the first online services before becoming a photographer. He has crossed Algeria on a motorcycle, Burkina Faso in a truck, and Monument Valley in a powered paraglider. He now participates in numerous expeditions for organizations such as the National Geographic Society and the BBC.

Daniel Laîné
French/Paris
Daniel Laîné has worked as a bike messenger, bureaucrat, university professor, sailor, farmhand, and travel guide. Since starting his photojournalism career with *Libération,* he has worked with magazines such as *GEO, l'Express, VSD,* and *Gamma,* and has been a correspondent in western and central Africa for Agence France-Presse. He has published three books, including *Kings of Africa,* which won Villa Médicis Hors-les-Murs ("outside the walls") and World Press Photo awards.

Andre Lambertson
American/New York
Andre Lambertson joined the Saba agency in 1997, the same year he became a contract photographer for *Time* magazine. His work has also appeared in *Life, The New York Times Magazine, The London Sunday Times,* and *U.S. News & World Report*. His many honors include a World Press Photo and four Pictures of the Year awards. Lambertson is part of the Smithsonian's *History of Black Photographers* exhibition, and teaches documentary photojournalism at New York's International Center of Photography. He is the recipient of the George Soros Media Fellowship.

Michael S. Lewis
American/Denver
A freelance photographer, Michael Lewis has worked on projects for the book division of the National Geographic Society since 1995. Recently he traveled to eight countries in Africa for a large-format book for the National Geographic Society, published in 2001. In addition to work for books and magazines, his images have been exhibited in Paris, Taipei, and Tokyo, and can be seen on his website, www.michaellewisfoto.com. Lewis also leads photo workshops in Africa with his partners, Mango African Safaris.

Kim Ludbrook
South African/Johannesburg
Kim Ludbrook is a senior photographer with the *Star* newspaper in Johannesburg and a stringer for the Associated Press. His work has been published in *Time, Newsweek, Libération, The Telegraph, Sports Illustrated,* and *Marie Claire*. He has had solo exhibitions and helped create the South African Press Photographers Group. Last year he won six awards at the South African Fuji Press Photographer of the Year competition. His images can be viewed at www.kim.co.za.

Gerd Ludwig
German/Los Angeles
Gerd Ludwig has been shooting primarily for *National Geographic* since 1989, mainly documenting his native Germany and the former Soviet Union after the fall of Communism. His recent book, *Broken Empire: After the Fall of the U.S.S.R.,* published by the National Geographic Society, is a retrospective of the images recorded during this 10-year period. Ludwig's work has also appeared in *Time, Life, Newsweek, Fortune, GEO,* and *Stern,* among other publications.

Pascal Maitre
French/Paris
Pascal Maitre has photographed conflicts the world over, and has published his work in *GEO, Stern, Time, Life,* and *Le Figaro*. His published books include *Afrique, Rwanda, Barcelona,* and *Zaire*. In 1986, Maitre won a World Press Photo Award for his work in Iran. He is associated with the agency GLMR Associés/SAGA Images.

> *A street portrait in Harare, Zimbabwe, by Alexander Joe.*

Alex Majoli
Italian/Milan and New York
Born in Italy in 1971, Majoli has worked extensively around the world, including Macedonia, Albania, the former Yugoslavia, Brazil, and Mongolia. He documented the last days of the Leros insane asylum in Greece, and has filmed music videos and documentaries. He is currently working on projects about the people of Albania and port cities around the world. In 2001 he became a member of the Magnum photo agency.

Jean-Luc Manaud
French/Paris
Born in 1948, Jean-Luc Manaud first worked in arts and theater photography, then began to specialize in documenting Saharan and western Africa. The founder of l'Atelier Press and Odyssey Images agencies, he has photographed for magazines such as *GEO*, *Le Figaro*, and *l'Express*. His work has been widely exhibited in France and elsewhere, and he is the author of many books, including *Le Désert Nu* and *Le Fleuve des Sables*. He is a member of the Rapho agency.

Greg Marinovich
American/Johannesburg
Greg Marinovich is co-author of the best-selling nonfiction book *The Bang Bang Club*, and a Pulitzer Prize–winning photographer. His images have appeared in *Time*, *The New York Times*, *The Washington Post*,

and the *Guardian* (London), among others. His numerous awards include a United Nations award of Recognition for Services to Humanity in 1994.

James Marshall
American/Brunswick, Maine
During the past 20 years, James Marshall has covered events as diverse as the fall of the Berlin Wall, the reunification of Hong Kong with China, and Alaska's Iditarod sled-dog race. He has co-produced three books, including *Hong Kong: Here Be Dragons* and *A Day in the Life of Thailand*, and contributed to others including *A Day In The Life of Israel*. Marshall is represented by Corbis and The Image.

Victor Matom
South African/Johannesburg
A self-taught photographer, Victor Matom was born in 1959 in Soweto, South Africa, and has been teaching photography to underprivileged youth since 1988. He is a 2001 recipient of the Mother Jones Photojournalist Award for his ongoing project *Sifikile* ("We Have Arrived"), on the Soweto community. He is a freelance photographer for local and international publications. His solo and joint exhibitions have been shown in Japan, Germany, Denmark, the Philippines, Britain, Hong Kong, and South Africa.

Dilip Mehta
Indian/New Delhi
A member of Contact Press Images,

Dilip Mehta has covered the Bhopal gas tragedy, as well as political and social developments in India, Pakistan, the United States, Russia, China, and a host of other countries. His pictorial essays have appeared in magazines such as *Time, National Geographic, Newsweek, GEO, Le Figaro,* and *The New York Times*. He is currently producing an in-depth photo essay on India for both the German and French editions of *GEO*.

Susan Meiselas
American/New York
Susan Meiselas received her B.A. from Sarah Lawrence College and her M.A. in visual education from Harvard University. She joined Magnum Photos in 1976. She is the author of three monographs, the editor of four collections, and the co-director of two films. She recently launched a website for collective memory and cultural exchange called *aka Kurdistan* (at www.akakurdistan.com). Her work has been shown internationally, and she is the recipient of several awards, including the Robert Capa Gold Medal and the Hasselblad Award. Meiselas was also named a MacArthur Fellow.

Pierrot Men
Malagasy/Fianarantsoa, Madagascar
Born in 1954 in South Midongy, Madagascar, Pierrot Men now manages a photography lab, Labo MEN, in Fianarantsoa. Since 1985, Men's work has been shown in over 40 national and international exhibitions, and appeared in nine books. Among other honors, he is the recipient of a Mother Jones Photojournalist Award.

Gideon Mendel
South African/London
Born in Johannesburg in 1959, Gideon Mendel studied psychology and African history at the University of Cape Town. He photographed change and conflict in South Africa in the days leading to Nelson Mandela's release from prison. In 1990 he moved to London and joined Network Photographers. He has been addressing the subject of AIDS in Africa since 1993, and over the past decade has received a number of awards, including six from World Press Photo, and the Pictures of the Year Canon Photo Essay Award.

Doug Menuez
American/Sausalito, California
Doug Menuez has covered a wide range of stories over his 20-year career for *Time, Newsweek, Life,* and

Fortune, including the Ethiopian famine, the Olympics, the AIDS crisis, and the rise of Silicon Valley. His work has been featured in numerous books, including eight Day in the Life projects. Menuez currently shoots advertising and fashion campaigns for major brands such as Coca-Cola, and his new book on tequila, *Agave Amanecer,* will be published in 2003.

Pedro Meyer
Mexican/Mexico City and Los Angeles
Pedro Meyer founded both the Latin American Colloquium of Photography and the Mexican Council of Photography. His work has been exhibited in more than 100 solo exhibitions, and in the collections of 40 museums. His several books include *Truths and Fictions*. A pioneer in digital photography, Meyer created the first CD-ROM to combine photographs and sound, the award-winning *I Photograph to Remember*. Meyer is also the founder, publisher, and editor of *ZoneZero* (at www.zonezero.com), which presents the work of photographers, artists, and writers and receives hundreds of thousands of visitors per month.

Yoshiko Murakami
Japanese/Paris
Born in Tokyo in 1966, Yoshiko Murakami is a graduate of the Nihon University of Arts, and has lived and worked in Paris since 1991. Murakami has received several awards, including a CCF and Jun-Taiyo Prize (Japan). She has published the book *Les Mains pour Voir*, and has had many exhibitions in Europe. She works for the French and Japanese press as an independent photographer.

James Nachtwey
American/New York
James Nachtwey's *Time* cover story about the African AIDS crisis in February 2001 served as inspiration for *A Day in the Life of Africa*. One of the most celebrated photojournalists of our time, Nachtwey has covered wars, conflicts, and critical social issues in every region of the world. A member of Magnum until September 2001, when he co-founded VII, Nachtwey has received numerous honors including six Magazine Photographer of the Year awards in the United States. He has published several books, and is a Fellow of the Royal Photographic Society. He holds an Honorary Doctorate of Fine Arts from the Massachusetts College of Arts.

> *Yoshiko Murakami found eager subjects on Mautsi Mountain in the tiny southern African kingdom of Lesotho.*

> *Logging in Ndoki, Congo, by Antonin Kratochvil.*

Claude Pavard
French/Paris
Claude Pavard has the good fortune to specialize in photographs of the Seychelles Islands. Over the past 30 years, he's participated in the creation of numerous books, films, and recently DVDs showcasing the beautiful islands, as well as other African countries. Among his other positions, Pavard sits on the Board of Trustees of the Seychelles Islands Foundation.

Pierre Perrin
French/Paris
A war correspondent in Iraq, El Salvador, and Lebanon, Pierre Perrin has published several books, including *Nomads: The Free People,* which follows the lives of six different nomad groups. He is the creator of two TV documentaries, *Autumn Voyage* and *Lord of the Islands*, and is a World Press Photo winner. His current project is *People with a Destiny* , portraits of people who are fighting for a cause.

Per-Anders Pettersson
Swedish/Cape Town and New York
Since 1985, Per-Anders Pettersson has covered major news and feature stories in more than 40 countries, most recently in Afghanistan, the Balkans, Ethiopia, Mozambique, Pakistan, Zimbabwe, and South Africa. His work has appeared in publications such as *Stern, GEO, Newsweek,* and *The Independent* (London). He has produced one book, and his work on the "Flying Squad," a South African police unit, was exhibited at the Visa pour l'Image international photojournalism festival in Perpignan, France. Pettersson is currently working on a book chronicling democracy in South Africa since 1994.

Larry C. Price
American/Denver
The assistant managing editor for photography for *The Denver Post*, Larry Price is a two-time Pulitzer Prize winner: first for his coverage of the 1980 coup in Liberia, and again in 1983 for his coverage of the civil wars in Angola and El Salvador. Price's photographs have appeared in *Time, Newsweek, U.S. News & World Report, GEO, National Geographic, Audubon,* and other magazines and newspapers. His other numerous awards include honors from World Press Photo.

Noël Quidu
French/Paris
A photojournalist with Gamma since 1988, Noël Quidu has covered conflicts in Afghanistan, Lebanon, the Persian Gulf, the former Yugoslavia, Rwanda, Chechnya, and other war zones. His work is regularly published in the world's largest news magazines. His report on the fall of Slobodan Milosevic in Belgrade was honored at the World Press Photo awards. Of his work, he says, "Often, images are the only things we retain of history."

Chris Rainier
Canadian/Aspen, Colorado
Chris Rainier's images of sacred places and indigenous peoples have been seen in *Time, Life, National Geographic, Smithsonian,* and German and French *GEO,* as well as publications of the International Red Cross, the United Nations, and Amnesty International. He is the author of two books, and is currently working on a new book about traditional and contemporary tattooing and scarification. He directs the *Cultures on the Edge* website (at www.culturesontheedge.org) with author Wade Davis. His work can also be seen at www.chrisrainier.com.

Eli Reed
American/New York
A 1982 Nieman Fellow at Harvard, Eli Reed was the first living artist to have a major exhibition at the Bruce Museum in Greenwich, Connecticut. His work has appeared in numerous books, and many international exhibits including his own *Black America* project. Since 1990, he has worked on a number of films including the Oscar-winning *A Beautiful Mind*. In 1992, he directed and filmed *Getting Out*, a documentary on Detroit gangs. A Magnum photographer since 1983, Reed has received numerous honors, including the Leica Medal of Excellence, the E. Eugene Smith Grant in Documentary Photography, and a World Press Photo award.

Leslie Reti
Australian/Melbourne
Leslie Reti is a practicing obstetrician/ gynecologist with an interest in public health. He has been a keen photographer for many years, and it was this combination of interests that led to his assignment at Baragwanath Hospital in Soweto. As well as being a photographic stringer, Reti volunteered in *A Day in the Life of Africa*'s Paris headquarters.

Patrick Robert
French/Paris
Since 1982, Patrick Robert has covered virtually every war in Africa and the Middle East. A Sygma photographer since 1987, he has won seven awards for his reports on the civil war in Liberia and Sierra Leone, and two for his coverage of the Kurds' exodus after the Gulf War.

Sebastião Salgado
Brazilian/Paris
Born in Aimores, Brazil, in 1944, Sebastião Salgado decided to become a photographer while visiting Africa as an economist in the early 1970s. He has gained international acclaim for his large-scale photographic projects, including *Workers,* a study of manual labor around the world, and *Migrations: Humanity in Transition.* Perhaps the world's most respected photojournalist, Salgado's more than 50 awards include the International Center of Photography's Photojournalist of the Year, the W. Eugene Smith Award for Humanitarian Photography, and the Alfred Eisenstaedt Life Legend Award. A member of Magnum from 1979 until 1994, Salgado is now represented by his own agency, Amazonas Images.

Jeffery Allan Salter
American/Miami and New York
A former *New York Times* staff photographer, Jeffery Allan Salter's work has appeared in six books and many major magazines, including *Rolling Stone, Fortune,* and *Forbes*. While also focusing on cinematography, Salter is a staff photographer for *Sports Illustrated,* and is represented by Corbis Saba. His photography can be seen at www.jefferysalter.com

Lougue Issoufou Sanogo
Ivorian/Abidjan
Lougue Issoufou Sanogo studied photography at the Abidjan Institute of Arts, and since 1990 has reported for Agence France-Presse, covering assignments throughout Africa including Liberia, Congo-DRC, and Sierra Leone. He has covered elections, war, and political violence, as well as major African sporting events, culture, and feature stories.

Emmanuel T. Santos
Australian/Melbourne
For the last 15 years, Emmanuel Santos has traveled to more than 25 countries, including trips to the Carpathian mountains, Ukraine, and the Maori tribal lands in New Zealand, in a quest to document the Jewish Diaspora around the world. Santos' photographs are featured in several museums internationally, and he was the recipient of a Philippine Presidential Award.

Jeffrey Henson Scales
American/New York
When Jeffrey Scales was 11, his father gave him his first Leica. Since then, he has documented a variety of communities throughout the United States and abroad. He is exhibited and widely collected—privately, and in museums in the United States. For more than 20 years, Scales worked as a photographer in the music and film industries. He has been a photo editor for *The New York Times* since 1998. His photos can be seen at www.hensonscales.com.

John Stanmeyer
American/Hong Kong
A fashion photographer in Milan during the 1980s with magazines such as *Interview* and *Harpers Bazaar*, John Stanmeyer started working as a photojournalist at a local Florida newspaper in 1989 while refurbishing a wooden ketch sailboat. Associated

with the Saba agency until 2000, he is a founding member of VII and has been a contract photographer with *Time* since 1998. Winner of a World Press Photo Award, he is currently working on a book about AIDS in Asia with his wife, a writer.

Chris Steele-Perkins
British/London
Born in Burma in 1947, Chris Steele-Perkins became a Magnum photographer in 1982. He has received, among other awards, a Robert Capa Gold Medal from the International Center of Photography and a World Press Photo Award. His work on Afghanistan and Mount Fuji has been exhibited internationally, and he is the author of seven books, including *The Teds* and *Beirut: Frontline Story.*

George Steinmetz
American/Los Angeles
George Steinmetz began his career in photography by hitchhiking through 17 African countries. He has completed 11 assignments for *National Geographic* magazine, and has won two World Press Photo awards. His current passion is photographing the world's deserts from a motorized paraglider, but Steinmetz claims that his life's most significant adventure is his daughter, Nell, and his recently born twin sons, Nick and John. His work can be seen at www.georgesteinmetz.com.

Tom Stoddart
British/London
A photographer for more than 30 years, Tom Stoddart has covered such major events as the fall of the Berlin Wall, the siege of Sarajevo, and Nelson Mandela's election victory. Stoddart's work has received much acclaim and many international awards. His harrowing photographs of the famine in Sudan raised public awareness of the situation worldwide and many thousands of dollars for charity. Most recently Stoddart has been documenting the devastating effect of AIDS in sub-Saharan Africa.

Djibril Sy
Senegalese/Dakar
Djibril Sy began his career in the photo lab of L'École Nationale des Beaux Arts de Dakar. Since then, he has worked as a photo studio assistant in Mauritania, run a photo service at the mayor's office in Dakar, and served as a photography professor. Currently he is a photojournalist at the PanAfrican News Agency.

Guy Tillim
South African/Paris
Guy Tillim started photographing in South Africa in 1986, where he has freelanced for national and international publications. He has contributed to a number of collective exhibitions of South African photographers, and had a 2001 solo exhibition, *Quito, Angola,* in the South African Museum. He was a 2001 finalist for the Prix CARE Internationale du Reportage Humanitaire.

David Turnley
American/New York
Winner of the 1990 Pulitzer Prize for photography, and two World Press Pictures of the Year, in 1988 and 1991, David Turnley has covered world events in 75 countries over the last 20 years. Turnley studied filmmaking at Harvard in 1997 and 1998, and has just directed and photographed an epic and widely acclaimed feature-length documentary, *La Tropical,* about a dance hall in Cuba. He holds an honorary doctorate from the New School of Social Research in New York.

Peter Turnley
American/Paris
Based in Paris since 1978, Peter Turnley has worked in more than 85 countries and covered most of the world's major news stories during past two decades. He has won the Overseas Press Club award and has received many awards from World Press Photo and Pictures of the Year. His work is published extensively worldwide. He has published four books, and his photos have appeared on the cover of *Newsweek* more than 40 times. A 2000 Harvard Nieman Fellow, Turnley has degrees from the University of Michigan, the Sorbonne, the Institut d'Études Politiques in Paris, and has an honorary doctorate from New York's New School of Social Research.

Laurent Van der Stockt
French/Paris
A Day in the Life of Africa was Laurent Van der Stockt's first assignment since recovering from a gunshot wound to the leg suffered on assignment in Israel. A staff photojournalist for Gamma Press Images, Van der Stockt's work has appeared internationally for close to 20 years, in publications such as *Newsweek, The New York Times, Stern, Paris Match, l'Express,* and *El País.* He is the father of twin sons.

Lori Waselchuk
South African/Johannesburg
Lori Waselchuk's photographs have been published in *Time, Life, Newsweek, The New York Times, The Washington Post,* and the *Chicago Tribune,* among others. She also produces documentary essays, and her most recent solo exhibition, *African Nights,* is touring internationally. Waselchuk was an Alfred Eisenstaedt Award finalist. She lives with her two children and husband in Johannesburg.

Patrick Zachmann
French/Paris
A Magnum member since 1990, Patrick Zachmann received the Prix de la Villa de Médicis Hors-les-Murs for his 10-year project on the Chinese diaspora, and in 1989 won the Prix Niépce. He contributes to the world's leading international newspapers and magazines; his several books include *Madonna!, W., or the Eye of a Long-Nose,* and *Malians Here and There.*

Hocine Zaourar
Algerian/Algiers
Hocine Zaourar served as a correspondent in Algeria for Sipa Presse-Paris from 1986 to 1989. He then spent five years as the Algeria correspondent for Reuters. He is a World Press Photo Award winner, and is currently a reporter-photographer for Agence France-Presse.

Francesco Zizola
Italian/Rome
A Magnum photographer, Francesco Zizola has covered international news for publications including *Newsweek, Time, Stern,* and *Le Figaro* since 1981. A winner of awards from World Press Photo, Pictures of the Year, and others, Zizola is currently completing his project *Heirs of 2000,* a series focused on the condition of children around the world, designed in cooperation with UNICEF. He has published three books, including *États d'Enfances* in the Photo Poche series.

Staff

Project Director
David Elliot Cohen

Producer
Lee Liberman

Senior Editors
Charles M. Collins
Dawn Sheggeby

Director of Photography
Eliane Laffont

Design Director
Thomas K. Walker

Senior Project Advisors
Ariane de Bonvoisin
Mark Greenberg
Reuel Khoza
Heather King
Alan Norman
Spencer Reiss
Garry Stock

Project Manager
Corinne Nagy

Partnership Director
Lael Weyenberg

Public Relations Director
Gina Privitere

Art Director
Patrick Lébédeff

Design Assistant
Shuana Ndiaye

U.S. Sales Director
Carole Bidnick

Finance Manager
Devyani Kamdar

Logistics Coordinator
Peter Goggin

Copy Editor
Magdalen Powers

Intern
Anna Battersby

Legal Advisor
Philip B. Feldman
Coblentz, Patch, Duffy & Bass LLP

Writer
Susan Wels

Assignment Editor
Louise Gubb

Editorial Consultant
Robert Pledge
Contact Press Images

Picture Editors
Guy Cooper
PictureDesk International

Michel du Cille
The Washington Post

Sandra Eisert

Michele McNally
Fortune

Zohra Mokhtari

Research Advisors
Prof. Joel Samoff
Center for African Studies,
Stanford University

James Lowell Gibbs, Jr.
Martin Luther King, Jr. Centennial
Professor of Anthropology,
Emeritus, Stanford University

Video Consultants
Robert Wiener
Rolf Behrens

Digital Photography Consultant
Kevin T. Gilbert
Blue Pixel Digital Experts

**A Day in the Life of Africa AIDS
Education Fund Advisory Board**

Lee Liberman, Chair

David Elliot Cohen

William S. Glass
Johns Hopkins University Center
for Communication Programs

Dr. Garth Japhet
Soul City Foundation

Susan Krenn
Johns Hopkins University Center
for Communication Programs

Dr. Richard Marlink
Harvard AIDS Institute

Dr. Rob Moodie
VicHealth

Prof. Leslie Reti
La Trobe University

Garry Stock

Les Editions du Pacifique
Didier Millet
Marie-Claude Millet
Valérie Millet
Loïc Cohen

Publishers and Distributors

Tides Foundation
Patrice Cochran
Charlie Fernandez
Christopher Herrera
Idelisse Malave
Jose Perez
Drummond Pike
Jason Sanders
Lauren Webster
Jon R. Tandler, Legal Advisor

Publishers Group West
Trigg Robinson McLeod
Angela Favero
Charles Winton
Mark Ouimet

Editions Filipacchi (Paris)
Marie-Françoise Audouard
Isabelle Lévy

**GEO, Gruner + Jahr AG & Co.,
Hamburg**
Ruth Eichhorn
Nadja Masri

Penguin Books Australia Ltd.
Robert Sessions
Peter Blake
Gabrielle Coyne

**Penguin Books (South Africa)
Pty. Ltd.**
Alison Lowry
Helen Suzor
Janine O'Connor

Penguin Books (New Zealand) Ltd.
Tony Harkins
Geoff Walker
Margaret Thompson

Printing
Tien Wah Press
Chiu Leng Campos,
Director

Original Website Team
Thomas K. Walker, Design
David Wisz, Development

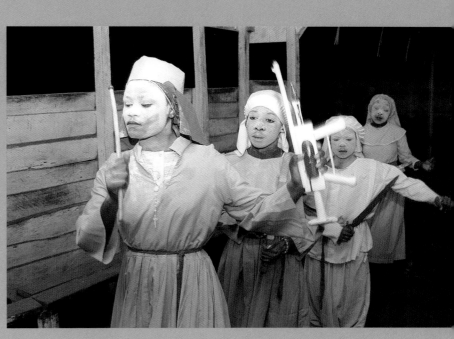

> *A religious ceremony in Malabo, Equatorial Guinea,
by Diego Goldberg.*

Thank You

Countless people in Africa and around the world helped make this project possible. Many generously gave their time, knowledge, and support. We are grateful to each of them.

Naba Abbasse
Aly Abdel Aziz
Cheru Abebe
Rhea Abramson
Ray Acevedo
Kimberlee Acquaro
Hassan Ahdab
Hilla Ahvenainen
Sara Akoko
Jackie Albouy
Bill & Lucie Alexander
Justin Paul Alexander
Liz Alexander
Pam Alexander
Timoteo Almeida
Emmanuel Alquier
Vincent Amalvy
Richard Amdur
Kent Anderson
Yemi Ann Aneke
Pambo-Pambo Anicet
Jeff Appleman & Suzanne Engleberg

Hagos Araya
Corine Archambaud
Jeanne Moutoussamy Ashe
Stéphane Aurange
Governor Abdel Aziz
Tiphanie Babinet
Ana Baca
Michèle Bailly
Peter & Michelle Baird
Corinne Baldassano
Cathy Baran
Ron Barboza
Guy Bardet
Chris Barnard
Prof. Louis Barnes
Maurice Barnes
Tony Barrett
Jennifer Barry
Kimberley Barry
Brenda Barton
Mara Batlin
John Battersby

Enid Beal
Rob & Erin Becker
Anneke Beech
Rahou Belghazi
Colin Bell
Jamil Bellakhal
François Bélorgey
Karin Bengeloune
Nathan Benn
Alex Benzaquen
Ron Berg
Geoffrey H. Bergen
Mamadou Beye
Bipin & Bharti Bhayani
Geoff Biehler
Agnes Biribonwa
Bius
Jeff Blackburn
Martha Blanchfield
Adam Block
Carol Bogert
Derryn Bond
Philippe Bonnot
Wendy Botha
Gérard Bouchereau
Daniel Boudet
Annie Boulat
Amel Boumediem

Gerard Bouquet
Kim Bourus
Sofia Boutsi
Béatrice Bouyer
Paul Bozymowski
Barbara & Stuart Brenner
Michah Brenner
Kyle Breuning
Lauren Breuning
Olivia Brillaud
Michael Brooks
Zvi Brooks
Lois & Jerry Browdie
JoBeth Brown
Judith Brown
Ron Brown
Schyleen Qualls Brown
Lavinia Browne
Greg Brunkalla
Wendy Buck
Chuck Burgess
Matt Burgess
Kathy Bushkin
Cathy & Michael Calhoun
Bruno Callabat
Mukti Campion
Elise Cannon
Joël & Betty Cardon
John Carlin
Pamela Carlton
David Carriere
Jeffrey Cassaro
Martha Casselman
Mike Cerre
Ani Chamichian
Heimata Champs
Alice Chan
Sharman Chan
Claudia Cheek
John Chiahemen
Eric Chinje
Arta Christiansen
Dale & June Christiansen
Tom & Barbara Christopher
Scott Chronert
Vincent Cimino
Michael Claes
Susan Clark
Leigh Claxton-Smith
Chester & Jessica Clem
David & Kathy Clem
Bethany Clement
William Coblentz

Dan, Stacey, Andrew, Maddie & Josh Cohen
Kara Cohen
Lucas Cohen
Norman & Hannah Cohen
William G.K. Cohen
Johnny & Shannon Colla
Alejandro Collins
Atif Collins
Chip & Sylvia Collins
Daniel Collins
Daniel Collins, Jr.
DeReath Collins
Edward Collins, Jr.
Hilary Collins
Julia Collins
Paula Collins
Penelope Collins
Sara Collins
Robin Comley
Kevin Conroy
Dr. Joseph Cook
Toby Coppel
Don W. Cornwell
Anne-Marie Couderc
George Craig
Michael Creedon
Jos Creemer
Isabelle Croisy
Jonathan Cropper
Luis Cubillos
Barry Curran
Sibylle D'Orgeval
Jose Da Silva
David Dahl
Abel Damergi
Aghali Danda
Lucille Dandelet
Lee Daniels
Debbie Darr
Jean Daudens
Frederick Davidson
Anne Davis Gillet
Inken de Boer
Alexandre de Bonvoisin
Benoit de Bonvoisin
Pierre de Bonvoisin
Steve de Bonvoisin
Michele de Jonghe
Sybille de la Hamaide
Roger de la Harpe
Nadege de la Vigne
João Miguel Monteiro de Pina

> *Near the Meroë ruins in Sudan by Chris Rainier.*

Marc de Temple
Tim Dean
Roy DeCarava
Ray & Barbara Demoulin
David Deniger
Marc Devroye
Mamadou Dia
Tara Roy DiClemente
Katherine Dillon
Augustine Dioh
Assane Diop
Samuel Diop
Dennis M. Doherty
Freddie Dorn
Paul Dossou-Yovo
Patrick Dourouze
Steve Draffen
Christopher Michael
Jackson Drake
Anne Dronnier
Virginie du Blanc
Alexis du Roy
Hendrik du Toit
Corinne Dufka
Melissa Duran
Oscar Dystel
Lois & Mark Eagleton
Michelle Ebanks
Ayperi Ecer
Emma Agnes Eckling
Onna Ehrlich
Gianmarco Elia
Patrick Endaya
Achenef Engdaw
Jeff & Susan Epstein
Jennifer Erwitt
Ahmend Esa
Bill Evans
Paul Eveloff
Cesaria Evora
Petunia Exacoustou
Belletech Eyakem
Connie Eysenck
Ido Ezra
Abby Falik
Bill Falik
Candy Cohen Falik
Shirley Faragher
Francesta Farmer
Karim Fehry Fassy
Lisa, Hope, Hannan &
Jack Feldman
Pierre Fernandez
Graham Fidler
Colin Peter Field

Patrick Finance
Jeremy Fingerman
Beverly Fisher
Kathy & Michael Fitzgerald
Lilibet Foster
Christopher Fowler
Jonathan Frantini
Cynthia Freeman
Peider Fried
Zhenya & Yury Friedman
Peter & Margot Friend
Susan Fryer
Sonia Fuentes
Jack Fulton
Johnny Furr, Jr.
Alex & Samira Furrer
Margarita Gaillochet
Jeff Gaisford
Rob Galbraith
Marco Ganouna
Nando Garcon
Nelly Garcon
Suzanne Garland
Cindy Garrone
Anna Gasner
Mike Gavshon
Abdoulaye Gaye
Thulani S. Gcabashe
Alain Genestar
Caroline Geraud
Bill Getz
Yves Gillis
Kai Gittens
Hope Gladney &
Thomas Skinnar
Michel Gnanou
Jérôme Goehner
Les Gold
Betty Jean Goldblum
Philip & Lauren Goldblum
John Goldblum & Asmita
Sherali
Tracey Goldblum
MaryAnne Golon
Armindo Manuel Soares
Gomes
David Gonski
Danny Gorog
Thandeka Gqubule
Richard Graille
Becky Green
Eric Green
Dominique Nicole Griffin
Joshua Grossnickle
Heinz Grub

Lisa Guidetti
Jim Gustke
Shine-On Hadebe
David "El Hag" Hagerman
Corey Hajim
Deron Haley
Doug Halperin
Chas & Samuel Hamilton
Charles J. Hamilton, Jr.
Carl Hansen
Sarah Harbutt
Charles Hardwick
Acey Harper
Ben, Hilary & Sam Harris
Bill & Robie Harris
Cassy Liberman Harris
David, Emily & Ella Harris
Gabriel Harris
Kamala Harris
Michael Harris
Toby Harris
Russell Hart
Karen Harvey
Michael Hawley
Luddy Hayden
Steve Hayden
Marta Heilbrun
Peter & Robyn Heilbrun
Sara Heilbrun
Jim Heiser
Brigitte Helali
John Heminway
Meg Henson
Lisa Herren
Kim Herter
Shaye Hester
Tony Hickey
Kenji Higuchi
Heino Hilbig
Dorothy Ho
Reed Hoffmann
John Hofsetter
Amanda Holiday
Nick & Linda Hoppe
Richard House
Jerry Hsu
Bill Hudson
Bill Hutton
Eniwoke Ibagere
Raita Igarashi
Toshiko Igarashi
Tunde Ilevbare
Jeannette Isaac
Claire Isaacs
Charles Isaacson

Shirley Jackson
John E. Jacob
Veronique Jacobs
Vuyani Jacobs
Ricardo James-Branger
Lee-roy Lethuli Jason
Steve Jobs
Morris Joffe
Don Johanson
Ineke Jongerius
Vernon Jordan
Bini Julien
William Kaiser
Titus W. Kakembo
Dorothy Kalens
Anna Kamdar & Todd
Simmons
Dipu, Dipti & Usha Kamdar
Ketan, Shilpa & Amit
Kamdar
Mira Kamdar & Michael
Claes
Paresh & Viren Kamdar
Prabhakar P. Kamdar
Pravin Kamdar
Vinoo & Chitra Kamdar
Jon Kamen
Jill & Steve Kantola
Jeffrey A. Katz
Jim Kaufman
Jesse Kornbluth
Denise Keim
Kipchoge "Kip" Keino
Doug Kellam
Patricia Kelly
Sami Kemer
Tina Kennedy
Harlan & Sandy Kleiman
Daniel & Ace Kilduff
Bernard Kilembe
Dr. Peter Kilima
Marshall Killduff
Mervyn King
Wade King
Bonnie Kinnare
Kevin Kinton
Harry Kirchner
Francoise Kirkland
Father Kizito
Randall Kline
John Knaur
Luke Knowland
Kadim Kor Diop
Sister Leonia Kornas
Lisa Kovner

Kwindla Kramer
Tracy Kronzak
Michael Kutzner
Clarence Kwinana
Jean-Pierre Laffont
Stephanie Laffont
Isabelle Lambert
Patti Langdon
Sylvie Languin
Billy Lascaris
Emmanuelle Laudon
Heather Lauver
Cedric Lavington
Jeff Lawrence
Stephanie Le Gras
Peter Leon
Jean-François LeRoy
Lori Levin
Josh Levine
Liz Levy
Annelle Lewis
Ed Lewis
Huey Lewis
Berry Liberman
Joshua Liberman
Karen Liberman
Louise Liebenberg
Mark Liebman
Jonathan Lifa
Leslie Lindell
Riley Lindell Sykes
Susan Linnee
Lesego Lippe
Monia Lippi
Kimmo Lipponen
Milton Little
Ann Lloyd
John Lloyd
Tom & Brenda Lloyd
Susan Lloyd & John Karrel
Meaghan Looram
Zed Ed Lopez
Joe & Mary Lorenz
Katie, Chris & Jenna
Lorenz
Manuel Namo Lourenço
Maurice Loustau-Lalanne
Joan Lucas
Paula Luff
Flannan Lum
Eric Lustman
Symplice M'Barga
Doug & Dodie MacArthur
Sarah Macauley
Felicity Machaha

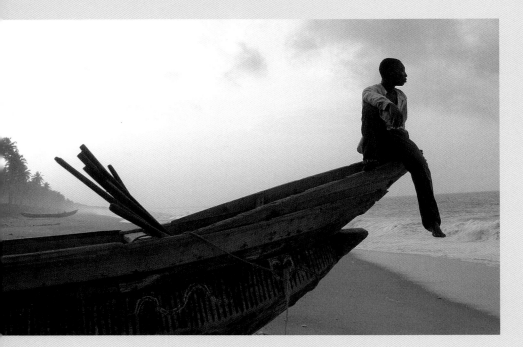

> *Early morning on Côte d'Ivoire's Atlantic shore, by Lougue Issoufou Sanogo.*

John & Diana Mack
Astrid & Samuel Mack-kit
Sandy MacKie
Robert MacKimmie
Sue MacKimmie
Sarah MacLachlan
Goodwin Makongolo
Idelisse Malavé
Malissa Malheiro
Meir Malinsky
Bochra Malki
Robert Mallett
Ithemba loo Mama
Carol Mann
Maria Mann
Leonie Marinovich
Melissa Maristuen
Steve Marriott
Brenda Marsh
Jerry Maryobane
Tom Masland
Joe Matsau
Minoru Matsuzaki
Yoshinori "Joe"
Matsuzawa
Zahn Matthee
Kenneth Matthews
Renee Matthews
Sacha & Xian Matthews
Jon Mayes
Stuart McAlister

Holloway McCandless &
Andy Belt
Jim McCarney
Neil McCarthy
Lance McCormack
Mardi McMillan
Molly McShane
Jeanne Menin
Tereza Menuez
John Mesjak
Bernard Messin
Jack Metz
Katie Meyer
Salvelio Meyer
Paule Micallef-Thonon
Jon Mecham
Julie Miller
Pamela Miller
Alexandre Millet
Nicolas Millet
Stéphane Millière
Richard Miner
Dave Minichiello
Bryon Miranda
Jacques Misery
Martha Mitchell
Ghislain Mitouamona
Maureen Mndaweni
William & Gail Monaghan
Haddadi Mohamed
Clement Mok

David & Lisa Monetta
Manny Monterrey
David Moody
Gloria Morales
Shonquis Moreno
Aubrey Morgan
Josh Morgan
Bernard Morin
Ed Mortimer
Margaret Mouton
Koni Mukoka
Pat Mulkey
Catherine Mwesigwa
Alexis N'Dema
Richard Nabare
Suzy Nagga
Christopher Nagy
David Nagy
Monique Nagy
Désiré Namé
Raymond Nasr
Susan Naythons
George Neill
Bill & Darrell Nelson
Grazia Neri
Christine Nesbitt
Michael Newler
Chris Newman
Dr. Edith Ngirwamungu
Minh Nguyen
Tee Nguyen

Doug Nichols
Jayne Nicholson
Arfan Njie
Victor Nosi
Larry Novick
Refiloe Ntsekhe
Chike Nwagbogu
Ofori Nyako
Margaret O'Conner
Fearghal O'Dea
Peg O'Donnell
Steve O'Rourke
Ochitti Ochora
Dr. Godwin & Lady
Rosemary Odumah
Kwabla Ofoe
Emiko Ogami
Harold Ogbe
Susie Ogilsby & Cornel
Riklin
Fayez Omar
Dullah Omarh
Abbey Omokhodion
Aku & Julia Omokhodion
Sola Omole
Kyosuke Ono
Idrissa Ouadraogo
David Ouimet
Ibrahim Ousman
John & Dawn Owen
Laurent Pageau
Jean-Yves Pageot
Ronald Palozzi
Francisco Pardorla
Heather Parsons
Richard Parsons
Meg Partridge
Jennifer Pascal
Craig Patterson & Toni
Brayer
Sandra Patterson
Gavin Pattison
Pia Paulson
Dominique Pavard
Lisa Pearce
Joshua Pearson
Ron & Anna Penner
Gabe Perle
Liz Perle
Linda Lamb Peters
Deirdre Peterson
Joel Petrus
Jean Christophe Peyre
Maureen Phelan
Sandra Phillips

Stan Phiri
Rebecca Phiyega
Tori Pinto
Michelle Pitts
Rose Polidoro
Veronica Pollard
Rosie Poluzzi
Charles K. Poole
Linda Powers
Eric Préau
Glyn Price
Hugh Price
Tom Privitere
Isabella Privitere-Coats
Marissa Privitere-Coats
Rob Privitere-Coats
Claudia Pronk
A. J. Pyatak
Mireille Queille
Liz Quinlisk
Aileen Randolph
Suzanne Randolph
Grace Rauh
Alessandra C. Ravetti
Peter Raymond
Thierry Raynard
Betty Redmond
Roy Remer
Gilles Renard
Lisa Reti
Nicole Reti
Eliane Reyff
Michael Reynolds
Skip Rhodes
Patti Richards
Peter Riddell
Bill & Jill Rieser
Denis Rimbert
Laura Robinson
Sheryl Robinson
Oussama Romdhani
Madelain Roscher
Cheryl Ross
John Rossant
Gabi Rozenwerth
Stuart Rubin
Jill Rudnick
Robert Ruscoe
Kiley Russell
Joan Ryan &
Barry Tompkins
Thomas F. Ryan, III
Jim Sackey
Nola Safro
Wayne Safro

Esther Salts
Curt Sanburn
Ellen Sanger
Bakary Sanogo
John Santoro
Kevin Saul
Cathy Saypol
Frank Scherma
Evan Schechtman
Hope Schmeltzer
Gilles Schneider
David Schonauer
Rose Ann Schott
Christophe Schpoliansky
Pat Schultz
Carol Schwartz
Ashley Shaw Scott
Robert Paul Scott
Philippe Seigle
Christian Seignobos
Jacqueline Sena Silva
Neo Serafimidis
Abdoul-Wahab Seyni
Ron Shapiro
Fred Sharples
Carol Sheggeby
Michael & Rosemarie
Sheggeby
Charlie Shorter
Randy Shorter
The Silla Family
Rob Silvers
Bruno Silvestre
John Simpson
Surjit Singh
Sheila Sitomer
M'hamed Skalli
Chris Sluka
Jeffrey Smith
Rick Smolan &
Jennifer Erwitt
Pheobe Smolan
Nancy Snyderman
Mario Soleiro
Mark Solomon
Gillian Sorensen
Michael Spicer
Lynne Staley
Eric Stang
Ioannis Stavrou
Lisa & Erick Steinberg
Michele Stephenson
Diane Stevens Robinson
Charlie & Mary Stewart
Donald Stewart

David Stoddart
Brian Storm
Dan Storper
David Mikhael Subotzky
Candace Sue
Conrad Sue
Frank Sue
Koichi "Kenny" Suzuki
Christopher Sweet
Elhadj Sy
Louise A. Tager
Bob & Patricia
Talbot Martin
Mariam Taleb
Zam Zam Tabit Taleb
David Talfryn
Sina Tamaddon
Jon Tandler
Chief Sammy Ole Tarakwai
Paul Tauber
Vukani Magubane Taylor
Dijan Te & Family
Claude Teton
Andrea Tetrick
Senator Amadou Thiam
Emma & Sam Thiam
Valérie Thiery
Micheal Tiampati
Todd Tieman
Joël Timaï
Andrew Thomas
Wayne Tlhagoane
Obadiah Tohomdet
Mark D. Tomlinson
Suzy Tompkins
Richard Tooro
Ella King Torrey
Victoria Treyger
Carl Trosch
Ross Trudeau
Kofi Tsikata
Ya Ye Tssaka
Sissie Twiggs
Richard Uku
Rosalie Vaccari
David Valdez
Carey Van Aswegen
Samantha Van der Walt
Dave Van Smeerdijk
Maxime Veron
Rebecca Vesely
Alex Von Perfall
Kevin Votel
Sylvia Vriesendorp
Dennis Walker

Mertie Walker
Zach Waller
Charles Ward
Cheryl Ward
Marva Warner
Juliette Warner-Joseph
Akira Watanabe
Françoise Vauzelle Weber
Deb Weekley
Penny Wensley
Eric Weyenberg
Anne Wickham
Marieke Eva Wiegel
Julian R. Williams
Pete Willmott
Ola Wirenstrand
Lisa Wolfe
Natacha Wolinski
Michael Wong
Sue Wong
Ashley Woods
Greg Woolley
Jennifer Wyatt
Kim Wylie
Frida Yara
Sylvia Zerbib
Francine Zermati
Tim Zielenbach
Trisha Ziff
Barry & Pam Zuckerman

ORGANIZATIONS

Acropolis Travel
Baraka Farm
Celica Church of
Christ Most Glorious
Congolese Ecoguards
Digital Pond
International Trachoma
Initiative
Kamuzu Academy
Kip Keino School
!Kung San People of
Tsumkwe
KZN Wildlife
Mangrove Project
Médecins Sans Frontières
Mother Of Mercy Hospice,
Chilanga, Zambia
National Tourist Office of
Djibouti
Nazareth House
Pfizer Inc. Colleagues
Poly Flash
Port Autonome
International de Djibouti
Putumayo World Music
Safari Par Excellence
Sand Rivers Safari Lodge
Selous National Park

SOS d'Abobo
Univer-Sel of Paludiers of
Guérande
The Village of Anani,
Ethiopia
Wildlife Conservation
Society
Working Group of
Indigenous Minorities in
Southern Africa

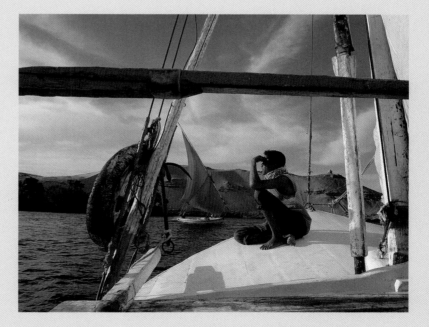

> *Sailing on the Nile near the Aswan High Dam in Egypt, by Alexandra Boulat.*

Corporate Partners

Underwriters

Pfizer

Pfizer, a company that discovers and develops medicines to save and enhance human lives, has a long-term commitment to Africa, based on nearly 50 years of doing business there. Through our operations and our health care partnerships, we are active in 26 African countries.

Pfizer is working in partnership with African governments, the worldwide medical community, non-governmental organizations, and charitable foundations to address several of the public-health issues facing Africa. Pfizer has established innovative healthcare alliances, built on a foundation of mutual trust and shared purpose.

Africans who contract the AIDS virus are often subject to life-threatening opportunistic infections. Through its Diflucan® Partnership program, Pfizer is working with governments to provide its antifungal medicine, Diflucan®, free of charge through government hospitals. While Diflucan® is not a treatment for HIV/AIDS, it has proven highly effective in treating two of the opportunistic infections that afflict large numbers of HIV/AIDS patients. The program, which includes patient education, physician training and ongoing support, was initiated in South Africa, and is expanding to other countries most in need.

Training doctors in the latest treatment options is vital to Africa's future. Pfizer and the Pfizer Foundation, in collaboration with partners, are actively involved in a new, large-scale initiative to train doctors from across Africa so they can transfer their knowledge to others at home. Through the Academic Alliance for AIDS Care and Prevention in Africa, they will build the first training and treatment facility in Africa, at the Makerere University Medical School in Kampala, Uganda. The facility will train medical professionals and provide an advanced clinical setting for treating patients with HIV/AIDS and other infectious diseases.

Much of Pfizer's experience in public-private partnerships comes from the success of the International Trachoma Initiative (ITI)—founded in 1998 by Pfizer and the Edna McConnell Clark Foundation. This program seeks to eliminate trachoma, a leading cause of preventable blindness, by the year 2020. ITI is actively fighting trachoma in six African countries and plans to expand the program further. In Morocco, trachoma-related blindness has declined by 75 percent in two years.

As Pfizer's experience has demonstrated, dramatic improvements in public health in Africa *are* possible. As the search to develop new cures continues, we are improving access to medicines and treatment for those who need it most. This, in turn, will help ensure a brighter future for Africa.

Olympus

Influential master photographer Edward Steichen once said, "Photography records the gamut of feelings written on the human face—the beauty of the earth and skies that man has inherited; and the wealth and confusion that man has created. It is a major force in explaining man to man."

A Day in the Life of Africa is an attempt to capture the continent's unique cultures, landscapes and wildlife, and preserve its most precious resource: its people. Participating in this project afforded Olympus the chance to provide its cameras and technology to some of the most talented photographers in the world. More important, however, was the opportunity for Olympus to make a significant contribution to help the people of Africa to fight, and eventually eliminate, the spread of the AIDS virus across the continent. As a global company, Olympus understands its responsibilities and the need to take actions that can help improve lives.

Before Olympus became known as a leading manufacturer of cameras, the company represented a pioneering spirit within the medical industry. Innovative thinking led Olympus to develop Japan's first microscope in less than a year's time. In the years since, Olympus products have been an integral part of medical advancements and milestones around the globe. *A Day in the Life of Africa* is yet another chance for Olympus to help globally.

Documenting the African environment required leading-edge technology and industry experience. With more than eight decades of optical expertise, Olympus was uniquely positioned to aid these world-class photographers in capturing the most realistic digital images, ensuring the quality required to create *A Day in the Life of Africa*. Olympus held technical training sessions and outfitted each photographer with two high-end digital cameras, along with portable printers, giving each photographer a photographic solution to capture that perfect moment digitally.

This book documents one of the most mesmerizing and fascinating continents on the globe and Olympus is proud to be part of this historic endeavor. Olympus and its family of dedicated employees around the world invite you to enjoy the images and passion found on these pages. Experience the expressions on the people's faces, the beauty of the countryside, and the magnificent creatures of Africa.

Anheuser-Busch

Since it was founded 150 years ago, Anheuser-Busch has always believed in supporting its communities. Whether it be providing disaster-relief assistance, helping protect and preserve our environment, or supporting scholarship programs for deserving students, Anheuser-Busch believes in making a difference in people's lives.

Today, we are proud to be able to help fund AIDS education through our participation in the *Day in the Life of Africa* project. This project provides us with a way to lend our assistance to an important global health effort aimed at improving many lives, while at the same time providing the world a unique glimpse into life on the African continent, as seen through the eyes of 100 of the world's most accomplished photographers.

Anheuser-Busch believes that contributing to causes that are good for society is also good for our company. Our community involvement extends through the areas of health, education, consumer awareness, environmental conservation, and cultural enrichment.

Through our support, people in underserved communities receive free health screenings. In 1983, Anheuser-Busch introduced its Community Health Mobile Program. Throughout the year, two mobile units travel around the country providing free health screenings—including tests for sickle-cell anemia, high blood pressure, and blood sugar.

Since 1979, Anheuser-Busch has helped raise nearly $160 million for nationwide educational efforts. In 1982, the company partnered with the Hispanic Scholarship Fund to help more than 17,000 Latino students attend college in the United States and Puerto Rico. Established in 1999, Anheuser-Busch's Urban Scholarship Program is a joint effort between the company, its local wholesalers and community-based organizations that helps support local students' efforts to attend college.

For a quarter of a century, our Great Kings and Queens of Africa program has made a valuable contribution to African-American culture. In cities across America, our traveling exhibit of 29 specially commissioned portraits has touched the lives of millions—giving them an opportunity to recall and honor the historic accomplishments of Africa's great leaders.

We've made many friends along the way, and we hope our dedication to communities will continue to fulfill our mission of making friends—here and throughout the world.

We hope you enjoy this fascinating book.

AUGUST A. BUSCH III

ChevronTexaco

It is with great pride that ChevronTexaco sponsors *A Day in the Life of Africa*, a project which celebrates a continent where we have forged lasting business partnerships for nearly a hundred years.

Active in more than 50 African countries, ChevronTexaco stands as sub-Saharan Africa's largest U.S.–based investor. And over the next five years, ChevronTexaco and its partners plan to invest $21 billion in the continent's energy future. With combined production exceeding 1 million barrels of oil a day, ChevronTexaco's African operations rank among the world's premier petroleum resources.

However, there is more to our activities in Africa than numbers and assets. It is our commitment to people and partnerships that are the true measure of our involvement.

ChevronTexaco constantly seeks ways to synergize resource development and environmental protection. ChevronTexaco is leading the proposed West African Gas Pipeline project, expected to cut greenhouse gas emissions by 100 million tons; its planned Gas-to-Liquids and Escravos Gas plants in Nigeria will eliminate routine gas flaring while producing ultra-clean diesel fuels. Other efforts include spending nearly $400 million in state-of-the-art upgrades for our facilities, and company-sponsored centers for environmental research, mangrove reforestation, and wildlife preservation.

Wherever it operates in Africa, ChevronTexaco understands its responsibilities as an involved community partner, supporting improvements in education, health, and local economies. Over the years, the company has provided jobs and management opportunities for thousands of Africans; today, close to 90 percent of its African workforce are national employees. Thousands of students have earned scholarships to colleges, universities, and technical schools. Additionally, the company has built schools, clinics, and housing, and sponsored facilities for screening of hepatitis, malaria, HIV, and other infectious diseases. Through the late Leon H. Sullivan's developmental group, ChevronTexaco helps provide basic job training skills and fund local businesses.

In 2001, the company sponsored AIDS education for African women journalists, launched a riverboat ambulance service in the western Niger Delta, and took steps to provide electricity for 100,000 residents near our operations in Nigeria. The company supplied farmers with tools, crops, and training in Angola, renovated the only hospital in Muanda, Democratic Republic of Congo, and helped partially rebuild the University of Brazzaville, the Republic of Congo's only university. In South Africa, Caltex supports Black Economic Empowerment and other efforts to achieve parity of financial opportunity.

In these and many other ways, ChevronTexaco is woven into Africa's richly varied fabric—its work, its communities, its future. Indeed, to no small extent, *A Day in the Life of Africa* is a day in the life of ChevronTexaco. And we are delighted to support efforts that serve to tell Africa's positive stories—not just from this *Day*, but for every day.

Apple

Apple technology has played an important role in the Day in the Life series for nearly two decades. Apple is particularly proud to support this landmark project that will benefit AIDS education programs in Africa.

Hotel Partner

Le Méridien

Le Méridien is a global hotel group with a portfolio of 145 luxury and upscale hotels (41,630 rooms) in 55 countries worldwide. In Africa and the Indian Ocean region, it is currently the leading upscale hotel group with more than 30 hotels covering all of Africa, from Egypt and Morocco in the north, to Malawi in the south. The majority of its properties are located in the world's top cities and resorts, throughout Europe, the Americas, Asia-Pacific, Africa, and the Middle East. The company also enjoys a strategic alliance with JAL-owned Nikko Hotels, providing loyal guests access to an additional 42 properties around the world. Headquartered in London, Le Méridien Hotels & Resorts Ltd. is owned by Nomura International PLC and managed by Terra Firma Capital Partners.

Music Partner

BMG

BMG is one of the world's premier music companies with more than 200 record labels in 42 countries, including Ariola, Arista Records, BMG Funhouse, RCA Label Group Nashville, and RCA Records. In addition, BMG owns one of the world's largest music publishing companies. Headquartered in New York City's Times Square and overseen by Chairman and Chief Executive Officer Rolf Schmidt-Holtz, BMG's operating units around the world include Arista Records, J Records, BMG Asia Pacific , BMG Distribution, BMG Europe , BMG Latin , BMG Music Publishing and RCA Music Group. BMG's worldwide superstars include Christina Aguilera, Patrick Bruel, Dido, Dave Matthews Band, Whitney Houston, R. Kelly, Kenny G, Annie Lennox, Sarah McLachlan, Modern Talking, Alicia Keys, Busta Rhymes, OutKast, Pink, Eros Ramazzotti, Santana, The Foo Fighters, TLC, Usher, Westlife, Barry White, and George Winston, among others.

Venture Funding

The LJCB Investment Group

The LJCB Investment Group is the investment vehicle for the Lee and Leon Liberman family group of companies of Melbourne, Australia. The Investment Group comprises a range of companies with diverse interests. LJCB's businesses are conducted in an international arena, with a focus towards private equity businesses. It also has a film- and book-production arm. The Group's philanthropic activities focus on Jewish, community, and humanitarian pursuits; education, science, and medicine; the environment; and the arts.

Sponsors

Lexar Media

Lexar Media has grown out of the digital photography revolution, which is why we are proud to have supplied the digital film memory used in *The Day in the Life of Africa*—the first all-digital project in the Day in the Life series. Our high-performance memory cards have a unique, patented design that brings out the ultimate performance of any digital camera. With image write-speeds of up to 24x, capacities to 1 gigabyte and unparalleled support, photographers who demand the most from their equipment choose digital film memory from Lexar Media. Leading digital camera manufacturers choose our products as well. Olympus, Nikon, Minolta, and others package Lexar Media digital film with their cameras because they value its performance and reliability. Lexar Media is at the forefront of digital photography as it transforms picture-taking worldwide, and we will continue to perfect digital image capture with even more innovative solutions for professionals and amateurs alike.

The World Bank Group

A Day in the Life of Africa is a broad view of Africa, home to more than 700 million people among whom are the poor, the wealthy, the innovative, the entrepreneurial, farmers and industrialists, teachers and students. You will find in this book evidence of what has been achieved in Africa and what remains to be done in the region's long walk to development. You will see images that fit media-created stereotypes and those that defy them. You will discover Africa as it is and signs of what it hopes to become.

The World Bank continues to work with the region's leaders to bring Africa fully from the economic periphery to the very heart of the global community. The pictures in this book explain why we have taken that option and why we are optimistic about the ultimate outcome.

JAMES D. WOLFENSOHN
President

Eskom

From the Cape of Good Hope to Cairo, the African continent is home to more than 12 percent of the world's population, which accounts for over three-quarters of a billion people from more than 800 distinct ethnic groups. Sadly, since the start of the AIDS pandemic, millions of Africans have died of the disease, and more African men, women, and children become infected daily.

At Eskom, Africa's largest electricity utility, we conduct business throughout Africa and are committed to extending the hand of partnership across the continent and beyond. As an African company, we have an intimate knowledge of operating conditions in Africa and believe that energy is key to development, economic growth, and the improvement of living standards. Eskom's AIDS program began with an awareness campaign in 1988, but seven years later, management decided that the emerging statistics made the fight against the disease a top strategic priority. In 1988 Eskom received the prestigious Business Excellence award from the Global Business Council for its response to HIV/AIDS, as well as a recognition certificate from the United Nations. It has also committed 30 million South African rand

($3 million) to research into the development of an AIDS vaccine.

Our company aligns itself with the view that Africa, with its natural wealth and intellectual capital, has the potential to become a huge economic success story. All we have to do is put our collective energies into its growth and development.

Eskom seized the opportunity to sponsor *A Day in the Life of Africa*, because we see it as a new hope for Africa. Not only is this project a celebration of African life; it is also one that will actually help save African lives. The publishing profits from the book will be used to fund AIDS education in Africa and, as we at Eskom have long realized, education is our single most powerful weapon against the spreads of the virus.

No matter where we work, Eskom will continue to use electricity to illuminate minds as well as homes.

REUEL J. KHOZA
Chairman

Publishers Group West

Established in 1976 and headquartered in Berkeley, California, Publishers Group West (PGW) is the largest exclusive distributor of independent publishers in North America. One of the top-10 vendors of books in the country, Publishers Group West represents over 120 independent publishers, who together are publishing some of the most topical, innovative, literary, and award-winning books available today. Part of PGW's proceeds from the sale of *A Day in the Life of Africa* will benefit AIDS-education programs in Africa.

Radical Media

@radical.media is a media and entertainment company with a network of full-service offices in New York, Los Angeles, London, Paris, Berlin, and Sydney. In addition to working with most of the world's advertising agencies on commercial production, we actively explore ways to link advertisers with original content. Our capabilities in this arena include feature film, television, and live theater production; emerging media, including interactive and graphic design; and branded content development. More information on @radical.media, our clients, and our work is available at our website, www.radicalmedia.com.

Pictopia.com

Pictopia is the Internet's premier photo lab, specializing in the very highest quality photographic prints from digital images, with an emphasis on new technologies and expert personal service. Pictopia is the place where photographers and our expert staff collaborate to fuse art with technology, achieving the utmost expression that best suits each image. Our state-of-the-art photographic printing process is a result of our integration of the world's very best materials, machinery, and unique proprietary technologies. From scanning and online image management to e-commerce print fulfillment, Pictopia offers clients the full spectrum of custom photographic services and solutions.

South African Airways

In 1934, the Union of South Africa acquired all assets and liabilities of a private airline, Union Airways, and absorbed it into a new national airline—South African Airways (SAA). By 1945, SAA was flying to the United Kingdom, and today it flies passengers to more than 120 cities worldwide. SAA has established a seamless and linear service to enhance the travel experience of our customers. From SAA's curbside concierge check-in service, through dedicated immigration, to the First Class lounges, and finally, onto the aircraft. The leading African airline, and *A Day in the Life of Africa*'s only African airline partner, SAA is proud to have helped project photographers fly to their assignments across the African continent.

Minds@Work

Established in 1999, Minds@Work created the Portable Smart Storage product category with the introduction of its debut product, the Digital Wallet. Minds@Work has since introduced its second-generation product line, MindStor. Both the Digital Wallet and MindStor products allow digital photographers to download digital images from any flash memory source to a high-capacity, battery-powered storage device. Each of the *Day in the Life of Africa* photographers was equipped with a 5-gigabyte MindStor, allowing them to shoot and store thousands of digital images in the field. For more information, visit www.mindsatwork.net.

AIDS Education Fund

The HIV/AIDS scourge that is ravaging the African continent is generally considered to be the most devastating to strike humankind since the Black Death decimated Europe in the Middle Ages.

When the beautiful photographs in this book were shot, on February 28, 2002, it was generally believed that more than 15 million people had already perished in the African AIDS pandemic, and as many as 25 million more Africans were infected.

The *Day in the Life of Africa* project is trying to make a difference in the fight against African AIDS. Here's how: When you purchase *A Day in the Life of Africa*, all of the publishing profits are directed to the Day in the Life of Africa AIDS Education Fund. This fund was created for the express purpose of channeling money into effective, on-the-ground AIDS-education programs on the African continent.

These programs are administered by Tides Foundation of San Francisco, in collaboration with advisors from the Harvard AIDS Institute, the Johns Hopkins University Center for Communication Programs, and South Africa's famed Soul City Institute for Health and Development Communication.

Programs initiated and supported by the fund utilize entertaining educational content and appropriate popular media to inform young Africans, in particular, about the perils, prevention, and treatment of HIV/AIDS. These programs always strive to be cost-effective and culturally appropriate. The core belief of the Fund is that educating African youth about HIV/AIDS is a key to Africa's future.

To contribute to the Day in the Life of Africa AIDS Education Fund or to get more information, please go to www.ditlafrica.com/aidsfund.

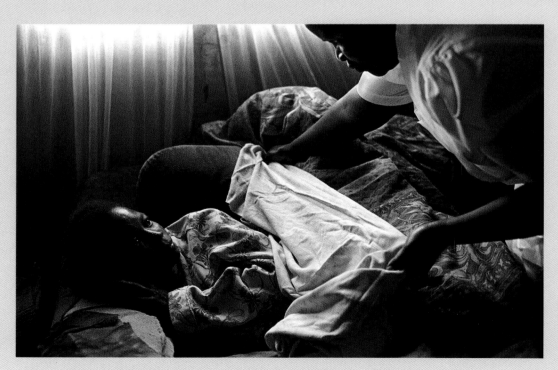

> AIDS patient Rosinah Motshegwa, 29, with her caregiver, by James Nachtwey in Khutsong, South Africa.